Beatific Soul

Jack Kerouac on the Road

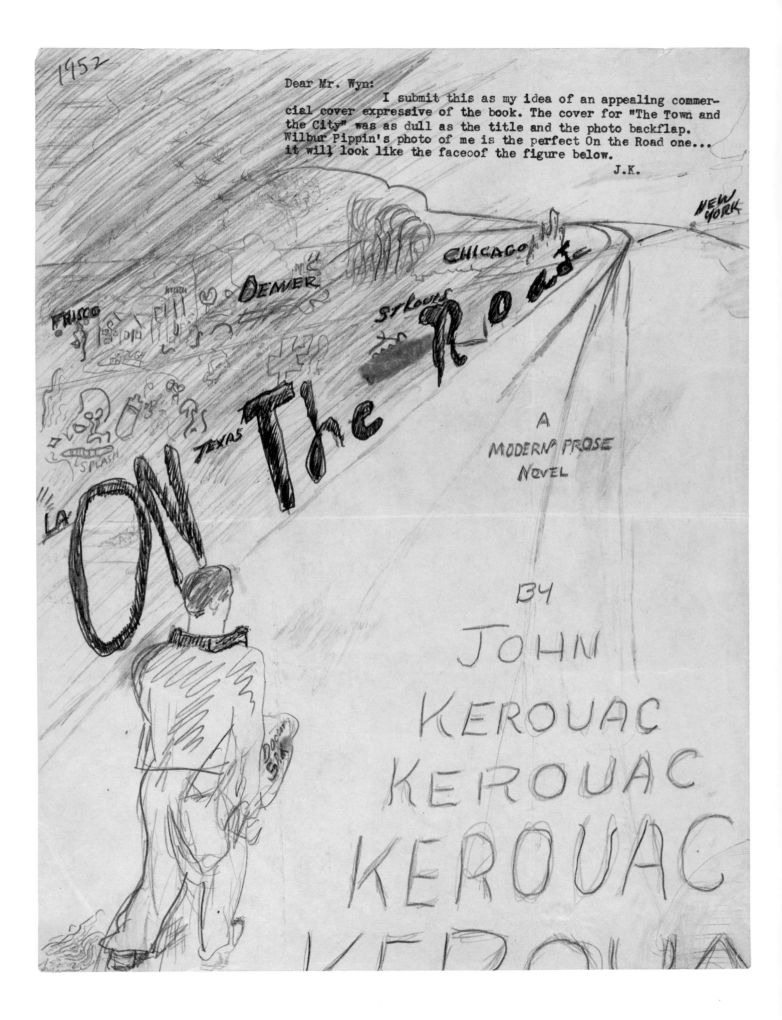

Beatific Soul
Jack Kerouac on the Road

Isaac Gewirtz

The New York Public Library

IN ASSOCIATION WITH

Published on the occasion of the exhibition
Beatific Soul: Jack Kerouac on the Road
presented at The New York Public Library
Humanities and Social Sciences Library
D. Samuel and Jeane H. Gottesman
Exhibition Hall
November 9, 2007–March 16, 2008

This publication has been made possible,
in part, by the Henry W. and Albert A. Berg
Collection of English and American Literature.

Support for The New York Public Library's
Exhibitions Program
has been provided by Celeste Bartos,
Mahnaz I. and Adam Bartos,
Jonathan Altman,
and Sue and Edgar Wachenheim III.

First published in 2007 by
The New York Public Library
476 Fifth Avenue
New York, NY 10018-2788
and
Scala Publishers Limited
Northburgh House
10 Northburgh Street
London EC1V 0AT
www.scalapublishers.com

Distributed outside
The New York Public Library
in the booktrade by
Antique Collectors' Club Limited
Eastworks
116 Pleasant Street, Suite 60B
Easthampton, MA 01027, USA

Edited by Barbara Bergeron
Designed by Katy Homan
Project Managed by Stephanie Emerson

Photography:
Matt Flynn: Figs. 1.1–3, 7, 9–11, 13; 2.1–3, 8–9,
13, 16, 19, 22, 28; 3.14; 4.1–3, 5–6; 5.1–13, 15–16;
6.1–9
Peter Riesett: Figs. 1.4–6, 8, 12; 2.4–7, 10–12,
14–15, 17–18, 20–21, 23–27; 3.1–13; 5.14

Produced by Scala Publishers Limited
Oliver Craske, Editorial Director
Claudia Varosio, Production Manager
Printed and bound in Singapore
10 9 8 7 6 5 4 3 2 1

ISBN: 978-1-85759-497-3
Cataloging-in-Publication Data is available from
the Library of Congress

Frontispiece: Jack Kerouac's proposed front
cover design for a paperback edition of *On the
Road*, 1952 (see fig. 4.1).

The New York Public Library
www.nypl.org

Contents

Foreword

The arrival of the fiftieth anniversary of Jack Kerouac's *On the Road* is an important moment in American letters for at least two reasons. First, because Kerouac (1922–1969) is generally regarded as chief of the triumvirate comprising himself, Allen Ginsberg, and William S. Burroughs, who were the fathers of the Beat movement; and second, because the sensation caused by the publication of *On the Road* on September 5, 1957, brought Kerouac to the attention of a national audience. The New York Public Library could not allow this significant anniversary to pass without an exhibition and accompanying publication, especially since, in 2001, the Library's Henry W. and Albert A. Berg Collection of English and American Literature acquired the Jack Kerouac Archive.

By that time the Berg had already, through purchase and gift, amassed the largest group of Kerouac papers in institutional or private hands, with the exception of the Archive itself. In 2006, the Library acquired for the Berg the William S. Burroughs Archive (i.e., his 1952–72 papers). The presence of these two archives is complemented by the Berg's holdings of significant papers by Allen Ginsberg and Gregory Corso, and of comprehensive collections of printed materials, including rare ephemera, by and relating to Gary Snyder, Lawrence Ferlinghetti, Philip Whalen, and Michael McClure. In addition, the Library's general collections contain vast resources in American history related to what might be called the "Beat period," dating from the mid-1940s, when the Beats were incubating their talents in Manhattan's Morningside Heights, to the end of the 1960s, when their group presence in American letters waned. Clearly, The New York Public Library may now proclaim itself *the* center for Beat research in the world.

To facilitate such research, both the Kerouac and Burroughs archives were organized, and electronic finding aids created for them, with the financial assistance of the Gladys Krieble Delmas Foundation. Thanks to the Foundation's generosity, the finding aids are available to researchers around the world via the Berg's website and the Library's Archival Materials Access Tool (AMAT), both accessible through the Library's home page (www.nypl.org). Our hope is that this book, *Beatific Soul*, and the exhibition it accompanies, will enhance for the general reader and Beat scholar alike an appreciation for the richness and breadth of Kerouac's pioneering achievement, and will encourage new research into the work and life of this important American writer.

Paul LeClerc, *President, The New York Public Library*

Preface

Beatific Soul: Jack Kerouac on the Road complements an exhibition of the same title, curated by this writer, presented at The New York Public Library in celebration of the fiftieth anniversary of the publication of *On the Road*. The title is intended to echo not only the title of Kerouac's most famous novel, but his equation of "beat" with "beatific," and to recall his perpetual journeying into himself, his art, and those ultimate questions sometimes called "spiritual." Both the book and exhibition are drawn almost entirely from materials in the Jack Kerouac Archive, which, since its arrival at the Library in 2001, has been housed in the Henry W. and Albert A. Berg Collection of English and American Literature. Virtually all of this material and, indeed, the vast majority of the Archive's texts—so numerous are they—remains not only unpublished but unexamined, despite a steady stream of researchers who have begun to explore the Archive's riches. *Beatific Soul*, employing the testimony of his manuscripts, notebooks, diaries, journals, photographs, and artworks, reinterprets aspects of his life and work, and enriches our understanding of commonly held assumptions about them. Featured in this effort is an account of the genesis and development of his early works, especially *On the Road*, and of his ideas on literature, art, spirituality, politics, and, to a limited extent, sex.

But the book and the exhibition, respectively, offer different experiences, and not just because we walk through an exhibition and leaf through a book. Whereas the exhibition is organized into eight thematic sections that interpret Kerouac's life and work based on the evidence contained in the archival materials on view, the six chapters of the book integrate many of these texts and graphic images into a systematic exposition of themes and interpretive arguments—an approach that is unsustainable in an exhibition. Conversely, the exhibition contains and interprets more than twice as many objects (approximately 275) as are illustrated in the book, many of them paintings and drawings by Kerouac that have never been displayed and which, of course, are best appreciated "live."

Of particular interest to the literary student will be the chapter "On Writing and the Creative Act," which features Kerouac's evolving theories about writing as well as his incisive comments about other writers, primarily those who comprise the nineteenth-century canon of British, American, French, and Russian literature, but occasionally, and generally in the harshest of terms, his contemporaries. Much of this evolution in Kerouac's approach to writing is also documented in two chapters that trace the genesis and development of *On the Road*, revealing both a years-long preparation process and a years-long process of revision. Significantly, regarding

the latter, only some of Kerouac's changes to the scroll text can be attributed to editorial pressures. He often said that he composed *On the Road* as he typed it in scroll format during the first three weeks of April 1951. As both the book and exhibition demonstrate, the claim, though accurate, is not true.

Perhaps equally surprising to those who know Kerouac chiefly through *On the Road* and the novels that followed it, the numerous early diary and journal entries in which he proclaimed his principles of creative writing show an uncompromising commitment to a Flaubertian measure of technical control. Not until the early 1950s would he begin to formulate his theories of "spontaneous prose," and even these formulations, as represented in the journal and diary entries, are not as absolute in their definition of "spontaneous" as his published statements would suggest. Moreover, all of the journal and diary entries on the subject presuppose a writer who has already spent many years in painstaking apprenticeship to his art. As for politics, Kerouac reveals himself in his journals, as early as 1941, to be a radical conservative of a populist-nativist sort, prophesying political and spiritual renewal through the virtuous, hard-working, family-oriented values of small-town America; mocking the liberal principles that he no doubt heard advocated by his Columbia friends; excoriating both big-city businessmen and Franklin D. Roosevelt alike as traitors; and even expressing sympathy (until America entered the Second World War) for the worker-friendly goals of "Hitlerism," though regretting its "vulgarity & crudeness."

The Archive's revelations are no less dramatic in regard to Kerouac's spirituality. Although many Beat scholars and critics have observed that his literary journey cannot be understood apart from his spiritual quest, the diaries, journals, and notebooks enlarge our understanding of the extent to which writing was for Kerouac a spiritual discipline. And although the depth of his commitment to Buddhism is well known from several published works, the diaries and journals show in even more intimate detail the rigor with which he pursued his inquiry into the sutras (i.e., the teachings of the Buddha), the discipline with which he gave himself to meditation, and the studious, if eccentric, manner in which he began to meld Christian ideas about God and personal salvation with Buddhist insights into the mind, meditation, and enlightenment.

Each of the above subjects could be the focus of several books, not only because of the Archive's voluminous holdings, but because the complexity of Kerouac's persona, thought, and artistic creativity can sustain a wide variety of interpretive approaches. Subjects that regrettably could not be treated in this book or could be only briefly touched upon include the evolution of each of Kerouac's published works; a reevaluation of the aims of the Beat "movement" and its points of similarity to and difference from the alternative American and European literary movements of the period; Kerouac's thoughts on the cinema and his attempts to write for the screen; the role of his French and French-Canadian heritage in his writing and in the formation of his identity; his fantasy sports materials, comprising mainly baseball and horseracing, with a brief foray into fantasy college sports journalism; and his attitudes toward sex, personal relationships, and his alcoholism, as well as the periodic outbreaks of bigotry that found voice in his diaries. I trust that the necessarily abbreviated number and treatment of the subjects examined here will, nevertheless, sufficiently intrigue Kerouac researchers, as well as novelists and poets, to

come to the Archive to learn more about this purest of writers and most conflicted of men, who wanted only to "write a huge novel explaining everything to everybody."

Note: The majority of Kerouac's notebooks are neither paginated nor foliated, and the page and leaf number citations therefore appear in brackets. The spiral-bound and vertically oriented notebooks in which he kept all of his diaries from the early 1950s forward, as well as most of his journals, proceed in a "stenographic" style. That is, he would write on the rectos of successive leaves until he reached the end of the notebook and would then turn over the notebook and proceed in the opposite direction, writing on the versos. This is why some of the cited foliations (e.g., the leaves on which an essay or diary entry appears in one of these notebooks) proceed in reverse order.

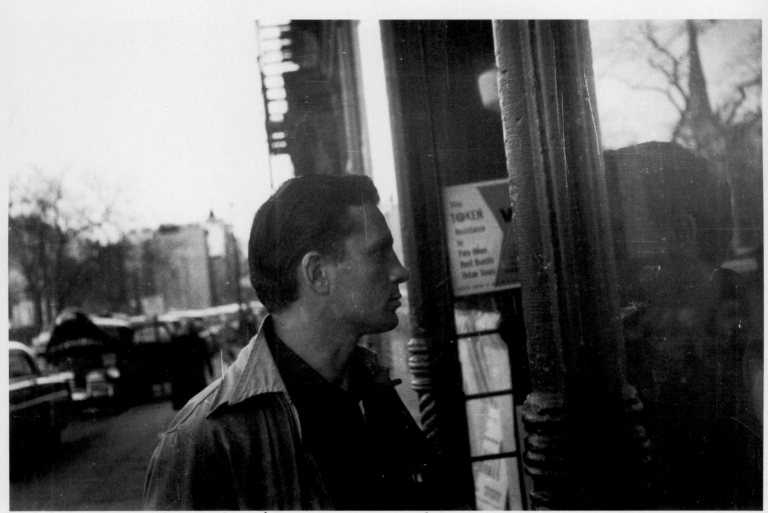

Jack Kerouac Avenue A across from Thompkins park 1953 New York, his handsome face looking into barroom door — This is best profile of his intelligence as I saw it sacred, time of _Subterraneans_ writing.
 Allen Ginsberg

The Beat Generation

In *On the Road*, Sal Paradise, the novel's hesitant, knight-errant narrator (temperamentally more akin to Sancho Panza than to Don Quixote), says reverently of his hero, the charismatic, fearless, car-jacking Dean Moriarty, "He was BEAT—the root, the soul of Beatific."[1] Just what and who was "Beat" is a question that Jack Kerouac addressed not only in his published works, but also, as we shall see, in his diaries and journals. The word itself was introduced to Kerouac by the junky, petty thief, and Times Square hustler Herbert Huncke (1915–1996), who met Kerouac in early 1945, and who would become a writer whom Kerouac, for a time, enormously admired.[2] "Beat" had long been an American slang synonym of "down and out," not only in the financial sense, but physically and emotionally; in 1960, recalling his own research into the word, Kerouac dated this sense of it to 1910.[3] But for him, as well as for Allen Ginsberg and William S. Burroughs (in Burroughs's case, this is implied by his writing rather than stated explicitly), "beat" always had a positive as well as a negative connotation, in the sense that only at the most desperate moments could one see honestly and speak truthfully. Still, when Kerouac joined "beatific" to "beat" in a 1948 journal, he made explicit the spiritual dimension of a goal that he and his friends had been seeking through their hours-long confessional/analytical conversations with each other about each other; through their discussions of writers and philosophers, often as they sped through the New York night on Benzedrine; and, most important, through their writing.

The core members of the Beat Generation were drawn from Kerouac's circle of friends formed in the Columbia University neighborhood of Morningside Heights after he had dropped out of Columbia for the second time, in 1942, and then shipped out twice on Liberty Ships as a Merchant Mariner: Lucien Carr (whom he met in September 1943), Allen Ginsberg (spring 1944), William S. Burroughs (July 1944), Herbert Huncke (January 1945), Neal Cassady (December 1946), and John Clellon Holmes (July 1948). Carr (1925–2005)—handsome, charismatic, well-read, extremely witty, and playfully sadistic—was the scion of an old, wealthy Louisiana family, and swanned his way through life with an aristocratic air of arrogant entitlement. When Kerouac met him, through Kerouac's society girlfriend Edie Parker, Carr was a freshman at Columbia, hotly pursued by numerous gay students and professors. (Carr and his girlfriend regularly sought refuge at Parker's apartment.) Kerouac himself admitted to having developed a bit of a crush on him. Perhaps for more than any other member of the Morningside Heights circle, his

Fig. 1.1

Allen Ginsberg, photographer. "Jack Kerouac Avenue A across from Thompkins [sic] Park 1953 New York, his handsome face looking into barroom door—This is best profile of his intelligence as I saw it Sacred, time of Subterraneans writing," [October?] 1953. 11" x 14".

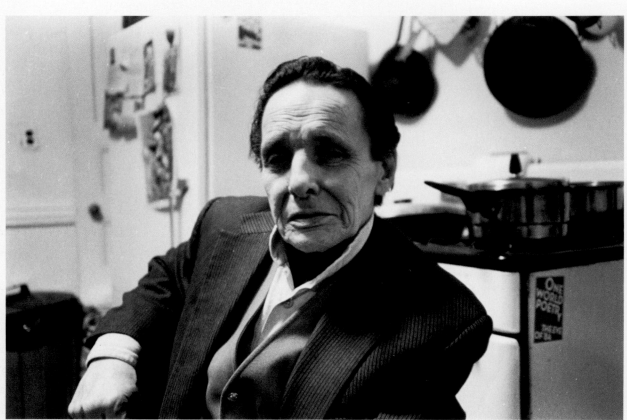

Wise Herbert Huncke, grateful for the attention, a knowing look. 1984. Allen Ginsberg

Fig. 1.2
Allen Ginsberg, photographer. "Wise Herbert Huncke, grateful for the attention, a knowing look. 1984." 11" x 14".
In *Desolation Angels* (Book One, Chapter 77), Kerouac describes Huncke parenthetically: "(Huck whom you'll see on Times Square, somnolent and alert, sad-sweet, dark, beat, just out of jail, martyred, tortured by sidewalks, starved for sex and companionship, open to anything, ready to introduce new worlds with a shrug)."

Fig. 1.3
"Morningside Heights." Pencil sketch on paper, April 30, 1957. 6" x 4".

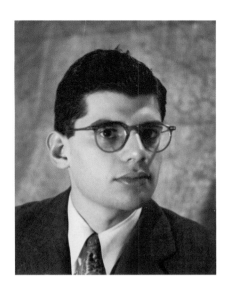

Fig. 1.4

Unknown photographer. Allen Ginsberg, early 1940s. 5" x 4".

inclusion among the Beats needs some explanation, since he was not a poet, novelist, dramatist, or artist of any kind.

After his Columbia schooling, cut short by a two-year prison term for killing a gay devotee ten years his senior, David Kammerer, who had been obsessed with him for more than a decade (see Chapter 2, "Early Life, Influences, and Writing"), Carr went to work for the UPI news wire service. Nevertheless, through the brilliance of his mind and conversation (Kerouac described his linguistic power as Shakespearian), he exerted an important literary and philosophical influence on Kerouac, as well as on Ginsberg, with his "New Vision"—a "philosophy" influenced by equal parts of Nietzsche and Rimbaud—from the time he and Kerouac met in 1943 until Carr killed Kammerer in 1945. But Carr's literary judgment continued to carry weight with Kerouac at least through 1957, when, proclaiming in a diary entry the greatness of his experimental novel *Lucien Midnight* (published as *Old Angel Midnight* in 1973), inspired by Carr, and *The Dharma Bums*, which he had just completed, he predicts that both works would be "too great for my contemporaries except maybe 2, 3 prophets like Allen [Ginsberg], Bill [Burroughs], Lucien [Carr], Gary [Snyder],* *Neal [Cassady]."4

Allen Ginsberg (1926–1997) was a Columbia freshman when he met Kerouac, four years his elder, at an age when such a disparity is meaningful. Adding to the contrast between the two, Kerouac was physically imposing (although only 5' 9", he had a broad, muscular frame) and ruggedly handsome, had served as a Merchant Mariner in the U-boat–infested North Atlantic, and, though he had as yet published nothing, was generally regarded on the Columbia campus as a writer with great promise. Ginsberg, on the other hand, was a skinny adolescent who knew little of life, was insecure about his appearance, and was confused and anxious about his homosexuality and his budding literary ambitions. By his own account, he was in awe of Kerouac and a bit frightened of him as well. Even as an adult, Ginsberg's regard for Kerouac contained an element of the worshipful teenager in love with the football hero, despite Kerouac's often repaying him, especially from the late 1950s forward, with accusations of betrayal and with Jew-baiting insults. The reading that Ginsberg gave in San Francisco's "Six Gallery," on October 7, 1955, of his poem "Howl" may be said to have introduced the "Beat" into the American literary imagination. The poem's opening is often quoted as an expression of Beat sensibility as well as its indictment: "I saw the best minds of my generation destroyed by madness, starving, hysterical naked, dragging themselves through the negro streets at dawn looking for an angry fix."

Kerouac's feelings toward Ginsberg seem to have become mildly ambivalent by at least as early as December 1953, when he refers to him in a notebook as "intelligent enuf, interested in the outward appearance & pose of great things, intelligent enuf to know where to find them, but once there he acts like Jerry Newman, the photographer [also a record producer, who appears in Kerouac's *Visions of Cody* and *Book of Dreams* as Danny Richman, and as Larry O'Hara in *The Subterraneans*] anxious to be photographed photographing—Ginsberg wants to run his hand up the backs of people, for this he gives and seldom takes—He is also a mental screwball[.]"5 Thereafter, Kerouac became almost paranoid about Ginsberg's alleged plagiarism, a feeling that was linked to his growing antipathy toward Jews, the expression of

Fig. 1.5

Allen Ginsberg. "Strophes: Howl for Carl Solomon / first page sample of 5 page work in progress," [1955?]. 11" h.

This typescript draft fragment of a working draft of "Howl" contains important differences from the poem's published version. Several of the "who" passages in the draft do not appear in the published version, some of the passages appear in an order different from the order of the draft text, and phrasing and punctuation are occasionally changed.

STROPHES:HOWL FOR CARL SOLOMON

first page sample of 5 page work in progress

```
I saw the best minds of my generation destroyed by madness,
    starving, hysterical, naked dragging themselves through the angry
        streets at dawn looking for a negro fix,
angel-head hipsters looking for the shuddering connection between
    the wheels and wires of the dynamo machine of night,
who poverty and tatters and hollow-eyed and high sat up
    in the supernatural darkness of cold water flats floating
        across the tops of cities contemplating jazz,
who bared their brains to heaven under the El and saw Mohhamedan
    angels staggering on tenement roofs illuminated,
who sat in rooms unshaven burning their underwear amid the rubbish
    of money and Bronx manifestoes listening to the Terror
        through the wall,
who passed through universities with  radiant cool eyes hallucinating
    Arkansas and Blake-light tragedy amid the scholars of the war,
who burned in Paradise Alleys of turpentine and Paint, and got busted
    in their beards returning through Laredo with a belt
        of marihuana for New York,
who purgatoried their torsos night after night with dreams, with drugs,
    with waking nightmares, alchohol and cock and endless balls,
who walked incomparable blind streets of shuddering cloud and lightning
    in the mind leaping toward poles of Canada and Alabama
        illuminating all the motionless world of time between,
who fell into peyote solidities of halls, backyard green tree
    cemetary dawns behind Manhattan, wine drunkenness over rooftops,
        boroughs of teahead neon green & blinking traffic reddened light,
        sun and moon and tree vibrations in the roaring winter dusks
        of Brooklyn, ashcan rantings and king light of mind,
who chained themselves to subways for the endless ride from Battery
    to holy Bronx until the noise of wheels and children
        brought them down on Benzedrine shuddering mouth-wracked
        and battered bleak of brain all drained of brilliance
        in the drear light of Zoo,
who sat all morning afternoon on beer in desolate Fugazzi's
    listening to the crack of doom on the hydrogen jukebox,
who talked continuously seventy hours from park to pad to bar to
    Bellevue to museum to the Brooklyn Bridge,
yackatayaking screaming vomiting whispering facts and memories
    and anecdotes and eyeball kicks and shocks
        of hospitals and jails and wars,
a lost batallion of platonic conversationalists jumping down the
    stoops off windows off the fire escape off Empire State
        out of the moon,
who vanished into Buddhist nowheres in New Jersey leaving a trail
    of ambiguous picture postcards of Atlantic Cryptic Hall,
who suffered eastern sweats and Tangerian bone-grindings and
    migraines of China under junk-withdrawal in Newark's
        bleak furnished room,
who lounged hungry and lonesome through Huston seeking jazz or soup,
    or followed the brilliant Spaniard to converse about
        America and Eternity, a hopeless task, & so took ship to Africa,
who lit cigarettes in boxcars boxcars boxcars racketing through snow
    toward lonesome farms in grandfather night,
who studied Boehme and Spengler, telepathy and jazz kaballah because
    the cosmos instinctively vibrated at their feet in Kansas,
who loned it though the streets of Idaho seeking visionary indian
    angels who were visionary indian angels,
who burned on highways juornying night to night to each other's
    hot rod golgotha Burmingham jail solitude watch ax
        or Los Angeles jazz incarnation,
```

which becomes a regular feature of his diaries especially, although such remarks are not confined to them. A few selections will suffice. In 1954, he begins a one-page manuscript with the phrase, "Neal is Beatific, I am beatific, Allen was beatific." He consigns Ginsberg's beatitude to the past because "his Slavic East European Long Ears grew out & I saw he was really the Devil, like [Pierre] Mendès-France, Bud[d] Schulberg, Herbert Gold & the secret ugly [...]"—the passage ends elliptically.[6] After tentatively ascribing beatitude to another Beat friend, John Clellon Holmes, Kerouac returns to his main theme—"Jewdom is an East European conspiracy & is Ezra Pound so crazy?"—and posits a Jewish predilection for Marxism (though he elsewhere depicts Jews as rapacious capitalists), which he bizarrely attributes to Judaism's supposed "Aramean" background.[7] Two years later, in a 1956 notebook,[8] he writes that he must try to forgive Ginsberg for his "evil schemes" before Ginsberg dies. In a 1967 notebook, he writes, "Every time I hear a 'Cultured Jew' speak 'French' it cuts into my heart to hear such Corruption—"[9] For Kerouac, a Jew speaking French is both a degradation of his exalted Gallic culture and another rank

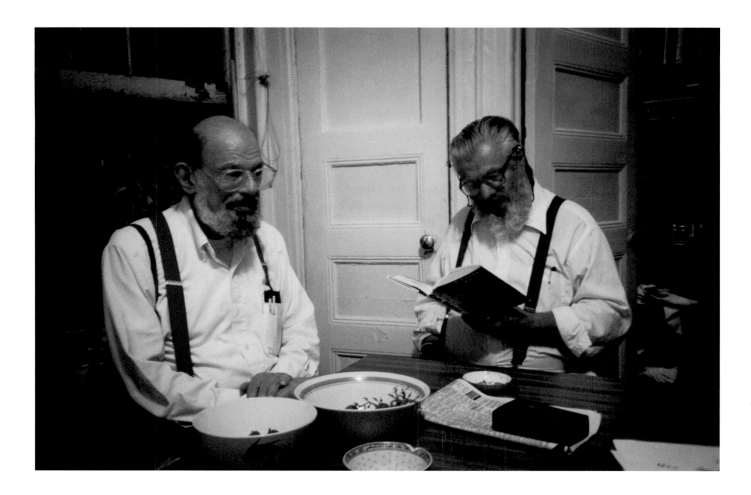

Fig. 1.6

Gordon Ball, photographer. Allen Ginsberg and Peter Orlovsky at kitchen table, [June 1996]. 8" x 11".

Peter Orlovsky came to San Francisco in 1953, after his discharge from the Army, and met the painter Robert LaVigne, whose model and lover he became. LaVigne introduced Orlovsky to Ginsberg in 1954, and they soon became lovers, moved in together, and began a life of partnership that ended only with Ginsberg's death. Orlovsky appears as "George" in Kerouac's *The Dharma Bums*, and as "Simon Darlovsky" in *Book of Dreams* and *Desolation Angels*. Here Orlovsky is reading the novel *Go Now*, by the poet and punk rocker Richard Hell.

instance of Jewish cultural theft. By 1969, less than a month before his death, in an interview for the *St. Petersburg Times*, speaking about the chief threat to America, he replies to a question, "The Mafia? The Communist is the main enemy—the Jew."[10]

Nevertheless, Kerouac maintained outwardly warm relations with Ginsberg through the late 1950s (as well as with several other Jewish friends), even, on occasion, writing positively of him in diary entries through the 1960s. As late as 1967, he acknowledges in a notebook that Ginsberg has always supported him and that the two of them are in some essential way eternally paired, noting matter-of-factly (after having accused Ginsberg of stealing one of his aperçus)[11] that Ginsberg regards him as an important literary figure, though he thinks himself far less complex than does Ginsberg, and wonders if such relationships existed between other literary couples, "between Shakespeare, say, & Earl of Northampton, or Blake & Crabbe, or Johnson-Boswell, Coleridge-Wordsworth, Joyce-Pound etc."[12] In 1963, Kerouac was willing to give Ginsberg public credit for having helped him appreciate Rimbaud, Verlaine, Hart Crane, Genet, Blake, and Dante.[13] But the warring factions of Kerouac's psyche would not allow him to maintain a relationship free of paranoia, bitterness, and feelings of betrayal, with Ginsberg or, for that matter, any of his Beat friends.

The one near-exception to this rule was Burroughs (1914–1997), whom Kerouac would recall toward the end of his life as having been "my great teacher in the night,"[14] and whose writing and integrity, in the sense of being true to oneself, he continued to honor, despite the occasional insults and jibes he flung at him in

his diaries and journals. Just as Ginsberg looked up to Kerouac, so did Kerouac regard Burroughs as a mentor, even as a kind of spiritual teacher. Kerouac's attitude is understandable. Burroughs, the son of a wealthy St. Louis family (owners of the Burroughs Adding Machine Company), was Kerouac's elder by eight years, had graduated from Harvard (where he had studied Shakespeare under G. L. Kitteridge), had an encyclopedic knowledge of world history and third world cultures, had lived in Vienna (where he studied medicine), and had visited other European cities. After residing briefly in Chicago, where he worked for a time as an exterminator, he followed his friends Lucien Carr and David Kammerer to New York. Carr eventually introduced him to Kerouac, who had just recently dropped out of Columbia, and to Ginsberg, who was a freshman there. In 1944, Burroughs met Joan Vollmer Adams, a friend of Kerouac's first wife, Edie Parker. Although he was homosexual, Burroughs initiated an affair with Vollmer (who was married and had a daughter), and they, Vollmer's daughter, and the Kerouacs (Jack and Edie) shared an apartment in Morningside Heights. In that same year, Burroughs became a heroin and morphine addict. The subject of drug addiction would figure prominently in his writing, most notably in *Junkie* (London, 1957) and *The Naked Lunch* (Paris, 1959).

Burroughs had about him an air of self-possession and assurance envied by Kerouac, who in unfamiliar social situations blustered his way through his anxieties or retreated with them into a corner. In the early years of their relationship, Kerouac would watch Burroughs with enthralled attention, as if he were a magus or holy man who might at any moment impart to him esoteric truths, in a word, gesture, or facial expression. His reverence for Burroughs illuminates a journal entry of July 24, 1945, in which he observes that when Burroughs "ruminates" on a "psychological phenomenon [...] he looks carefully down in front of him, almost like a priest at prayer-time, and, with hands folded, tries to plumb the depths of things. It is a very remarkable thing to see ... it is when the asceticism of his face becomes a kind of mystic freezing. This is when, with eyelids lowered piously, he looks more like a Medieval saint than ever."[15]

By the fall of 1946, in a piece entitled "On Bill Burroughs," Kerouac declares in his journal that "I'm no longer a sycophant of Burroughs' myself, but I can tell you that it is much easier and more profitable to sit at this 'gray gloomy man's' feet than anyone else I know. He's not a remarkable thinker or anything like that. He's just the world's greatest actor in the moody fantastic drama of his own life." Kerouac may no longer have been a sycophant, but he was no less in thrall to Burroughs, despite his protestation to the contrary. On the page following this declaration of independence, the degree of affectionate fascination with which Kerouac continued to regard Burroughs's baroque persona and gnomic temperament can be seen in his account of a typical visit to Burroughs's apartment:

> For a while he had a machine-gun under his bed. When I used to visit him in his apartment in the slums later on, he used to open the door very cautiously, just a few inches with the chain secure, and stick his nose to see who it was, perhaps even to sniff a bit. He always said he could smell cops. Then, after he was satisfied playing this little game, making sure that I indeed was myself, he would unlatch the chain and open the door a few more inches and let me

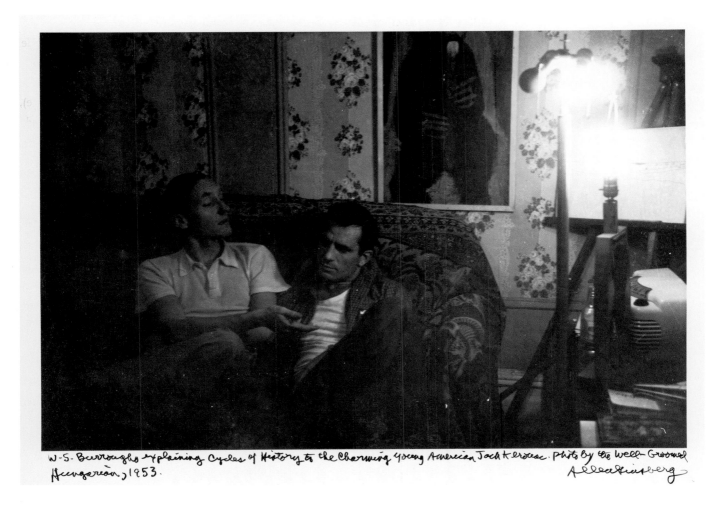

W. S. Burroughs explaining cycles of History to the Charming Young American Jack Kerouac. Photo by the Well-Groomed Hungarian, 1953.

Allen Ginsberg

Fig. 1.7

Allen Ginsberg, photographer. "W. S. Burroughs explaining cycles of History to the Charming Young American Jack Kerouac. Photo by the Well-Groomed Hungarian, 1953." 11" x 14".

In *Vanity of Duluoz* (Book Eleven, Chapter XII), Kerouac recalls his first conversation with Burroughs as "Harbinger of the day when we'd become fast friends and he'd hand me the full two-volume edition of Spengler's *Decline of the West* and say 'EEE di fy your mind, my boy, with the grand actuality of Fact.' When he would become my great teacher in the night."

in squeezing. I remember the time he did this and I found his [sic] wearing a derby hat and a dirty old vest over his bare chest. "What are you doing?" I asked. He said he was pounding birdseed in a pan to see if he could roll it up in cigarettes and smoke it. He was always busy at something or other.[16]

In 1945, Burroughs took Vollmer as his common law wife, and the following year they moved, with Vollmer's daughter, to a Texas farm. After various domestic developments, including the birth of a son and a marijuana arrest, Burroughs, while out on bail, fled to Mexico with his wife and the children. He would not return to the United States, except on very brief visits, for the next twenty-four years. In 1951 he shot his wife at a party, during a drunken game of "William Tell." He was arrested, but the Mexico City authorities declared her death accidental and freed him. After sending Vollmer's daughter to live with her grandparents, and his son to St. Louis to live with his own parents, Burroughs traveled for the next several months through parts of South America, during which time he wrote *Junkie* and *Queer* (which remained unpublished until 1985). In the mid-1950s he settled in Tangier (he had been drawn to the city after reading about it in Paul Bowles's *The Sheltering Sky*), where he began to write about an imaginary city called Interzone, a combination of New York, Mexico City, and Tangier, and its inhabitants, constructing hallucinatory, interconnected narratives for its numerous characters. With the assistance of Kerouac and Ginsberg, a portion of it was edited into *The Naked Lunch*,

Fig. 1.8

William S. Burroughs. "Panama: Paregoric gags you" [first line], from: "Original material for Naked Lunch and Soft Machine, and earlier. Mostly unpublished[.] Material dates from 1954. Most of it was written after 1957 and before 59. Mostly written in basement room of Villa Mouneria," 1954–59. 11" h.

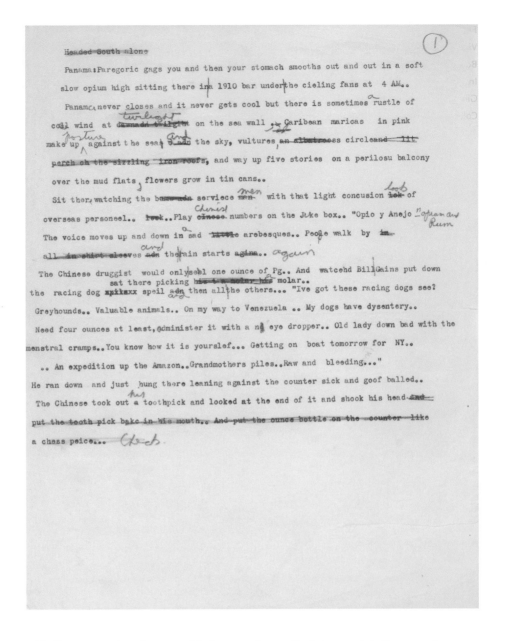

with Kerouac typing the assembled papers into a fresh typescript. Kerouac also gave the book its title, intending it as a metaphor for revelation.

The novel reflects Burroughs's dissatisfaction with traditional narrative; instead, he relies on dream-like juxtapositions of scenes, the connections between which are emotional and thematic, an approach similar to certain passages in Ginsberg's "Howl." Similarities can also be found to James Joyce's stream-of-consciousness exposition, with the difference that Burroughs's subject often seems to be consciousness itself, focusing on the drama of the mind's movement, with its content serving the secondary purpose of tracing its currents and eddies. Despite the grave seriousness of his characters' dilemmas, Burroughs writes with an often hilariously funny gallows humor that is a bit reminiscent of Kafka, an effect he achieves by applying a meticulous, almost clinical observation to the description of the most extreme psychological and physical states.

One of the many "folios" into which Burroughs organized his Archive (now in the Berg Collection) is dedicated "to Kells Elvins and Jack Kerouac." Elvins was

Fig. 1.9

Victor Bockris, photographer. "Burroughs and Bowie Knife," 1979. 10" x 8".

In 1974, accepting an offer, facilitated by Ginsberg, to teach creative writing at the City College of New York, Burroughs returned to America, finding an apartment (where this photograph was taken) in a converted YMCA on the Lower East Side, the fortress-like ambience of which led him to call it "The Bunker." Unsuited to teaching, he instead took to the road giving readings, earning a living that allowed him to spend most of the year in New York, where he began to socialize with many notables of the city's underground and avant-garde, such as Andy Warhol, Patti Smith, and Lou Reed, as well as such literary figures as Terry Southern, Susan Sontag, and John Giorno, and, later, artist Jean-Michel Basquiat.

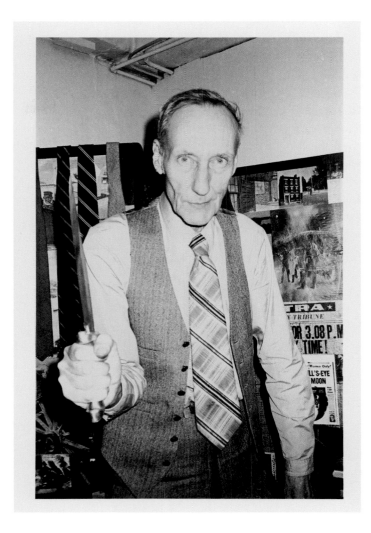

Burroughs's high school friend and lover, and the co-writer of Burroughs's first story, "Twilight's Last Gleaming."[17] Burroughs has affixed to the folio folder a snapshot that he took of Elvins in Tangier and a news clipping photograph of Kerouac. That Burroughs would pair the two men shows the depth of his feeling for Kerouac, about which he is explicit in the typescript of his essay "Jack Kerouac" and the obituary he wrote, "On the Death of Jack Kerouac." In the former, he credits Kerouac for his writing career:

> It was Kerouac who kept telling me I should write and call the book I wrote Naked Lunch. I had never written anything after high school and did not think of myself as a writer and I told him so ... "I got no talent for writing ..." [...] He insisted quietly that I did have talent for writing and that I would wrote [sic] a book called Naked Lunch To which I replied "I don't want to hear anything literary." He just smiled. In fact during all the years I knew Kerouac I cant remember ever seeing him really angry or hostile. It was the sort of smile in a way you get from a priest who knows you will come to Jusus [Jesus] sooner or later [...]."[18]

Into the small circle of friends who were to form the core of the New York Beats—the writers Kerouac, Ginsberg, and Burroughs, the visionary Carr, and the guide to the lower depths Huncke—strode Neal Cassady (1926–1968), meeting

Fig. 1.10

Allen Ginsberg, photographer. "Neal Cassady drove Prankster's Further bus to visit Millbrook 1964, I went up from New York with Kesey brothers, [Timothy] Leary joshing Neal. Election time bus sign: 'A vote for Goldwater is a vote for Fun,'" [July] 1964. 14" x 11".

In 1964, Neal Cassady (shirtless, at right) joined Ken Kesey's Merry Pranksters, as driver of the day-glo–painted 1939 International Harvester school bus, on their cross-country trip to promote Kesey's second novel, *Sometimes a Great Notion.* In July, they stopped to visit Timothy Leary in Millbrook, New York, where Leary's Castalia Foundation, dedicated to the psychological and spiritual uses of LSD, was based. Leary (at left) joined the Pranksters briefly on the bus.

Kerouac in December 1946, the same month that Kerouac's marriage to Edie Parker was annulled. One marriage had ended and another had begun. Cassady, born in Salt Lake City and raised in Denver flophouses by an alcoholic father from whom he was regularly separated by stays in reform schools for stealing cars, was bright and verbally gifted. By the time he met Kerouac, to whom he was introduced by the Beat friend Hal Chase, he was also a skilled hustler. To Kerouac and Ginsberg he represented the all-American outlaw hero, who actualized their vision of a spiritually renewed America that would replace consumerism and conformity with sexual openness and compassion. Kerouac's sense of brotherhood with Cassady has long been well documented through the evidence of the novels *On the Road* and *Visions of Cody,* as well as Kerouac's letters to him, but the numerous pre-scroll drafts of *On the Road* reveal the extent to which Kerouac made this wished-for relationship explicit (for more on this subject, see Chapter 3, *"On the Road* Proto-Versions: Drafts, Fragments, and Journals"). Kerouac would have gone on the road even if Cassady had never entered his life; his desire to discover America—its history and people, its vastnesses and its bowered, secret places—had long been gathering strength in his imagination. But when he met Cassady, he felt that he had encountered the embodiment of all the uninhibited openness to experience and refusal to accept authority unquestioningly that was for Kerouac the promise of America. It was Cassady's example, however disillusioned Kerouac later became with his selfishness and manipulativeness (attributes Kerouac also possessed), that allowed Kerouac to hope that he, too, might find the courage to drop his fears and live in the beatitude of the moment.

The letter that Cassady sent Kerouac in December 1950, and which Kerouac credited with giving him the idea for "spontaneous prose," might not have had the galvanizing effect on him that it did, had it not been reinforced by his experience of Cassady's charismatic personality. The few excerpts from the letter that were transcribed (the letter itself was lost soon after it was received) are not impressive. But according to those who knew him, Cassady, at least in conversation, was linguistically adept. John Clellon Holmes, who with Kerouac formulated the idea of the "Beat Generation," wrote about Cassady in a 1978 letter:

> Yes, he spoke grammatically—though he used street-idioms. But he never slipped into the metronomic & idiot use of "you knows," "likes" etc. that made the 60's such a verbal wasteland. [...] He was never your monosyllabic grunting "hipster." His vocabulary was large & serviceable: most thieves, junkies, whores, "outsiders," are like this; it's only the middle-class rebels & drop-outs who put down language—a resentment of Papa. Real people are way beyond this, and language & knowledge are constantly called upon to explain their special view of existence.[19]

Although Kerouac would never doubt the authenticity of Cassady's gift as a writer or that he had special access to a demoniac or divine energy, his later anger with and disgust for Beatdom and all that it had come to mean for him crystallized around the figure of Cassady, on July 24, 1963, when he appeared on Kerouac's doorstep "with his mistress gun moll & a silly sneery beatnik teenager, in a stolen car, from the West Coast, marijuana & all, & he wants MONEY MONEY, FOOD,

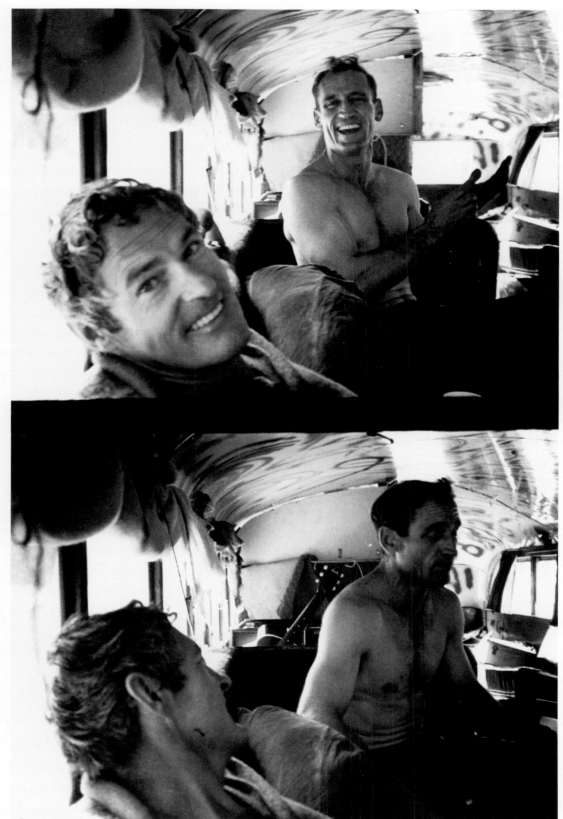

Neal Cassady drove Prankster's Further bus to visit Millbrook 1964,
I went up from New York with Kesey brothers, weary looking Neal. Election time bus sign: "A vote for Goldwater is a vote for Fun!" Allen Ginsberg

SLEEP IN MY HOUSE—" Kerouac, recalling the incident five days later, marvels at the arrogant selfishness and rudeness of his uninvited guests, and swears off the company of beats and hipsters forever:

> Now I finally tell Neal this is too much, give him only what I owe him ($10) (from collect phone call), but when they also demand food the girl herself suddenly (in front of my poor mother Memere in her own house) starts raiding my best expensive canned delicacies—I grab some & put em back—Nevertheless Memere spreads a royal snack—The beatnik Bradley tosses slices of bread superciliously around, & when finished, puts his feet on our kitchen table—This is the night, as I sat there sweating, that I renounce all beats or hipsters or whatever ill-mannered & scrounge-minded hoods & shitasses forever & change my life & tastes in humans forever—[20]

He was, perhaps, even more disappointed in Cassady's later incarnation as a Ken Kesey Merry Prankster (see fig. 1.10), and driver of the bus "Further" on the Pranksters' notorious road trip from California to New York. He felt that Cassady was making a fool of himself and was being manipulated by Kesey. Despite it all, however, Kerouac's sense of deep connection to Cassady never weakened. A prosaic yet poignant relic of this is the simple, domestic note from Cassady, dated December 17, 1952, that Kerouac kept among his papers: "Dear Jack, look in the oven. N."[21]

Rounding out the New York Beats was Gregory Corso (1930–2001), who met Kerouac in October 1951 through Allen Ginsberg. Ginsberg had met him by chance in a Greenwich Village lesbian bar, the Pony Stable, and the two soon realized that the couple Corso had been observing having sex in an apartment across the street was none other than Ginsberg and his then girlfriend. Like Cassady and Huncke, Corso had been a small-time criminal. He had grown up in various poor, Italian-American foster homes in the Village and the Bronx, living, for the most part, in the streets and breaking the law casually, as the opportunity arose. While Corso was serving a three-year sentence for robbery, an older inmate introduced him to the joys of language with the gift of a dictionary, sparking a passion for literature. By the time of his release, he had read through much of the prison library and had begun writing poetry. In 1956, Corso left New York for San Francisco, drawn by the presence of his friends Kerouac and Ginsberg, and of other Beat writers, such as Gary Snyder, Lawrence Ferlinghetti, Philip Whalen, and Michael McClure. One of his best-known poems is "Bomb," a copy of which Kerouac typed in the shape of a mushroom cloud.[22] In the poem, the atomic bomb represents the alpha and omega of existence, in whose explosion all opposites are resolved and dissolved. Corso yokes together disparate images to represent the destruction of the natural and human order, as if the entire world had been struck by an enormous tidal wave. "Bomb" was first published in 1958, by Lawrence Ferlinghetti's press, City Lights.

Ferlinghetti (b. 1919), Gary Snyder (b. 1930), Philip Whalen (1923–2002), and Michael McClure (b. 1932) form the West Coast contingent of the Beat movement, though they may also be grouped with the poets of the San Francisco Renaissance. Ferlinghetti's City Lights press, established in 1955, published the works of many Beat and other alternative poets, as did Amiri Baraka's journal *Yugen*, but its most

historically significant publication was Ginsberg's "Howl," in 1956. Snyder's association with the Beats came through Ginsberg, who had been urged to meet him by Kenneth Rexroth (1905–1981). Snyder was an inspiration to the West Coast Beats and to Ginsberg, because of his successful adaptation of ancient Chinese and Japanese poetry to modern uses. Philip Whalen and Kerouac became friends in 1955, the year that Kerouac came to know Snyder, and as was the case with Snyder, their friendship was facilitated by their mutual involvement in Buddhism. Whalen's commitment to Zen led him to become a monk in 1973.

Having completed this brief survey of the Beats, whose names will appear from time to time in the course of this book, it is worth asking if the Beats should even be regarded as part of a movement. Unquestionably, an understanding of their achievement is enhanced when seen in the context of other alternative currents in American literature of the time, such as the Black Mountain poets, the San Francisco Renaissance, various avant-gardists of the East and West coasts, and individual pioneers like William Carlos Williams or Rexroth. But it does seem that the work of the Beats possessed a unique pairing of features: a desire to find new forms to express what they wanted to say, and an awareness that what they wanted to say could not be separated from the moment-to-moment challenge of being alive. That is, they tried to find a "spiritual" way through the world, in part by breaking down the barriers between their lives and their work.

For Kerouac, the identity of Beat and beatific was central to his definition of what he and his friends were trying to do in the late 1940s. By the late 1950s, he had come to see his friends as having lost their way and having perverted the Beat idea in the process. For a long time he refused even to call the Beat a movement, because of the political uses, specifically leftist, to which Beat had been put, beginning in the late 1950s; as his Beat former friends intensified their political involvements in such causes, his anger at them intensified. One of Kerouac's earliest uses of the word "Beat" in the context of his vision of renewal for America, to be led by sexually and spiritually liberated youth, occurs in 1948, in notes for a letter, apparently unpublished and perhaps never sent, to a Columbia acquaintance and future Pulitzer Prize–winning architecture critic, Allan Temko (d. 2006). Kerouac prophesies the arrival of "the only real revolution we've had so far, arising from spiritual and sexual energy," whose champion would be the Beat generation, America's (white) outsiders: "I want you to know that a new generation is existing, and rising, in America, and I call them 'The Beat,' and that everything they do, including their very existence, is illegal. We are all becoming arch-criminals as the society seems to tighten up hysterically."[23]

A decade later, reflecting on his hopes for the "beat generation" or, as he had once thought of naming it, "the hip generation,"[24] Kerouac writes in his diary in the Mexico City summer of 1957:

> The Beat Generation, that was a vision we had, John Clellon Holmes and I, and Allen Ginsberg, in an even wider way, in the late Forties, of a generation of crazy illuminated hipsters suddenly rising & roaming America, serious, curious, humorous and hitch hiking anywhere, everywhere, ragged, beatific, beautiful in an ugly graceful new way—a vision gleaned from the uses we had

heard the word <u>beat</u> spoken on street corners on Times Sq & in the Village, in other cities in the down-town city, right in postwar America*—The subterranean heroes who'd finally turned from the 'random' in action [____?] the [____st?] & were trying drugs, digging boys; talking [____?]; having flashes of insight, having poor if glad, prophesying a new style for Americas[.][25]

A few months later, under the heading "The Ideal of the Beat Generation," he writes in his diary, probably in reaction to the mainstream media's lumping together leather-jacketed bikers with "beatniks": "The beat generation is no hoodlumism. As the man who suddenly thought of that word 'beat' to describe our generation—Beat doesn't mean tired, or bushed, so much as it also means <u>beato</u>, the Italian for beatific: to be in a state of beatitude, like St Francis, trying to love all life, trying to be utterly sincere with everyone, practicing endurance, kindness, cultivating joy of heart." Kerouac then recommends solitude, whether in a cabin, park, or even in one's own room, as a means of realizing this state of "beatness," or "beatitude."

But Kerouac was no longer writing as a prophet who still hoped to persuade a wayward people, but as an angry thirty-five year old who had seen the dreams of his youth betrayed, as he now believed, by his unworthy fellow apostles and former disciples. Just a few months earlier he had vented, in an unpublished aborted draft of a memoir he entitled "Beat Generation,"[26] his revulsion at what he saw as the moral degeneracy of his 1940s Beat friends. Ironically, he was at the time in Tangier helping Burroughs organize and edit part of his "word hoard" into the novel that would become *The Naked Lunch* (the title of which Kerouac supplied). He begins his tale not with the story of how he met his fellow Beats, but with Joan Haverty, his second wife, kicking him out of her West 20th Street apartment after he finished typing the scroll of *On the Road* toward the end of April 1951, though he does not mention the novel. A few months later, diagnosed with thrombophlebitis in his legs, he enters a Veterans Administration hospital in the Bronx. His reaction to a message he receives there from Allen Ginsberg initiates the real subject of his memoir—the immorality of his fellow Beats—and constitutes one of many instances, chiefly in his unpublished papers, of his hypersensitivity to being seen as homosexual. Ginsberg had sent a sweet note to his sick friend, "Leaving for Mexico tonight—be a good angel," the intimacy of which, especially because it could have been read by the hospital staff, infuriated Kerouac then and now, seeing it in recollection as typical of the "silly messages" his friends send him and which make him "look like a fag in the eyes of simple people and I think 'I'm well rid of the whole generation.'"

He then grimly calls up a rogues' gallery of his neurotic and maladjusted Beat friends and bitterly records how casually destructive they were to themselves and to others. Lucien Carr, he recalls, was regularly beaten up as a result of deliberately provoking policemen and soldiers. The image of Ginsberg that comes into his mind is that of the masochist hysteric from "the night in Harlem in 1947 when he screamed at me demanding that I beat him up." Neal Cassady is blamed, as if Kerouac bore no responsibility for his own actions, for their cross-country quests for "girls & pot & jazz all ending in gray exhaustion & probably my present disease

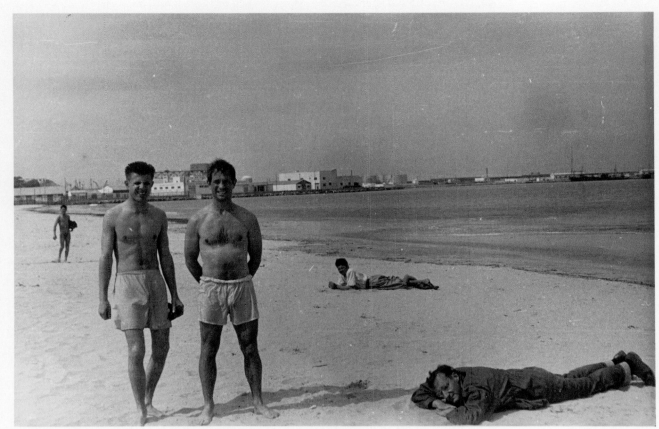

Peter orlovsky age 21 Jack Kerouac Age 35 William Burroughs Age 43, The Beach Tanger Maroc with boy observer. Allen Ginsberg Ætat 31 1957 March–April

Fig. 1.11

Allen Ginsberg, photographer. "Peter Orlovsky age 21[,] Jack Kerouac Age 35[,] William Burroughs Age 43, The Beach Tanger Maroc with boy observer. 1957 March–April." 11" x 14".

[alcoholism?]." Herbert Huncke is reduced to a simple misfit who spent his life either "in jail" or "greenfaced on Times Square." Even Burroughs, the memory of whose company he will recall affectionately and with delight some years later, in the last book he wrote—the bleak, ironic, and grimly funny memoir, *Vanity of Duluoz*— he dismisses as an often-arrested drug addict, histrionic and vainly cruel: "silly cutting off his little finger [...] and about to shoot his wife in the brow," but not before he "exposed her to polio, made her an alcoholic." He ends this list of the weak and maladjusted with the phrase "and many more," as if the rest of his Beat friends from that period could be described similarly. The tone of this list of accusations is akin to that of a legal brief, and all the more chilling for its cold-bloodedness. Just a few months earlier, in late 1956 or early 1957, in his notebook *More Mexico Blues*,[27] Kerouac had written a similar but somewhat more subdued passage, which he added to the end of the first chapter of *On the Road*, contrasting the virile All-American Dean Moriarty (i.e., Neal Cassady) with his neurotic, weak, mocking, pretentious Beat friends: the "Nietzschean anthropologist," the "nutty surrealist," the "critical anti-everything," the "slinking criminals" (see Chapter 4, "*On the Road*: The Scroll and Its Successors").

Having shown to his satisfaction how unworthy his friends were to champion his Beat idea, he tries to impart to the reader the kernel of the insight that engendered it. To do so, he returns to the memory of his Bronx hospital stay, when, lying in bed, he lost himself in the memory of a long-ago rainy night by the sea, and

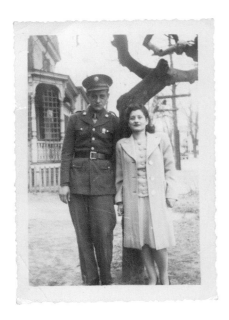

Fig. 1.12

Unknown photographer. Sebastian and Stella Sampas, Lowell, Mass., Easter 1943. 4.5" × 3.25".

In November 1966, Stella Sampas, pictured here with her brother, Sebastian, became Kerouac's third, and last, wife.

recalls it now, thereby melding past and present, like Whitman in his famous *Leaves of Grass* poem "Out of the Cradle Endlessly Rocking": "the sea, the sea washing washing, in the shore, on the liquid Whitmany shore of America whose be[___?]ing song I want to sing, [...]—" But instead of remaining true to his transcendent insight into life's inexpressible beauty, he wasted his life among friends who corrupted him and his vision. He then tries to pretend that he has already dissolved this bitterness, with a mechanical invocation of Buddhism's Avalokitesvara, the bodhisattva of compassion, who, Kerouac is sure, will help bring enlightenment to all: "my whole life among the vain & arrogant intellectuals & bohemians & subterraneans feels a waste, a foppery, a pointless buffoonery—I now come out and make this confession to the world & to my eventual son how foolish I have been, we all have been, this silly <u>beat generation</u> [...]—Because a greater day is coming, the day of the diamond silence which wont at all be <u>day</u>, or <u>night</u>, but paradise—And I dedicate this story to Avalokitesvara."

Some of Kerouac's bitterness and resentment may be attributed to the long-deferred recognition he felt was his due. Before *On the Road* was published, he had little to show for his prodigious literary efforts. He had published an overly long, overly ambitious novel in 1950, *The Town and the City*, based on a contrast between life in his home town of Lowell, Massachusetts, and in New York City, where he had gone to attend a year of prep school and then Columbia University, in preparation for his literary career. The novel is written in a traditional narrative style reminiscent of his then literary hero, Thomas Wolfe (though in a 1965 diary entry he referred to it as his "Dreiser" novel),[28] and he had high hopes for it. But it elicited only a few reviews, and these were mostly ambivalent or, at best, lukewarm in their encouragement of the young novelist. An excerpt from *On the Road* had appeared in the *Paris Review* in 1955, and some of his poetry had been published in the early 1950s, all of which had enhanced his already mythic stature among the East Coast avant-gardists and the poets of the San Francisco Renaissance as a pioneering, form-shattering genius, though Kerouac always felt that the West Coast's "cool" hipsters looked down on him as a thug and wild man.

But with the publication of *On the Road,* Kerouac became a full-fledged celebrity in a way inconceivable today for a serious writer in America. The book received a glowing review in the daily *New York Times* (the Sunday *Times* review was negative), and the Black Mountain poet Charles Olson proclaimed him "the greatest writer in America." His opinions were eagerly sought by nationally syndicated newspaper columnists and by celebrity interviewers on television and radio, who promoted him as the voice of the middle-class, white, twenty- and thirty-somethings of the Eisenhower generation who had rejected the American dream of becoming well-paid cogs in the corporate machine. *On the Road* was told in the first person by a narrator who was in a state of crisis, unsure of himself, yet who saw growing ever more insistently alive in his imagination the mystery of America's vast spaces, filled with forests, plains, deserts, and mountains, and with the small towns and cities that still preserved a piece of authentic America in their downbeat neighborhoods. The narrator knew that traveling into this unknown, which was coincident with the unknown in his psyche, might be his salvation. In the course of relating his journeys, he matter-of-factly revealed many of his most intimate thoughts and desires,

however unflattering to himself or others, in a style that combined an intense lyri-cism with a journalist's reportorial approach to plot, and a raconteur's feel for dia-logue. Characters were not developed in the traditional sense; though Kerouac/ Paradise would occasionally give a bit of background when introducing one of them, the reader's knowledge of who they were developed as the characters revealed them-selves in action, and as the narrator might see fit to introduce other bits of their his-tory, if it proved necessary to understand something they had just done or said.

One of the great ironies of Kerouac's becoming famous for *On the Road* was that by 1957 he had forsaken what might be called a "road" lifestyle and had even begun to question the validity of "hipsterism." Instead, he found himself yearning for a more settled existence, which, in his idyllic vision, would still include late-night jazz-clubbing and getting drunk at parties and in bars. But when dawn broke, he would be able to stagger back to a cozy house in some small town in Long Island or Westchester, which would be kept tidy by an obedient homemaker wife who would allow him his Manhattan excursions unencumbered by her presence, and who would stoically accept the contempt of his jealous mother, who would live with them as queen of the household. Amazingly, Kerouac eventually found such a saintly wife in Stella Sampas, sister of the closest friend of his adolescence, though since the threesome of husband, wife, and mother lived in Orlando and not outside New York City, she did not have to contend with the attractions of Manhattan. Within a year or two of the publication of *On the Road*, Kerouac slowly faded from the literary scene, in part because he did not want to live in New York and play the role of big-city writer. For this reason and because few could quite see the point of what he was trying to do, the novels and poetry that were subsequently published sold poorly and brought him little mainstream critical attention, except when a reviewer wished to hold up one of them as an example of all that was wrong with the Beats and with the beatnik subculture they had spawned.

That something had gone terribly wrong with the other Beats and those who imitated them was a judgment that Kerouac heartily endorsed. In his diary entry for February 11, 1960, he notes with great irritation that the "'Beatnik' movement" has been co-opted by such "political types" as "[Norman] Mailer,[29] West Venice [California] Communists etc." (Mailer would have objected that he was not a beatnik but a hip-ster) and that the San Francisco police have been responsible for this politicization "by their silly persecution & police tactics (brutality & racism in some cases)." Lamen-tably, he says, these developments foretell the evolution of the "Beatnik Movement" into a political movement of the Left. Sacrificed in this process will be "the original idea of Beatific Joy as was experienced by Sal Paradise in <u>On the Road</u> and by the narrator of <u>Howl</u> to some extent and by Neal in his letters & by Hart Kennedy in [John Clellon] Holmes' Go ... all that will be lost in social get-togetherness." "Beati-tude," however, is an "individualistic phenomenon," not something to be sought in groups. "The search for enlightenment ... is not political."[30] Because the Beat idea had been corrupted, he did not wish to be identified with it any longer. Several months later, he records his disgust at being misrepresented by the American media machine:

> Realized last night how truly sick & tired I am of being a "writer" & a "beat"—
> it's not me at all—yet everybody keeps hammering it into me—that's why I

wanta be alone with the dumb beasts of the country so I begin to feel like TiJean [his childhood French nickname, short for "Petit Jean"] again instead of their goddam "Jack Karrawhek"— The monster they've built up in the papers is beginning to take shape inside my body like Burroughs' "Stranger"—by simple process of endless repetition of insinuation—They're going to INSIST that I fit their preconceived notion of "Beatnik Captain," as tho I was some degenerate Bearded Insurrectionist—[31]

When, several years later, Kerouac again emerged into the general public's awareness, after his discovery by a new generation of white, rebellious, middle-class twenty- and thirty-somethings, he resembled even less a "Beatnik Captain" than he did in 1960. He was a strong supporter of the Vietnam War, and he urged the conservative thinker and *National Review* editor William F. Buckley, whom he had met in 1940 through classmates at Horace Mann, to run for President. To arrange the logistics of his September 3, 1968, appearance on Buckley's television interview program, "Firing Line" (the topic was "The Hippies"), Kerouac corresponded with Buckley's office and with Buckley himself. In an August 23 letter, he assures him that "I was sincere when I recommended you for president of USA. Never mind what Ginsberg said; he is Left Wing, I am a Republican partisan (as I told your secretaries on the phone)."[32] Yet it would be a mistake to see Kerouac's political conservatism, nativism, and bigotry as a development dating to the late 1950s (and then exacerbated by the Vietnam War and the culture skirmishes of the 1960s), and largely attributable to his denigration and neglect by the literary establishment. In a late 1941 journal,[33] Kerouac energetically proclaims his agreement with Anne Morrow Lindbergh's *The Wave of the Future: A Confession of Faith* (1940), in which she characterizes Nazism as a manifestation of the "Forces of the Future" rather than the "Forces of Evil," with which epithet, she regrets, it has been maligned by propagandists. "The things that we dislike in Nazism," she declares, are comparable to the atrocities committed during the French Revolution, which "No one today defends"; nevertheless, "few seriously question the fundamental necessity or 'rightness' of the movement."[34] Kerouac glosses her statement that Nazism is like "scum on the Wave of the Future" with the observation that the "vulgarity & crudeness" of "Hitlerism" is a phenomenon that is merely "in accord with all new movements"; what is important about it is that it promises "Economic freedom—that is, all shall eat!" (By 1942 Kerouac had decided that Hitler was a threat to America and had to be stopped.)

A literary manifestation of these attitudes may be found as early as 1946 (earlier, garden-variety examples are cited in Chapter 6, "On Writing and the Creative Act") in an unpublished essay, "Reflections on 'Ulysses' of James Joyce."[35] In order to attack Joyce and *Ulysses*, which, as a seventeen year old, he had praised as the "Greatest book ever written," he employs a crudely nativist argument. He finds that Stephen Dedalus's substitution of his actual father by the despised Jew Leopold Bloom as a spiritual father is an act reflecting "Stephen's own outcast feeling in Ireland." This has made him realize "that Joyce is an eternal black sheep from the native fold, which I cannot admire because it is an admission of defeat & weakness, a running-away to alien forms on the continent." As for Joyce's use of classical references, this only proves to Kerouac that Joyce "is not quite sure of the nobility of

his theme. Deeper than that, I feel that Joyce is not quite sure of the nobility of Ireland and Irishman [Irishmen]." Kerouac then formulates a chauvinist tautology of sorts. Love of life cannot exist without love of father and homeland. Since "Godliness is love of life," whoever does not love his father and country is un-Godly. This is why, says Kerouac, "the simplest peasant is a God," but "Mr. Joyce, who brilliantly hates life, and says so in his esoteric novels, is not a God, but the very opposite of a God, a cunning exile."

In a 1949 essay, "Article on Youth Movements,"[36] Kerouac proudly declares himself to be a reactionary and mocks the American Left's disparaging use of the word. In his view, "reactionary" should be regarded as a term of praise, since, for example, both Shakespeare and Dostoevsky were reactionaries. He ridicules leftist social reformers who sit "at the hem of Eleanor Roosevelt's dress," and sarcastically wonders how Keats could possibly have written a poem without first running off to make a political speech in favor of the common man, or how Handel dared to compose *The Messiah*, when instead he should have been trying to improve society. In short, the making of art, for Kerouac, is incompatible with the socially progressive impulse. As for that pathetic segment of contemporary youth which "will hate its parents [...] in the interests of Progress," they are a mere noisy minority, greatly outnumbered by the silent majority of fruitfully employed, family-respecting youngsters. Fortunately, the parent-haters are easily identified: "sexually unattractive, completely unathletic and physically deficient, and on the whole somewhat repulsive" and "graceless." This set of qualities he traces to their "failure in family life, love, work, or normal competition in the schoolyard." The "cleverer" of the "young malcontents," the most dangerous of the lot, are spiritually deficient sensualists and pseudo-intellectuals whose chief delight is engaging in "second-hand malice against American culture" and who are unquestioning defenders of "Liberalism." He signs the piece, "A rebel reactionary." The father-and-fatherland-worship manifested in these early pieces is traceable to Kerouac's own difficult relationship with his father, for which he felt guilty and for which he was neurotically compensating (this issue is examined in Chapter 2).

After reading carefully through Kerouac's diaries, journals, and fugitive autobiographical pieces, it is impossible to escape the oppressive reality of a psyche at war with itself. He was the macho athlete who lusted after women and despised homosexuality yet was also occasionally drawn to men, a fact he could barely acknowledge, even in his diaries.[37] He had a searching, questioning mind that rebelled against the religious orthodoxies he had been taught as a child, yet he craved their security and comfort. He is known as the celebrator of life on the road, yet he lived most of his life with his mother. He was naturally gregarious (if at first shy) and open-hearted, yet assimilated his parents' bigotry, largely as an act of filial devotion. He yearned for a life of big-city literary renown, yet feared and despised the city as an incubator of sin—its writers and artists mockers of religion and patriotism, and its cramped, polluted spaces bereft of the natural world that helped him maintain contact with the spiritual. He was enraged and saddened by the consumerism that had come to dominate American society and that was inexorably swallowing up the natural landscape with shabbily constructed suburbs, yet he regarded as near-traitorous anyone who criticized capitalism except from his own

Probably 704 E. 5 Street Apartment, Kerouac's last visit to my house — a few days after Kesey/Neal Millbrook visit, I had some DMT left. 1964. Allen Ginsberg

Fig. 1.13

In his caption, Ginsberg refers to the Pranksters' visit to Millwood, New York, at the end of their cross-country bus trip. Upon their arrival in New York in July, Cassady introduced Kesey and the Pranksters to Ginsberg, who was charmed; Kerouac was not. DMT (dimethyltryptamine) is a hallucinogenic drug.

religious/nativist/populist perspective. He hated war, but defended the war in Vietnam because it was being fought against Godless Communists and because it was attacked by his "anti-American" Beat friends.

Yet despite his conflict-riven psyche he succeeded in opening wide the American novel to form-breaking possibilities that had, it is true, been foreshadowed by the modernist movement and Henry Miller, but only now appeared in a distinctly American cultural and linguistic context. This he accomplished not so much, ironically, in *On the Road* (though it was revolutionary enough) as in *Visions of Cody*, occasionally in *The Subterraneans*, and even in *Visions of Gerard*, in which the appearance of conventional exposition and an attitude of worshipful awe toward his dead brother belie the effectiveness of his recreation of the moment-to-moment mind of a child. But it is in *Visions of Cody* and *The Subterraneans* that his hard-won lyrical style, rhythmic prose, and visual/verbal associative faculties flow freely in a stream-of-consciousness mode that, while it does not approach Joyce's achievement, does, as Mailer said of Burroughs, occasionally (even if sometimes marred by sentimentality in *The Subterraneans*) make the comparison not absurd. D. H. Lawrence, in *Studies in Classic American Literature*, described Whitman's achievement as a "wide, strange camp at the end of a great high-road," beyond which other poets could not advance, precisely because he had camped "at the end of the road, and at the edge of a great precipice. Over the precipice, blue distances, and the blue hollow of the future. But there is no way down. It is a dead end." Much the same could be said of Kerouac, who, at his best, dances on the edge of a cliff. Those who have attempted to follow his example have fallen—it requires talent, nerve, and intelligence to dance furiously at the edge of the known. Kerouac usually kept his balance, not just because he possessed those gifts, but, equally important, because he had served a rigorous and lengthy writer's apprenticeship before attempting the elaborate and spontaneous improvisations to come.

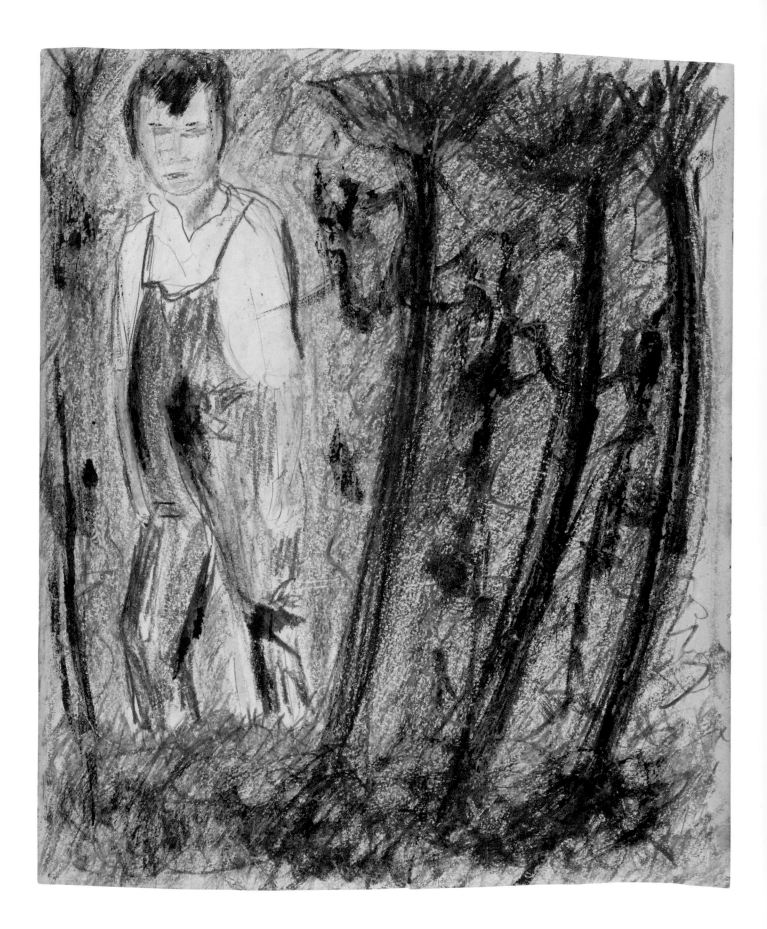

Early Life, Influences, and Writings

The influence of a writer's family relationships on his work is accepted as a truism of literary criticism, but in Kerouac's case the influence was especially pronounced and long lived. He was born Jean-Louis Lebris de Kerouac (nicknamed Ti-Jean) on March 12, 1922, in Lowell, Massachusetts, a mill town on the Merrimack River, to French-Canadian parents, observant Roman Catholics, the children of Québecois immigrants to the United States. His mother, whom he often called Mémère (this was his spelling, perhaps a corruption of the French "ma mère," "my mother," or possibly the Quebec French dialect—*jouale*—equivalent of "grandma"), was born Gabrielle-Ange Levesque, in New Hampshire. His father, Leo Alcide Kerouac, born in Vermont, was a linotype operator who had owned a printing business in Lowell, which failed during the Depression; an occasional fight promoter; and the manager of a social club that contained a bowling alley and pool hall.

Kerouac's first language was *jouale*, and he did not learn English until he was six, when he entered the St. Louis de France Parochial School. The Catholicism that he learned there and at home, chiefly from his mother, left a lasting mark on his religious outlook. He attended St. Louis de France from the first through the third grade, transferred to St. Joseph's Parochial School for the fourth and fifth grades, and then entered a public junior high school. But Christianity remained for him entwined with his idealized memories of a golden childhood in Lowell, when family and neighborhood were a refuge from the dangers of the outside world, a feeling that he much later expressed in the drawings "The Crucifix Clothesline" (fig. 2.2) and "Family Blessed by Unnoticed Angel Going Away."

Jack's brother, Gerard, his elder by five years, was born with rheumatic fever, from which he died at age nine. Consequently, Jack's sister, Caroline ("Nin"), his elder by three years, was his regular playmate during the first years of his life. Gerard's early death, when Kerouac was four, helped engender in him a deep, life-long sadness. (Perhaps the most frequently used adjective in *On the Road*, as well as in most of Kerouac's other novels, is the word "sad," which he applies not only to people, but to trees, mountains, clouds, stars, buildings, streets, and articles of clothing.) Kerouac was affected so deeply not merely because he had lost a brother whom the entire family and the nuns at his parochial school regarded as a saint. Repressed guilt and his compensatory reactions to it also played a role in his traumatization. In *Visions of Gerard* (written 1956; published 1963), one of Kerouac's autobiographical Duluoz novels ("Duluoz" being the name he gave to his alter ego),

Fig. 2.1

"Self-Portrait as a Boy." Oil, crayon, charcoal, pencil, and ink on paper, ca. 1960. 13" x 10.5". Kerouac drew this self-portrait from a photograph taken when he was seven years old.

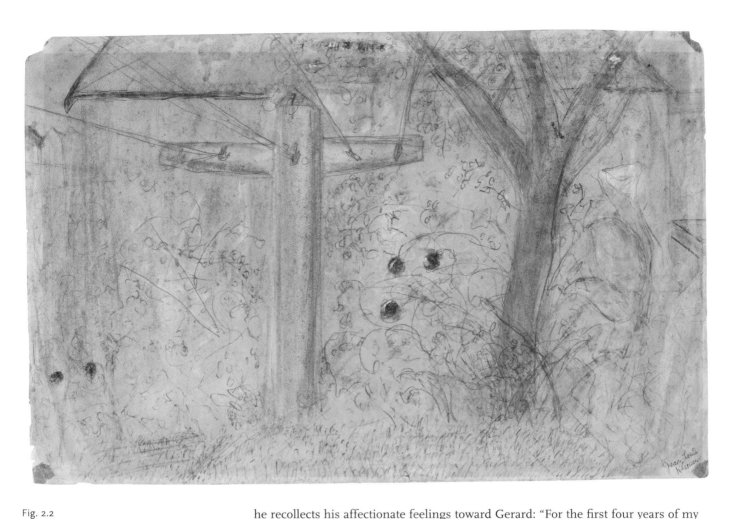

Fig. 2.2

"The Crucifix Clothesline." Pastel, charcoal, and pencil on paper, signed "Jean-Louis Kérouac," ca. 1958. 11.5" x 17.5".

Kerouac's Christian faith remained for him entwined with his idealized memories of his childhood in Lowell, a feeling expressed in this painting.

he recollects his affectionate feelings toward Gerard: "For the first four years of my life, while he lived, I was not Ti Jean Duluoz, I was Gerard, the world was his face, the flower of his face, the pale stooped disposition, the heartbreakingness and the holiness and his teachings of tenderness to me."[1] In 1959, Kerouac composed one of several brief autobiographical statements found in the Archive. In all of them the death of Gerard is remembered as marking a turning point in Kerouac's life: "They say that until his death I was a little butterball with red cheeks, so stout and funny my nickname was Ti*pousse (Little Thumb). After his coffin was lowered in the rectangle of mud in Nashua N.H. on a rainy day, they say I became pale, thin, quiet, solitary."[2] From that time forward, Kerouac was plagued by inchoate fears of death, which took the form of a recurrent nightmare that he was being pursued by a "shrouded stranger." The world had become a dangerous place to the child, a battleground between the forces of good and evil, and this apprehension of the world in terms of dualities would undermine his relationships with others and his understanding of himself for the rest of his life.

Kerouac recorded his fears and conflicts not only in his diaries and journals, but in at least one of his paintings, "Two Girls in the Woods" (fig. 2.3). The two prepubescent girls who are depicted in what seems to be an archetypal garden (note the oversized figure of the falcon-like bird) do not represent childhood innocence. The pretty girl on the left has thick blonde hair atop which burns a large red bow; she wears a short, form-fitting dress with a silken waist-sash, and has opened wide her thick, rouged lips in a cry of exultation. The plain, shorter girl on the right,

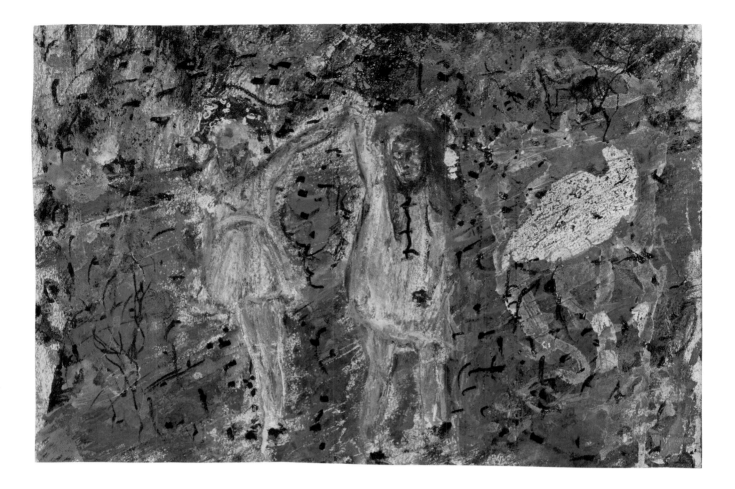

Fig. 2.3

"Two Girls in the Woods." Oil, crayon, and ink on paper, ca. 1960. 9" x 13.5".

scowling fiercely, has gray, flat hair, and is clad in a sack-like dress (longer than that of her companion) with a crudely sewn, buttoned front. At first glance, the two girls might seem to be holding each other's hands aloft in shared victory, but in light of the extreme contrast between the two, the gesture could be interpreted as one of ritualized humiliation, in which the blonde, eroticized girl has forcibly raised the hand of her less attractive, poorer companion, compelling her to recognize the other's superiority. Or perhaps the two figures represent a parable of the victory of instinct and sexuality over thought and conventional morality, which was a credo that Kerouac proclaimed often in his diaries and journals throughout his life.

Despite Kerouac's childhood fears, this period was also a time of awakening to the mystery and wonder of existence. In *Visions of Gerard*, he recalls walking one night through the snowy streets of Lowell as a child of perhaps six and being overwhelmed by a sense of wonder. This may be the moment that he attempted to recreate in the painting "Boy in the Snow at Night" (fig. 2.4), which also alludes to the duality of his childhood recollections, in which feelings of love and fear quickly succeeded each other. One house is filled with a warm, golden light; the other is dark and cold. The child in the painting stands between the two houses and looks hopefully toward the one with lighted windows, his fresh footsteps in the snow connecting him to the glowing refuge of love and safety.

As an adult, Kerouac's religious sensibility was informed by the familial and Lowellian hagiography about his brother, Gerard, and, conversely, Kerouac's vision of Gerard was shaped by his own evolving spirituality. To the adult Kerouac, Gerard

Fig. 2.4

"Boy in the Snow at Night." Oil and enamel on board, ca. 1958. 11.9" x 12.2".

This painting may have been inspired by the childhood epiphany Kerouac wrote about in *Visions of Gerard*, and which he perhaps recalled in "My Sad Sunset Birth" (see Chapter 5, note 2, below): "The day I was born, there was snow on the ground and the descending sun colored westwise windows with an old red melancholia, as of dream. I was walking home with my sled, aged six. [...] 'What is this?' I asked myself, noticing the sudden swoop of a sad moment as it flew across our rooftops. 'What is this strange thing I see?'" Kerouac affixed the black tape to the painting's edges.

was a Christian saint, a second St. Francis, whose special gift was a compassion for animals. In his diaries and journals, Kerouac occasionally even goes so far as to compare Gerard to Jesus, and prays to him, asking that he help him stop drinking.[3] But Kerouac does not confine Gerard's spiritual excellence to the Christian realm. Just as Kerouac's own spirituality eventually reflected an eclectic mixture of Christianity and Buddhism (see Chapter 5), so does Gerard embody the perfections of both of these traditions, possessing a "diamond kindness and patient humility of the Brotherhood Ideal propounded from afar down the eternal corridors of Buddhahood and Compassionate Sanctity."[4] That is, Gerard had achieved the enlightened state described in the Buddha's Diamond Sutra (Kerouac's favorite), the teachings of which he often abbreviated to a phrase compounded with the word "diamond."[5] For Kerouac, Gerard was a living paragon of a life lived purely for God.

Only in his early twenties did Kerouac acknowledge his ambivalence toward Gerard. In 1945 he wrote to his sister, "Nin," about his recent conversations with an unnamed "psychoanalyst," who suggested that a self-destructive urge had compelled him to run away from himself repeatedly, both to the Merchant Marine and to an emotionally damaging relationship with his first wife—flights prompted by guilt over a repressed childhood act. (The "psychoanalyst" was probably his friend William S. Burroughs, since Kerouac records in his diary that Burroughs had suggested the above explanation to him.) Kerouac then shares the rest of his new insight with his sister:

Fig. 2.5

Unknown photographer. Gerard Kerouac. Confirmation photograph, ca. 1927. 10.5" x 8".

In *Visions of Gerard*, Kerouac often achieves a magical transposition of his imagination into his brother's consciousness, at once little-boy and saintly: "Now Gerard ponders his sins, the candles flicker and testify to it—Dogs burlying in the distant fields sound like casual voices in the waxy smoke nave, making Gerard turn to see—But in and throughout all a giant silence reigns, shhhhhing, throughout the church like a loud remindful ever-continuing abjuration to stay be straight and honest with your thought—"

Now all I remember about Gerard, for instance, is his slapping me on the face, despite all the stories Mom and Pop tell me of his kindness to me. The psychoanalyst figured that I hated Gerard and he hated me—as little brothers are very likely to do, since children that age are primitive and aggressive—and that I wished he were dead, and he died. So I felt that I had killed him, and ever since [...] I have been subconsciously punishing myself and failing at everything. [...] But psychoanalysis can make me remember the kind things Gerard did to me, and the kind feelings I had for him—which this would balance against the terrible guilt complex and restore normalcy to my personality. Nothing else can make me remember the kindness I felt for Gerard, since I've been trying like hell, and all I can remember is that slap in the face.[6]

Perhaps psychoanalysis (or Burroughs's analysis) succeeded to some extent, since *Visions of Gerard* does contain Kerouac's accounts of his brother's acts of kindness toward him and of his love for Gerard. But a suspicion lingers that much of this idealized portrait represents Kerouac's creative reimagining of family mythology and that a good deal of his repressed hostility and guilt survived unacknowledged to reemerge in *Visions* as attestations of love and devotion.

Kerouac's relationship with his parents was, understandably, far more complex and even more ambivalent than his relationship with Gerard. Kerouac responded to his mother's love and manipulation with a highly complicated amalgam of filial love, sense of obligation, and guilt and resentment. Her influence can be attributed to a large extent to physical proximity. Although Kerouac is regarded in the popular imagination as the mythic, modern wanderer, he actually spent most of his life with Mémère, especially so after his father's death in 1946 (he had promised his father to "take care" of his mother, which he interpreted, under her prodding, as living with her), in close quarters, in Lowell (twice), Queens (twice), Denver, San Francisco, Long Island, Cape Cod, and Florida (twice). That she was, in his youth, loving and supportive of his efforts to become a writer, as well as a controlling enabler of her son's alcoholism (she, too, was a heavy drinker), and adept at arousing and manipulating his guilt, made her influence on someone with his sensitive nature and need for approval almost irresistible. The earliest surviving piece of writing by Kerouac is, appropriately enough, a Valentine's Day card that he presented to her in 1933 (fig. 2.6). Her letters to him, even in his thirties, are occasionally addressed to "my sweet boy" or "my sweet honey boy," and the tone of some of these passages is that of an adolescent girlfriend.

An uneducated woman from a French-Canadian community that was deeply suspicious of outsiders and that reconstructed its religious faith to conform to its fears and superstitions, Gabrielle saw her restrictive sexual morality and her bigotry as a manifestation of her piety, attitudes that are revealed in her letters to her son. She was at first enthusiastically supportive of his efforts to become a writer, an ambition that he had announced while still in high school. Throughout his schooling in New York, at the prestigious and largely Jewish Horace Mann School for Boys (1939–40), at Columbia (1940–41), and even for some years after he dropped out of Columbia, Gabrielle continued to assert her faith in his literary ability, which helped counteract her husband's disparagement of his chances at succeeding in the "writing

Fig. 2.6

Valentine's Day card from Kerouac to his mother. Crayon and pencil on paper, February 14, 1933. 5" x 3".

This Valentine's Day card is the earliest known example of Kerouac's writing. He signed it "Ti-Jean" ("Petit Jean"), one of his two family nicknames. The other, used during his very early years, was "Ti-pousse" ("Little Thumb"). Kerouac found in his mother the emotional security that he could not find in his friends and lovers, though he also chafed under her rigid moralism and controlling temperament.

game," as he is quoted as calling it in *Vanity of Duluoz*. (*Vanity*, which is cited often in this chapter, is a sardonic, occasionally bitter, occasionally elegiac, partially fictionalized memoir covering the years 1935–46, from Kerouac's first foray into team football to his father's death. Its conversational style is shot through with brilliant flashes of bleak, generally self-mocking humor and deadpan wit, and is resonant with lyrical descriptions of nature and with mordant, epigrammatic pronouncements, through which Kerouac expresses his childhood awe, both innocent and ancient, in the face of the world's inexplicable beauty and suffering.)

Gabrielle, like Leo, was intensely antisemitic, but she propounded her hostility with theological arguments, believing that Jews were inherently evil, and dreaded the influence that they might exert over her son. For the two semesters that Kerouac attended Horace Mann, his contact with them was unavoidable and therefore had to be tolerated for the sake of his education. But while he was at Columbia, and certainly after he had dropped out, what excuse could there be for his continuing to associate with such degenerates? Following Leo's death in 1946 and Kerouac's 1947–48 cross-country road trip, which sparked the idea for the road novel that would eventually become *On the Road*, she warned him in even harsher terms about the danger of his being led into depravity while away from her protective influence. This fear was probably aroused by the even deeper anxiety of being left to live alone. As Kerouac began to assert his independence ever more insistently, even suggesting the unthinkable in a 1952 letter, that is, that he no longer live with her, she began to reproach him, savagely and with crude sarcasm, for being an ungrateful son. Kerouac's admission that he had been seeing a psychoanalyst, despite adding that he was no longer doing so, particularly alarmed her, since, as she wrote to him, psychoanalysis was a pseudo-science foisted upon a gullible public by Jews who did not have the ability to become medical doctors.[7]

The friends whom he had made at Columbia she regarded as menaces to her son's morality and success. As late as 1958, by which time, it might be thought, she would have resigned herself to letting her adult son choose his own friends, she wrote at least two letters to Allen Ginsberg, telling him that he was not fit to associate with Christians and to sever all contact with Jack. One of these letters, dated July 13 and addressed to Ginsberg in Paris, is filled with hatred for his homosexuality, drug use, and being a Jew. She tells him that "I don't ever want you to write Jack, either here or through other people," or even to try and contact him. She has, she says, read Ginsberg's letters to her son, and "I don't want an immoral lout like you around us. You are not free to associate with us Christians." To emphasize the gravity with which she regards her mission to protect Jack from him, she tells Ginsberg that her husband, on his deathbed, made her promise to keep Ginsberg away from Jack. Warning that Burroughs is included in the same ban, she writes, "You miserable bums all you have in your filthy minds is dirty sex and dope. Well this is to warn you. I've given your name to the F.B.I. So when you get back they will be on your tail. [...] and another warning. Don't ever mention Jack's name or write any more about Jack in your 'dirty' 'Books.' [...] I raised Jack to be decent and I aim to keep him that way—if you want Men for your dirty actions, get your own Kind [....] We don't want sex fiend or dope fiens around us." She wrote another very similar letter to him on November 15, 1959.[8]

Fig. 2.7

Unknown photographer. Left to right: Jack Kerouac, Caroline ("Nin") Kerouac, Gabrielle Kerouac, and Leo Kerouac, 1944. 3.5" x 5.75".
In *Vanity of Duluoz* (Book One, Chapter V), Kerouac ascribed his father's unpopularity to his feisty frankness: "because whenever somebody gave him some gaff he let em have it. He punched a wrestler in the mouth in the showers at Laurier Park after a wrestling match had been thrown, or fixed. [...] He ran a little weekly newspaper called the Lowell *Spotlight* that exposed graft in City Hall. [...] he was an exceptionally honest and frank man. He was only Mister Five-by-Five, 5 foot 7 tall and 235 pounds, yet he wasn't afraid of anybody."

By 1959, Kerouac was living steadily with his mother, except for the occasional, brief trip, but this did not diminish Gabrielle's resentment, the source of which, apparently, was her inability to accept writing as a respectable, manly profession. In a diary entry of October 1961, Kerouac complains bitterly about her attempt to undermine his confidence, though he maintains his adamantine resolve to continue to write:

> After writing 12,000 words of BIG SUR last night my mother now whines "You don't do anything, you sleep all day[.]" She doesn't want me to write books anyway, it's more honorable to just die; my books are just disgraces— Today's THURSDAY OCTOBER 5, 1961[.] And I'm Alone for real now, in the midst of a book henpecked by an old deaf mother—it's really midnight now, the next day, & I've got no one to help me believe in books especially my own—I announce right now, the big revolution is going to take place,—KEROUAC IS GOING TO WRITE THE DULUOZ LEGEND ANYWAY[.] Hor Hor Hor[.] And if my books stink, as she & the critics think, okay, I'm free at least to write what I want thereby[.][9]

Understandably, Kerouac's inability to move out of his mother's home(s), which, after the publication of *On the Road*, he bought for her, and her resentment toward any woman in whom he showed serious interest, subverted any possibility of his maintaining a long-term relationship with a woman, until his marriage—his third and last—to Stella Sampas. Gabrielle's view of women, excepting herself (presumably), was that they were sexual predators; but should her son succumb to their wiles, she warned him not to be so foolish as to fall in love with them, a warning that he records in his diary two months after the "old deaf mother" entry: "Ma says that for every girl you lose there are ten others—they'll lay anybody for a lemon."[10]

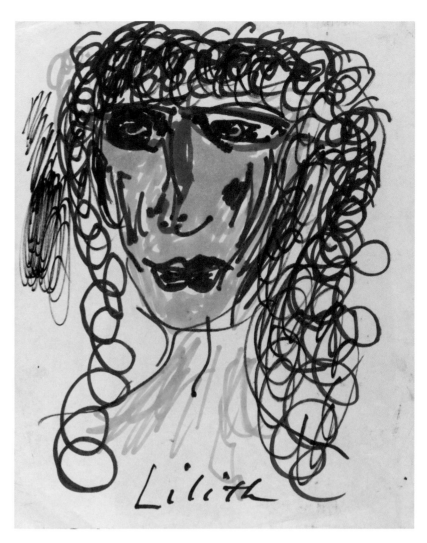

Fig. 2.8

List of women, 1962. 10.75" h.

Kerouac's list of the women with whom he has had sex should probably be seen as a symptom of his obsession with statistics, as well as a reflection of his desire to objectify his partners. The largest numbers are recorded for "Edie" [Parker] (no. 1), his first wife; "Joan H.[averty]" (no. 31), his second wife; "Joan Adams [Vollmer]" (no. 23), who was to become William S. Burroughs's common law wife; and "Harlem" (no. 28), probably a pseudonym for Alene Lee, the African American woman whose affair with Kerouac became the subject of his novel *The Subterraneans* (1958). His Lowell High School sweetheart, Mary Carney, is almost certainly the woman whom he calls, in a tasteless quasi-pun, "Mary Filth," i.e., "carnal" (no. 14).

Fig. 2.9

"Lilith." Multicolored felt pens on paper, ca. 1964. 11" x 8.5".

Lilith is a female demon who appears first in ancient Mesopotamian and then Judaic sources. Rabbinic lore ascribes to her the role of Adam's first wife, but the only mention of her in the Bible is in Isaiah. In the Kabbalah she is portrayed as a seductress who ensnares men in sin, and this is how she has been primarily portrayed in Western culture. In 1963, Kerouac replied to one of the questions that John Clellon Holmes had posed for an article he was writing on him: "Women. At present (1963) I banish them from my life, because of the dishonesty of their eventual motives. Their motives are:—(your money, your baby replica, then you out of the way)."

As for Kerouac's relationship with his father, certainly his childhood memories were of a warm, vivid personality whom he adored, though they began to clash regularly after Kerouac began his studies at Columbia. Leo was an inveterate bettor on the horses, and in Kerouac's earliest surviving diary, the twelve year old casually notes in the entry for February 4, 1935, "Horses won but Pa got arrested with some other guys in the Jockey Club. Anyhow he made five bucks."[11] This diary contains entries for the first months of 1935 and ends with a review of 1934, in a "Memoranda" section, which presents a brief history of his friendships with several boys, Mike Fournier, Eddy Sorenson, Bill Chandler, and George Apostolos (who would remain a lifelong friend), whom he had met from two to eight years previously. Bowling and shooting pool with these friends are often mentioned, which is understandable since, as he notes, "in September [1934], my father was elected to run the Pawtucketville bowling alleys." He also recalls the horse ("Daisy") that his father bought him but which had to be sold, after which Leo bought him a Collie/German Shepherd whom Kerouac named "Beauty."

After Leo lost his printing company during the Depression, he earned a livelihood as an occasionally independent job printer and as an employee of several New England printing firms, supplementing his income by managing the Pawtucketville Social Club. Appropriately enough, considering his love of horse racing, he printed the racing forms for regional race courses. That Leo successfully transmitted to Jack his love of horse racing, as well as of boxing and baseball, is apparent in the sports and horse racing scrapbooks (see, for example, fig. 2.10) that Kerouac maintained from 1935, when he was twelve, to 1937, and in his newssheets, which he "published" in 1937 and 1938.[12] Kerouac also kept scrapbooks of college and professional sporting events, and "published" two typewritten newssheets on professional sports: *Sports of Today* (June 1937)[13] and *Sports: Down Pat* (Fall 1937–Spring 1938), in the latter of which his primary topic was baseball, though he also included a few stories about horse racing. The issue "Strolling Along Flatbush" is devoted to the Brooklyn Dodgers' 1938 team. Kerouac concludes his favorable survey of the Dodgers by remarking that no one will be able to mock them with what was, apparently, a perennial, sarcastic question, "Is Brooklyn in the league this year?," since the Dodgers now have "the strongest team in years" and "should finish fifth or sixth, if not in the first division" (i.e., among the first five places).[14]

Oddly, football, the sport at which Kerouac would excel and which would bind him to his father in solidarity against their imagined enemies, as well as allow Kerouac to become the agency of his father's professional misfortune, is not represented in the Archive by newspaper clippings about college or professional teams. Kerouac played football for his Junior High School, and by the time he entered Lowell High he had developed into a strong and elusive running back, as well as an occasional defensive back ("two-way" players were common then) who was known for his punishing tackles. He was somewhat short by the football standards of even that day (as an adult he stood five-foot-seven), but he was muscular and agile. Although he did not start for the Lowell team, he made an impact in most of the games in which he played. He won his greatest high school football glory in a 1939 game, described in *Vanity of Duluoz*, against a strong Lawrence High School team in which he scored the game's only touchdown (see fig. 2.11).

Fig. 2.10

2nd page of entry for January 18 and facing page, with entries for January 19–22, in *Diary / Whole Year of 1936*, January 1– September 17, 1936. 8.5" h.

On the left-hand page of this diary and sports scrapbook, a newspaper photo shows Joe Louis after knocking out Charley Retzlaff in the first round of their bout, in Chicago. In the preliminary wrestling match, Yvon Roberts, a French wrestler whose nationality would have made him especially appealing to Kerouac, defeated Ed Don George. On the racing front, the horse Whopper was the winner of the $35,000 Hialeah Inaugural. Kerouac comments, "I expect him to win the Santa Anita $100,000.00 Handicap Next month, Feb. 22." On the facing page we see some of Kerouac's typical diary entries; in the last one, he writes that he stayed home from school to tend to his ill mother.

Leo attributed his son's lack of playing time to the cravenness of Lowell's coach, Thomas Keady ("Keating" in *Vanity of Duluoz*), who, Leo alleged, favored the sons of the socially prominent and wealthy. However, Kerouac also concedes in *Vanity of Duluoz* that his father's temper may have played a role in antagonizing the city's notables and the coach. That the Lowell coach was an Irish-American only strengthened Leo's belief that Keating's motives were base, since Leo was suspicious of members of any ethnic group but his own. Kerouac absorbed a great deal of this bigotry, which flared up again at Columbia when the football coach, Lou Little ("Libble" in *Vanity*), an Italian-American, used him only sparingly in his freshman year. Leo was also virulently racist and antisemitic, views that also had a profound and lasting effect on his son.

In his senior year, Kerouac's football career collided disastrously with his father's livelihood. Leo's bosses at the Sullivan Brothers printing firm were closely tied to Boston College and its football coach, Frank Leahy, and threatened to fire Leo if Jack rejected Boston College's offer of a football scholarship. (The April 3, 1940, letter containing Leahy's offer is in the Archive.) Leahy, who was even then nationally renowned, would, the following year, lead the Boston College football team to the most successful season in its history. He already knew that he would be leaving Boston College for Notre Dame, where he had been a starting offensive lineman for the last three teams coached by the legendary Knute Rockne.[15] While on one of his recruitment visits to New York (described in *Vanity*), during which he feted Kerouac, he would have told him about his plans, in order to entice him to accept Boston College's football scholarship offer; Kerouac strongly implies in *Vanity* (see

Fig. 2.11

Unknown photographer. Jack Kerouac scoring touchdown for Lowell against Lawrence High School, [1939]. 3.25" x 4.75".

Kerouac won his greatest high school football glory in a 1939 game against a strong Lawrence High School team, which he described in *Vanity of Duluoz* (Book One, Chapter VII): "But a few plays later Kelakis flips me a 3-yard lob over the outside end's hands and I take this ball and turn down the sidelines and bash and drive head down, head up, pause, move on, Downing throws a beautiful block, somebody else too, bumping I go, 18 yards, and just make it to the goal line where a Lawrence guy hits me and hangs on but I just jump out of his arms and over on my face with the game's only touchdown." This photograph was developed in reverse.

Fig. 2.12

Mock panegyric for Joe DiMaggio, [1941?]. 3.75" h.

Kerouac zestfully indulged his anti-Italian animus in a parody panegyric to Joe DiMaggio (whose baseball prowess he genuinely admired), written in the accent and broken syntax of a newly arrived Italian immigrant. The occasional mockery of Italian-Americans that one finds in Kerouac's works, journals, and diaries reflected a bigotry that he learned from his father, who especially resented immigrants. In a February 28, 1966, diary entry, Kerouac absurdly rails against the presence of too many Italians in Dante's *Inferno*: "Blah blah blah blah blah—you make me sick, Dante—there are more people in hell than Italians[.]"

A hearsay to DiMaggio. HEESA OUR JOE NOW!

Lasta spring when da Yanks isa loss-a foist place
Who's da ball play' is blame-a for make such disgrace,
And everyone tell heem: "I broke-a you face?"
Giuseppe Boccigallupo Scozzafava Mannaga l'America DiMagg'.
But, joosta dis week when they take-a da lead
Hey, sport, tell me who'sa da Push 'em Up Keed?
Joosta look on da sport page, pasean,' and you'll read:
Giusseppe Angelo Mussolini Garibaldi Vittore Emmanuel DiMagg'.
 by Ike Hurd.

below) that he was aware of Leahy's intention to go to Notre Dame.[16] But Kerouac had also been offered a football scholarship to Columbia, which, prior to his matriculation, would pay for his attendance at Horace Mann School for Boys, a highly respected preparatory school in the Bronx, where he would earn lacking credits in mathematics and French, even as he would take the full senior year curriculum.

In *Vanity of Duluoz*, Kerouac presents his choice of Horace Mann/Columbia over Boston College as a straightforward, even inevitable decision. After all, he writes, neither Boston nor South Bend could compete with New York, the city of his dreams, especially once he had read a few of Thomas Wolfe's novels: "what on earth was I expected to learn from Newton Heights [Boston] or South Bend Indiana on Saturday nights and besides I'd seen so many movies about New York [...] the waterfront, Central Park, Fifth Avenue, Don Ameche on the sidewalk, Hedy Lamar[r] on my arm at the Ritz."[17] Still, the decision could not have been easy, since he made it knowing that he was jeopardizing his father's job and the family's financial security.

Amazingly, Kerouac was supported in his choice of Columbia by his mother, "because she eventually wanted to move there to New York City and see the big town,"[18] and her selfishness in the face of the threat to Leo's job is so lacking in common sense as to seem childish. After Kerouac accepted the Columbia scholarship,

Just a trifle too high to be called a strike against batter Jack Kerouac, the ball plunks into the waiting mitt of catcher George Sloat.

Fig. 2.13

Jack Kerouac at bat. Photograph in *The Horace Mannikin*, 1940. 9" h.

In this photograph from Horace Mann's yearbook, Kerouac, at bat for the school's baseball team, takes a high pitch for a ball. The yearbook's baseball team profile says of him: "Jack, about the fastest man on a fast team, will use his speed to good advantage as lead-off batter." His picture also appears among those for the graduating seniors, captioned in part, "A powerful and agile running back in football, he also won his spurs as Record reporter and a leading Quarterly contributor. Was an outfielder on the Varsity Nine."

his father was, indeed, fired from Sullivan Brothers. Many years later, in *Vanity of Duluoz*, Kerouac movingly imagines the misery that he thereby inflicted on Leo: "He went downtrodden to work in places out of town, always riding sooty old trains back to Lowell on weekends. His only happiness in life now, in a way, considering the hissing old radiators in old cockroach hotel rooms in New England in the winter, was that I make good and justify him anyway."[19] "Making good," as we learn, meant succeeding not only academically, but on the gridiron as well. Unsurprisingly, therefore, by the time Kerouac arrived at Horace Mann and, a year later, at Columbia, he could no longer view football only as a game in which he would prove his courage and strength, and make his father proud. Much more was now at stake. The game had been transformed by his moral imagination into a desperate trial by arms in which the chevalier son fought for his own and for his ruined father's honor and manhood.[20] Only by winning gridiron glory could Kerouac redeem Leo's purgatorial exile in the New England cockroach hotels and sooty trains, thereby proving himself a son worthy of the sacrifice that he had forced upon his father.

Having accepted Columbia's offer, in the fall of 1939 Kerouac began his preparatory year at Horace Mann, where he starred as a running back on the football team, whose coach taught him to quick-punt.[21] Although Kerouac also played baseball, he readily admits in *Vanity of Duluoz* that he was not a good hitter.

Despite this passion for sports, especially football, Kerouac had already conceived an ambition to become a great writer. A few days after he began classes at Mann, he proclaimed this intention in a journal that he had just begun. Explaining his decision to write with a pen instead of a typewriter, he compares himself to Johnson, Thackeray, and Dickens, and says that his decision is a "silent tribute to those old gladiators, those immortal souls of journalism" (see fig. 2.14).[22] His entries are characterized by the pretentiousness of an adolescent's idea of nineteenth-century British, high literary style, and by extreme self-consciousness. Clearly, he wrote the journal in the expectation that it would be read by others, after he had become a famous author, an expectation indicated not just by the journal's stilted style, but by the frequent direct addresses to the reader. Even his statement that he has begun the journal "as an outlet for my thoughts" is introduced by the phrase, "Now, dear reader ..."

In the journal Kerouac describes his first-semester curriculum as "A stiff schedule," but expresses confidence that if he does well, he will win his promised scholarship to Columbia. The intelligence and commitment to learning that charac-

Fig. 2.14

:—Journal—: Fall, 1939, September 21–25, 1939, p. 2. 9.5" h.

In *Vanity of Duluoz* (Book Two, Chapter II), Kerouac poked fun at the Anglophilic preciousness of the "old gladiators" lines, with the parenthetical comment, "('Harrumph!' I'm thinking. 'Egad! Zounds, Pemberbroke!')."

2

that I should not proceed in my literary ventures with such ease as would befit a typewriter. I feel that a recurrence to the old method would sort of leave a silent tribute to those old gladiators, those immortal souls of journalism.

Stay! I am not in any way suggesting that I am included in their fold, but that what was good enough for them, should by all means suit me.

I should have said in the first place that the very bulkness of this "cahiers" attracted my eye at the very outset this afternoon. I purchased it, and decided to start a journal. And of course, a typewriter could hardly force its way between the binding, so that I am really forced to use pen & ink.

It, however, gives a sense of coziness, to be scratching on the surface of a huge sheaf of binded paper, by lamplight, much the same as Thackeray, Johnson, Dickens, et al, must have done.

terize Kerouac's diary and journal entries of this period were confirmed in his academic accomplishments at Mann, where he took English, French, Geometry, Advanced Math, and Science, in which subjects (except for Geometry) he improved or maintained his good grades, as his report card shows, from the first to the second quarter; he finished the year with a 92 average. The verso of the report card contains the teacher's "General Impressions": "a fine citizen in every regard. a good first semester."[23] Although he was a native French speaker, his French was, as noted above, of the French-Canadian *jouale* dialect, so he first had to master the rules of traditional French grammar before he could excel. His superior academic record is a tribute not only to his intelligence, but to his thirst for knowledge and, in light of his athletic commitments and long daily commute, to his prodigious energy.

Beyond the academic and athletic, Kerouac encountered a challenge of a very different sort at Horace Mann. The great majority of the students were Jews, and Kerouac for the first time was encountering them socially. In the journals and diaries of this period, through the Columbia years, he occasionally expresses a

casual antisemitism that was relatively mild, considering his upbringing by parents who were virulently antisemitic. An aggravating factor, in this regard, was that most of his classmates were the sons of wealthy Manhattanites, some of whom were chauffeured to school, whereas Kerouac lived with his maternal step-grandfather and grandmother in a cramped Brooklyn rooming house, rode the subway for two and a half hours each way to and from the Bronx, and lunched on a single peanut butter and jelly sandwich. But Kerouac was naturally warmhearted and gregarious, and became friends with several Jewish students. In later years, he even included the names of two Jews on team rosters in his fantasy baseball league, an honor he bestowed on only a handful of friends. (One of the two, Seymour Wyse, a Horace Mann classmate, Kerouac regarded as a friend throughout his life, and he credited him in *Vanity* and in his diary with helping him to improve his fantasy baseball game. In 1943, Wyse is listed as the Manager of the Pittsburgh Plymouths, and in 1958, of the Chicago Blues.) In a 1950 journal entry, Kerouac accords Wyse the distinction of being listed among the friends about whom he wishes to write a "Visions" novel. Kerouac's attitude toward his Jewish classmates in general, as recorded in *Vanity of Duluoz*, was characterized more by benign curiosity than hostility, and in this respect differed from that of his fellow football team "ringers": "What annoyed me was the way the football team, that is, the other ringers from New Jersey, looked down on me for playing around with the Jewish kids. It wasnt that they were anti-Semitic, they were just disdainful I think of the fact that these Jewish kids had money and ate good lunches, or came to school some of em in limousines, or maybe, just as in Lowell, they considered them too vainglorious to think about seriously."[24]

One friendship that Kerouac made at Horace Mann—with the French-born Henri Cru—would endure for most of his life; they would eventually share an apartment, as well as adventures, in California and New York. Years later, Cru would occasionally supplement his income by running confidence scams, but Kerouac always delighted in his company; his charm, effervescence, and wit were an antidote to Kerouac's melancholia. In *On the Road*, Cru is depicted as Remi Boncoeur, "a tall, dark, handsome Frenchman (he looked like a kind of Marseille black-marketeer of twenty); because he was French he had to talk in jazz American; his English was perfect, his French was perfect. He liked to dress sharp, slightly on the collegiate side and go out with fancy blondes and spend a lot of money." It was Cru's girlfriend, Edie Parker, a Grosse Pointe, Michigan, socialite, who would become Kerouac's first wife.

Kerouac returned to Lowell for the summer of 1940 to spend time with his parents and sister before beginning classes and football practice at Columbia in the fall. This period was also a time for relaxing and reacquainting himself with his high school friends, for reading several Thomas Hardy novels and a biography of Jack London, and for trying to memorize "long words" by pasting them on his bedroom walls.[25] That summer Kerouac also intensified a friendship with Sebastian Sampas, the eldest son of a Greek-American family who lived nearby. Although *Vanity of Duluoz* implies that the two first met during that summer of 1940, Kerouac's essay on a high school theater group called "The Pioneer Club," the earliest extant piece of literary writing by Kerouac (ca. 1937), shows that he knew Sampas at that time.[26] Sampas would become Kerouac's most intimate friend and

Fig. 2.15

Sackley Studio, photographer. Sebastian Sampas, Lowell, Mass., [1942]. 9.5" x 6.5".

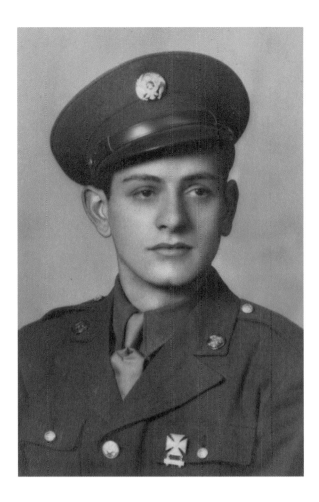

would introduce him to the novels and short stories of William Saroyan, whose work for a time influenced Kerouac's literary aims, and, much more significantly for Kerouac's development as a novelist, to the works of Thomas Wolfe, whom Kerouac would soon call "my God." Sampas was sensitive, poetic, and mystically religious, the antithesis of the rowdy, skirt-chasing athletes who were Kerouac's other friends. Sebastian organized a group of young men in Lowell under the name "the Young Prometheans," which Kerouac joined, who were dedicated to discussing literature, art, and the spiritual renewal of America. Shortly after the country entered the Second World War, Sampas joined the Army as a medical corpsman and was killed in 1944 at Anzio. Kerouac grieved deeply over his death and often recalled him in diary and journal entries until the end of his own life. In the "Author's Introduction" to his novel *Lonesome Traveler* (1960), Kerouac credits Sampas, a "local young poet who later died on Anzio beach head," with his decision, at age seventeen, to become a writer. In the course of their friendship, Kerouac came to know Sebastian's sister, Stella, who in November 1966, toward the end of Kerouac's life, became his third wife, caring for him tenderly through his final, alcohol-debilitated years, as she did for his ailing mother as well.

In the fall of 1940, Kerouac began his freshman year at Columbia, where the frustration of his Lowell High football experience was repeated when he was used only sparingly by his coach, Lou Little. Because Little was Italian-American (he had anglicized his name), Kerouac's resentment against him assumed an anti-Italian cast. When Little did play him, Kerouac performed well, even brilliantly on occasion.

Fig. 2.16

"Stella by Jack." Pencil on lined notebook paper, ca. 1963. 9" x 12".

Although the varsity team included freshmen, the freshmen also fielded a team of their own. It was during one of their games, in October 1940, against St. Benedict preparatory school, that Kerouac broke his leg. Earlier in the game, he had run back a kick-off for ninety yards, which included a dazzling cut-back, and was tackled on St. Benedict's five-yard line. Almost thirty years later, reflecting on this moment of college football glory, which would be his last, in *Vanity of Duluoz*, Kerouac, ever the anti-authoritarian, sardonically noted that on completing his run, he looked to the Columbia sideline and saw his delighted coaches "doing little Hitler dances." At the beginning of Columbia's next offensive series, Kerouac was chosen to receive St. Benedict's punt. The ball soared so high, he says, that he should have called for a fair catch. Instead, "vain Jack" tried to run with the ball and was pounced upon by two St. Benedict players, whose "four big hands squeeze like vises" around his ankles. He, "puffing with pride," tried to break out of their grasp by violently twisting his body, causing "a loud crack and it's my leg breaking."

For most of the next week, Kerouac limped through the team practices in agony. Coach Little told his assistants not to listen to his "lamenting" and grumbled that he was "putting it on." But toward the end of the week, Little relented and sent Kerouac to the hospital for an X ray, which revealed that he had suffered a broken tibia. Little's humiliating comments would be a source of resentment for Kerouac for the rest of his life. "I hobbled every night to the Lion's Den, the Columbia fireplace-and-mahogany type restaurant, sat right in front of the fire in the place of honor, watched the boys and girls dance, ordered every blessed night the same rare

filet mignon, ate it at leisure with my crutches athwart the table, then two hot fudge sundaes for dessert, that whole blessed sweet autumn. [...] For years afterward, however, Columbia still kept sending me the bill for the food I ate at training table. I never paid it. Why should I? My leg still hurts on damp days. Phooey. Ivy League indeed."[27] The crutches remained one of his prized possessions, and are now in the Archive.

Although Kerouac was bitterly disappointed by his football experience, his studies exhilarated him. Like thousands of Columbia freshmen before and after him, he was required to take the school's famous Contemporary Civilization (CC) course, and his notes (fig. 2.17) reveal the seriousness, focused attention, and excitement with which he read the books he was assigned, and how he attempted to incorporate what he learned into his plans for the novels he hoped to write.[28] Although William S. Burroughs has been credited with introducing Kerouac to Oswald Spengler's *The Decline of the West*, we can see from these notes that he had read Spengler several years earlier. This is not to deny that the emphasis that the older, Harvard-educated Burroughs placed on Spengler's importance, and his interpretation of his work, were influential, as Kerouac himself affirmed.

Aside from the historical and philosophical works from which Kerouac drew ideas to explicate in his novels, equally important for him, as for most writers, were his diaries and journals. His fall 1940 *Journal of an Egotist* contains an account of an embarrassing incident in a Contemporary Civilization class, in which he was called on by his instructor and could not answer because he had been daydreaming.[29] Although this precise incident does not find its way into his fiction, his sense of himself as a rebel outsider whose intellectual and imaginative capacities both intrigue and threaten his professors is an important aspect of the central character of *Orpheus Emerged*, a novella he wrote in 1945[30] that was published posthumously. Even at this early date Kerouac maintained a clear distinction between the kind of information he entered in his diaries and that which he entered in his journals, although this distinction, in practice, was not absolute. Diary entries generally appeared more frequently and were more personal in content, whereas the journals recorded notes and observations for literary use. By his own account, he began his first serious diary, which he seems to have felt marked his passage from adolescence to adulthood, on June 1, 1941 (fig. 2.18), at the conclusion of his freshman year at Columbia. He had already compiled at least two journals, both of them serious in their intentions—the Horace Mann journal of fall 1939 (see above), and the *Egotist* journal of fall 1940. So, when he writes on June 1, 1941, "My diaries in the past seem now to have been nothing but horribly accurate data, dealing with horseracing, baseball, football," clearly he is referring only to his diaries and not to his journals. From now on, he resolves, his diaries will not be repositories for sporting news, though he fears that he will "never be as horribly accurate as I was with my beloved sports. In my blooming poetry lies nothing but dignified despair."

In the June diary, he cites the authors whose work he has been reading: Dostoevsky, Whitman, O'Casey, Shaw, Wolfe, "the Bible—Job, Ecclesiastes, Genesis, and Exodus," O'Neill, Joyce, and Saroyan. His entries on classical music, from this period and for the rest of his life, reflect the pleasure he derived from listening to it: "Sibelius—my favorite piece, his 1st Symphony—has everything. It reminds me of

**COLUMBIA / Oxford / WORKING PHILOSO-
PHY + MINERVA=STABILITY, 1940, p. 5.
8.5" h.**

The title page of this notebook reads,
"Random Notes for Future Use in
Humanities, Contemporary Civiliza-
tion [...] Gleanings from Interesting Class Discus-
sions; With Index." Shown here is the first
page of Kerouac's notes for "Theories of
History." On another page, a "Graph of
Culture" is based on Oswald Spengler, who,
Kerouac notes, "assumes a birth, life & a
death to all cultures." Several proto-versions
of *On the Road* (see Chapter 3) are replete
with references to this theme, which is also
explored in the scroll and in the published
version, though less explicitly.

stately pines in the snow. Tschaikowsky's 'Arabian Dance'; overture to [Leoncavallo's]
'Il Pagliacci'; and Wagner's 'Nieblengund Ring' are my favorites. I'm dubious about
the name of Wagner's 'Ring.' His music is haunting, strange; Tschaikowsky is satis-
fying and stirring; Sibelius Symphony No. 1 is lofty and powerful, to me."[31] But the
diary's main focus is literary. On June 14, he records his intention "to start the novel
[i.e., *Vanity of Duluoz*] today [he had been planning it since June 1]. It's easy to write
—it's organising a book that's difficult. I'm off on a start anyway. Wrote a rough
draft of the first chapters, and will go on tomorrow." A comment penned later, typi-
cally sarcastic, at the head of that page reads, "Such effrontery! Trying to write a
'good novel' at nineteen...." The June 14 entry also records his conviction that he is
bipolar: "Life seems empty, and I guess it actually is. You have to keep up 'The Lie'
to get along—but a manic depressive like myself does not do so steadily. I'm sub-
merged in melancholia—and the dignified despair I spoke of is appearing."

During his first year at Columbia, by far the strongest influences on Kerouac's

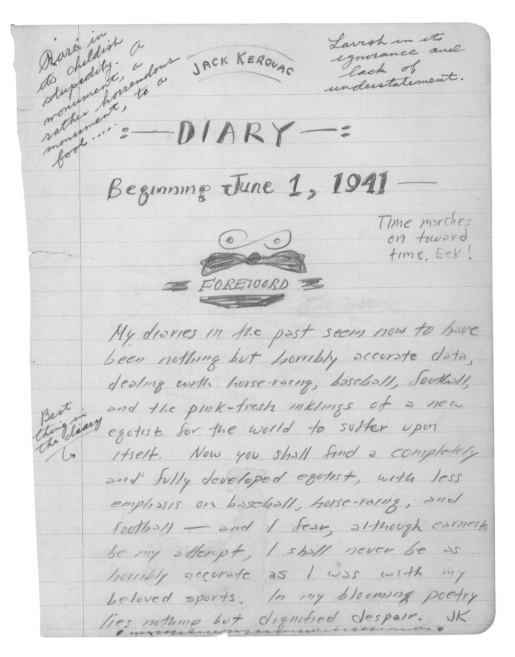

Fig. 2.18

**Diary Beginning June 1, 1941, June 1–19,
1941, p. 1. 9.75" h.**

As can be seen at the head of the diary's
first page, Kerouac reviewed his entries
after he concluded the June 1941 diary and
commented sarcastically on their immaturi-
ty: "Rare in its childish stupidity. A monu-
ment, a rather horrendous monument, to a
fool....." and "Lavish in its ignorance and
lack of understatement."

theories of literary composition, a subject on which he wrote scores of pages in his
journals and diaries of the 1940s, were the novels of Thomas Wolfe, particularly *Of
Time and the River*; James Joyce's *Ulysses*; and the poetry of Walt Whitman, the Ur-
poet of the open road. In 1948, Kerouac would take a course in American literature
at the New School with one of the rising stars of New York intellectual life, Alfred
Kazin (whose Archive is also in the Berg Collection), and his lectures on Whitman
would greatly enrich Kerouac's understanding of the poet, as he duly notes in his
journals for this period. Of Wolfe Kerouac wrote in *Vanity of Duluoz* that "he just
woke me up to America as a Poem instead of America as a place to struggle around
and sweat in. Mainly this dark-eyed American poet made me want to prowl, and
roam, and see the real America that was there and that 'had never been uttered.'"
He later recalls that one night in the winter of 1941, "I go over the [Brooklyn] bridge
in a howling wind with biting sleet snow in my red face, naturally not a soul in
sight, except here comes this man about 6 foot 6, with large body and small head,

striding Brooklyn-ward and not looking at me, long strides and meditation. Know who that old geezer was? Thomas Wolfe."[32]

In his aborted sophomore year (he would drop out of Columbia in the middle of the fall semester) and during the war years that followed, his chief additions to this list of writers were Nietzsche, Dostoevsky, Yeats, Rimbaud, Genet, and to a somewhat lesser extent Céline. The influence of this latter group was at its height in 1944, as can be seen in the collection of manuscripts and journal entries that Kerouac referred to as his "1944 'Self-Ultimacy' Period" papers, many of which contain notes and fragmentary drafts for the novel that would become *The Town and the City*. The manuscript beginning "The Zarathustrian principle of life is opposed by the principle of love" is divided into three sections, the first of which explores Nietzschean principles espoused by the hero, "Michael" Duluoz, the family name he would soon be given in other early drafts, and whom Kerouac would rename Peter Martin in the novel's published version. The second section comprises a series of quotations from Nietzsche, Lucretius, and Rimbaud, with commentaries that connect them to the characters Michael (the Dionysian) and MacKenzie (the Apollonian). The third is a series of notes for an essay on similarities shared by the works of Blake, Nietzsche, and Yeats.[33]

Jean Genet became an influence only in 1945, when Allen Ginsberg, whom Kerouac had met a year earlier, introduced him to his work through the gift of a paperback comprising several of his novels. Kerouac kept the book in his library (it is now in the Berg Collection), highlighting and underlining favorite passages. In June 1963, in an unpublished draft response to a questionnaire sent to him by a friend, the Beat novelist John Clellon Holmes,[34] Kerouac credits Ginsberg also for enriching his understanding of Rimbaud. Other writers whose names appear frequently in this period are Henry David Thoreau and Mark Twain. At the beginning of a group of leaves torn out of a notebook, under the heading "Study Plan," an entry that was written around January 1, 1942, or shortly thereafter (since it is followed by a January 4 entry), we find this comparison: "Henry Thoreau's passion for the woods and some colored Blues saxophone player in a smoky Harlem cell are one and the same—both come under the heading of PASSION FOR LIFE, without which life is not great or powerful, but simple vegetation."[35] (Kerouac may have been listening to jazz at a Boston club that very night, since the entry was written at 3 a.m.) In a journal entry dated July 14, 1945, he writes even more emphatically, "Thoreau is a model for the world, and not merely America, to be aware of."[36] Of Twain he wrote, in his 1947–48 *Forest of Arden* journal's "Statement of Sanity," with a fulsome admiration and respect that he never bestowed even on Wolfe, Joyce, or Dostoevsky:

> But there are great writers who were true men in every sense—Mark Twain is one. An uncomplaining man, a man who did not believe that literature is a constant tale of sorrow and nothing else. [...] Mark Twain piloted steamboats, dug for silver in Nevada, roamed the West, "roughed it," told jokes with other men, hunted, worked as a foreign correspondent, newspaper editor, lecturer, and was a family man—and yet, he did not have to sacrifice all that to his "art." He lived <u>and</u> wrote he was a full man and a full artist, equally happy and whole as unhappy and unwhole, equally gregarious as he was lonely [...]. <u>He</u>

was just writing what he felt like writing, not what he thought "literature" demanded of him.

That Twain, though a great writer, could engage life fully and "sanely" impresses Kerouac, and when he compares him with the writers whose overwrought, morbid introspection had seduced him for several years, he recoils: "Finally, we [i.e., he and his Columbia circle] had the 'beyond-good-and-evil' nonsense of Nietzsche, Rimbaud, and Gide—NUTS EACH ONE."[37] Occasional passages containing praise of Emily Dickinson appear in the journals and diaries of the Columbia years, and even into the 1950s and 1960s Kerouac would praise her (see Chapter 6, note 10, for a pornographic poem he addressed to her), sometimes citing the authority of her frequent use of dashes in a half-humorous attempt to answer critics who mocked his own predilection for them. But of all these writers, only Wolfe, Joyce, Whitman, Thoreau, Dostoevsky, and Twain maintain any substantial presence in Kerouac's journals and diaries after the 1940s. Even references to Wolfe, once his "God," fall off sharply after the early 1950s.

Upon Kerouac's return to Columbia and the football team in the fall of 1941, Coach Little "insulted" (Kerouac's word) him again in front of the entire team, saying that he had not learned to execute the coach's famous reverse, end-around run, at the recollection of which Kerouac scoffs, in *Vanity of Duluoz*, "as if I'd joined football for 'deception' for God's sake." Realizing that Little would not start him in the season's first game, against Army, or, indeed, the entire season, he rashly decided to "go into the American night, the Thomas Wolfe darkness, the hell with these bigshot gangster football coaches. [...] The Ivy league is just an excuse to get football players for nothing and get them to be American cornballs enough to make America sick for a thousand years."[38] Accordingly, toward the end of October 1941, Kerouac left Columbia (without telling Little) and returned home, now in West Haven, Connecticut.

Kerouac's grief in the wake of his father's premature death from stomach cancer in 1946 was intensified by the memory of their shouting matches over his decision to drop out of Columbia and over other life choices that confirmed Leo in his view that his son was a "bum." The journals and diaries of the early 1940s are filled with angry references to these arguments, in which Kerouac sometimes mocks what he sees as his father's philistinism, although Leo had, as Kerouac admitted much later, read and appreciated the works of some of the great nineteenth-century French novelists. Reviewing his Archive in the early 1960s, he berates himself, in annotations to his journals and diaries, for so childishly disdaining his father, and affirms that "Pop" really did know best. This attempt to assuage his guilt also took the form of exalting all of Leo's attributes, now seen as heroic, including his bigotry, which Kerouac saw as an instance of his father's truth-telling manliness, one more idealized attribute of the hardworking, self-sacrificing (white) American male.

After working for several months in Hartford, Connecticut, as a gas station attendant (to join a friend who was working there), Kerouac returned to Lowell, where Leo had found a linotype job, and spent much of his time reading Dostoevsky, Conrad, and Twain. In the journal for this period (November 26–December 15, 1941), which he self-mockingly entitled *Journal (Stupid)*, he declares that he has dropped his "athlete complex," and sets forth his grand literary ambition and the reading

program that will help him achieve it.[39] Infuriated by what he saw as President
Roosevelt's and anti-German propagandists' attempt to push America into the war
in Europe (recall his gloss on Anne Morrow Lindbergh's book, discussed in Chapter
1), he was for a time diverted from his habitual self-analysis and preoccupation with
literature. Instead, he fills his journal entries with his thoughts on politics. Although
disgusted with the "traitor" Roosevelt and his supporters, he looks ahead confidently
to the time when the United States and the Soviet Union will create an alliance
based on a true brotherhood of the two peoples that will allow the best aspects of
capitalism and Socialism to moderate each other. After the Japanese attack on Pearl
Harbor, he bitterly records America's entry into the war. But a week later, he has again
shifted his focus, declaring his intention to concentrate on his interior life, and pro-
nounces himself happy, having reached an "epochal stage" in his development as a
person and as a writer, realizing that he must return to the cultivation of his "fertile
individualism" and "to work, by writing, on the fruits of my life's adventure."[40]
Shortly after this entry was written, Kerouac registered for enlistment in the Naval
Air Force and, to fill the time until his induction, applied to the Lowell *Sun* for a job
as a delivery truck helper. Fortunately for him, the *Sun*'s owner remembered his
football heroics, and on the strength of that fond memory, and knowing that he had
been attending a good university in New York, gave him a job as a sports reporter.

To be a sports reporter had long been Kerouac's dream, as it would be again
on occasion, and his situation at the *Sun* was particularly well suited to his needs,
since it allowed him time to write *Vanity of Duluoz* (not the memoir of his later
years, but an autobiographical novel in the style of Joyce's *Ulysses* and "Stephen
Hero") in the afternoons at his office desk, as well as other short stories and essays,
of which there are scores in the Archive. Many of these delineate small town/big
city conflicts of values, which would become the central theme of his first published
novel, *The Town and the City*. We also begin to see in these brief writings the expres-
sion of Kerouac's conviction, for which he found support in Whitman, that writers
and critics have mistakenly emphasized literary form at the expense of free—that
is, true—expression; the clearest statement of this kind that emerges from this
period is a two-page affirmation beginning "I am going to stress a new set of val-
ues" (fig. 2.19).[41] Kerouac would spend his evenings reading voraciously at the
public library until it closed, setting for himself a course of study that began with
earth's prehistory and slowly moved forward to the earliest of ancient cultures. He
would then go to the "Y" for an hour or so of exercise, after which, at home, he
would sit in a rocking chair, warm his feet in the oven, and read a book into the
early hours of the morning.

After two months of this exhausting schedule, he abruptly decided one day,
anticipating his inevitable entry into the armed services, to leave the *Sun*, go on
the road, and see a bit of the South, the mythology and history of which had always
enchanted him. On the March day he quit, his editor had scheduled him to inter-
view the baseball coach of a Lowell factory team. Instead of going to the interview,
Kerouac returned home and stared at the wall, disdaining (or fearing) to inform
anyone, though he later wrote a letter of resignation.[42] When Leo discovered what
his son had done, he was furious, unable to understand why he had given up so
enviable a job. Several days later, Kerouac left Lowell to join a childhood friend,

I am my mother's son. All other identities are
artificial and recent. Naked, basic, actually,
I am my mother's son. I emerged from her womb
and set out into the earth. The earth gave me
another identity, that of name, personality,
appearance, character, and spirit. The earth
is my grandmother: I am the earth's grandson.
The way I comb my hair today has nothing to do
with myself, who am my mother's son and the
earth's grandson. I am put on this earth to
prove that I am my mother's son. I am also
on this earth, my grandmother, to be her
spokesman, in my chosen and natural way. The
earth owns the lease to myself: she shall take
me back, and my mother too. We have proven
the earth's truth and meaning, which is, simply,
life and death.

"I woke up in the middle of the night
and realized to my horror that I did
not remember who I was. I knew not
my name nor my appearance. When I
went to the mirror, I failed to re-
cognize my image. That is why I am
my mother's son and the earth's grand-
son, and nothing else. I am here to
prove that fact, and in so doing, I
am also the earth's spokesman: that is
so because I wish to prove it twice,
once for the earth, and again for my
brothers, so that we may live together
in beauty."

Say, fellow, you know who I
am? I'm Jack Kerouac, the
writer: husky, handsome,
intellectual Jack Kerouac.
Notice how I comb my hair
and see my handsome gar-
ments. I'm the boy from
Brazil. I love jazz, I
love North Carolina, I
love Socialism. I'm sel-
fish, I'm irresponsible,
I'm weak, I'm afraid. I'm
Jack Kerouac the poet, the
seaman, the scholar, the
laborer, the newspaperman,
the lover, the athlete,
the flyer, the Lowellian? (I am my mother's son.)

Fig. 2.20

GROWING PAINS or A MONUMENT TO ADOLESCENCE / Voyage to Greenland, July 18–August 19, 1942, p. 3. 8.5" h.

Kerouac's description of an alcoholic debauch in South Boston prior to his setting sail shows his talent for, and delight in, describing scenes of, as he puts it, "human degradation."

July 19
BOSTON'S SOUTH END

of the crew go about with sheathed knives and daggers. I think it's more of a semi-romantic fancy than a necessity. Today was a hot, torpid day. I went up to the poop deck, and sat reading the funnies in the shade of our big 4-inch deck gun. I dozed there for a while. This is a big ship — a combination troop transport and freighter. In the hold, there are sleeping accommodations for 1,000 soldiers. At night, Eatherton (a youngster with adventuric notions) invited me out for a carousal. I went, though the hot weather had me feeling low. He took me to the South End in Boston, where we drank enormous quantities of beer in an atmosphere of human degradation, filth, and mottled souls. Three drunken women, hags with dull, beaten faces and scrawny shanks, were thrown out of the barroom. We met "Pop" there, who is one of our cooks — a colored gent who says "denner" for dinner and comes from Harlem. Later, we wandered back to the waterfront

George J. Apostolos, in Washington, D.C., where he remained through most of the spring of 1942, loafing his way through a well-paying construction job at the Pentagon, which he quit for no apparent reason (or was fired from) in order to work "as a short-order cook and soda jerk in a Northwest Washington lunchcart."[43] Then, in June, he left Washington for Boston and joined the Marines, but immediately went to the National Maritime Union hall, where he was given the position of scullion on the Liberty Ship S.S. *Dorchester*. The literary result of this voyage was the journal *Voyage to Greenland* (fig. 2.20), which conveys his sense of excitement at setting out on his first sea voyage and includes some affecting lyrical passages that describe the sea in its various moods. Kerouac's reading during the voyage included H. G. Wells, Thoreau, Rabelais, and E. B. White, who, he says derisively, writes "smugly, snugly of the war. [...] He chats happily about his farm, while young men die on all fronts!"[44]

Returning to Boston on the *Dorchester* in early October 1942, he came home to Lowell to find a telegram from Coach Little asking him to rejoin the football team for the season's first game, against Army. The proposition, after several months of scullion work in rough North Atlantic waters, was attractive. Back at Columbia, he took courses in Chemistry and Shakespeare, among others. But as much as he enjoyed and profited from his education, he was willing to sacrifice it, and the golden future it promised, if his football prowess, an essential part of his identity, was not acknowledged. So, after having sat on the bench, seething with anger and humiliation, for the entire Army game, he decided, while listening to Beethoven's Fifth on the radio in his dorm room, to leave the team. This meant that he would again have to drop out of Columbia. Not being allowed to play football was, for Kerouac, a humiliation. In refusing to reward his talent, Coach Little had betrayed Kerouac's chivalric idealization of the sport, in which merit must be recognized and the worthy footballer-knight be given the opportunity to prove his manhood. In Kerouac's case, this meant the opportunity to redeem his honor and the suffering he had caused his father. Though his official career at Columbia had now come to an end, papers in the Archive show that he was at least auditing and submitting work for courses at Columbia in the fall semester of 1943, an experience reflected, as we saw, in the novel *Orpheus Emerged*, in which the mysterious and worldly-wise Paul attends university classes as an unregistered student.

At the end of October 1942, he returned to Lowell, where he transformed the *Voyage to Greenland* journal into the unpublished novel *Merchant Mariner*, apparently copying it out as a fair copy from a final draft in March 1943 (fig. 2.21).[45] Around 1968, the approximate date of an explanatory note Kerouac placed atop his still unpublished sea novel, he retitled it *The Sea Is My Brother*. Set primarily in New York, New Haven, Boston, and on a Liberty Ship bearing war matériel across the North Atlantic, the novel is narrated primarily from the point of view of two characters. The first is Wesley Martin, a thirtyish, good-hearted, former semi-pro pitcher, profound, though not an intellectual, a devil-may-care working-class Vermonter, most recently from North Carolina, separated from an upper-class wife, "Eddy," with whom he lived only briefly, and whom he had left to join the Merchant Marine ten years earlier. From his temperament, background, and appearance (if not his age), Wesley is the character who has the most in common with Kerouac. ("Eddy" is the alter ego of Kerouac's first wife, the Michigan socialite Edie Parker, whom he met in October 1942.) The second principal character, whose perspective dominates the second half of the novel, also displays elements of Kerouac's nature and background. He is Bill Everhart, an Assistant Professor of English at Columbia University, who meets Wes by chance in a bar. They become friends, and Bill ships out with Wes on the S.S. *Westminster* the next day, leaving behind a conflicted relationship with a frail and bitter, but good-hearted, father.

Shortly after returning to Lowell, Kerouac received the Navy's induction notice, went to Boston to take the Navy Air Force exam, failed it (in part, perhaps, because of self-sabotaging rudeness), and was sent to the naval base at Newport, Rhode Island, where he was inducted into the Navy, taking the *Merchant Mariner* manuscript with him. The manuscript was later used by the Navy as evidence of his mental instability, a charge that had its source in his throwing down his rifle during a

Fig. 2.21

MERCHANT MARINER / FIRST MANU-
SCRIPT—MARCH, 1943 / THE SEA IS MY
BROTHER, 1943, title page. 9.5" h.

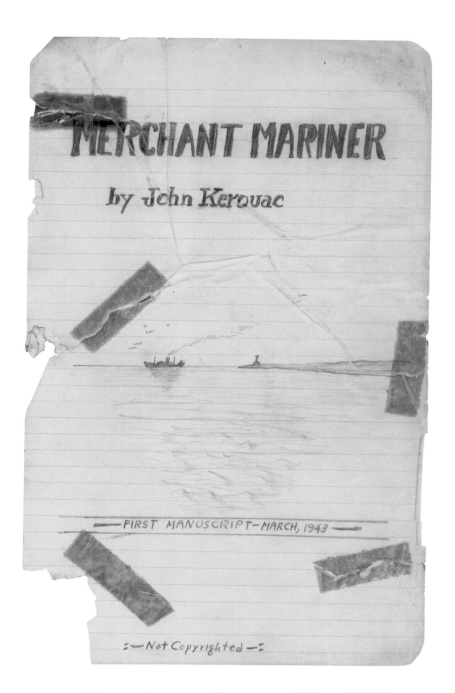

marching drill, a month or two into basic training. This act of rebellion seems to have been the result both of the cumulative effect of military discipline and of his realization that he could not kill in cold blood. Arrested and placed in the brig, he was interrogated by his superior officers; he told them that he was a field marshal and asking to be put away with "the other nuts." In the base's psychiatric ward, he repeated the field marshal claim to the examining psychiatrist, asserted that his name was Samuel Johnson, and asked to be executed by firing squad. During his incarceration in the psychiatric ward, he seems to have seriously wondered if he might in fact be mentally disturbed. In a two-page manuscript written at the time, he confronts his ambivalence about participating in the war and lists, occasionally humorously, his psychological problems and character flaws. The manuscript's second page contains about two dozen capsule judgments about his character, written in quotation marks, as if excerpted from the Navy psychiatrists' official diagnosis,

Fig. 2.22

"Liverpool Testament," September 24, 1943, p. 1. 11" h.

Art finds its truest form, Kerouac writes, when it is most freely expressed, as in *Ulysses*. For example, although Hugh Walpole's *The Blind Man's House: A Quiet Story* (1941) is a genuine work of art, Walpole did not achieve the freedom of expression that Joyce, Proust, Wolfe, or Dostoevsky would have, had they treated the same subject. Joyce would have seen that the "spiritual intuition" of Walpole's blind protagonist was the manifestation of a "death drive." Also, Joyce "might not have treated upper and middle-class England with such unconscious apologetic defense of their deliberate complacency, their social degeneration, their failure to admit economic independence."

but several of them are so unscientific, moralistic, and occasionally witty as to indicate that Kerouac was their author ("A romantic & realist all at once," "Very lazy, backbiting, cheap and selfish ... no damned good," "An egoist, carnally inclined, a youth who might have made a splendid Homeric Greek," "Never had a sincere idealistic emotion regarding woman ... this cannot be held as an encouraging sign"). Under the heading "Personal Opinions" (the doctor's?), Kerouac has filled in, "Mildly insane; temperamental; martyr complex; lazy beyond salvation; brilliant creative mind without direction and consistent energy."[46]

As for the manuscript draft of *Merchant Mariner/The Sea Is My Brother* that he brought with him into the Navy, he used it to type a new draft while serving as a merchant seaman on the S.S. *George Weems*, a Liberty Ship bound for Liverpool with a hold full of 500-pound bombs, in June 1943.[47] During his stay in Liverpool, Kerouac would wander the streets of the great industrial city, and in the course of one such ramble he experienced one of his frequent epiphanic insights into literary style and its relationship to content. In a six-page manuscript that he eventually entitled "Liverpool Testament,"[48] he foresees the future of literature in the novels of

Proust, Dostoevsky, Wolfe, and Joyce, the last of whom, with Nietzsche, is his primary influence. On the first page of the "Testament" (fig. 2.22), Kerouac says that he wants his novel, *Vanity of Duluoz*, to be "as long and as encyclopedic" as Joyce's *Ulysses*, a work that exemplifies freedom, which he defines as a kind of acuity of insight and a liberation from unexamined assumptions. He articulates his hope of carrying forward the pioneering innovations of Joyce et al. in *Vanity of Duluoz*, which he had begun in the summer of 1941 in the Lowell *Sun* newsroom. A melancholic and lyrical autobiographical novel in the manner of Thomas Wolfe for the years 1939–42, this unfinished novel survives in fragmentary drafts in the Archive. Kerouac here characterizes it as "an experiment in complete artistic freedom" and sets forth his ideas on what constitutes true artistic expression.

On the penultimate page of the "Testament," Kerouac declares that art is not a "set of ideals" or a list of ethical principles. Rather, it is inextricably bound up with life, and the two are dynamic phenomena that exist "through the necessity of their nature" (quoting Spinoza). This, he says, is the idea that he is trying to express in *Vanity of Duluoz*. Recalling the Liverpool epiphany almost thirty years later in the ironic memoir *Vanity of Duluoz*, Kerouac dates his "idea of 'The Duluoz Legend'" to that "gray rainy morning" in Liverpool, on the day of the *Weems*'s departure back to New York, and gives a bit of autobiographical context to his artistic statement of purpose: "a lifetime of writing about what I'd seen with my own eyes, told in my own words, according to the style I decided on at [...] whatever later age, and put it all together as a contemporary history record for future times to see what really happened and what people really thought."[49]

Back in New York in November 1943, Kerouac began living with his girlfriend, Edie Parker, who shared an apartment with Joan Vollmer, William S. Burroughs's future wife, on the sixth floor of 421 West 118th Street. Kerouac later recognized the transformation wrought by his new living arrangement: "in start coming the new characters of my future 'life.'"[50] The three most important "characters" were Lucien Carr, Allen Ginsberg, and Burroughs (by the time Kerouac met Neal Cassady, in December 1946, he had long since left Edie). Carr, the scion of an old, wealthy southern Louisiana planter family, was a Columbia sophomore who had been frequenting the Parker/Vollmer apartment with his girlfriend, Célene, to escape the attentions of infatuated gay men. In *Vanity of Duluoz*, Kerouac gushes about Carr's physical and intellectual attractions: "What's amazing about him is his absolute physical male and spiritual, too, beauty. Slant-eyed, green eyes, complete intelligence, language pouring out of him, Shakespeare reborn almost, golden hair with a halo around it [...] and even this old dreamy hardhearted seaman and footballer, Jack, got to like him and drop tears over him."[51] In late May of 1944, Kerouac met Ginsberg (a casual encounter; they would not become friends until a month or so later), who, a roommate of Carr's the previous year, had met Edie through him while Kerouac was at sea on the *Weems*. In July, Kerouac met Burroughs, who had heard about him through Carr and was intrigued.

Each of these new friends, and the dynamic created by their interactions, forced Kerouac to delve deeply into himself and reexamine assumptions about who he was and what kind of writer he wanted to be. Carr's murder of David Kammerer, a gay friend who was besotted with Carr, in August 1944 seemed to embody for

Fig. 2.23

"Dialogs in Introspection," from the "1944 'Self-Ultimacy' Period" papers, p. 1. 9.5" h.
The dialog reads as if it had been written under the influence of Søren Kierkegaard's Christian existentialist masterwork of 1847, *Either/Or*, in which the conflicting demands of the aesthetic and moral impulses are given dramatic form. (Kerouac refers to Kierkegaard several times in his journals of the mid-1940s.) The footnote to the word "criminality" in the first of the "Creative" utterances almost certainly refers to Lucien Carr's murder of David Kammerer. A significant argumentative burden is borne by references to writers and literary characters, all of which are cited by the Creative force: Goethe's Faust, Emerson, Dostoevsky's Raskolnikov (*Crime and Punishment*), Rimbaud, James Joyce's Stephen Dedalus (*Ulysses*), and Thomas Mann.

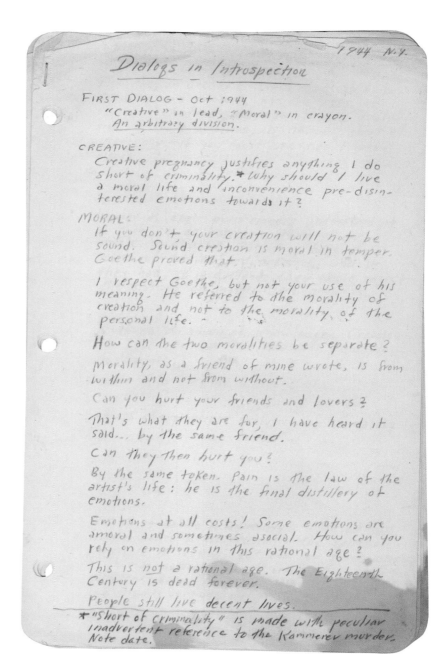

Kerouac the unhealthy, hothouse atmosphere of his friends' personal relationships. It also led to Kerouac's imprisonment in the Bronx County Jail for about a week, and to his first marriage. Carr confessed the murder to Kerouac and Burroughs, who were later arrested for not having immediately notified the police. Carr served two years of a twenty-year sentence at Elmira Correctional Facility, in upstate New York. Because Kerouac's father refused to pay his $500 bail, Kerouac was compelled to marry Edie Parker, whose mother provided the bail money on that condition.

As might be expected, this charged atmosphere is reflected in Kerouac's writing of the period, which was voluminous, and the great majority of which remains unpublished. As the Archive's holdings show, throughout 1943, 1944, and 1945 Kerouac produced thousands of pages of fiction, poetry, and essays on literary, philosophical, and, to a lesser extent, sociopolitical subjects. The most personal and intense of these writings, comprising almost three hundred pages, Kerouac gathered in a large folder that he labeled "1944 'Self-Ultimacy' Period," which

also included papers dating from 1943, 1945, and 1946. Typical of their focused introspection is the eight-page manuscript, aptly titled "Dialogs in Introspection" (fig. 2.23), conducted between the opposing forces in Kerouac's psyche—the creative/instinctive/spiritual, on the one hand, and the moral/rational, on the other. Also present among the "Self-Ultimacy" papers are several short works in French (and several others bearing French titles), Kerouac's translation of a poem by Rimbaud, and several dream-like tone poems that prefigure Kerouac's much more systematic examination of the dream state in *Book of Dreams* (written 1952–60; published 1960).[52]

Kerouac's overwrought state during this period is further attested to by his having written, in at least two manuscripts, words or phrases in his own blood (see fig. 2.26) and by intentionally dripping his blood over some of the pages. He placed both of these manuscripts among his "Self-Ultimacy" papers. In *Vanity of Duluoz*, he relates how he wrote on a card in his own blood: "I lighted a candle, cut a little into my finger, dripped blood, and wrote 'The Blood of the Poet' on a little calling card, with ink, then the big word 'BLOOD' over it, and hung that up on the wall as reminder of my new calling. 'Blood' writ in blood." On the card's verso, which he marked with an "X," also in his blood, he explains that he used the blood-stained string attached to the card "as tourniquet for finger, Nov. 10, 1944—" Then, on a page on which he copied two epigrammatic passages from Nietzsche and Rimbaud respectively, "I reopened the wound and tourniqueted more blood out of it to make a cross of blood and a 'J.D.' and a dash over the linked words of Nietzsche and Rimbaud."[53]

The two largest works of the "Self-Ultimacy" period are the short novels *Orpheus Emerged* (noted earlier) and another that would eventually bear the title *And the Hippos Were Boiled in Their Tanks*. These two works are more revealing of Kerouac's psyche and artistic concerns at the time than anything else that he wrote, and also effectively convey a sense of the often sado-masochistic relationships that existed among members of the Kerouac-Ginsberg-Burroughs-Carr-Kammerer (et al.) circle. Kerouac co-wrote *And the Hippos* with Burroughs (they took the title from a gruesome story about a fire at a London zoo), who with Kerouac and Ginsberg would form the progenitor-triumvirate of the Beat "movement." Only excerpts were published at the time, and shortly thereafter the final draft disappeared. However, the Archive contains an earlier working draft in carbon typescript bearing Kerouac's penciled emendations and signature, to which he has assigned the working title *I Wish I Were You (1945) Philip Tourian Story / '45 Ryko Tourian Novel*.[54] He placed it in a folder entitled "1951 SCRAPS & MY 'TOURIAN' VERSION," indicating, perhaps, that this version bears more of his own contributions than does the published text.

The novel recounts the knifing murder of David Kammerer by Lucien Carr (in the draft, either "Philip Tourian" or "Ryko Tourian"), precipitated, according to Carr, by Kammerer's attempt to rape him. The Archive's draft, however, ends before arriving at the point in the narrative when the murder is committed. The novel portrays Manhattan as a toxic netherworld dominated by brutes and con men: "Manhattan will continue as it is, a place that kills everything that comes to it, one way or the other" (see fig. 2.24). Burroughs figures prominently in the first half as a magus-like figure who possesses the clarity and courage to bear witness to and comprehend the

someone who will." He was calm and dignified in spite of the beating he'd taken...he was smoking a cigarette and did not touch his swollen jaw and lips, nor call attention to his injuries.

The cop said, "Well what do you want me to do? You've had too much to drink, Mister...why don't you go home and forget about it?"

The man turned around and walked out. Now the owner of the Continental Cafe had come down from his apartment upstairs and the cops were telling him what had happened.. The owner listened to all this with a haggard and harried look. He was silent awhile, staring at the plain clothes men yet not seeing them, just worrying about everything in general that happened to him all the time. "You guys better not be here," he finally said. "That prick looks like he will cause some trouble."

The three detectives looked at each other and put down their drinks. One of them finished his drink quickly and started out. They walked out together looking worried.. The owner of the bar leaned on the counter and rubbed his scalp...

In a few minutes the man in the gray suit was back with five plain clothes men from the nearby precinct station. They took the license number of the place, talked to the owner a while, and left..

Dennison put both hands on the counter in front of him. The juke box was still playing "You Always Hurt the One you Love." Dennison watched the owner go back upstairs to his apartment, shaking his head..

There were no further disturbances that night... On the average there was one disturbance a night. After that, possibilities seemed to be exhausted...

Later on, it is true, just about closing time, four sailors came by and said, "Let's go in here and start a fight."

"No you don't!" the owner cried. "We're closing up," and with that he closed the door in their faces.. After that the owner went behind the bar and counted up the proceeds for the night while his bartenders got dressed and ready to go home... The chairs were upended all over the place, ready for the floorcleaners' nightly labours. The floorcleaner was a little Negro with a big bottle of whiskey in his pants pocket...

"I done laid down a hipe," he kept moaning. "I done laid down a hipe."

Whatever it meant, it sounded awfully discouraging.. Dennison went home. He read the News and Mirror on the subway downtown...

When he got to his room he assembled on top of the bureau a glass of water, an alcohol lamp, a table spoon, a bottle of rubbing alcohol and some absorbant cotton. He reached in the bureau drawer and took out a hypodermic needle and some morphine tablets in a vial labeled Benzedrine. He split one tablet in half with a knife blade, measured out water from the hypodermic into the spoon, and dropped one tablet and a half tablet into the water in the spoon.. He held the spoon over the alcohol lamp until the tablets were completely dissolved. He let the solution cool.. He dropped a pinch of absorbant cotton in the spoon and gently insinutated the tip of the hypodermic into the cotton: then he sucked up the fluid into the hypodermic, through the cotton, leaving the spoon as dry as a bone. He fitted on the needle and started looking around for a soft spot on his arm. He wasn't at the intraveinous stage yet.. After awhile he slid the needle into his arm and slowly pushed the plunger down to the base of the needle.. Almost immediately, complete relaxation spread over him.

He sighed happily and went to bed, putting out the light. He saw first an Oriental palace with dancing girls dressed in all manner of fabulous costumes, and heard the tinkle of their anklets. This absorbed his attention for awhile.. It was an amazing setting, worthy of a Hollywood production. The longer he looked at it the more incredible it grew. ✶

~~So ended~~ ~~our began~~ ~~his day.~~ ~~No one rang his buzzer that night..~~
~~We were all scrubbling around somewhere else in Manhattan, the lot of us, seeking the night...~~ ~~Even the night~~ ~~ends.~~ ~~tempus edax rerum.~~ ~~Dennison knew when it was time to go to bed.~~

✶ *Add psychological visions*

implications of the city's evil. But he also is selfish enough to remain essentially unscathed by it, despite his drug addiction. The novel ends with the Kerouac, Carr, and Kammerer characters sitting in a movie theater, watching the French film *Le quai des brumes* (*Port of Shadows*; 1938), in which an army deserter finds love and destruction among the underworld cutthroats of a sinister, smoke- and fog-bound LeHavre. The novel's vision of urban life as a bleak wasteland was one that Kerouac shared with Burroughs, especially because New York City had become for him a hell on earth, both psychologically, in his everyday life, and metaphysically.

During the years 1944–45, Kerouac also wrote several essay-like expositions of his new insights into literary style and technique, which he set forth with great clarity and a wealth of detail. Two such examples are particularly revealing. In the first, "The 'God's Daughter' Method" (related to the story "God's Daughter"), dating probably from 1945 and part of the "Self-Ultimacy" papers,[55] he says that the modern sensibility has sought artistic expression in revolutionary ways. Referring to himself in the third person, he admits that since he began writing at age seventeen, "he has learned little about the technique of his art." Nevertheless, he does know that just as the musician works in a mode of "Hear-thinking" and the painter in "See-thinking," so the poet creates through "Sense-thinking." When the poet creates, he must contend not only with words, but with the limitations of grammar, just as the musician and painter work, respectively, with a "grammar of harmony" and a grammar that is a "harmony of contour and color." On the second page of the "Method," Kerouac condemns what he calls the "Obscurity of meaning in modern art" and lists six points to remember when writing. The last four stress adherence to the truth of the sensual experience of reality. In the fifth, he promises to ignore any works, even the canonical ("the tradition"), that are not true to the author's original sense experience. The sixth point asserts this principle most emphatically and fully, and posits that the creative force that transmutes the original sense experience into art is "all that you are, [...] is yourself." Kerouac has drawn a diagram to illustrate this dynamic. In the brief last line he reveals his understanding that the sense-based literature he is proposing is anti-narrative, by which he means that all narrative unfolds in time, whereas the sensual moment is always "now," even in memory.

In another "essay," "On the Technique of Writing,"[56] akin in the specificity of its explanations to a creative-writing manual, Kerouac describes how he constructed the first page of "poetic prose" for the story "God's Daughter," setting forth the reasons—alliterative, rhythmic, imagistic, tonal—for his having chosen each of the phrases and many of the individual words that comprise that first page (fig. 2.25). It is of great importance to him that the proper tone be formed by combining the appropriate rhythm and the desired mood. Also, imagery should be repeated throughout an extended passage, each time in slightly different form, shifting its shades of meaning. But the most important necessary condition for creating "poetic prose," in his view, is that the writer remain true to his sense-memory of the events, scenes, and people that he is attempting to describe. Many years later, in his paperback copy of Yeats's *The Celtic Twilight* (Signet, 1962), he underlined this passage in "A Teller of Tales": "what is literature but the expression of moods by the vehicle of symbol and incident."

Here is rhythm, movement, sound, sense, light, mood, tone. Everything that the sense wants said, is said. And it is said economically, yet fully. "Flashes back" tells immediately that the trailer is glittering red... the word "flash" is strong. The reflection of the "man" as the truck passes only adds to his incredibly lonely stature. "Back to the highway darkness" reiterates the night; but more important, gives movement — the truck comes from the darkness, then it is only logical that it returns to the darkness. "Toward Knoxville" is a sense-requirement... it cannot be ignored.

This is superb prose. The problem is, how long can one continue the method with success? For now the truck must begin to labour up an incline at the terminus of the town.

This new situation forces me to alter the preceding sentence. Regard this: the explanation follows: "Now, coasting, it trundles down Main Street, high snouty tractor containing two men, hauling a long red trailer that flashes back the tavern light and the man — and is gone blinking brakelights." ("Blinking brakelights"; truly a second sense, serves here a function of movement. But it is not an excellent choice; it has a certain redundancy. I may omit it.)

"Growling, coughing into second speed, the truck labours back up to the highway darkness toward Knoxville and the wholesale merchant."

Having altered the preceding sentence, I nevertheless produced a good last sentence. It has dispatch and logic. But the preceding sentence is sadly impaired — it has lost timing. So I bethink myself a second-sense preferable to that of "blinking brakelights." Perhaps — "and is gone, down to the other end of town." Acceptable to the method!

NOV. 20, 1944

Fig. 2.25

"On the Technique of Writing:—," pp. 13–14 in spiral notebook "I Bid You Love Me—Workbook," November 10–December 26, 1944. 8.5" h.

This period of emotional turmoil and stylistic experimentation coincided with Kerouac's struggle to write his first full-length novel, eventually entitled *The Town and the City*, the earliest notes for which date from October 1944. He explored narrative possibilities in several different versions, writing scores of fragmentary drafts for each one, sometimes changing the characters' names from draft to draft even while working within a single version, at other times using the same names in different versions. Having recently read John Galsworthy's *The Forsyte Saga*, he decided that his novel was to be the first in a saga chronicling the histories of three partially fictionalized Lowell families ("Galloway" in the novel), including his own, told through the drama of his own life. The title would be *The Legend of Duluoz*, after the pseudonym that he had adopted in the summer of 1941; in several drafts and in many notes from 1944–45, the name is rendered variously as "Daluoas," "Dalouas," and other closely related variations.

The earliest full-scale draft of *The Town and the City*, entitled *"Galloway" and All Its Appurtenances* (another title, "I Bid You Love Me," appears on the first page of text but is crossed out on the title page), is dated November 4, 1944, and its title page (fig. 2.26) bears the word "BLOOD," written in Kerouac's blood (perhaps put there during the bloodletting of November 10, cited earlier), as well as a quotation from Nietzsche's *Ecce Homo*.[57] Kerouac also smudged drops of his blood on most of the pages of the first half of the manuscript. He began this draft shortly after returning to New York by bus in early November 1944 from Norfolk, where he had disembarked from the S.S. *Robert Treat Paine*, on which he had served as a deckhand on a voyage from New York to Norfolk. Immediately upon his arrival, he went to the

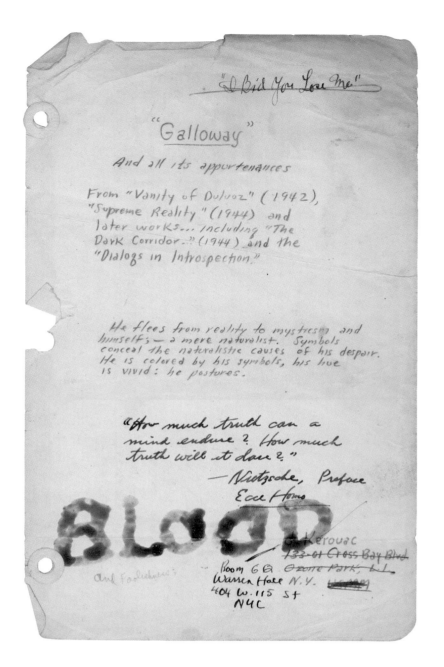

Columbia campus, where he took over an empty dorm room. His epigraph on the
"Galloway" title page, about fleeing "reality to mysticism and himself," signifies his
flight from naturalism to symbolism, about which he writes in numerous contem-
poraneous journal entries. In them, as in *"Galloway,"* can be seen the influence of
the authors whose works he was then exploring: Nietzsche, Rimbaud, Yeats, Huxley,
and the mysterious nineteenth-century author Isidore Lucien Ducasse, "Le comte
Lautréamont," whose novel *Maldoror* had languished in obscurity until it was dis-
covered and celebrated by the Surrealists. Ginsberg, who was still a Columbia stu-
dent, brought Kerouac these authors' books from Butler Library. Kerouac has affixed
to the verso of the *"Galloway"* title page his recapitulation of his hero's rationale for
leaving his home town, and a list of the novel's themes.

 In late 1944, Kerouac produced at least two drafts of another version of the
"Galloway" novel, the second of which is in the Archive and bears the working title
1944 "Galloway" Novel "Michael Daoulas[,]" A Later Re-Doing of Vanity of Duluoz of

'42.[58] As the first of its two title pages states, its six chapters represent an expansion of the *Vanity of Duluoz* novel that he was writing in January–February 1942, while a sports reporter at the *Sun*; the second title page states that the manuscript comprises a working outline for Book Three of *The Town and the City*. The chief innovation of this version is stylistic. Although it is told, for the most part, in the third person, the narrative is interspersed with abrupt shifts into the first person from the perspective of whichever character has last been described. The autobiographical character of the novel is clear: the hero is a Boston College (read "Columbia University") dropout and a reporter on the Galloway *Star* (i.e., Lowell *Sun*), who lives with his parents (the father, like Leo, is a printer) and spends several nights a week at the local library researching a book about the prehistory of humankind. Even the friends of the hero, Michael Dalouas, are modeled on Kerouac's circle in Lowell. Kerouac's friendship with Sebastian Sampas, transformed into Michael Dalouas's friendship with Christopher Santos, is central to this novel's concerns, since Sampas represents for Kerouac the sensitive, artistic side of his own nature, which he feels is at war with the aggressive, brutal aspects of his "jock" mentality. For instance, Michael tells Christopher that he and eight of his friends had sex with "Grimy Gertie," and the sensitive Christopher is revolted by the account of aggressive male sexuality.[59] For the Kerouac alter ego, New York becomes the haven in which he will be able to indulge all sides of his nature—the artistic, the danger-seeking, and the sexual.

About six months later, in September 1945, Kerouac produced a sixty-nine–page manuscript comprising a detailed treatment of a new plan for the "Galloway" novel. As the first of the manuscript's two title pages shows, Kerouac also thought of using these notes for a novel, left unfinished and never published, to be called "An American Passed Here," drafts of which can also be found among his *On the Road* pre-scroll versions. He added the title *1945 Daoulas "Galloway"* in red pen when he was organizing his Archive in the 1960s.[60] The manuscript is divided into some two dozen "sections," in each of which Kerouac describes the action and its setting, summarizes character relationships (one section, 6C, includes a passing reference to the suppressed homoeroticism of the young American male athlete's group-bonding rituals; see fig. 2.27),[61] and explains the meaning of the literary symbols and philosophical ideas to which his narrative will refer. Kerouac's intellectualism—his philosophical ideas and theories on style—which is so foreign to the narrating persona of *On the Road* (at least of the scroll and post-scroll versions) and the succeeding novels, is presented here in full flower, as he reassures himself of his novel's importance by invoking the authority of Goethe, Thoreau, Emerson, Joyce,[62] and T. S. Eliot (section 7 is to be written in the spirit of "The Waste Land"), whose styles and favorite themes he invokes in order to explain his own. The first page of text, typical of the others, is burdened with the intellectualizing that characterizes Kerouac's exposition for this novel and for the pre-scroll versions of *On the Road*. The "Goethean urge," we learn, is to be compared and contrasted with the "New Englandiana" of Thoreau and Emerson. If this were not presumptuous enough, in the final lines we are told that the novel is to be modeled on *Ulysses* ("on a less thorough scale, of course"), with the action taking place over the course of a weekend and enriched with numerous flashbacks. At the bottom of the second title page (beginning, "The Plan for the Novel"), which Kerouac has signed and

Fig. 2.27

**NOTES ON GALLOWAY AND AN AMERI-
CAN PASSED HERE / 1945 DAOULAS "GAL-
LOWAY" / THE PLAN FOR THE NOVEL
"Galloway" (Forming a large part of Book
Three of "The Town and the City"),
September 1945, Section 6C ("'The Boys Get
Drunk' Section"). 9.5" h.**

After picking up girls in a nightclub and pil-
ing into a car, Michael and his friends, all of
them drunk, drive about until, bonding "in a
male, drunken enthusiasm," "they drop the
girls." Kerouac has double-starred this pas-
sage, linking it to the double-starred com-
ment, "The great homosexual American virili-
ty," but then, uncomfortable with this expla-
nation (which may reflect Ginsberg's and
Burroughs's interpretive influence), he under-
mines it with the dismissive parenthetical
comment "(as they would have it in New
York's queer bars)."

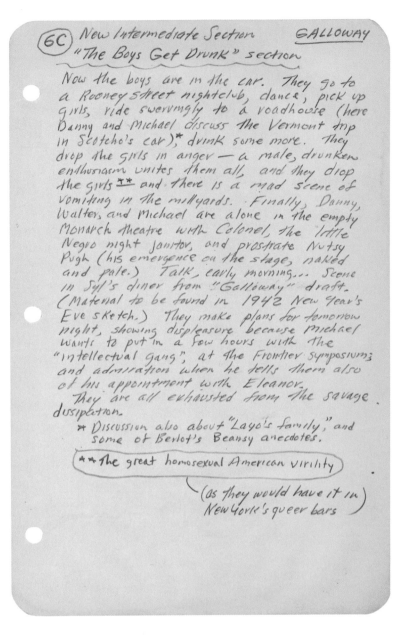

dated, he presents a simplified version of the genealogy of the "Galloway" novel to
this point: "From 'Vanity of Duluoz,' February 1942, to this outline, completed
September 1945." Appreciating how much more difficult he has made his job of
completing the novel by adding even more ideas for his characters to embody, he
then presciently crosses out the line stating his intention to finish the novel by the
spring of 1946.

Tracing the evolution of *The Town and the City* becomes increasingly difficult
as themes, characters, and plot lines that would be developed in rich detail in *On
the Road* and *Visions of Cody* begin to emerge in manuscript drafts and journal notes
under the rubric of the "Galloway"/*Town and the City* novel. The problem is embod-
ied in microcosm in an eighteen-page manuscript of 1945, "Notes for an American
Passed Here," in which Kerouac has delineated roles for some one hundred charac-
ters.[63] The heroes include Michael Daoulas, as expected, but also Paul Breton (an
instance of Kerouac's pride in his Breton heritage) and, most significantly, Peter
Martin, the only character who would survive intact, under the same name, into the

published version of *The Town and the City*. Each of the three, like the three heroes of the published version of *The Town and the City*, reflects aspects of Kerouac's character, temperament, and philosophy. Kerouac begins his "Notes" by tracing the cynicism of the "Lost Generation" to the shattering of their post-Victorian idealism by the First World War. A bit later, he provides a character key to the friends and family members who will appear in the novel; "Key Americans" presents their significance in the novel as American "types" and cultural symbols. Because of the enormous number of characters with which Kerouac had peopled the novel, only the most careful planning could prevent the narrative from crumbling under its own weight. An example of this planning is a long, but partial, list of characters, subdivided by the main character in whose orbit they exist. On the verso of this list Kerouac has written, "Here are over 100 characters; each must be fitted as a specific symbol into the American Culture theme of 'An American Passed Here.'" This manuscript also contains a most intriguing and revelatory literary/ graphic image. Using a "pie-slice" wheel, Kerouac depicts "The Ten-year Spiritual (or Psychological?) Circle of 'An American Passed Here,'" with each "slice" of the wheel corresponding to a year in Kerouac's life, from 1936 to 1945, and containing a description of a stage of his spiritual or psychological development (see fig. 2.28).

At least one version of the "Galloway" novel, represented by several drafts and groups of notes, recounts the Martin family saga as a spiritual tragedy patterned explicitly on *The Brothers Karamazov*; Kerouac began reading Dostoevsky in the early 1940s, and the Russian novelist remained an inspiration, if not a direct influence, for most of the rest of Kerouac's life. However, in his 1946 journal, Kerouac works toward the realization that the atmosphere of Christian mysticism pervading *The Brothers Karamazov* was not transposable to a twentieth-century American novel.[64] He announces that he will instead create an alter-ego character for the novel, "an intermediary, a half-American, a half-expatriate, [...] perhaps a true American artist of the most rigorous order, in brief, myself, the name to be Peter Martin." The reason for this change, as explained in the March 28 entry, is that he is redefining the primary theme of *The Town and the City*. He now conceives of it "along anthropological lines," so that it may reveal how American culture generates "Dionysian American attitudes."[65]

Even during the last two years of writing and rewriting *The Town and the City*, Kerouac continued to conduct research on historical and philosophical subjects, hoping thereby to enrich it. In a journal entry for March 1947, after having made some notes about the novel, he says of his two favorite libraries, "the one in Boston and the one in New York [i.e., The New York Public Library], always fill me with an unspeakable feeling of delight when I go to them, [...] seeing mad old men wander around in deep meditation, seeing pigeons in the court from the window of the library john, seeing pretty girls sitting and reading, and finally participating in a general gloating feeling that this is 'culture' of the highest order and that all we who are gathered here are inveterate deep thinkers. I like to stalk around like a mad thinker with my topcoat flying behind me."[66]

All of this research and intellectualizing did not help *The Town and the City*; it is an overlong novel stuffed to bursting with myriad characters and events, and the ideas that they are intended to symbolize. The most conventional of Kerouac's novels

The Ten-Year Spiritual (or psychological?) Circle of "An American Passed Here"

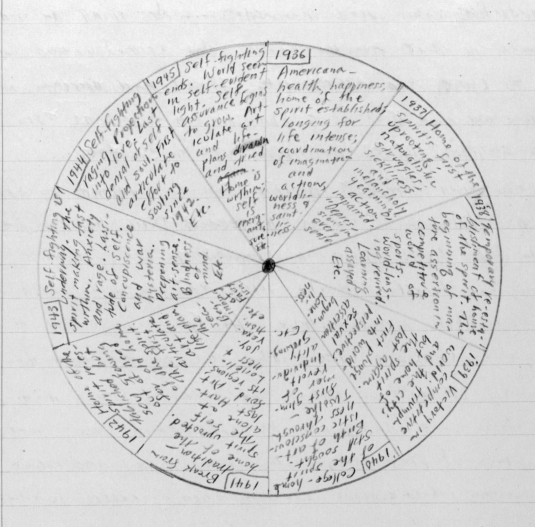

Fig. 2.28

**"Notes for an American Passed Here," [1945],
p. 7. 10" h.**

The period covered by this spiritual "pie
chart" could have been intended for Peter
Martin, the protagonist of the "Galloway"
novel, though perhaps under the "American"
title, or Kerouac might have intended it for a
Kerouacian protagonist of a different novel
that would be entitled "An American Passed
Here."

in terms of its structure, character development, and style, it is also the least suc-
cessful. The reason for this may be, in part, that the last two years of its writing,
1948–49, were a torture for Kerouac, not only because he had overreached, but
because he realized that his entire approach to writing the novel was not true to his
own experience of the world. This realization began to dawn on him shortly after he
set out, in July 1947, on the first of his several cross-country road trips, hitchhiking
most of the way to California, via Denver most notably of all the cities, and back,
and returning to New York in October. For the next six or seven years, life on the
road would seem to him the key to communing with the mystery of America—its
vastness, the beauty and desolation of its landscapes, its small towns, and its peo-
ple—and to being true to oneself and to others. In the journal entries dating from
his first road trip, in 1947, but especially from 1948 forward, he begins to experi-
ment with a new way of writing that he felt was more faithful to his experience, and
he became increasingly impatient and frustrated as he sat before the typewriter in
his mother's house in Queens, slogging his way through the overly complex but tra-
ditional plot exposition toward the conclusion of *The Town and the City*. So tedious
did he find the task that in order to motivate himself, he enlisted his beloved base-
ball and his obsession with statistics in the cause, devising a "batting average" sys-
tem based on the number of words he wrote each day, the time it took him to write
them, and other factors that he says are too complex to list or explain. He then cal-
culated and recorded his writer's "batting average" on an almost daily basis. On July
27, 1948, for instance, he announces, in the *Forest of Arden* journal, "did 24 pages,
batting .329."[67]

With the novel's publication by Harcourt, Brace, in January 1950, Kerouac
recorded his belief that he had achieved an artistic success, despite all of the
difficulties it had posed, but he knew that it represented a dead chapter in his cre-
ative life. Still, it was a time for celebration, and he composed a poem on the occa-
sion for Allen Ginsberg,[68] which he presented to him with a copy of his book. Some
of the poem's more unfortunate phrases, like "A nuder think," "Trembling veil,"
and "Prophetic Rose," are typical of the incoherence and cliché into which he could
lapse when striving to imitate the profundities of Rimbaud, or of Yeats in his sym-
bolist period. But Kerouac was about to undergo a creative journey that he hoped
would strip him of these vestigial, adolescent tendencies, although the transforma-
tion would take much longer than he suspected.

WINTER 1947-'48

Hitch-hiking trip July - Oct. 1947

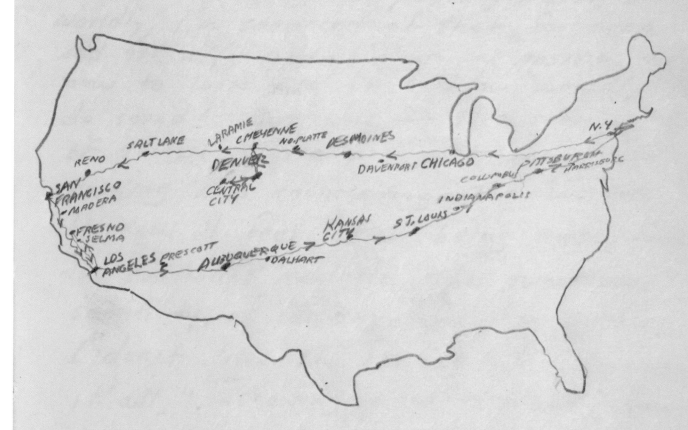

And all the great territories......

On the Road Proto-Versions: Drafts, Fragments, and Journals

In July 1947 Kerouac set forth on the cross-country-and-back-road trip that would inspire him to write *On the Road*.[1] The published version took its final form only after a creative and publishing journey as full of twists, side trips, and backtracks as the novel's semi-fictionalized account of the journeys themselves. As the drafts, fragments,[2] and journal notes for the novel show, Kerouac's desire to write a road novel, and to do so in what he would call his "own voice," unfortunately coincided with the midpoint of his struggle to complete *The Town and the City*, begun in October 1944 and over which he would labor with fierce doggedness, day by day, for five years.

From the beginning of the first road trip, in July 1947, through early spring of 1951, virtually all of the drafts, fragments, and notes for *On the Road* were written in the often sentimental and leaden manner of *The Town and the City*, expressing Kerouac's adolescent desire to create a Galsworthian family saga in the grand and moody, lyrical style of Thomas Wolfe. Unsurprisingly, therefore, the notebook in which we find Kerouac's earliest entries about the July–October 1947 trip is devoted primarily to notes on *The Town and the City*, with occasional entries about his close friends. As in the 1946 notebooks, he mercilessly lashes himself forward to complete *The Town and the City*, obsessively recording daily word totals and "batting averages" in order to motivate himself to continue with a novel in which he no longer fully believes, and which he prays will soon be finished so that he can commence his road novel.

He could not, however, refrain completely from exploring the literary possibilities of the 1947 trip. The notebook that covers the period beginning with the summer of 1947 and ending in the spring of 1948 contains a carefully drawn map of the United States, with the cross-country round trip diagrammed upon it (fig. 3.1).[3] But it is in the *Forest of Arden* notebook of the summer of 1948, in the entry for August 23, that he first broaches the idea for a road novel, which he will call *On the Road* (see fig. 3.2): "I have another novel in mind—'On the Road'—which I keep thinking about:—about two guys hitch-hiking to California in search of something they don't really find, and losing themselves on the road, and coming all the way back hopeful of something else. Also, I'm finding a new principle of writing." His summary of its plot—"two guys hitch-hiking to California"—does not reflect the actuality of his 1947–48 trip, which began with Kerouac traveling to Denver alone by "hitch" and by bus, and later continuing to California with Neal Cassady by car. Although Kerouac's

Fig. 3.1

Map and itinerary of 1947 road trip, in *1947–1948 JOURNALS NOTES*, June 16, 1947–May 4, 1948, p. [35]. 8.5" h.

Well, those are my sentiments ... As for me, the basis of my life is going to be a farm somewhere where I'll grow some of my food, and if need be, all of it. Someday I won't do nothing but sit under a tree while my crops are growing (after the proper labor, of course) — and drink home-made wine, and write novels to edify my soul, and play with my kids, and relax, and enjoy life, and goof off, and thumb my nose at the coughing wretches. I tell you they deserve nothing but scorn for this, and the next thing you know, of course, they'll all be marching off to some annihilating war which their vicious leaders will start to keep up appearances (decent honor) and 'meet expenses.' After all, what would happen to the precious system-of-expenses if our exports met with Russian competition. Shit on the Russians, shit on the Americans, shit on them all. I'm going to live life my own "lazy-no-good" way, that's what I'm going to do. — Tonight I read "Notes From the Underground." The other night I had read "Heart of Darkness," you know. I'm going to do a lot of reading now. Also reading "Tom Sawyer Abroad." I started the final chapter in a relaxed style, just to see how that works. The only trouble with my writing is too many words ... but, you see, "true thoughts" abound in the Town & City, which nullifies the slight harm of wordiness. Now I'll sharpen things. I have another novel in mind — "On the Road" — which I keep thinking about :- about two guys hitch-hiking to California in search of something they don't really find, and losing themselves on the road, and coming all the way back hopeful of something else. Also, I'm finding a new principle of writing. More later.

Fig. 3.2

Entry for August 23, 1948, 2nd page, in
1947–'48 JOURNALS FURTHER NOTES /
Well, this is the forest of Arden—, May 5–
September 9, 1948. 8.5" h.

The dated entries in this journal begin on the
thirteenth leaf, recto, under the heading
"*DIARY CONTINUED*," and record
Kerouac's progress with *The Town and the
City*, his social activities, emotional states,
dreams, family matters, the books he is read-
ing, and his love life. Kerouac mentions his
plan for a road novel after having recorded
that he has just finished reading Dostoevsky's
Notes from the Underground and that the
other night he had read Joseph Conrad's
Heart of Darkness, even as he continues to
read Mark Twain's *Tom Sawyer Abroad*.

first choice for a title was "On the Road," he would eventually consider almost a
hundred others, choosing "The Beat Generation" in late 1956, and returning to "On
the Road" only at the insistence of Malcolm Cowley, his editor at Viking.

In the fall of 1948, Kerouac completed the rough draft of a road novel that
bears a title Kerouac gave it some twenty years later, in the course of organizing
his Archive—*Ray Smith Novel of Fall 1948 (last chapt. is "Tea Party"[)]*.[4] "Ray Smith,"
the narrator-protagonist of this novel, shares the name Kerouac would give himself
as the narrator-protagonist of *The Dharma Bums* (written in November 1957), and
many elements of the character's biography mirror Kerouac's. Also, most of the
incidents in *On the Road* that relate to his 1947 trip from New York to Chicago to
Denver, and from there to Los Angeles and San Francisco, appear in *Ray Smith*.
These include Kerouac's romantic attempt to begin his trip by hitchhiking north
from Manhattan rather than west, in order to start out from Cape Cod (journeying
from easternmost America to westernmost, all on Route 6), a mistake that left him
drenched and desolate in a rainstorm by the side of the road near Bear Mountain,
about fifty miles north of New York City. In *On the Road*, the event is narrated in a
brisk and vivid manner; although the first-person narrator, Sal Paradise, fully con-
veys the misery he experienced, he does not wallow in it as does the third-person
narrator of *Ray Smith*.

The protagonist's wait at the gas station is also the point in the novel at
which *Ray Smith* diverges radically from *On the Road*. In the latter, the family in
the car that pulls into the gas station gives Sal a ride back to New York, where he
will board a bus to Chicago. In *Ray Smith*, Ray meets a young man at the station,
Warren Beauchamps, a hitchhiker also headed for California, and the two team up.
Beauchamps is the second of the "two guys hitch-hiking to California in search of
something they don't <u>really</u> find," and he seems clearly modeled on Lucien Carr.
Beauchamps is of French descent; he is "eighteen or nineteen" years old, "a blond
boy, handsome, with arched eyebrows and a quizzical expression of forced disdain
for the whole thing"; he is wealthy and patrician; and, perhaps most telling, the
respective temperaments of the two men and the psychological dynamic of their
relationship reflect those of Kerouac and Carr. Beauchamps (like Carr) possesses a
social ease that Smith (like Kerouac) lacks, and Beauchamps' conversation occasion-
ally mystifies Smith, as if Beauchamps understands the truth about relationships
and motivations much more deeply than does Smith ("He [Smith] knew now that
he was always going to be lost in these conversations"). Nevertheless, as in Kerouac's
(or Sal Paradise's) relationship with Cassady (Dean Moriarty), the two share a sense
of wonder about the world and themselves that imbues their conversations with a
luminous energy and intimacy. *Ray Smith* makes clear that Carr was for Kerouac
the pre-Cassady object of Beat adoration, the androgynous-seeming satyr whose
aristocratic disdain for middle-class convention and the law seduced the members
of Kerouac's circle as utterly as would Cassady's more assertive, Dionysian woman-
izing and car-jacking persona. *Ray Smith* makes the reader wonder what *On the
Road* might have been like had Cassady never entered the Beat circle of Morning-
side Heights and had Kerouac taken to the road with Carr. In fact, a group of notes
for *On the Road* that Kerouac began in April 1949 shows explicitly that Kerouac
wondered about this himself.

Ray Smith is only the first of at least a half dozen proto-versions of *On the Road*, each of which is represented in the Archive by anywhere from a few to several dozen drafts, as well as scores of fragments and hundreds of pages of working notes. The following year Kerouac produced a four-page plot outline, "PLOT OF 'ADVENTURES ON THE ROAD'";[5] he continued to work on this version through early 1951. He picked it up again in 1969, the last year of his life, and it was published in 1971 as the novel *Pic*. As that plot summary shows, Kerouac had, in 1949, already worked out most of the major narrative features that would appear in *Pic*, though the summary diverges in its second half from the published text. As in the published version, Pictorial Review Jackson ("Pic") is an African American boy from North Carolina who is orphaned and then taken care of by his grandmother. But unfortunately for Pic, the grandmother's father and husband are hostile to him (the great-grandfather had been blinded by Pic's father). Threatened with being sent to an orphanage, Pic is rescued by his older brother, "Slim," a jazz tenor saxophonist, who takes him to New York to live with him and his wife, Sheila. Slim, however, can find no work in New York, so the "family" sets out for California. En route, they meet Dean Poemeray, "an old friend of Slim's from his reformatory days," who is traveling with his girlfriend, Marylou, and they give the Pic "family" a ride to San Francisco. After several wrenching twists in the plot that take all of them back to New York, Poemeray and the Pic "family" return to California. The appearance of Poemeray, the Neal Cassady character, is significant, since he does not appear in the published version of *Pic*. Kerouac would use Cassady as a character under this name, in an alternate spelling, "Pomeray," in other proto-versions of *On the Road*, including those that he adapted and incorporated into *Visions of Cody* (Kerouac's novel about Neal Cassady's youth, prior to his arrival in New York), and in the novels *The Dharma Bums*, *Desolation Angels*, and *Big Sur*, as well as in *Book of Dreams*, which he began writing, according to the evidence of the Archive, no later than 1950.

In January 1949 Kerouac embarked on his second cross-country, round-trip road adventure. Whereas the 1947 trip began as a solitary hitchhiking ordeal, this time he set out, high-spirited and wild with expectation, with his friend Cassady in a 1949 Hudson coupe, accompanied by Luanne Henderson, Cassady's wife, and Al Hinkle, Cassady's friend since the days of their Denver childhood. Kerouac's excitement at encountering the West and the pockets of Old West culture and characters that he found in Colorado, Montana, and the Dakotas fueled his desire to produce a Western saga that would also convey the essence of his and his friends' lives—their sense of being outlaw saints, beaten down yet beatific, in their on-the-road search for the meaning of America and their own existence. Emerging from this second road trip is probably the most remarkable document Kerouac produced during this period, and one of the most compelling in the entire Archive, written in a hardcover, ledger-style notebook given to him by Cassady. A record of the trip, it contains his reactions to anything that impresses itself on his imagination, including reflections on people and places from his recent past. The notebook's front cover bears the simple title *Journals 1949–'50*. But the title that Kerouac inscribed on its first page *(RAIN AND RIVERS[:] The Marvelous notebook presented to me by Neal Cassady in San Francisco:—Which I have Crowded in Words—:)* is far more intimate and expressive.[6]

Throughout the journal, a spirit of excitement, imminent discovery, and breathless awe of America and its people prevail, conveyed in a style that is direct and conversational, yet also, by turns, whimsical, lyrical, and metaphysical—a style markedly different from the turgid prose and impossibly convoluted plots of the creaky and melodramatic Old West sagas that, as will be seen below, Kerouac was writing at the time. Most of the *Rain and Rivers* entries, not all of which are related to the trip, are undated, and the book is divided by headings, both mundane and poetic, into one- or two-page sections, some of which reappear in the *Road* scroll and its published version in slightly different form. These include "The Saga of the Mist" (fig. 3.3a) and "Little Raindrop That in Dakota Fell" (fig. 3.3b), as well as the following, with representative passages:

"Old 'Frisco[:] The Strange Dickensian Vision on Market Street": "I passed a strange little hash-house near or beyond Van Ness [...]. Something went through me, a definite feeling that in another life this poor, dear woman had been my mother, and that I, like a Dickens footpad, was returning after many years in the shadow of the gallows, in English 19th century gaols"

"The Butte Night": "I watched the wonderful characters in there ... old prospectors, gamblers, whores, miners, Indians, cowboys [...]. Another gambling saloon was indescribable with riches: groups of sullen Indians (Blackfeet) drinking red whiskey in the john; hundreds of men of all kinds playing cards; and one old professional house-gambler who tore my heart out he reminded me so much of my father"

"Dark Zorro of the California Night": "All look like characters in a movie, like seconds, or stunt-men, or stand-ins .. never like the hero. In the East you keep seeing the bloody hero himself. That is why California is poignant"

"The Trance in My Queer House": "The night of the eclipse of the moon, 11 P.M. April 12, 1949, I had a dream and a trance, in my queer house in Ozone Park ... that is to say, it was suddenly the same ambiguous house of my dreams, with many meanings and existences, like a great well-placed word in a line of poetry or prose. It was that very house that sometimes rattles ... and it is set on the edge of the world instead of Crossbay Blvd."

"A Beginning for Doctor Sax": "'It was on a hill right above the water, a queer manse with crooked roofs, and many dolorous windows, and weeds [...] It is called the Myth of the Rainy Night'"

"The Divide": "The Continental Divide is where rain and rivers are decided [...] I am Rubens ... and this is my Netherlands beneath the church-steps. Here I will learn the Day."

A few months after Kerouac began the *Rain and Rivers* notebook, he made his first entry into a complementary journal of sorts, a spiral-bound ledger notebook entitled simply *1949 Journals* on the front cover, and subtitled on the first page *1949 Road-Log*.[7] It was intended, in large part, as a record of his progress with, and evolving ideas for, *On the Road*, but is densely filled with rich entries on a wide variety of topics, including his progress with *The Town and the City*, which was now nearing

Fig. 3.3a–b
RAIN AND RIVERS[:] The Marvelous note-
book presented to me by Neal Cassady in San
Francisco:— Which I have Crowded in
Words—:, January 31, 1949–February 1954,
with blank entry for 1955. 9.25" h.

3.3a: p. 1, "The Saga of the Mist—"
"N.Y. across the tunnel to New Jersey—the
'Jersey night' of Allen Ginsberg. We in the car
jubilant, beating on the dashboard of the '49
Hudson coupe ... headed West. And I haunt-
ed by something I have yet to remember."

The Saga of the Mist —

Trip from New York to San Francisco, 1949.
N.Y. across the tunnel to New Jersey — the
"Jersey night" of Allen Ginsberg. We in the
car jubilant, beating on the dashboard of
the '49 Hudson coupe ... headed West. And
I haunted by something I have yet to
remember. And a rainy, road-glistening,
misty night again. Big white sign saying
"West" → "South" ← ——— our gleeful
choices. Neal and I and Louanne talking of
the value of life as we speed along, in
such thoughts as "Whither goest thou America
in thy shiny car at night?" and in the
mere fact that we're together under such
rainy circumstances talking heart to heart.
Seldom had I been so glad of life. We
stopped for gas at the very spot where
Neal and I had stopped on the No. Carolina
trip 3 weeks before, near Otto's lunch diner. *
Then we drove on playing bebop music on the
radio. But what was I haunted by? It
was sweet to sit near Louanne. In the
backseat Al and Rhoda made love. And
Neal drove with the music, huzzaing.
We talked like this through Philadelphia and
beyond. And occasionally some of us dozed. Neal
got lost outside of Baltimore and wound up in
(* And remembered the funny strange events there.)

completion, and diary- and journal-like entries encompassing an extensive variety of
literary, religious, philosophical, and personal subjects. In the *Road-Log*'s first entry,
dated April 27, 1949, Kerouac is exuberant over his progress: "Started 'On the Road'
with a brief 500-wd. stint of 2, 3 hours duration, in the small hours of the morning.
I find that I am 'hotter' than ever" (see fig. 3.4a). Six months later (October 17), he
reports that he has "sealed in" 25,000 words, and comments that "I really begun
[sic] On the Road in October of 1948," clearly referring to the *Ray Smith* fragment.

Particularly interesting to literary researchers will be the opinions that Kerouac
offers in the 1949 *Road-Log* on a considerable number of writers, and on the subject
of creative expression in general. For instance, on November 30 he declares that
readers are instinctively drawn to the works of writers possessed by a "tragic fury"
and "passionate intensity," among whom he includes Swift, Tolstoy, Twain, Cervantes,
Rabelais, and Balzac, but not Spenser, Melville, Hopkins, E. M. Forster, James Joyce,
Stendhal, Ouspensky, T. S. Eliot, and Proust, though he greatly admired all of the
latter. Drawing a lesson from this for his own work, he concludes, "In my recent
absorptions anent 'Road' I'd been wrapped in a shroud of words and arty designs.
That's not life—not how one really feels. Not passion! Here goes again on Road.

3.3b: **p. 65, "'Little Raindrop That in Dakota Fell.'"**

This long lyrical passage is included in somewhat altered form in *On the Road*.

"LITTLE RAINDROP THAT IN DAKOTA FELL" 65

the tide down the eternal waterbed, a contributing to brown, dark, watery foams; a voyaging past endless lands & trees & Immortal Levees (for the Cities refuse the Flood, the Cities build Walls against Muddy Reality, the Cities where men play golf on cultivated swards which once were watery-weedy beneath our Flood) — down we go between shores Real and Artificial — down along by Memphis, Greenville, Eudora, Vicksburg, Natchez, Port Allen, and Port Orleans, and Port of the Deltas (by Potash, Venice, and the Night's Gulf of Gulfs) — down along, down along, as the earth turns and day follows night again and again, in Venice of the Deltas and in Powder River of the Big Horn Mountains (name your humble source) — down along, down along — and out lost to the Gulf of Mortality in Blue Eternities.

So the stars shine warm in the Gulf of Mexico at night.

Then from soft and thunderous Carib comes tidings, rumblings, electricities, furies and wraths of Life-Giving Rainy God — and from the Continental Divide come Swirls of Atmosphere and Snow-Fire and winds of the Eagle Rainbow and Shrieking Midwife Wraiths — then there are Labourings over the Toiling Waves — and Little Raindrop that in Dakota fell and in Missouri gathered Earth and Mortal Mud, selfsame Little Raindrop Indestructible — rise! be Resurrected in the Gulfs of Night, and Fly! Fly! Fly on back over the Down-Alongs whence previous you came — and live again! live again! — go

Great God, how much must I pirouette to get back to myself! <u>Peste</u>!" On the following two pages (fig. 3.4b), the mood of frustration continues as he explains how life becomes a "circle of despair," depicting the psychological dynamic with circular diagrams that illustrate deflections of purpose from "pale forgotten goals"; the deflections orbit uselessly around an unknown, centripetal cause— "one dark haunting <u>thing</u> [•]." On the facing page he identifies his own haunting, deflecting force as the "Shrouded Stranger I dreamt once. It is ever-present and ever-pursuing."

One of many compelling personal entries in the *Road-Log* is the one for May 19, 1950, written after a five-month hiatus from the journal and, apparently, from writing *On the Road*. In this entry, Kerouac recounts a marijuana-induced vision of two weeks earlier, which took the form of a scolding "French-Canadian older brother" claiming to be "un ambassadeur du Bon Dieu," but whom Kerouac identifies as his "original self." The "brother," he writes, "came to me, almost incarnate, in a tea-vision two weeks ago and has been with me ever since." The brother's words "strike home & heavy," as he accuses Kerouac of attempting to suppress his Canuck identity:

That first morning he acknowledge[d] several things I asked him—Allen Ginsberg & [art critic] Meyer Shapiro & [literary and social critic Alfred] Kazin [Kerouac's teacher at the New School, in 1948] were great men because they were not trying to dejew themselves—& therefore I should not try to defrench myself. As simple as that. He told me Carr was a silly ass; that Neal was okay even if 'un excité'; he told me to slap my lady love down and make her <u>mind</u>; and such as things as that, all simple, direct and true. He even told me to go to church and shut up [i.e., stop complaining]. He hinted I should go to Lowell, or Canada, or France, and become a Frenchman again and write in French, and shut up. He keeps telling me to shut up. When I can't sleep because my mind is ringing with gongs of English thought & sentences, he says, "<u>Pense en Francais</u>," knowing I will calm down and go to sleep in simplicity. I'm taking this brother with me on this trip to Mexico and see what happens. Many times he says, "Eat!" and I get up and eat. I think he is my original self returning after all the years since I was a child trying to become "un Anglais" in Lowell from shame of being a Canuck; I never realized before I had undergone the same feelings any Jew, Greek, Negro, or Italian feels in America, so cleverly had I concealed them, even from myself, so cleverly and with such talented, sullen aplomb for a kid.*

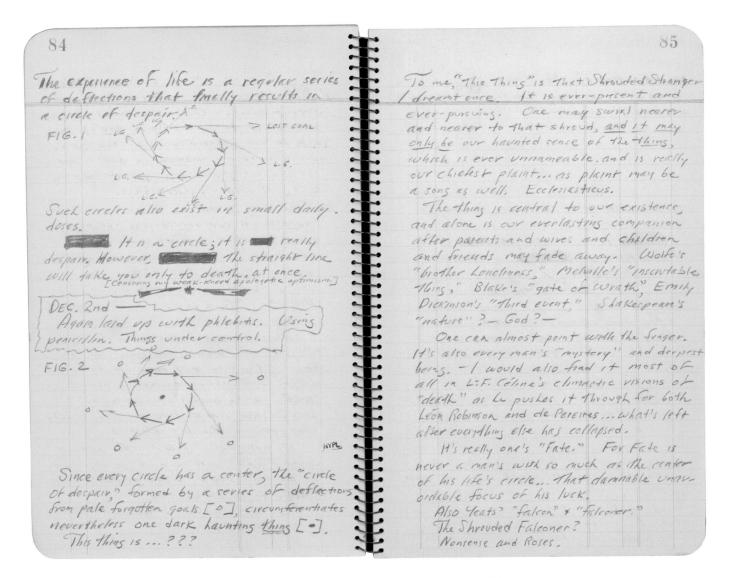

3.4b: **pp. 84–85.**

The asterisk leads to a note at the bottom of the page, "*Wrote a novel at <u>eleven</u>, 'Peter' (!)" (The novel is not in the Archive.) At the end of the entry, disconsolate over his lack of progress with the "Road" manuscript and musing sadly on the vanity to which all aspirations are reduced by death, he asks, "will anything have been settled?"—that is, will he have accomplished anything by the time he dies. Rousing himself, he promises his "brother" emphatically, "I'll see to it that it is, <u>mon frère</u>."

The *Road-Log* also provides us with detailed insights into the novel's "Smitty" character, Kerouac's alter ego, who made his first appearance in the *Ray Smith* novel of 1948 and whom Kerouac included in some other pre-scroll versions of *On the Road*. Indeed, so closely does the character resemble Kerouac himself that it would not be far from the truth to say that he survives in Sal Paradise, the narrator of the published novel. A particularly interesting insight into "Smitty" found here is a form of meditation that Kerouac attributes to his alter ego and which he seems to have developed on his own: "My Smitty in 'On the Road' has a simple almost childish method of arriving at pure knowledge of the world. He stands somewhere, at home or on a streetcorner or in a subway, and closes his eyes. He stares at the darkness in his eyes, then opens them wide, looks, and says 'Why?' All this is a complicated thing. The effect is to make the world show its mystery, its skirts, as it were at an odd

ON THE ROAD * ① JOHN "RED" MOULTRIE.

Definite "unities" (as yet un-named).

① The folded night on the Susquehanna —
"Ain't this thing the loneliest old river
you've ever seen?" Red & Smitty.

② The tent in the San Joaquin Valley —
with the girl & her baby boy; picking
cotton, with the Okies; Fall coming on;
the Mexes & their whiskey & trucks. Smitty.

③ Marin City & the barracks cops-job — steal-
ing groceries; the long rains; the canyon
at night; the vision of Zorro by moonlight.

④ Vern's Wild Frisco — including shack in
Richmond; selling dictionaries with Smex;
the railroad job, Frisco to Bakersfield.

⑤ River-smelling Spring in New Orleans
Dennison's ramshackle house

⑥ Bayou in Louisiana — & Rainy Texas Town
Stranded in the mossy palace at Midnight
(Sabine R.)

⑦ Central City in Summer — (Fire G.-type)
events!

⑧ Lovelock, Nevada — & Truckee!

⑨ Butte in January — & Madman & Angel!

⑩ New York (Bnx. Jail) in Spring (Riker's
Island.)

ORDER: — ⑩, ①, ⑤, ⑦, ⑧, ③, ④, ②, ⑨

* which, beside being a novel, and a saga of the
seasons (& madman-angels), is also a travelogue.

embarrassing moment. The <u>hex</u> of the mystery shows its presence." The rest of the page analyzes "Smitty's" yearning for God and the resulting turmoil in his psyche. This look into "Smitty" is without doubt a look into the depths of Kerouac's mind.

By November he had completed an elaborate outline for the novel (judging from an April 15 date that appears midway through the manuscript, it was probably begun early in the year, perhaps nearly contemporaneously with the beginning of the second road trip), with copious notes and commentary, entitled "NIGHT NOTES & Diagrams for <u>ON THE ROAD</u>" (see fig. 3.5a–d). As the manuscript makes clear, he has already written significant sections of the novel and is now attempting to make a fresh start, though he modifies his plans several times in the course of the "Notes." On the manuscript's first page of text, unnumbered, bearing the title "'<u>ON THE ROAD</u>'[:] Readings & Notes 1949," we find an unlikely source of inspiration for the author of *On the Road*. He quotes from the introduction to *The Ecstasies of Thomas De Quincey* (London, 1928), in which the editor, Thomas Burke, calls De Quincey "a 'goblin' of the London night" and notes that he would "hawk his manuscripts around to new magazines with the diffident air of the beginner." It is easy to see why this description struck a chord with Kerouac, since he too was a creature of the night and

3.5b: p. 42.

At the bottom of the page, Kerouac has drawn a goblin-like face floating over the Susquehanna River, which bears the title "Ghost of the Susquehanna." This is a reference to Kerouac's encounter, on his first road trip, with a spectral old man, which he described in "Night Notes" and used in *On the Road*: "I thought all the wilderness of America was in the west till the Ghost of the Susquehanna showed me different."

felt awkward and embarrassed when attempting to sell his work. Burke's use of the word "goblin" is especially resonant for Kerouac, who notes parenthetically, with an asterisk at the bottom of the page, that there are "(* dark-toed Goblins in Dr. Sax)."[8]

The "Notes" proper begin with a ten-item list of "Definite 'unities' (As yet un-named)" (see fig. 3.5a), the first of which is an allusion to an event that does not appear in the scroll or the published version of *On the Road* until the end of Part One: Kerouac's brief encounter with an old, bearded hobo, the "Ghost of the Susquehanna," on a foggy, desolate stretch of Pennsylvania road along the banks of that river. Kerouac is chilled by the desolation of his surroundings, which only exaggerates the old man's mysterious, portentous aspect. But like all of the proto-version drafts and notes, this manuscript is peopled with amalgams of men and women Kerouac knew or met on the road; in addition, characters who are mentioned only casually or not at all in the published version occasionally assume a position of great importance in the notes and proto-versions. (The characters mentioned on page 1 of the "Notes" are two of this version's three central characters, John "Red" Moultrie and Smitty, i.e., Ray Smith. The former seems to be based on Neal Cassady's father, as well as on an aspect of Kerouac's psyche that created nightmares

"NIGHT NOTES & Diagrams for <u>ON</u> <u>THE</u> <u>ROAD</u>," completed November 1949. 9.4" h.

3.5c: **p. 53.**

(53) ROAD

What does Smith care, if, when he smiles
at someone because he thinks it will make
them happier, they snarl at him — it is
no concern to him.

＝

A man really has one splendid oppor-
tunity to be good in an evil world like
this — but if the world were suddenly
good, if everybody one morning were
like Charley Chaplin,* doing their best,
smiling, dodging, tipping their caps, I
think the "good man" might suddenly
decide to be evil. Just to be different!
Why not! His evil would no longer
harm! *Smitty?

<u>Finally</u>
"Road" is mainly a study of the young
people of this age who "refuse to
work," as it were, and who roam
the country half on the verge of crime,
half on the verge of hoboism, and the
remaining time do work, and have to,
of course. The Beat Generation, but
their "hip" interests are the same as
the "cooler" segment of the generation
who have found some way to manage.
Vern is a "hot" hipster, not cool.
It is just that the forms of this "ge-
nerationism" yield to any individuality.

about a pursuing shroud, and the latter to be based on Kerouac himself, as in the *Ray Smith* novel. The third protagonist is Vern Moultrie, whom Kerouac compares to Cassady in several respects.) An asterisk following the page's heading, "On the Road," leads to an explanatory note at the bottom of the page: "*which, beside being a novel, and a saga of the seasons (& madman-angels), is also a travelogue." On page 7, Kerouac lists the characters he will include in a jail scene (recalling his imprisonment in the Bronx following the Kammerer murder): "the Hawk, Willie Gallo, Red (the other one), the soldier brought back from China, Yogi [Yogi Garfinkle, i.e., Allen Ginsberg, who "discusses Nietzsche with him every blessed morning"], the one-legged boxer, the big Czech, the Chinese (Billy Soon), the little music-sheet swindler, the old man (of the dirty broken-bottle case in the poolroom), Bronx Blackie (cop-shooter); and the guards."

By the middle of "Night Notes," under the date April 15, 1949, Kerouac resolves to rework completely the plot of *On the Road*, exhorting himself to learn from the lesson of *Doctor Sax*, a fantasy novel he was writing, whose hero is a magus-like figure akin to the eponymous hero of the radio mystery program "The Shadow." Doctor Sax has dedicated himself to destroying an evil, magical serpent

3.5d: Final page, Map of United States for "Itinerary & Plan."

Note the presence, in the list of characters, of Dean Pomeray, i.e., Neal Cassady, who would bear the name Dean Moriarty in the published version of *On the Road*. Marylou, i.e., Luanne, was Cassady's wife when he first came to New York, and would retain this name in the published version of *On the Road*.

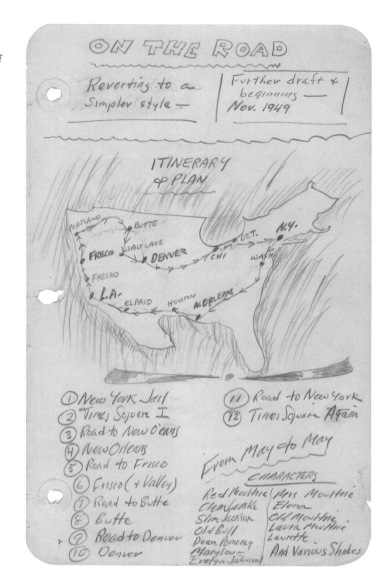

before the serpent can emerge from his lair beneath a sinister-looking old mansion in the child-narrator's home town (i.e., Lowell) and destroy the world. Kerouac would continue to work on *Doctor Sax* through 1952 (it would not be published until 1959), but clearly he had already completed extensive preparations for it.[9] He may even have begun to write at least a first draft of it by this date, since he asks himself, writing in blue ink, "It took so many months to finally compress Doctor Sax into shape ready for writing. Why not learn a lesson?" and responds in violet ink, "Dismantle the plot of 'On the Road' you have now (as was done eventually to Sax) and, for experiment's sake, make a new one. Change LOCALES, and that changes psychological quirks. See what <u>really</u> holds together; then pull the lines in. Who is Smitty? What <u>is</u> all this?"

Kerouac would pose and answer this last question about *On the Road* and himself scores of times and from different perspectives (psychology, literary style, character development, philosophy, spirituality, sexuality, sociology, economics, etc.) over the next two years, in journal and diary entries, manuscript fragments, working drafts, and separately gathered leaves of notes. He does this several times in "Night Notes," as when he asks himself if Dr. Sax was "Red's boyhood daydream of himself

[...] in some old silver miner's castle on the Platte," or "perhaps on remembrance of a childhood trip to Riverside, Mass.," the latter of which has the sound of a genuine Kerouac childhood memory. Most intriguing, we see that Kerouac had imagined that "Doctor Sax" would be no more than a story within this version of *On the Road*, as he considers the possibility of the story's standing on its own: "Sax could there-fore follow—that is as itself, not in Red's incomplete sense and by another name—after On the Road ... simply as a phantasy & myth." In another answer to "What is all this?" Kerouac provides "a simple story-sense" summary, the way "the movie-writers sum up": "'On the Road' is about a young man who has reached the 'bottom' —jail (ON INNOCENT COMPLICITY)—and upon his release is so beat & miserable that he really has no place to go" (see fig. 3.5b). Later in "Night Notes" he writes, "Smitty is myself in 1949."

What emerges from these notes and the hundreds of pages like them that Kerouac wrote for the pre-scroll versions of *On the Road* is that the writing of drafts and the making of notes were for him part of the process not just of creating or re-creating a quasi-fictional world and the characters who inhabit it, but also of discov-ering the essence of who he was, who were his friends, and what it was that made each of them essentially different from all the others. For instance, Kerouac finds "an element of Lucienne's wisdom in Red————as if I had become the Warren now instead of the Ray. [...] What Red has, however, which Warren didn't have, is Smitty in him ... his abyss, of sorts ... perhaps Red's considerations are precisely those I had predicted for myself when I should ever sell my works & make a living, a career."[10]

At the conclusion of "Night Notes" he addresses the question of what *On the Road* is and what he is trying to accomplish by writing it, which inevitably brings him to ask, in effect, "What is the Beat Generation?" In formulating his reply, he distinguishes between "hip" and "cool" Beats, a distinction that was already a source of friction between the Beats of the East and West coasts. But whether of the hip or cool variety, the Beat idea itself seems to him a "new nihilism" similar to that described by Dostoevsky in *The Possessed* and by Turgenev in *Bazarov*, that is, a movement possessing its own language, ideas about sexual freedom and the trans-formation of society, and, perhaps most important for Kerouac, "innocent wonder."[11] This last characteristic marks the best of Kerouac's writing, and it is the quality he says is exemplified by the character Smitty. Concluding "Night Notes," he asks pointedly, "And what is it after all to be beat?" to which he replies, "the innocence of not understanding [...] the money-ways of civilization," and follows this response with an analysis of the Beat attitude to work, money, and authority. But an aster-isked note rephrases his answer much more simply and effectively: "The innocence of not understanding the world," adding, "in which sense children are beat."

During most of the period that Kerouac was working on "Night Notes," he was also writing a multidraft outline version of *On the Road*, on which the "Notes" com-ment and for which he took guidance from the "Notes." This twenty-three–page typescript, variously paginated and heavily emended in Kerouac's hand, comprises five fragmentary drafts (the numbering indicates that large portions of some of the drafts are lacking) dating from September 1949. He entitled them collectively, perhaps at a somewhat later date, "The Hip Generation" (see fig. 3.6).[12] The drafts present somewhat differing accounts of a family saga whose origins lie in the Old West.[13]

I EARLY APPURTENANCES (The Hip Generation)

A SONNET DEDICATED TO RED MOULTRIE

When Summer softly strays my love afar, as always,
 And turns with hope of home of Autumn dark;
When yet even Autumn hints of homelessness
 And sighs at me with leaves and groaning boughs,

With hints that even home will poorly miss;
 When I then foresee old elusive Winter
Shall my Christmas quite deceive, and sense Spring
 Again revolving with pretty talk of love,

Then I see me wandering among the mockeries
 And wonder that seasons think me so foolish
That I not love them just for what they are
 In lieu of wily winks in all these trees and wind.

Thorns they merely are in the hardy hedge
 Of all my loves, the rosebush of my soul.

Earl John Moultrie, known as Red, decided many things when he suddenly
stood transfixed in his cell that May night in New York---with his gaunt,
bony, melancholy face that was always turned aside and down in pensive-
ness; as now, over a cool and contemplative jaw; and his smooth auburn
hair that combed close to his head and gave him a burnished, rocky look,
and brown eyes that sometimes were red in the light of bulbs. He was merely
merely standing there before the bars of steel, fairly tall and wiry-
strong, with the dull calm of a man who might walk as if in white sneakers
across some tennis court, with motionless arms hanging, knuckly hands dim
with freckles, a soft brown spot like a dark signature onhhis cheek, and
a part at the back of his head where his hair always stuck up so gently---
just a mild yet severe young man in baggy trousers and an old shirt frayed
from many washings in the sink in the cell. Yet his mind was on fire and
he was deciding many things in a flash at last, and mainly, and finally,
he decided:
But-"The only wrong I've ever done is believe that wrong exists and go
around with that idea in my head and look at everybody through such eyes.
But when I am dead I will look back on life only with love, as though
nothing that happened really mattered that way, and therefore I will see
that everything was right after all, and so strangely dear. Why is it
that we forget in one moment what we did the moment before? Because it
doesnbt really matter, and the only wrong is in our heads. All we do
is wonder what we're doing, while love leads us by the hand. Because when
When I am dead I will look back and the rounder will be gone, and all the
rounding is done; the whore will be gone, and all the whoring is gone;
the thief will be gone, and all the thieving is done; the killer will be
gone, and all the killing is done; and the lover will be gone, and all the
loving is gone. So it is necessary To believe even right now on earth
that nothing is wrong, this moment, and to do this I must overlook this
moment of dumb existence when everything seems so wrong in my head and in
the heads of others, and begin to go about as if looking back from my
 and the Graces fall like
 snowflakes all around. O Beatitude!

Kerouac tries, a bit clumsily (understandable, given the extraordinary complexity of the challenge he had set for himself), to integrate his ideas about the virtues of the Old West, their corruption by modern consumerism, and the need for a spiritual renewal in America, with the symbolic meanings he wishes his characters to convey, even as he requires that the psyches of his characters mirror those of his friends and relatives. As he made clear in "Night Notes," and as he would in other notes and journal entries for other pre-scroll versions of *On the Road*, each of his novel's characters represents not only a real person, or various aspects of different real persons, but also an "American type," as he phrased it. For instance, Smiley "represents 'list' sad, drunk, absentminded American"; Champa ["Charlie" Moultrie, now called "Charlie Gavin"] "the aggressive fool of our noons ... the 2 extremes of a decay."[14]

This highly complicated symbolic strategy, heavily influenced by the example of Dostoevsky, is also reflected in the convoluted plot developments of all of the pre-scroll versions in their numerous fragmentary drafts. Kerouac tried to create a symbiotic relationship between plot and character symbolism, in order to reflect every nuance of his ideas about American history and about the significance of his and his friends' existence in relationship to each other, to American history, and to the cosmos. Inevitably, he was unable to achieve such a grand and unrealistic ambition, and none of the pre-scroll drafts is sizable enough to constitute more than a lengthy short story. Nevertheless, once he found a way to tell his story directly, in his own voice, he was able to incorporate into the scroll, much more obliquely and subtly than he had done in the proto-versions, the insights about America, himself, his friends, and the world that he had been exploring and analyzing since 1947 and even, in some cases, as early as 1944, when they first appeared in his notes for *The Town and the City*. From the reader's perspective, these early struggles possess another virtue. The heavy-handed didacticism of the drafts, and certainly the explicit statements in the notes, help to clarify his intentions, as well as raise intriguing questions of origins and interpretation regarding the scroll and the published version of *On the Road*.

Briefly summarized, "The Hip Generation" drafts comprise one instance among several of Kerouac's attempt to illustrate the joined themes of Old West virtue, its corruption, and its potential redemption, by portraying the odd friendship that binds together three young men, who seem to be patterned after himself, Neal Cassady, and Lucien Carr. The novel, however, places them in the fictional context of having grown up together on the outskirts of Denver. The Old West is here embodied in the person of Wade Moultrie (the uncle of Earl John "Red" Moultrie, who was featured in "Night Notes"), the head of a prominent Denver clan. He is an enterprising, carousing, and good-hearted Georgia native who, after fighting for the Confederacy as a young man in the Civil War, goes west to seek his fortune, meets adventure in the American wilderness, becomes a moderately successful miner in Butte, Montana, and then moves to Denver, where he succeeds in business and falls in love with a young woman named Ameline. (In the second draft of the story, Wade never reaches Denver, but becomes a mining success in Butte and remains there.) After a brief separation from Ameline, Wade returns to Denver to marry her, becomes a farmer on the outskirts of the city, and ensconces himself and his bride in "a comfortable brick house." (In "The Hip Generation," as in several other pre-

scroll versions of *On the Road* and in his notes for *The Town and the City*, Kerouac makes a great point of correlating the quality of the houses inhabited by the fatefully intertwined three families to their respective socioeconomic classes.) The Kerouac and Cassady figures enter the story through the two tenant farmers who work Wade's land. The first is Wade's younger brother, Bruce "Smiley" Moultrie ("easygoing and rather charming"), Red's father, who lives in "a neat frame cottage." The second is Vern Pomery ("a stocky, simple man originally from Missouri, who worked well when he was sober"), who lives in a "shack"; this is the father of Vern Pomery, Jr., who, as in "Night Notes," represents, for the most part, Neal Cassady.

In three other drafts, all narrated in the first person by the Kerouac alter ego, a third young man, named Wayne, a son of Wade's brother Charlie, is added to the narrative mix; this character is apparently based on Lucien Carr and/or Bill Cannastra, a brilliant young lawyer well known in literary and theater circles, and a friend of Kerouac, Ginsberg, and Carr.[15] Wayne is handsome, blond, has "a knack for talking to people," laughs "crazily" whenever he sees the motivation for his friends' behavior (of which they are ignorant), and is the leader of the group comprising himself, Red, and the Vern/Cassady character, now called Dean, a change that links Cassady more closely to his eventual representation, as "Dean Moriarty," in the published version of *On the Road*. An important feature of two of the first-person narratives is that Red and Vern/Dean are half brothers, with the same biological mother, which reflected Kerouac's and Cassady's view of each other. In the second of the first-person drafts, "Details of the 'Day When Everything Happened,'" said to have occurred on July 4, 1936, the characters are clearly the descendants (and their friends) of those involved in the Moultrie saga, but the Moultrie name has been changed to Gavin (as it is also in several later proto-versions) and the narrator "Red" is called "Chad." This draft is most notable for introducing the character of Laura, which, in the published version of *On the Road*, is the name of the woman whom Sal Paradise falls in love with and marries. In the scroll she is identified as Joan (Haverty), Kerouac's second wife, who, before meeting him, had been Bill Cannastra's girlfriend. In this draft, Laura is a young woman for whom Chad, Wayne, and Dean compete in ways that may have been based on the behavior of their real-life counterparts when vying for women, or at least on how Kerouac perceived that behavior. Chad, the Kerouac character, is morbidly sensitive, painfully shy, and quick to anger when Laura feigns indifference; Wayne, the Carr/Cannastra character, is exuberant, cynical, and perverse, probably not even interested in Laura beyond the opportunity she provides for him to manipulate her and his two friends; and Dean, the Cassady character, is quietly intense, watchful, and occasionally resentful of Carr's ability to attract Laura.

By February 1950 Kerouac had again reconceived *On the Road*, and he produced a "Cast of Characters"[16] for a version that centers both on the Gavin family and on a newly introduced family with which its destiny is intertwined—the Rawlinses. New characters are added to this version, and many of the old ones reappear. This list is of particular interest because Kerouac includes the characters' attributes, and elaborates on familiar themes—such as the brotherhood of the Kerouac and Cassady characters—in slightly different forms. Dean Pomeray, Jr. (i.e., Neal Cassady), is described as a "Hipster, hot-rod racer, chauffeur, jailbird, teahead

[i.e., marijuana smoker]." Chad Gavin, the son of Bruce and Mary Marshall Gavin, and Kerouac's alter ego, is a "Brooklyn baseball player; scholar, jailbird, roamer." Because Dean Pomeray, the elder, fathered Dean, Jr., with Bruce's wife, Mary, with whom he ran off, Chad and Dean "are half-brothers in blood." They are also each "1/16th Comanche," since Mary was the "grandaughter [sic] of full-blooded Comanche squaw." The destruction of Native American peoples and culture loomed large in Kerouac's view of American history, and in attributing a portion of this identity to himself and Cassady he was asserting his and Cassady's right to be considered heirs to the spiritual patrimony of aboriginal Americans. (Also, according to Kerouac family lore, the family's French-Canadian ancestors had intermarried with women who were at least part Native American.) This heritage included, most importantly, a special relationship with the land itself, a theme that was to figure prominently both in *On the Road* and in *The Subterraneans*. Among the important characters who make their first appearance in a pre-scroll version, showing that Kerouac had begun to bring the narrative into contemporary times, are "Old Bull Seward," i.e., William S. Burroughs ("Times Square Character; old junkey; seer"); "Clem Lemke," i.e., Herbert Huncke ("neighborhood friend of Chad Gavin in Brooklyn; junkey hipster; mystic"); and "Marylou Dawson Pomeray," i.e., Luanne Henderson ("young wife of Dean Pomeray, Jr., from New Orleans & Denver"). At the bottom of the page, Kerouac has added the poetic note, "And All Waifs of Eternity in the American Raw Night-Road."

Three days after Kerouac compiled the "Cast of Characters" for the "reconceived" *On the Road*, he began his *EARLY 1950 Notebook*,[17] a twenty-two–page journal written on leaves torn from a spiral notebook and later inserted into the *1949 Road-Log*. Its first entry (see fig. 3.7) reveals that the Chad Gavin character has now definitively become the protagonist of *On the Road*. Kerouac notes that he has been reading Balzac's novel *César Birotleau* (part of the series *La comédie humaine*), and says that as he was reflecting on how he has "been grinding & grinding my mind on the Road idea for years now," he recalled Balzac's admonition, "'don't confuse the fermentations of an empty head with the germination of an idea.'" He could not help feeling that Balzac "refers to someone like me." Yet Kerouac immediately recovers his self-assurance and tells himself, "But the 'Road' plot is rich because of the 'years'—no other reason." This would prove a sage observation, if not about the specifics of the plots on which he was toiling, then certainly about the life and writing experience he had gained, which was essential to the creative burst that produced the scroll. He seems to intuit that his writing has been too explicit and didactic in its intentions and that it could use a bit more indirection. On February 28 he writes, "Also, I'm going to express more and record less in 'On the Road'— I'm going to point out ways instead of describing paths." The generally negative and lukewarm reviews that *The Town and the City* received (it was published at the beginning of March 1950) both disappointed and angered him, but within the week he had recovered sufficiently to see that he could learn both from the experience and from the criticisms themselves: "All this swirl has interrupted the work I was doing on Road. But I'm learning so much from reception of my book that I'm still revising some main idea for it. One learns so much being published— about the cultural scene and the people of the world who are concerned with it.

Fig. 3.7

I believe that my own vision needs broadening, like Tom Wolfe's 'deathbed window,' perhaps to a final bird's-eye view of the world and Time which is like Mark Twain's in the Mysterious Stranger and like something else which is slowly formulating in my mind."

Following the visitation of the chastising "older brother" in early May of 1950, described in the *Road-Log* (see above), Kerouac responded to the spectral admonition and gave a French background to the chief protagonists of the various drafts of the Old West saga that he produced during the rest of the year, such as "Nicholas Breton" (reflecting Kerouac's pride in his Breton heritage), "Victor Duchamp" (the novel for which the Duchamp notes were written is described as a new "Galloway" novel),[18] and "Wilfred Boncoeur." Arriving in Mexico City in early July 1950, Kerouac began what he called a *"Road" Workbook*, which he completed at home several weeks later, in Queens. It contains treatments and notes for four drafts of *On the Road* (one of the drafts really is a distinct version), as well as diary entries reflecting his struggles in settling on a plot and set of characters, self-exhortations on how he should write, his definition of "modern" literature (chronology is irrelevant), and his account of how he has prayed for divine guidance and the manner in which it was

Fig. 3.8

"Gone on the Road," July 26, 1950, p. [99], in
"'Road'" *Workbook*, July 1950. 8.75" h.

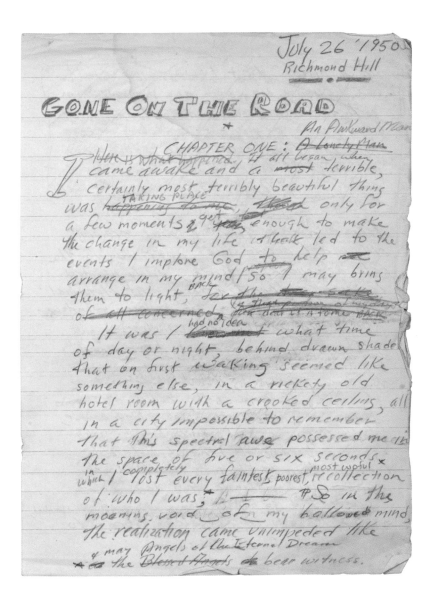

granted and received.[19] The protagonist of the first draft is Wilfred "Freddy" Boncoeur,
who, under the heading "Survey of the Cast," is described as a fifteen-year-old
French-Canadian from New Hampshire who "wants to find & rejoin his lost father;
and does so after thousands of miles of hitch-hiking through U.S.A. and driving in
Mexico; only to be robbed by the old man; and tormented by the girl he meets on
the road [...]." His hitchhiking partner is his cousin (called, simply, "Cousin"), and
the girl he yearns for is Laura, the daughter of his mother's best friend.[20]

In the notes for a twenty-two–chapter second draft, Freddy is joined by a bewil-
dering host of other characters, including "A roaming French Canadian cook" who
"has a great slew of friends & relatives all over the United States that he sees on the
road" (both Freddy and the cook are in love with Laura); a brother of Freddy (whether
he is older or younger is not clear), who has vowed to become a "Walking Saint,"
out of love for Laura and "because [in walking] he seriously does penance for the
sins of the world," and whom Kerouac compares to "the old Pilgrim in [Dostoevsky's]
A Raw Youth"; and Dean Pomeray, the Neal Cassady figure. On July 26, Kerouac
began a third "Road" draft in his *Workbook*, called "Gone on the Road." It opens in
a Des Moines hotel room, with the narrator awakening in the early morning to the

realization that he is going to die (see fig. 3.8). The main theme of this draft is the protagonist's search for his father, and this, as well as individual scenes, places it among the body of work that eventually became his novel about Neal Cassady's pre–New York life, *Visions of Cody*.[21]

The notebook is supplemented by a nine-leaf insert, five leaves of which comprise Kerouac's notes and some passages for another "Road" version, this one focused on Freddy's travels with the scolding "older brother" of Kerouac's vision. This last Freddy is modeled upon the aspect of Kerouac's psyche that the brother had rebuked: "An alien within the alienated"; "He is French-Canadian, apologizes for English"; "Has his 'ghostly brother' who reprimands him everywhere." Above all, this protagonist will not be, as Kerouac sees it, a compromise figure like Peter Martin of *The Town and the City*, but will be true to his French-Canadian roots: "No Martinization this time, the real F-C soul—the real F-C feeling about <u>cats</u> & everything. About the sky." Perhaps because Kerouac intends to be true to the particulars of his individual experience, he feels that this latest plan for the novel will have universal application: "This is a <u>universal</u> heroic." This collection of notes and draft passages also contains Kerouac's explanation of why he has invested the road experience with such significance: "The Road trip is the physical crucial opening of the world for him [i.e., Freddy and, presumably, Kerouac himself], therefore its events are crucial."

Kerouac has therefore established two seemingly opposing movements in his plans for the novel. He has committed himself to a frank depiction of his cultural identity—what might be seen as a narrowing of his focus through the particularization of the narrator's identity; but at the same time he has come to realize that the essence of the road experience for him is an escape from particularity into the universal. Perhaps this is why he wishes to distance himself from the fictionalized figure of the "brother." He now decides that the "brother" may be a cousin, and for several pages he uses the two terms interchangeably. He then reverts to the "brother" identity, but in a conditional way, explaining that the "cousin" is "Real brother but [Freddy] calls him 'cousin' after fashion of Quebec country folk, meaning: 'My kind.'" "My kind," but only ethnically; Freddy and the cousin are moral opposites: "Cousin is always good because he resides in goodness. By some accident of destiny half of Freddy resides foolishly in evil. No exculpation this time!" The concluding exclamation is probably an allusion to Peter Martin of *The Town and the City*. Kerouac feels that he let himself off the hook in his previous novel and is determined to paint a more truthful and, as he sees it, ugly portrait of himself in the road novel.

As Kerouac delves deeper into this "Freddy-Cousin/Brother" version, however, his characterizations of each of the twinned protagonists become more morally complex. "Cousin," unlike Freddy, always has a job and represents the "job consciousness of America & France etc." But because of this exaltation of duty he is less forgiving than Freddy of their father's flaws: "His attitude toward old father in Butte is sterner, less imaginative" and more "practical." But Kerouac has not forsaken his desire to maintain the good/evil dichotomy. He compares "Cousin" to an actual person in his life, his Harcourt, Brace editor, Robert Giroux ("Cousin is Giroux too"), whom he greatly respected as a moral authority. He also notes that Freddy and his brother ("Cousin"), though they have the same father, have different

Fig. 3.9

Private Ms. of Gone on the Road Complete First Treatment And With Minor Artistic Corrections, August 1950, title page, 12.25" h.

mothers, which means that the "Burden of F's evil therefore lies on his real mother ... dead, the 'Arizona waitress.'" As was Kerouac's wont, he cites several canonical authors in an attempt to define the task before him: "join Twain, Celine & Defoe together! Stevenson's 'Kidnapped' in the sense of his 7-year, changing substance." Kerouac then finds, as he often did in his notebooks and journals, that his characters have taken on attitudes or approaches to life for which he must find motivations, and that the more he tries to imagine them as actual human beings within his plots, the more vigorously they break out of his carefully delineated categories of good and evil: "But Cousin <u>never changed</u> at all. What does <u>that</u> mean? That some men are practical & unimaginative, can be made to do anything—while the wild-hearted ones are individualists, intractable, and free?"

The question of style is one that Kerouac typically returns to in his journals, diaries, and notebooks. Convinced that he has not written and is not writing in a voice that is authentically his, he now believes that he will first have to toil through the writing of two more novels—*On the Road* and *Doctor Sax*—before he will be able to find it. Only after completing these novels will his true adult voice be able to emerge in a novel about the Civil War—ideas for which he occasionally delineated in his journals and which he had made part of the biography of Wade Moultrie/Gavin, the *pater familias* of his Old West sagas—and in another novel about the sea: "I must write the child voice of Road, and the baroque-Melvillean voice of Sax before reaching the true personal style of myself—adult in Civil War. [...] Adult voice will inch along into Balzac & Shakespeare uses & works. T & C [*The Town and the City*] was <u>childlike</u> voice, not yet <u>true child</u>; Sax <u>adultlike</u>, not yet true adult of Civil War—& sea-novel 'The Dreaming Babe Above the Ship—(or S.S. Dreaming Babe.')" Kerouac's style underwent its first great revolution in the creation of the *On the Road* scroll, once he had realized that his "voice" must emerge naturally from his life experience, not through an act of will and through practice, which is to say, as mere technique.

One month later, in August 1950, Kerouac began another important draft of *On the Road*, the working title of which was *Private Ms. of Gone on the Road* (see fig. 3.9). The manuscript's title page bears a quotation allegedly from a book called *Chronicles of the River*, but the title, as well as the quotation and the author's abbreviated name ("Chas. Mad"), were probably Kerouac's creations. (Perhaps they are a tentative title and narrator's name for one of the several novels that Kerouac was writing at the time.) Set entirely in Iowa, this draft became the core of *Visions of Cody* (1973), only excerpts of which were published during Kerouac's lifetime. It is one of the larger fragments among the Archive's pre-scroll versions, comprising the novel's first seven chapters ("Resuming on main ms. Sept. 16, 1950," Kerouac wrote at the bottom of the last page).[22] It describes Neal Cassady's life prior to coming to New York and meeting Kerouac and Ginsberg through their mutual friend Hal Chase. As in the first draft of the *"Road" Workbook* of July 1950, the novel is narrated in the first person by a bleak-souled man (a "part time short-order cook in a diner by the tracks," we soon learn) whom we first meet as he awakens in a run-down hotel overlooking the Des Moines railyards. In Chapter 6 the narrator meets Dean Pomeray, the Cassady figure, who would be called Cody Pomeray in four of Kerouac's novels, and the narrative, from that point on, revolves around Cassady's

PRIVATE MS. OF

Gone on the Road

COMPLETE FIRST TREATMENT
AND WITH MINOR ARTISTIC CORRECTIONS

"If you go over the river a second time," said the explorer to
the captain, "then make it easier for such poor passengers
as will have to pass this way, than it was for me,
for I have other rivers suffer me."
— From "CHRONICLES OF THE RIVER"
by Chas. Mad —

J. Kerouac
94-21 134th ST.
RICHMOND HILL, N.Y.
Aug. 1950

Fig. 3.10

"On the Road," "I—The Night of September 27," No. 1, October 2, front page, of *American Times*, [Nos.] 1–3, October 2–4, 1950. 12.25" h.

attempt to hitchhike to South Bend, Indiana, to see a Notre Dame football game, a story that he tells, as Dean Moriarty, in *On the Road* (Part Three, Chapter 9).

As in several previous versions, Kerouac seems to enjoy fantasizing about what his relationship with Cassady might have been like had the two of them known each other when they were younger. In the draft fragment's final chapter, "Dean Pomeray Explains," Kerouac indulges this fantasy to an extent, when the Cassady figure explains to the Kerouac narrator that he had admired him from his baseball-playing days and that he, too, had known Laura, the narrator's love, as in other proto-versions. Pomeray reveals that he had visited New York in 1945 and had attended a party at which the narrator had argued about Nietzsche with his friend Hal Prince (i.e., Hal Chase), and that he had watched the narrator "very closely," which is what Cassady did, according to Kerouac, with people who fascinated him.

Not quite two months later, Kerouac embarked on yet another version, which is one of the more puzzling "Road" manuscripts in the Archive. Its plot differs in important respects from the others—the Old West theme is not embodied in any of the characters, except as representing America's hope; the Korean War is a prominent factor;[23] and the fifteen-year-old protagonist, Freddy Boncoeur, lives in a settled, family environment with his uncle,[24] though he will soon take to the road—but its most obvious points of difference from earlier efforts are, first, that it is a performance piece and, second, that Kerouac formatted the manuscript as if it were a newspaper. Entitled *American Times*,[25] it comprises three issues, "published on October, 2, 3, and 4, 1950." The Boncoeur family name is familiar from earlier versions, but this odd hybrid of newspaper/radio drama represents a new "take" on the road theme. The drama opens in a Lowell cafeteria (see fig. 3.10), in which Ernest Boncoeur, a middle-aged idealist who is opposed to America's military involvement in Korea, sits reminiscing with his friend Charles Reilly, a sportswriter, with whom Boncoeur had mined copper in Butte, Montana, ten years earlier. On the verso of the first issue's single leaf, Kerouac introduces Freddy Boncoeur, Ernest's nephew, "the little hero of this story who never dreamed at that moment he would travel eight thousand miles on the road before another year was past." In the second issue (October 3) we learn that Uncle Ernest's belief in the possibility of America's spiritual rebirth was revived on the night of September 27, a personal transformation that was part of a new spirit of hope ("a spark among showers of them doubtless burning across the land"). Kerouac, beginning in the early 1940s, often recorded in his journals and diaries that his and his friends' desire for a spiritual renewal of America was, indeed, coinciding with a spirit of renewal felt by others of their generation across the country, a belief and hope that can be traced back to Lowell's Young Prometheans.

Ernest's youngest son and Freddy's first cousin, the somber eighteen-year-old Bonaparte, then makes an entrance, and we are introduced to an idealized version of the warm family life of the French-Canadians living in New England exile. Clearly, by this point in 1950, *On the Road* was to be a novel as much about how French-Canadian life and culture had become inextricably bound up with America's history and destiny, as it was about the reflection of that history and destiny in the lives of the book's protagonist and his circle of friends. In the October 4 issue of *American Times* we learn that Freddy had been instructed to call Bonaparte "cousin," which

ON THE ROAD
I – The Night of September 27

"At first I thought the Americans weren't going to make it. Do you know what I'm talking about? Not the bridgehead at Pusan and the power of the North Korean armies — what they called 'fanatical' in the papers to find an excuse for real Asiatic courage — but the question of America being in the right. Call me a sentimentalist, call me newer names, call me anything — I've always felt America, taken as a general spirit that breathes over a general continent has been in the right in its relatively short history. I said to myself when this war started last June: Here is 1950 the century of the Americans reaching its biggest middle stage and — it can't be a century of American greatness if this Korean thing becomes the first example in history of a deliberate cruel American crime. Oh Lord, I don't know anything about history; the second, the second, the second — I forgot all about Hiroshima. But let me figure.... I've got to believe in something around here. Whoever ordered that bombing? Who? All right! Then I said to myself, this will be America's second stupid foolishness. What made me change my mind? Not the victory they've just completed. Just a feeling, nothing but a feeling. Well yes, the victory — how could they win if winning wasn't right? Of course the meanest man can always serve his summons on the poor — But I believe in what I say and I take the blame for the poor way I express myself. Look at these canned asparagus — it's a shame to eat these things — pale, no taste — asparagus in the season is like a mouthful of May, the month of May."

So spoke Uncle Ernest, on the night of September 27, 1950, in the cafeteria in Lowell, Massachussetts, to his old friend from San Francisco. Together these men had graduated from the class of '19 in High School; together, for a spell, they had worked side by side as copper miners in Butte, Montana; but now was the first reunion in ten years. and Charles Reilly, already considered a veteran sportswriter in San Francisco circles, visiting the East again on his first long vacation with a feeling that everything once important to him was no longer so, saw no cause to get excited over Ernest's argument. Even in their undergraduate days Charley was always the "skeptic," Ernest the "idealist." It was so now, but both were older and their titles, as such, worn thin. Belief still burned in Ernest's eyes but only inside their tired hollows.

The sportswriter gripped him by the arm. "Ernie. You'll drive yourself gray before your time. Why bother with every foolish thing that comes into your head. People will go on living long after your worries are in the ground with that carcass of yours. It's growing older, too."

"Two old friends getting together after ten years?" cried Ernest almost with tears. "Isn't it some-

identifies Bonaparte as the "older brother" vision that Kerouac wrote about in his *Road-Log*. But this cousin is an embittered and more extreme version of the moralistic champion of French-Canadian identity who had appeared to Kerouac. Bonaparte sees the world, and especially America, as "rotten," and regards his idealistic father, filled with romantic visions of the American West, as a fool. Kerouac did not complete the newspaper series, and the reason why he chose to employ this format is not clear, though newspaper-type publications held a charm for him. He had used a newssheet format to write about his fantasy baseball league and fantasy horse-racing circuit, and had hoped to become a sportswriter. Also, his father had briefly published a newspaper, *The Spotlight*. Perhaps the familiar format assisted him in his writing.

A complicating factor in interpreting this manuscript is that shortly after Kerouac wrote it, he decided that it should be read aloud as a performance, presumably on the radio. A page of notes that Kerouac wrote soon after completing the three issues of *American Times* states that the *Times* is to be "narrated in the voices of Americans themselves, beginning with Vol. I, 'Adventures On the Road' told by a 10-year old Negro boy." Kerouac may have been thinking of the novel *Pic*, which he was already writing. Other ethnic communities and various cultural communities would also be represented by narrators, "Mexicans, Indians, French-Canadians, Italians, westerners, dilettantes, jailbirds, hoboes, hipsters and many more," each speaking "Americanan," a word that Kerouac created to denote the "diverse language" of America.[26] His recognition of this diversity leads him to reflect that he wrote *The Town and the City* in "a literary American voice," and to ask, "What is my own voice?—because I am an artist, none ever hear it nor my ideas either." By embracing a radio drama format he would, at the same time, be embracing the diversity of America's myriad communities, each with its own authentic voice, thereby freeing him to find his own. In 1950, radio was still the mass medium it had been since the early 1930s, the chief source for most Americans not only of their news, but of their entertainment, even more so than the movies. A lasting childhood memory for Kerouac was the radio drama "The Shadow," and it is easy to see why the idea of a radio drama version of *On the Road* would have appealed to him as a means to reach as many Americans as possible in order to fan the sparks of renewal ready to burst into flame across the land.

Probably because Kerouac soon realized the impracticality of this approach (he had no contacts in the radio industry), he set aside his idea for the newspaper/radio drama format. But the French-Canadian emphasis remained strong. In a ten-page manuscript entitled "On the Road ÉCRIT EN FRANCAIS," Kerouac begins the novel, as he would the scroll, with the death of the protagonist's father.[27] However, little else about this French-language version bears any similarity to the scroll or to the published version. The protagonist, Peter Martin, who played the same role in *The Town and the City*, lives for a time with his mother in Ozone Park (this much corresponded to real life and to the scroll), and his poor brother (read "brother-in-law") returns to Galloway ("North Carolina") to live with his wife in an old cabin in the woods (a small house in the suburbs). Other brothers reflect one or another aspect of Kerouac's personality; for instance, "Mickey" hits the road in order to see the South and is not heard of for several years, and "Joe" disappears completely

with a young girl into the wilds of Alaska. Kerouac's French is hardly pure ("il a pris une walke") but it probably reflects accurately the extent to which English had seeped into *jouale*. In any case, he seems to have been comfortable writing in it, and on the first page he translates a paragraph into English. Kerouac sometimes did this in his journals through the late 1950s; he will observe that he is about to write a particular passage in French and then translate it into English, because he feels that he can express this particular scene, thought, or feeling better in French than in English.

Kerouac maintains the French-Canadian emphasis in the last substantive, English-language draft of *On the Road* that he wrote prior to the scroll. Like the fragment "Écrit en Francais," this manuscript, entitled the "'Ben Boncoeur' Excerpt," was written in January 1951. It features the by-now familiar Boncoeur name and a family, modeled on that of *The Town and the City*, composed of three brothers, Ben, Roland, and Anthony, and their mother. As in that novel, each of the brothers represents an aspect of Kerouac, but one of them may be regarded as the Kerouac alter ego. As Kerouac indicates on the slip of paper that he stapled to the manuscript and that serves as its working "title page," the alter ego is "Ben Boncoeur," whose name Kerouac had crossed out on an early 1950 draft in favor of "Victor Duchamp."[28] The manuscript's first ten pages are situated in a hospital in which Ben is a patient, no doubt reflecting Kerouac's memory of his Veterans Administration Hospital stay in the Bronx for thrombophlebitis in the spring of 1950. We soon learn that Ben has become a successful actor in New York and, accordingly, a celebrity in his home town of Galloway. However, he has undergone a spiritual crisis, and while in Mexico, where he went to meditate on his plight, he seriously considered entering a monastery. He is brought back to Galloway, by train, by his brothers, and now sees that he must leave New York forever, settle in Galloway, get a job on the Galloway newspaper, "and be a decent hardworking man again." This desire to lead a "normal" life in small-town America, rather than be a man of letters in evil New York, where sin and his Godless, ironic friends tempt him from the path of goodness that his parents had mapped out for him, would recur in Kerouac's journals and diaries, as well as in his intimate conversations, throughout the 1950s, though it is not made explicit in the scroll or in the published version of *On the Road*.

But what strikes a reader first when seeing this draft fragment is that it opens with an early draft of *On the Road*'s concluding passage (as published), which famously begins, "So in America when the sun goes down." In the "'Ben Boncoeur' Excerpt," this passage, introduced by Kerouac's heading, "AN EXAMPLE OF HOW TO BEGIN A GREAT NOVEL," reads:

> One night in America when the sun went down—beginning in the East at dusk of the day by shedding a lovely gold in the air that made dirty old buildings look like Rembrandt's temples of golden darkness, then outflying its own shades as it raced three thousand miles over the raw bulge of the continent to the West Coast before sloping down the Pacific, leaving the great rearguard shroud of night to creep upon our earth, to darken all of the rivers, cup the peaks and fold the final shore in, as little lights twinkled & everybody mused—

Kerouac used this conceit of the sun traveling westward across "all that raw land that rolls in one unbelievable huge bulge over to the West Coast" as a conclusion for the scroll (and the published version), reprising the few very good phrases almost verbatim.

He also refashioned this passage in the opening of a pair of two-page drafts grouped under the title "Love and Sadness, A Drama on the Racks: Whither Goest Thou, America?"[29] (Kerouac, as noted above, considered almost one hundred titles for *On the Road*.) The first draft again features Anthony and Roland Boncoeur, who are bringing their unnamed brother home from New York, by train, after he has been released from the hospital. In the second draft, however, the protagonist is named Michael Bretagne, to whom Kerouac gives his own childhood memories of playing fantasy horse racing with his marbles. Another difference between the two drafts is that in the first, the sundown-in-America description is rendered in the past tense, whereas the second draft is in the present tense and bears a close similarity to the scroll and published versions of *On the Road*.[30] The second paragraph of the second draft reads:

> But in America when the sun goes down, beginning in the East at dusk of the day making shrouded golden darkness [...] to flame three thousand miles over the bend and groaning bulge of continent to the West Coast before sloping down the Pacific, leaving the rearguard night to creep upon the earth, darken every river, cup the peaks and fold the final shore in [...].

The published text reads:

> So in America when the sun goes down and I sit on the old broken-down river pier watching the long, long skies over New Jersey and sense all that raw land that rolls in one unbelievable huge bulge over to the West Coast, and all that road going, all the people dreaming in the immensity of it [...] the evening star must be drooping and shedding her sparkler dims on the prairie, which is just before the coming of complete night that blesses the earth, darkens all rivers, cups the peaks and folds the final shore in [...].

The very last of the substantive pre-scroll versions of *On the Road* again features Bretagne, now Michel (no longer "Michael"), as the story's protagonist. The fifty-seven–page manuscript, *LA NUIT EST MA FEMME / LES TRAVAUX DE MICHEL BRETAGNE*,[31] is in French; Kerouac began it in February 1951 and finished it that spring, almost immediately prior to beginning the scroll. The biographical details of this first-person narrative are patterned on Kerouac's own life, including his experience in writing and publishing his first novel, and his childhood, such as occasionally working with his printer father ("'foldez' des papier") and his sense of linguistic displacement: "J'ai jamais eu une langue a moi-même. Le Francais patoi j'usqua-six angts, et après ça—les grosses formes, les grands expressions de poète, philosophe, prophète. Avec toute ça aujourdhui j' toute mélange dans ma quin." But this French manuscript also contains an important page-length portion of text in English (see fig. 3.11), introduced by the narrator, "Michel," who tells us, at the end of the French portion immediately preceding the English, that he will now write in the tone of a great American writer, apparently Hemingway. To some extent, this French draft, or at least that portion of it devoted to the character of Michel Bretagne/Jack Kerouac,

Fig. 3.11

*LA NUIT EST MA FEMME / LES TRAVAUX DE
MICHEL BRETAGNE*, February–Spring 1951,
p. 8. 9.5" h.

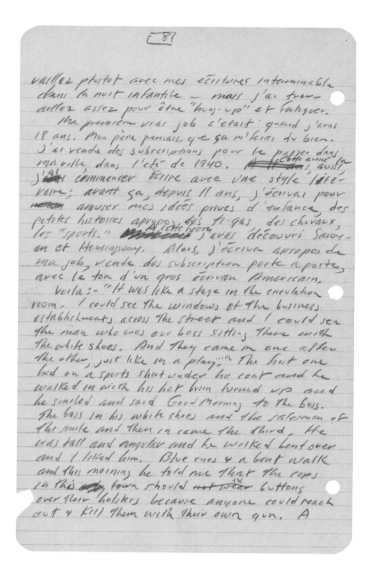

is explicated by a two-page typescript in English that Kerouac placed immediately after *La Nuit*, headed simply "Michael Bretagne."[32]

Among the draft's most interesting passages is that in which "Bretagne" pays homage to his literary influences—his short list of great writers—and in a few phrases offers fresh insights into their best work:

> I had discovered Tom Wolfe that month before Xmas; since then I have not read anyone so grand, so poetic so serious in America. He and Melville, Thoreau, Whitman, Twain, we never say that their greatest works were novels proper; with the exception of Huck Finn their best inspirations were in the form of unknown and unsoundable <u>books</u>—Look at 'Moby Dick,' 'Walden, Leaves of Grass, Life on the Miss., and Of Time and the River.' I wanted to write in a large form with [sic] was free and magnificent like that, a form whcih [sic] would give me the chance to go out the window and not stay in the room all the time with old ladies like Henry James and his European sisters. I had not yet read Henry James but I had glanced at his manner.

For Kerouac, then, the works that his alter ego cites are not "fiction," at least not in the sense in which most writers and readers would think of them, but metaphysical

Fig. 3.12

investigations, or even spiritual teachings ("unknown and unsoundable"), which are based in the truest sense on the lives of their authors, whether or not the incidents they recount conform to biographical facts. Of course, Bretagne/Kerouac's statement about Whitman's poem or *Walden* is true in the trivial sense (they are fiction only in the way that any literary re-creation of experience may be so called), but his intention is to draw our attention to something deeper about these works and about *Moby-Dick, Life on the Mississippi*, and *Of Time and the River*. For Kerouac, the important point about all these works, including, implicitly but most importantly, the one he is about to write, is that they are based on their authors' confrontation, with great energy and absolute honesty, of themselves and their world.

Although the late drafts in French bear a closer resemblance in style and spirit to *On the Road* than do the drafts that precede them, they, too, lack the propulsive force of the scroll or the published novel. However, about three weeks prior to Kerouac's sitting down at his typewriter to begin the scroll, he produced a thirteen-page typescript, "Flower That Blows in the Night,"[33] that not only captures the rhythm of the scroll's cascading prose, but a portion of which he used, with little emendation though with some expansion, as the core of one of the best-known scenes in *On the Road*. This is the scene in which Sal Paradise and Dean Moriarty, with two girlfriends, enter a San Francisco jazz club in "the little Harlem of Folsom Street," where they hear a "wild tenorman" (i.e., tenor saxophonist) "blowing at the peak of a wonderfully satisfactory free idea, a rising and falling riff that went from 'EE-yah!' to a crazier 'EE-de-lee-yah!' [...] They were all urging that tenorman to hold it and keep it with cries and wild eyes, and he was raising himself from a crouch and going down again with his horn, looping it up in a clear cry above the furor. A six-foot skinny Negro woman was rolling her bones at the man's hornbell, and he just jabbed it at her, 'Ee! Ee! Ee!.'" This typescript, which Kerouac introduced with an expository paragraph (later crossed out) on the difference between "cool" and "hot" hipsters (see fig. 3.12),[34] like the scene in *On the Road* that was based on it, shows the large extent to which jazz, specifically Bebop, helped define Kerouac's vision of the world, his writing, and his understanding of the "Beat Generation," the depiction of which had become an important motive in the writing of *On the Road*. The typescript's final four pages, featuring the protagonists Dean [Pomeray? Moriarty?] and Chad [Gavin?], contain the basic elements of the scene as it appears in the scroll; the lineaments of its complete development (except Moriarty's comparisons of the musicians with his and Paradise's friends), including the tall African American woman dancing to the tenor saxophonist's solo, Pomeray/Moriarty's active involvement in the solo, and the black preacher who jumps out of a cab and runs straight into the club yelling "Go! Go! Go!" ("BlowBlowBlow," in the scroll and in the published version); and even some of the very phrases that Kerouac would use in the scroll.

Another noteworthy instance of Kerouac, within a month of starting the scroll, writing scenes in his new style is a four-page manuscript, "Watson's Gang," which, from its location in the Archive, can be dated to February or March 1951. "Watson's Gang" tells the story of how the adolescent Cassady, through his daring, wiles, and charisma, works his way into a pool hall gang in a poor Denver neighborhood so skillfully that the leader, "Tom Watson" (i.e., Jim Holmes), becomes his most avid follower. Watson introduces his protégé to his cohorts, and

150
John Kerouac
94-21 134th St.
Richmond Hill, N.Y.
& c/o Harcourt, Brace

<u>In Italics</u>: There are two kinds of hipsters, the cool and the hot. The
cool hipster is the new rococo intellectual, generally
wearing horn-rimmed glasses for purposes of identification,
who loves cool bop and Bartok, Reich and Genet, Illinois
Jacquet (even when false) and tea; the hot hipster is the
new rococo wrangler, descendant of the earlier "wranglers"
who left the outlands to work in city garages, and loves
hot-rod races, Willie Jackson (never false), spends time
in state joints and calls his tea <u>wild s--t</u>. There is
another distinction to be made, this time between America
and South Africa. In America the veteran teahead speaks
of his best stuff as "real Mexican hemp"; in South Africa
the Johannesburg character of the streets calls it "real
Swaziland boom." America has its border, South Africa
its bush. This is the fable of two hot hipsters and a
blowing tenorman in the American backstreet night.)

* * * * * * * * * *

Retitled GO GO GO by Bob Giroux March 1950

Dean and Chad came hurling into town in a mud-spattered Buick
just as the neon lights glowed on the main drag at dusk. They had come
one thousand, four hundred miles in less than 30 hours over all kinds
of roads through the desert, mountains and the coastal plain, taking
turns at the wheel and subsisting on candy and Cheese Crax (they were
well-nigh broke), tired and beat now, but glad they made it, and glad
of all no less.

 "There she is, man!" yelled Dean with excitement as they
zoomed off the bridge onto Main Street. "There she is---and no more
land! After this it's all water, the whole oceanic waste of the
world. And this...THIS!" cried Dean pointing with his whole rigid
arm somewhere to the right, ~~to which Chad turned to look with willing
eagerness,~~ "is, I am given to understand, a real hip town and is
well-known for its facilities...<u>facilities</u>," continued Dean rolling
his finger in a rondure at the air, in imitation of W.C.Fields talking
about "walls of human flesh" in the picture "Mississippi" which they
had seen three days ago in an all-night movie in Chicago, "<u>facilitie</u>
for a man to get his kicks, You will remember Times Square last winter

So there was Dean with his weather beaten face growing more excited and redder by the hour and his big raw hands wrapped around a cue, looking bashfully at his new friends and planning, every [one?] thing they said or did, planning deep inside his mind the positively best, in fact only way to begin completely, helplessly impressing everyone & winning over their favor so conclusively & including their souls that eventually of course they all must turn to him for love and advice; mad Dean who eventually did run the gang, who was now just being merely coy and quiet knowing instinctively the best way to start despite the fact that he never knew a gang before and the only thing he'd done was grab some poor kid by the arm in the junkyard or a newsboy in the street or some of the bicyclists on the paper route and make long strange speeches to them like the great speech he made to Watson that afternoon but they were far too young to understand [to be? and were?] frightened.[35]

The text of this manuscript, though it does not appear in the scroll or in the published version of *On the Road*, is repeated virtually verbatim in *Visions of Cody* (Part 2),[36] which shows that Kerouac's decision to split off his account of Cassady's pre–New York years into a separate novel was made perhaps as late as a week or two before he began the scroll.

Aside from such fragments as those described above, which Kerouac copied from, adapted, and expanded as he wrote the scroll, he had prepared a chronological chart for each of his main characters, dating from 1946 to early 1951, that enabled him, at a glance, to manage their complicated comings and goings (see fig. 3.13).[37] (The verso bears his crude drawing of the United States, on which he no doubt had intended to plot the history of his road trips, but which he left blank.) This chart must have been completed in early 1951, because Kerouac placed it with notes from that year that are related to *On the Road*. We know that even at this late date he considered reconceiving the novel so that it might be regarded as a sequel to *The Town and the City*, as shown by the presence of the names of "Peter Martin" and his brothers; "Leon Levinsky," Ginsberg's alias in *The Town and the City*; and names from proto-versions of *On the Road* like "Slim Jackson (& Pic)." He was even considering reinserting the character of "Doctor Sax" into *On the Road*, an early option that he had soon discarded, yet he reappears here. Note that his chronology boxes are blank because he is the novel's lone fictional character.

Soon after this "character chronology" was prepared, Kerouac wrote a "Prospectus" for *On the Road* (see fig. 3.14),[38] in which he declares that it will be only "the first of a series of novels I'm planning to write about different types of men and women in our generation [...] the exact haunting experience of their lifetimes, with the central vision of it alwyas [sic] their relation to that great America we all talk about but is still unknown to us, that can't be explained in generalities but has to be worked out detail by detail like a giant sculpture before it's down on paper a complete world in words." Kerouac's other main goal in writing *On the Road* is to make the reader aware of the near miraculous improbability of Cassady as a phenomenon, "all of it [i.e., the novel] showing how he came from that dark birth and the crude cons of a kid and wild impossible hopes to learn to love life no matter what happens. To me it's primarily a novel about America, its unwritten energies, in the midst of official bigtime fluff-offs its secret voice crying in the Wilderness."

	1946	1947	1948	1949	195	195
Pa & Ma Martin	Leaves farm — West Haven — Ozone Park — works			To Denver — back to Richmond still		To South
Peter Martin	J.B. leaves farm — investe murders — Jail — 1st witness — Ozone Park — starts book	writes — Denver — Calif. Hears Cru — Susquehanna —	Jimmy Baker	Trip to Calif. & Butte — back — book accepted — Denver — Calif. — back to N.Y. — rooming with Francis	Autograph Boston & Denver — Sara — Mexico — marries Laurie	Writes book Sick Breakup Laurie West
Francis Martin	Conversion — work — radio	Made editor		Accepts Peter's manuscript —	Publishes P's book — 1st trip to Europe (Comes to Denver)	Sad editor
Joe Martin	Pat leaves him — shoots holes in house — & vanishes				In Florida with Girl Friday	vanished
Ruth Martin Marlowe	Lives in south — miscarriage		Has baby —	Ozone Park & Denver	Kinston	Rocky Mt
Liz Martin (Frederick)			Polio in Texas	Busted —		Shot by Dennison
Mickey Martin	Works in Calloway Circus — Cookie factory — West Haven — trip to Wash — back — Ozone	Wash. const. & lunch counter — Jeanie — Denver (Uncle Bill Martin) Army	Army	Goes to France with boys from Denver — G.I. Bill	Denver — goes to Mexico with Peter & Dean — Mic. college —	Marries Ame. girl in Mexico Settles down in L.A. haggard salesman
Will Dennison	Wife returns — troubles in N.Y. — Lexington	Lives in Texas bayou — Dean, Huxley, Levinsky visit — Willie born —	Moves to New Orleans (Algiers) Dick has polio —	Busted — moves to Rio Grande, New Mexico with family	Mexico — works "Junk" — Peter visits with Mickey & Dean	Further down to Peru — Yage — Tangier Queer Naked Lunch
Dean Pomeray	First trip N.Y. with Marylou — flights —	In Denver — Marylou, Carolyn, Leon — in Texas — drives Will to N.Y. — Xmas with Liz — (Joan Anderson) Xmas	Frisco — divorce from Marylou —	Trip to N.Y. — (2) Peter comes — Diane Nrt.	Frisco — Mexico divorce —	Frisco, Carolyn — Saint dreams — R R Brakeman In California Family man
Leon Levinsky	His Ma on 17th	Denver deldrums — Bayou Texas — Dakar deldrums —	Harlem Holy Deldrums —	Busted — hospital	Xmas at Pok's —	Empire State Bldg — "Sparkler" — World Telegram — Chiapas Mad caves
Junkey	In N.Y.	In Texas	In N.Y. — "Fires of hell" — Confession —	Busted — Sing Sing —	Sing Sing	Out Xmas Thief in N.Y.
Kenny Wood	Copyboy — "conversion" — Jeanne deneshnn —	Works — BHale —	Works, drinks —	Becomes big newspaperman —	Meets Francis, etc. — Sara Halls — trip to Cape — Liz & trip to Mexico — cops & accidents —	Marries Cessa Son Simon Sad baloony — Sheridan Sq. Society boy
Judie				Peter & Dean visit — "Great south — cops —	Letters from Peter — Marries golf pro — Fat	
Uncle Charley Martin	West Haven —			In Butte —	In Denver — St. Louis steamboat —	
Slim Jackson (+ Pic)		No. Carolina — Iowa — Times Sq. —	Times Square —	Blowing in Frisco (Bayou)		
Dr Sax						

PROSPECTUS

On the Road is going to be the first of a series of novels I'm planning
to write about different types of men and women in our generation, their
careers, their deep characterisitics, their special personal downfalls
one by one, the exact haunting experience of their lifetimes, with the
central vision of it alwyas their relation to that great America we all
talk about but is still unknown to us, that can't be explained im ge-
neralities but has to be worked out detail by detail like a giant sculp-
ture before it's down on paper a complete world in words. My intention
is to get at it novel by novel, each with a central character to pene-
trate it on a new level, till I get down to the bottom of the meaning
and the vision to my satisfaction. For this I want to use a language
that's unmistakably American without being unintelligent, poetic with-
out being too fancy, richly intricate without being hard to understand,
because of the hitherto unused combinations of material and ideas that
I'll have to use if I'm going to carry out the whole lifework to my
satisfaction and the reader's.

The Dean Pomeray of On the Road is only the first in this system
of characters. In writing about Dean my intention as it'll be with all
the others, is to explain him, sympathize with him and admire his soul.
This is an American kid of great energy and joy and raw natural talent
who was born with nothing, knew nothing, went hungry in his childhood
which was like a big joke played on him, suffered everything, and yet
God knows why came leaping out of the darkness of his birth with an
insatiable and tremendous desire to learn everything, to know all peo-
ple, above all to love life---and as this story unfolds, showing his
early life with his father among the bums, then Tom Watson and the pool-
hall world, his first suit of clothes, stealing 500 cars in one year
just for joyrides and to show off to the boys and the consequent reform
school, followed by Beattie G.Davies the schoolteacher who introduces

Fig. 3.14

"ON THE ROAD PROSPECTUS," [March?
1951], p. 1. 11" h.

What strikes the reader of Kerouac's various pronouncements concerning the aims or purposes of *On the Road*, from 1947 until 1951, is the consistency of his language in describing the main themes the book will address. Despite the plot variations and even genre changes in his notes and drafts for the novel—from a species of Old West/New West family saga that features occasional road forays by various characters, to a road novel in which the Western-family-saga element is muted and the French-Canadian background of the main characters is emphasized—its chief subject remained America and the spiritual renewal it was undergoing through the agency of its beatific souls, whether as seen through a Kerouac alter ego, or through the Kerouac alter ego's reaction to a Cassady-like figure. This remains true almost to the moment when Kerouac tapes together the first two or three of the twelve ten-foot rolls of tracing paper that eventually comprised the scroll, and feeds them into his typewriter. Yet in the four years leading up to the three-week creative burst of April 1951, he had so radically altered his "style" that the word seems inadequate to describe the transformation it represented, both in his approach to the act of writing and in his consciousness.

The first-person narrator of *On the Road*, like the novel's other characters, is not a symbol for a philosophical idea, and is not even an "American type," whatever lingering aspirations Kerouac may have harbored in this regard. Rather, he now understood that the ideas he had formulated about America's meaning, its spiritual renewal, and his and his friends' roles as agents of this renewal represented a distancing of himself from the original experience that he wanted to communicate, what in 1945 he had called the writer's "Sense-thinking." He now realized that the truth embodied in the beauty of the American landscape and in the variety of its people needed to find its expression in a way that remained faithful to his experience of them. After years of search, study, and practice, Kerouac had finally found his own voice, and in so doing, to his delighted surprise, he had learned to sing.

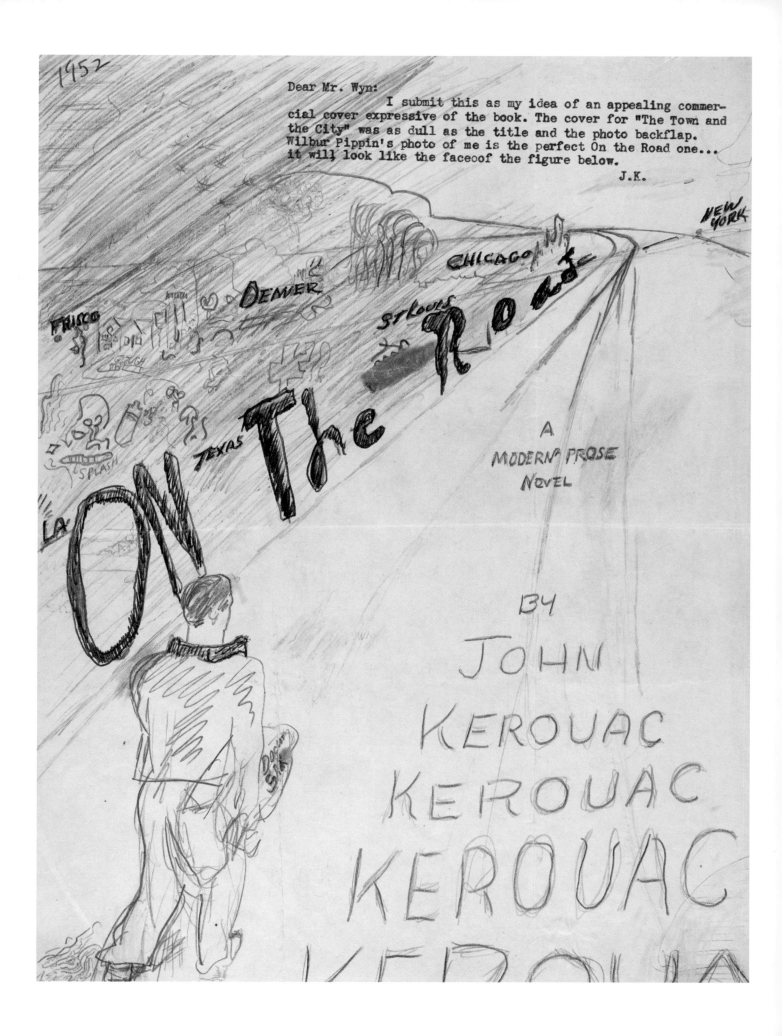

On the Road:
The Scroll and Its Successors

As we saw in the previous chapter, Kerouac expended prodigious amounts of time and energy on the pre-scroll versions of *On the Road*. Although most of this writing bears little resemblance to the scroll text (see fig. 4.4a–e)[1] or to the text of the published novel, the themes, characters, and landscapes that he explored so thoroughly in those preliminary efforts stood him in good stead when he sat down before the typewriter on April 2, 1951, or thereabouts (no diary or journal entry records the day), in the second-floor apartment of his second wife, Joan Haverty, at 454 West 20th Street, in Manhattan's Chelsea neighborhood (see fig. 4.2).[2] In addition to the character/chronology chart he was planning to use (see fig. 3.13), and may in fact have used—though he replaced the pseudonyms with the characters' real names— Kerouac prepared a one-page "Self-Instructions" list (see fig. 4.3) that, as he noted many years later, "Sat at side of typewriter as Chapter guide."[3]

Years after *On the Road* was published, Kerouac referred to the paper on which he typed the scroll as "teletype paper," but it was actually tracing paper (of the kind that architects use) bundled in twelve-foot rolls that he found in Haverty's apartment. The advantage of feeding the rolls into the typewriter, as Kerouac saw it, was that he would not have to stop typing at the end of each sheet of paper and replace it with a fresh sheet, thereby interfering with the creative flow. (He may have taped the ten rolls together to make the 120-foot scroll before feeding it into the typewriter, or, thinking that a 120-foot scroll spilling over the table onto the floor would be unwieldy, he may have decided instead to tape two or three sections together at a time.) When Kerouac completed the scroll, probably on April 22, he took it to Robert Giroux, his trusted Harcourt, Brace editor, who told him that it could not be edited in scroll form and needed to be retyped. Kerouac's reaction was to storm out of Giroux's office, but he soon acceded to necessity and began to type a copy on individual sheets. On returning home one day in early May, he found his wife in bed with a waiter from the restaurant at which she was working. Kerouac immediately moved out of the apartment and into the West 21st Street loft of his Columbia friend Lucien Carr, where Allen Ginsberg was also living for a time.[4] There, Kerouac finished retyping the scroll so that he could submit it to publishers, though not again to Giroux, with whom he refused all further contact. Within two years he had sent the typescript to Little, Brown; Dutton; Dodd, Mead;

Fig. 4.1

"ON The Road: A MODERN PROSE NOVEL." Pencil and red pen, 1952. 11" x 8".

For a few months in 1952, Kerouac hoped that *On the Road* would be published as an Ace paperback, since the owner of Ace Books, A. A. Wyn, was the uncle of Carl Solomon, a close friend of Allen Ginsberg (whose poem "Howl" is famously dedicated to him; see fig. 1.5). Kerouac prepared this drawing for the front cover, which he describes in a typed note to Wyn as "my idea of an appealing commercial cover expressive of the book." It depicts Kerouac as seen from behind, carrying a saxophone case on which is inscribed "Doctor Sax," as he walks down a road stretching from the West to the East Coast, and along which is drawn a schematic representation of the country.

Fig. 4.2

Arvind Garg, photographer. 454 West 20th Street, New York City, 2006. 18" x 12".

In the second-floor Chelsea apartment of Joan Haverty, his second wife, Kerouac typed the *On the Road* scroll in three weeks in April 1951.

opposite:

Fig. 4.3

"(Original Self-Instructions List for composing <u>On</u> <u>The</u> <u>Road</u> 1951) (Sat at side of typewriter as Chapter guide)," [April 2?], 1951. 9.25" h.

Kerouac intended this "Chapter guide" to help him weave together the many strands of his meandering narrative, although he did not incorporate into the novel all of the ideas listed here. Next to the word "Butte" (middle of page), i.e., Butte, Montana, he has added "the source of the Ole Miss," whereas, in fact, the river's source is Minnesota's Lake Itasca. Kerouac added the explanatory note at top when he was organizing his Archive in the 1960s.

Viking; Ace Books (see fig. 4.1); and, in late 1954 or early 1955, Knopf. They all rejected it.

During the first two years that the novel languished in publishers' offices, Kerouac finished *Doctor Sax*, used some of the excised *On the Road* sections that had been devoted to Cassady's early youth to begin *Visions of Cody*, and wrote *Maggie Cassady*, the story of his first love affair, with his Lowell sweetheart Mary Carney. Throughout this period Kerouac was on the move, living in San Francisco with the Cassadys for five months beginning in December 1951; in Mexico City in the summer and fall of 1952; back in California, where he worked for a time as an apprentice brakeman on the Southern Pacific Railroad; home with Mémère in Richmond Hills, Queens, in December; on Long Island for January–February 1953, writing *Maggie Cassady*; and, in May–June 1953, back in California, in San Jose, where he again worked as a brakeman on the Southern Pacific.

In 1953, Allen Ginsberg, who had been acting as Kerouac's agent since 1951, brought his work to the attention of Malcolm Cowley, a freelance consultant, editor, and talent scout for Viking; Cowley's assistance and advocacy would prove indispensable to the publication of *On the Road*, as well as to the publication of an excerpt from the novel and of shorter pieces.[5] In a letter of August 6, 1954,[6] Kerouac thanks Cowley for having interceded with Arabel Porter, an editor at the *Hudson Review*, who had just agreed to publish his "Jazz Excerpts" in *New American Writing*, an anthology series she was editing. He also tells Cowley that he has "retitled On the Road to Beat Generation"; Cowley would later prevail upon Kerouac to reverse this decision. Kerouac's list of the publishers to whom he has submitted his typescript

1951

Original Self-Instructions
List for (composing)
On The Road 1951)

(Sat at side of typewriter
as (chapter guide)

Shining mind—dark mind

Talk about Neal with Hal ——> 'describe Burf' *He talks of Jeff*
Describe Allen monkeydance *& mad about the void.*
Full descriptions of Al,Jim,Tomson
Oregon country (3 Califs.)
Description of Hank Korean ship
Thieves and socialites
Shrouds of Frisco over Banana King
Carnival & bridge dream Frisco 47
Little Raymond looks at tel wires
Canvas cottonbags like nightmare bags
Bea's sisters
Bea on crates: You say everything be awright--I know exactly why y.say that
Selma ticketshack---Fall made me want to go in m'pants
Description of Square just before Greek pan *trolley letter* *confession &*
Letters helps transation 47 to Xmas 49 (from Neal) And Hunkey fires
 Idiot girl--atombomb Turkey,box of salt, blue lights
Dialog for Neal Louanne & bed *(& Frozen Ohio)*
Allen's whither goest thou *directed in thy shiny car at night?*
Memory of 'something forgot' in New Jersey
Wash boat ---"at the edge of all this might" *& so Allen wayward end*
Joan paper...wants to know whats happening *& chamois.*
Suicide girl...talk on rail
Motorcycle kid...lets all go to cunttown
Lampshade said..
Butte...the source of the Old Miss *Bra*
More of denver fiasco $700 moving bill
Neal and thebaseball night All I do is die.
Describe Utah Godcloud *& trip over overkind—Kenosha & golden afternoon*
Neal sleeping at Salt Lake...uptrhust thumb,like child
Description of view from Johnny's ...from Moultrie
Story of baptism...big old mud turtle (roasting peetaters)
Neal and baseball kids...feeling
Nancy like Louanne *—juicylush dimpled, waist bigger than breast, like*
Description of girl in Westwood *Jeannie — plump preoccupied legs, no panties*
Ed Uhl & Farmington Utah
Where you eat at Edie's st.
Essay on Detroit movie...Zorro, etc. and Dream of Neal & Hassel of earth
Neal in Detroit pol.sta. with papers etc.
Neal and I in yard.. of Chrysler man
NY April hints
Prepare Geo Glass
Brierly and mexboys
No castle
Prepare Frank's pop (hometown America)
Neal tells Frank of bouncing ball on Welton
Describe Sabinas girls *— brown knees covered with dust*
More of the holy tour in Mexcity ...including Bill - *Bold noble Dean*
New poem for end "What will come of Neal?"

THE SCROLL
Fig. 4.4a–e

[*On the Road*], [April 1951], 119' 5" long.
Collection of James Irsay.

The digital images of the scroll number 143 "pages," each page comprising ten inches of text, which includes, on all but the first image, an additional one-inch overlap at the top from the previous "page." The final, surviving "page" is incomplete as a result of Lucien Carr's dog, Potchky, chewing up the approximately ten final "pages," as indicated by Kerouac in a note written along the right-hand margin of the last "page," in May 1951. At the time, Kerouac was living in Carr's West 21st Street loft (as was Allen Ginsberg) and retyping the scroll text on separate sheets of paper in order to be able to submit the novel to publishers.

(including Little, Brown, where it was kept "a long time, rejected") concludes with the statement that it "is now at Dutton." Presumably, either Kerouac or Cowley would have contacted Dutton to arrange for its return. Cowley was relatively successful in representing Kerouac. By the following summer, as he tells Kerouac in a July 12, 1955, letter,[7] he had facilitated the forthcoming publication in the *Paris Review* of an excerpt from *On the Road* that Kerouac (or perhaps Cowley) had entitled "The Mexican Girl" and which recounts Kerouac's brief affair with a poor Mexican-American woman in California (described in Part One, Chapters 12–13). Cowley seems to have genuinely valued Kerouac's writing and acted as an energetic advocate for it. In the July letter, he tells Kerouac that the *Review*'s fiction editor, Peter Matthiessen, though "enthusiastic" about the piece, "is also bothered by the style in places, by adverbs like 'frantically' and expressions like 'her eyes were deep blue soul-windows.' He wondered if you wouldn't want to revise and chasten the style. I told him not to bother you, that you would spare him a few adverbs, but that he shouldn't strike out too many." However, in the case of the novel itself, Cowley was constrained to act as Viking dictated, since Viking was the only firm interested in publishing the novel and Cowley was in their employ as well as Kerouac's.

Two months later, on September 16, 1955, Cowley writes[8] to Kerouac to give him the good news that the novel "is now being very seriously considered, or reconsidered, by Viking, and there is quite a good chance that we will publish it," and urges him to return to the title "On the Road." However, he warns Kerouac that three things must first occur: (1) "we," presumably he and Kerouac, would have to make the right "cuts and rearrangements," by which Cowley meant, as he later specified, that the plot had to be simplified; (2) the text would have to be able to pass legal decency standards; and (3) anything in the book that might incite a libel suit must be removed. Cowley is sympathetic to Kerouac's writing "all in a breath, pouring out what you feel." But for the first time he criticizes his approach, urging him to regard the first creative effusion not as a finished work, but rather as raw material that requires revision: "But there are those two sides of writing, the unconscious and the conscious, the creation and the self-criticism, the expression and the communication, the speed and the control. What your system ought to be is to get the whole thing written down fast, in a burst of creative effort, then later go back, put yourself in the reader's place, ask whether and how the first expression ought to be changed to make it more effective. If you'd do that job of revision too, then most of your things would be published, instead of kicking around publishers' offices for years."

The typescript copy of the scroll, which Kerouac executed so that he would have a readable text to send to publishers, may no longer be extant; in any case, it is not in the Archive, and it has not appeared on the market. (Perhaps it rests among the papers of the last publisher to receive it.) However, Kerouac prepared at least two other typescripts based on the scroll text. The first of these (to be called the "second" typescript;[9] see fig. 4.5a–h) was obviously created in response to Cowley's September 1955 warning letter. In addition to this typescript, the Archive contains the typescript that Viking used as the copy text for the galleys and for the published text of *On the Road*. Kerouac identified it by writing "ORIG. EDITORS' TYPED MS. of 'ON THE ROAD'" in black felt pen on a gray card, which he placed atop the pile of typed sheets (see fig. 4.6a–g).[10]

i first met met Neal not long after my father died...,I had just gotten over a
serious illness that I won't bother to talk about except that it really had some
thing to do with my father's death and my awful feeling that everything was
dead. With the coming of Neal there really began for me that part of my life
that you could call my life on the road. Prior to that I'd always dreamed of g
west, seeing the country, always vaguely planning and never specifically tak
off and so on. Neal is the perfect guy for the road because he actually was
on the road, when his parents were passing through Salt Lake City in 1926, i
jaloppy, on their way to Los Angeles. First reports of Neal came to me thi
Hal Chase, who'd shown me a few letters from him written in a Colorado reform
school. I was trmendously interested in these letters because they so naively
and sweetly asked for Hal to teach him all about Nietzsche and all the wonderi
intellectual things of that Hal was so justly famous for. At one point Allen
I talked about these letters and wondered if we would ever meet the strange N
Cassady. This is all far back, when Neal wasnot the way he is today, when
a young jailkid shrouded in mystery. Then news came that Neal was ou
school and was coming to New York for the first time; also there was
had just married a 16 year old girl called Louanne. One day I was ha
the Columbia campus and Hal and Ed White told me Neal had just arrived
living in a guy called Bob Malkin's coldwater pad in East Harlem, the
Harlem. Neal had arrived the night before, the first time in NY, with the beau-
iful little sharp chick Louanne; they got off the Greyhound bus at 50 St. and
out around the corner looking for a place to eat and went right in Hector's, and
since then Hector's cafeteria has always been a big symbol of NY for Neal. They
spent money on beautiful big glazed cakes and creampuffs. All this time Neal
was telling Louanne things like this, "Now darling here we are in Ny and and al-
thought I haven't quite told you everything that I was thinking about when we
crossed Missouri and especially at the point when we passed the Booneville refor-
matory which reminded me of my jail problem it is absolutely necessary now to
postpone all those leftover things concerning our personal lovethings and at once
begin thinking of specific worklife plans...," and so on in the way that he had in
his early days. I went to the coldwater flat with the boys and Neal came to the
door in his shorts. Louanne was jumping off quickly from the bed; apparently he
was fucking with her, He always was doing so. This other guy who owned the plac
Bob Malkin was there but Neal had apparently dispatched him to the kitchen, pro
bably to make coffee while he proceeded with his loveproblems....for to him se
was the one and only holy and important thing in life, although he had to sweat
and curse to make a living, and so on. My first impression of Neal was of a young
Gene Autry--trim, thin-hipped, blue eyes, with a real Oklahoma accent. in fact
he'd just been working on a ranch, Ed Uhl's in Sterling Colo. before marrying L.
and coming East. Louanne was a pretty, sweet little thing, but awfully dumb and
cpable of doing horrible things, as she proved a while later. I only mention
this first meeting of Neal because of what he did. That night we all drank beer.
and I got drunk and blah-blahed somewhat, slept on the other couch, and in the
morning, while we sat around dumbly smoking butts from ashtrays in the gray light
of a gloomy day Neal got up nervously, paced around thinking, and decided the
thing to do was Louanne making breakfast and sweeping the floor. Then I went away.
This was all I knew of Neal at the outset. During the following week however he
confided in Hal Chase that he absolutely had to learn how to write from him; Hal
said I was a writer and he should come to me for advice. Meanwhile Neal had got-
ten a job in a parking lot, had a fight with Louanne in their Hoboken apartment
God knows why they went there and she was so mad and so vindictive down deep that
she reported him to the police, some false trumped up hysterical crazy charge, and
Neal had to lam from Hoboken. So he had no place to live. Neal came right out
to Ozone Park where I was living with my mother, and one night while I was working
on my book or my painting or whatever you want to call it there was a knock on the
door and there was Neal, bowing, shuffling obsequiously in the dark of the
hall, and saying "Hel-lo, you remember me, Neal Cassady? I've come to ask you to
show me how to write." "And where's Louanne?" I asked, and Neal said she'd appa-

hung up with Norman Schnall at the time....and Neal told Allen of people in the
west like Jim Holmes the hunchbacked poolhall rotation shark and cardplayer and
queer saint...he told him of Bill Tomson, Al Hinkle, his boyhood buddies, his
street buddies...they rushed down the street together digging everything in the
early way they had which has later now become so much sadder and perceptive.. but
then they danced down the street like dinglodies and I shambled after as xx usual
as I've been doing all my life after people that interest me, because the only
people that interest me are the mad ones, the ones who are mad to live, mad to
talk, desirous of everything at the same time, the ones that never yawn or say a
commonplace thing..but burn, burn, burn like roman candles across the night. Allen
was queer in those days, experimenting with himself to the hilt, and Neal saw that,
and a former boyhood hustler himself in the Denver night, and wanting dearly to
learn how to write poetry like Allen, the first thing you know he was attacking
Allen with a great amorous soul such as only a conman can have. I was in the sam
room, I heard them across the darkness and I mused and said to myself "Hmm, now
something's started, but I don't want anything to do with it." So I didn't see
them for about two weeks during which time they cemented their relationship to mad
proportions. Then came the great time of traveling, Spring, and everybody in the
scattered gang was getting ready to take on trip or another. I was busily at work
on my novel and when I came to the halfway mark, after a trip down South with my
mother to visit my sister, I got ready to travel west for the very first time. Neal
had already left. Allen and I saw him off at the 34th street Greyhound station. Up-
stairs they have a place where you can make pictures for a quarter. Allen took off
his glasses and looked sinister. Neal made a profile shot and looked coyly around.
I took a straight picture that made me look, as Lucien said, like a 30 year old
Italian who'd kill anybody who said anything against his mother. This picture Allen
and Neal neatly cut down the middle with a razor and saved a half each in their
wallets. I saw those halves later on. Neal was wearing a real western business
suit for his big trip back to Denver; he'd finished his first fling in New York,
I say fling but he only worked like a dog in parkinglots, the most fantastic park-
inglot attendant in the world, he can back a car forty miles an hour into a tight
squeeze and stop on a dime at the brickwall, and jump out, snake his way out of
close fenders, leap into another car, circle it fifty miles an hour in a narrow
space, shift, and back again into a tight spot with a few inches each side and
come to a bouncing stop the same moment he's jamming in the emergency brake; then
run clear to the ticket shack like a track star, hand a ticket, leap into a newly
arrived car before the owner is hardly out, leap literally under him as he steps
out, start the car with the door flapping and roar off to the next avaialble park-
ing spot: working like that without pause eight hours a night, evening rush hours
and after-theater rush-hours, in greasy wino pants with a frayed furlined jacket
and beat shoes that flap. Now he'd bought a new suit to go back home in; blue with
pencil stripes, vest and all, with a watch and watch chain, and a portable type-
writer with which he was going to start writing in a Denver roominghouse as soon as
he got a job there. We had a farewell meal of franks and beans in a 7th avenue
Riker's and then Neal got on the bus that said Chicago on it and roared off into
the night. I promised myself to go the same way when Spring reallybloomed and op-
ened up the land. There went our wrangler. And this was really the way that my
whole road experience began and the things were to come are too fantastic not to
tell. I've only spoken of Neal in a preliminary way because I didn't know any more
this about him then. His relation with Allen I'm not in on and as it turned out
later, Neal got tired of that, specifically of queerness and reverted to his natu-
ral ways, but that's no matter. In the month of July, 1947, having finished a good
half of my novel and having saved about fifty dollars from old veteran benefits I
got ready to go to the West Coast. My friend Henri Cru had written me a letter
from San Francisco saying I should come out there and ship out with him on an a-
round the world liner. He swore he could get me into the engine room. I wrote back
and said I'd be satisfied with any old freighter so long as I could take a few
long Pacific trips and come back with enough money to support myself in my mother's
house while I finished my book. He said he had a shack in Marin City and I would
have all the time in the world to write there while we went through the rigmarole
of getting the ship. He was living with a girl called Diane, he said she was a mar-
velous cook and everything would jump. Henri was an old prep school friend, a Frenc
hman brought up in Paris and France and a really mad guy---I never knew how mad
and so mad at this time. So he expected me to arrive in ten days. I wrote and con-
firmed this....in innocence of how much I'd get involved on the road. My mother
was all in accord with my trip to the west, she said it would do me good, I'd been
working so hard all winter and staying in toomuch; she even didn't say too much
when I told her I'd hiave to hitch hike some, ordinarily it frightened her, she
thought this would do me good. All she wanted was for me to come back in one piece.

and what is he doing right now?" Hal had decided not to be Neal's friend any more, for some odd reason, since the winter, and he didn't even know where he lived. "Is Allen Ginsberg in town?" "Yes---" but he wasn't talking to him any more either. This was the beginning of Hal Chase's withdrawal from our general gang---and he was going to stop talking to me xxxxxxxxx too in a short while. But I didn't know this, and the plans were for me to take a nap in his house that afternoon, at least. The word was that Ed White had an apartment waiting for me up Colfax avenue, that Allan Temko was already living in it and was waiting for me to join him. I sensed some kind of conspiracy in the air and this conspiracy lined up two groups in the gang: it was Hal Chase and Ed White and Allan Temko, together with the Burfords, generally agreeing to ignore Neal Cassady and Allen Ginsberg. I was smack in the middle of this interesting war. There were social overtones too that I'll explain. First I must set the stage about Neal: he was the son of a wino, one of the most tottering bums of Larimer street and had in fact been brought up generally on Larimer street and thereabouts. Neal used to plead in court at the age of six to have his father let free. He used to beg in front of Larimer alleys and sneak the money back to his father who waited among the broken bottles with an old bum buddy. Then when Neal grew up he began hanging around the Welton poolhalls and set a Denver record for stealing cars and went to the reformatory. From the age of eleven to seventeen he was usually in reform school. His specialty was stealing cars, gunning for girls coming out of high school in the afternoon, driving them out to the mountains, screwing them, and coming back to sleep in any available hotel bath tub in town. Meanwhile his father, once a very respectable and hardworking barber, had become a complete wino---a wine alcoholic which is worse than whisky alcoholic---and was reduced to riding freights to the South in the winter, to Texas, and back to Denver in the summer. Neal had brothers on his dead mother's side---she died when he was small---but they also disliked him. Neal's only buddies were the poolhall boys--a bunch I came to meet a few days later. Then Justin W. Brierly, a tremendous local character who all his life had specialized in developing the potentialities of young people, had in fact been tutor to Shirley Temple for MGM in the thirties, and was now a lawyer, a realtor, director of the Central City Opera Festival and also an English teacher in a Denver high school, discovered Neal. Brierly came to knock on a client's door; this client was always drunk and having wild parties. When Brierly knocked on the door the client was drunk upstairs, where was a drunken Indian in the parlor, and Neal---ragged and dirty from recent work in a Nebrask manure field---was screwing the maid in the bedroom. Neal ran down to answer the door with a hardon. Brierly said "Well, well, what is this?" Neal ushered him in. "What is your name? Neal Cassady? Neal you'd better learn to wash your ears a little better than that or you'll never get anywhere in this world." "Yes sir," said Neal smiling. "Who is your Indian friend? What's going on around here? These are strange goingson I must say." Justin W. Brierly was a short bespectacled ordinary-looking middlewest businessmen; you couldn't distinguish him from any other lawyer, realtor, director on 18th and Arapahoe near the financial district; except that he had a streak of imagination which would have appalled his confreres had they but known. Brierly was purely and simply interested in young people, especially boys. He discovered them in his English class; taught them the best he knew in Literature; groomed them; made them study till they had astounding marks; then he got them scholarships to Columbia University and they returned to Denver years later the product of his imagination--always with one shortcoming, which was the abandonment of their old mentor for new interests. They went further afield and left him behind; all he knew about anything was gleaned from what he'd made them learn; he had developed scientists and writers and youthful city politicians, lawyers and poets, and talked to them; then he dipped back into his reserve of boys in the high school class and groomed new ones to dubious greatness. He saw in Neal the great energy that would someday make him not a lawyer or a politician, but an American saint. He taught him how to wash his teeth, his ears; how to dress; helped him get odd jobs; and put him in high school. But Neal immediately stole the principal's car and wrecked it. He went to reform school. Justin W. stuck by him. He wrotehim long encouraging letters; chatted with the warden; brought him books; and when Neal came out Justin gave him one more chance. But Neal fouled up again. Whenever any of his poolhall buddies developed a hatred for a local prowlcar cop they went to Neal to do their revenge; he stole theprowlcar and wrecked it, or otherwise damaged it. Soon he was back in reform school and Brierly washed his hands of him. They became in fact tremendous ironical enemies. In the past winter in N.Y. Neal had tried one last crack for Brielry's influence; Allen Ginsberg wrote several poems, Neal signed his name to them and they were mailed to Brierly. Taking his annual trip to N.Y. Brierly faced all of us one evening in the Livingston lobby on

see what you can do straightening out the house." I followed Neal bustling downstairs. The guy who ran the drugstore said "You just got another call..this one from San Francisco...for a guy called Neal Cassady. I said there wasn't anybody by that name." It was Carolyn calling Neal. The drugstore man, Sam, a tall calm friend of mine, looked at me and scratched his head. "Geez, what are you running, an international whorehouse?" Neal tittered maniacally. "I dig you man!" He leaped into the phonebooth and called Frisco collect. Then we called Allen at his home in New Jersey and told him to come in. Allen arrived two hours later. Meanwhile Neal and I got ready for our return trip alone to North Carolinato pick up the rest of the furniture and bring my mother back. Allen Ginsberg came, poetry under xxxhis arm, and sat in an easy chair watching us with beady eyes. For the first half hour he refused to say anything, or that is, he refused to commit himself. He had quieted down since the Denver Doldrum days; the Dakar Doldrums had done it. In Dakar, wearing a beard, he had wandered the backstreets with little children who led him to a witchdoctor who told him his fortune. He had snapshots of crazy streets with grass huts, the hip back-end of Dakar. He said he almost jumped off the ship like Hart Crane on the way back. It was the first time he was seeing Neal since they parted in Houston. Neal sat on the floor with a music box and listened with tremendous amazement at the little song it played..."A Fine Romance"--xxx"Little tinkling whirling doodlebell. Ah! Listen! We'll all bend down together and look into the center of the music box till we learn about the secrets...tinklydoodlebell, whee." Al Hinkle was also sitting on the floor; he had my drumsticks; he suddenly began beating a tiny beat to go with the music box that we barely could hear. Everybody held their breath to listen. "Tick....tack... tick-tick....tack-tack." Neal cupped a hand over his xxxxx ear, his mouth hanged open, he said "Ah! Whee!" Allen watched this silly madness with slitted eyes. Finally he slapped his knee and said "I have an announcement to make." "Yes? Yes?" "What is the meaning of this voyage to New York? What kind of sordid business are you on now? I mean, man, whither goest thou?" xxx "Whither goest thou?" echoed Neal with his mouth open. We sat and didn't know what to say; there was nothing to talk about any more. The only thing to do was go. Neal leaped up and said we were ready to go back to North Carolina. He took a shower, I cooked up a big platter of rice with all xxxxxx that was left in the house. Louanne sewed his socks and we were ready to go. Neal and Allen and I zoomed into New York. We promised to see him in thirty hours, in time for New Year's Eve. It was night. We left Allen at Times Square and went back across the tunnel and into New Jersey. Taking turns at the wheel, Neal and I made North Carolina in ten hours."Now this is the first time we've been alone and in a position to talk for years" said Neal. And he talked all night. As in a dream we were zooming back through sleeping Washington and back in the Virgina wilds, crossing North Carolina line at daybreak, pulling up at my sister's door at nine A.M. And all this time Neal was tremendously excited about everything he saw, everything he talked about, every detail of every moment that transpired. He was out of his mind with real belief. "And of course now no one can tell us that there is no God. We've passed through all forms. You remember Jack when I first came to New York and I wanted Hal Chase to teach me about Nietzsche. You see how long ago? Everything is fine, God exists, we know time. Everything since the Greeks has been predicated wrong. You can't make it with geometry and geometrical systems of thinking. It's all THIS!" He wrapped his finger in his fist; the car hugged the line straight and true. "And not only that but we both understand that I couldn't have time to explain why I know andyou know God exists." At one point I moaned about life's troubles, how poor my family was, how much I wanted to help Pauline who was also poor and had a daughter. "Troubles, you see, is the generalization-word for what God exists in. The thing is not to get hung up. My head rings!" he cried clasping his head. He rushed out of the car like Groucho Marx to get cigarettes---that furious ground-hugging walk with the coat tails flying, except he had no coat tails. "Sine Denver, Jack, a lot of things...Oh, the things...I've thought and thought. I used to be in reform school all the time, I was a young punk, asserting myself---stealing cars a psychological expression of my position, hincty to show. All my jail-problems are pretty straight now. As far as I know I shall never be in jail again. The rest is not my fault." We passed a little kid who was throwing stones at the cars in the road. "Think of it" said Neal."One day he'll put a stone through a man's windshiedl and the man will crash and die...all on account of that little kid. You see what I mean? God exists without qualms. As we roll along this way I am positive beyond no doubt that everything will be taken care of for us...that even you, as you drive, fearful of the wheel" (I hated to drive and drove carefully)"the thing will go along of itself and you won,t go off the road and I can sleep. Furthermore we know America, we're at home; I can go anywhere in America and get what I want because it's the same in every corner, I know the people, I know what they do. We give and take and

in the ribs to understand. I tried my wildest best. Bing, bang, it was all Yes
Yes Yes in the backseat and the people up front were mopping their brows with
fright and wishing theyd never picked us up at Travel Bureau. It was only the be-
ginning too. After a wasted night in Sacramento, xxxxxxxxxxx the fag slyly bought
a room in a hotel and invited Neal and I to come up for a drink, while the couple
went to sleep at relatives, and in the hotel room Neal tried everything in the book
s to get money from the fag, submitting finally to his advances while I hid in the
bathroom and listened. It was insane. The fag began by saying he was very glad
we had come along because he liked young men like us, and would we believe it, but
he really didn't like girls and had recently concluded an affair with a man in Fri-
sco in which he had taken themale role and the man the female role. Neal plied him
with businesslike questions and nodded eagerly. The fag said he would like nothing
better but to know what Neal thought about all this. Warning him first that he had
once been a hustler in his youth, Neal proceeded to handle the fag like a woman,
tipping him over legs in the air and all and gave him a monstrous huge banging. I
was so non-plussed all I could do was sit and stare from my corner. And after all
that trouble the fag turned over no money to us, tho he made vague promises for
Denver, and on top of that he became extremely sullen and I think suspicious of
Neal's final motives. He kept counting his money and checking on his wallet. Neal
threw up his hands and gave up. "You see man, it's better not to bother. Give them
what they secretly want and they of course immediately become panic-stricken." But
he had sufficiently conquered the owner of the Plymouth to take over the wheel with
out remonstration, and now we really traveled. We left Sacramento at dawn and were
crossing the Nevada desert by noon after a hurling passage of the Sierras that made
the fag and the tourists cling to each other in the backseat. We were in front,
we took over. Neal was happy again. All he needed was a wheel in his hand and
four on the road. He talked about how bad a driver Bill Burroughs was and to de-
monstrate---"Whenever a huge big truck like that one coming loomed into sight it
would take Bill infinite time to spot it, cause he couldn't SEE, man he can'T SEE
--2--- " he rubbed his eyes furious to show----"And I 'd say whoop, lookout, Bill
a truck, and he'd say 'Eh? What's that you Say Neal?' 'Truck! truck!' and at the
VERY last MOMENT he would go right up to the truck like this"---and Neal hurled
the Plymouth head-on at the truck roaring our way, wobbled and hovered in front
of it a moment, the truckdriver's gm face growing white before our eyes, the people
in the backseat subsiding in gasps of horror, and swung away at the last moment-
"like that you see, exactly like that, that's how bad he was." I wasn't scared at
all: I knew Neal. The people in the backseat were speechless. In fact they were
afraid to complain: God knows what Neal would do, they thought, if they should ever
complain. He balled right across the desert in this manner, demonstrating various
ways of how not to drive, how his father used to drive jaloppies, how great dri-
vers made curves, how bad drivers hove over too far in the beginning and had to
scramble at the curve's end, and so on. It was a hot sunny afternoon. Reno, Battle
Mountain, Elko, all the towns along the Nevada road shot by one after another and
at dusk we were in the Salt Lake flats with the lights of Salt Lake City infinites-
imally glimmering almost a hundred xxxxxxxxx miles across the mirage of the flats,
twice-showing, above and below the curve of the earth, one clear, one dim. I told
Neal that the thing that bound us all together in this world was invisible: and to
prove it pointed to long lines of telephone poles that curved off out of sight over
the bend of a hundred miles of salt. His floppy bandage, all dirty now, shuddered
in the air; his face was a light---"Oh yes man, dear God, yes, yes!" Suddenly he
collapsed. I turned and saw him huddled in the corner of the seat sleeping. His
face was down on his good hand and the bandaged hand, automically and dutifully
remained in the air. The people in the front seat sighed with relief. I heard then
whispering mutiny. "We can't let him drive any more, he's absolutely crazy, they
must have let him out of an asylum or something." I rose to Neal's defense and lea
ned forward to talk to them. "He's not crazy, he'll allright, and don't worry about
his driving, he's the best in the world." "I just can't stand it" said the girl
with a suppressed hysterical whisper. I sat back and enjoyed nightfall on the de-
sert and waited poorchild Angel Neal to wake up again. He woke up just as we were
 on a hill overlooking Salt Lake City's neat patterns of light (the tourists wanted
 to see a famous hospital up there) and opened his eyes to the place in this spec-
 tral world where he was born unnamed and bedraggled years ago. "Jack, Jack, look,
 this is where I was born, think of it! People change, they eat meals year after
 year and change with every meal. EE! Look!" He was so excited it made me cry.
Where would it all lead? The tourists insisted on driving the car the rest of the
way to Denver. Okay, we didn't care. We sat back and talked. In any case they got
 too tired in the morning and Neal took the wheel in the Eastern Colorado desert
 at Craig. We spent almost the entire night crawling cautiously over Strawberry
 Pass in Utah and lost immeasurable time. They went to sleep. Neal headed pelmell

This "Editors'" (or "third") typescript was the one that Kerouac submitted to Viking as his final draft; it was then emended further—according to Kerouac, without consulting him—by his Viking editors, Cowley and Keith Jennison. Kerouac would have produced the typescript for the same reason that he transcribed the scroll in May of 1951—in order to have an easily readable copy to send to publishers. It is the product of at least two different drafts,[11] the first of which was created in 1953–54, as indicated by a number of factors, including the address that Kerouac typed on the last page, "Jean-Louis / c/o Lord & Colbert / 109 E.36th St. / New York, N.Y.," and which he later crossed out. (After the birth of a daughter, Janet, in February 1952, to Kerouac's estranged wife, Joan Haverty, he began using the pseudonym Jean-Louis because he was afraid that Haverty would make claims of child support based on his literary earnings.) The literary agents Sterling Lord and Colbert dissolved their partnership in 1954;[12] that Kerouac crossed out the firm's name and address indicates that he completed the typescript no later than the end of that year. In addition, ample textual evidence exists to prove this, as will be seen below. Also of use in dating this typescript is the manila envelope in which Viking returned it to Kerouac, postmarked December 13, 1957: it bears his inscription in black felt pen, "BEAT GENERATION / ROAD / 1953." (This inscription is consistent with Kerouac's effort, late in life, to date his papers.) By late 1953, he had still not decided which title he preferred, and did not make a final decision until late 1956. This "third" typescript adhered very closely to the scroll, except for name changes; three substantive textual additions, two of them incorporated from the second typescript; and excisions, most of which were incorporated from the second typescript, in 1956. It was presumably the initial draft of this typescript that was seen and commented on by Cowley.

Some of the differences between the scroll and the second and "third" typescripts are excisions and rewordings that Kerouac carried out in an attempt to comply with Cowley's instructions, most of them concerning sexual terminology and descriptions of sexual activity, as well as the use of the real names of the people about whom he was writing. To reduce the risk of lawsuits, Viking instructed Kerouac to use pseudonyms. Kerouac had already begun this process in 1953, as shown by the "third" typescript, probably because Cowley had already alerted him to this necessity. Cowley also thought that the number of road trips described in *On the Road*—four—and their similarity to each other made a coherent narrative impossible. (The dates and itineraries of the four trips are, in simplified form, July–October 1947, New York–Denver–San Francisco–Los Angeles and back; end of December 1948–February 1949, Rocky Mount, North Carolina, i.e., "Testament, Virginia," in the published text–New York–New Orleans–San Francisco and back; Spring 1949–Winter 1950, New York–Denver–San Francisco–Detroit and Grosse Pointe, and back; Spring–Summer 1950, New York–Denver–Mexico and back.) He wanted Kerouac to telescope the action, by selecting representative scenes and events, or bits of them from each of the trips, and to condense the narrative into a single trip, or at least to combine the second and third trips.[13] Kerouac never went this far, but he did greatly simplify the narrative line in the second typescript, especially through the crayoned excisions; these portions remain in the "third" typescript, from which they were transcribed into the published text.

Other differences between the scroll and the second and "third" typescripts take the form of additions and occasional excisions that originated with Kerouac voluntarily, some of them reflecting a change in his attitude toward his road experiences (to be expected, after a period of several years) and some of them stylistic. A final category of changes (aside from punctuation, spelling, and capitalization) includes the cuts and *additions*, occasionally of long phrases and even entire sentences, in what appears to be a woman's hand, in pencil, and other changes, probably in a man's hand, in blue and red pencil, almost all of which relate to spelling and capitalization. Neither of the hands is Kerouac's,[14] nor do they seem to be Cowley's or Jennison's; the latter might best be regarded as Kerouac's *general* editors, in the sense that they were authorized to instruct him to make changes that addressed Viking's legal concerns about libel and sexual content, as well as to require Kerouac to make whatever stylistic and narrative changes they thought necessary. But the editor responsible for carrying out these directives line by line on Kerouac's typescript was Helen Taylor, as is made clear in a Viking interoffice memo.[15] One cannot imagine that she or any editor would have added so extensively to a work without consulting the author, so one must assume that Kerouac communicated these additions to her or to Cowley and Jennison. Some of the excisions, however, must be among the changes that Kerouac alleged he had not seen before the book was published and the typescript returned to him. Most of the cuts seem to have been made in the belief that the action was being "tightened," as editors like to say (and which Cowley had urged), but they often reveal a tin ear for the rhythms and conversational asides and ellipses that give Kerouac's prose its propulsive force and help impart authenticity to the narrator's persona.

Kerouac even revised the scroll itself as he typed it, excising words and phrases with type-overs, probably, on average, twice a "page" (i.e., the equivalent of a page), but often more frequently. The scroll also reveals occasional additions of a word or phrase by hand, and, much more frequently, excisions, usually of a word or two, executed by drawing a line through them, most frequently of "obscene" words. An important example of this can be found on the scroll's first "page" (see fig. 4.4a). As Paradise enters Cassady's apartment, Louanne jumps off the bed, because "apparently he was fucking with her." Kerouac drew a line through "fuck," substituting "ball," and crossed out the last name of the co-renter of the apartment, Bob Malkin. The second typescript substitutes "banging" for "fucking," but Kerouac, later fearing that the novel would not be published if he did not deal more severely with its sexual language and descriptions, as well as with Viking's libel concerns, crayoned-out the offending passages, so that the text of the second typescript now reads, "Marylou was jumping off the bed. The other guy who owned the place [the entire name, "Bob Malkin," is now crossed out] was there," etc. In the "third" typescript, Kerouac tried to reintroduce in milder form an allusion to the sexual activity that Paradise's entry into the apartment had just interrupted, by altering the Marylou passage to read, "Marylou was jumping off the couch [toned down from "bed"] buttoning up: Dean had dispatched the occupant of the apartment to the kitchen," etc. But an editor has crossed out "buttoning up," so that in the published text, which follows the "third" typescript and its excision, Marylou's jumping off the couch is robbed of any contextual meaning (see fig. 4.6b). Also, Kerouac's neutral

allusion merely to "the occupant" of the apartment (Viking's libel concerns had forced the excision of Malkin's name) leaves the reader to wonder who this is—a phantom leaseholder?—since the only occupants previously mentioned are Moriarty and Marylou. Thus, Kerouac's need to accommodate Viking's concerns about sex and libel render a simple statement obscure and confusing to the reader.

An examination of the second typescript reveals a systematic attempt by Kerouac to condense the narrative and simplify its plot and its many authorial asides, though it is a longer text than the scroll. In several places in the scroll, Kerouac excises twenty- or thirty-line passages by drawing lines through the affected block of text (see fig. 4.4d), in order to reduce the number of diversions from the main narrative, though it remains unclear whether he began this process before or after he started the second typescript in 1955, in order to accommodate Viking's instructions. In any case, the large "cuts" in the scroll were restored in the "third" typescript and in the published text. An approximate comparative word count is useful to keep in mind as the various differences among the typescripts are considered: the scroll contains approximately 139,000 words (including an estimated count for ten "pages" of text at the end, which were chewed up by Lucien Carr's dog, Potchky, in May 1951, while Kerouac was retyping the scroll on separate sheets in Carr's loft); the second typescript, about 158,000 words; and the "third" typescript, which contains virtually all of the scroll text, plus additions, chiefly incorporated from the second typescript, about 175,000 words.[16]

The second typescript is a compelling document and needs to become an object of serious inquiry by Kerouac scholars for at least two reasons. First, it bears witness to a panicked Kerouac unmercifully mutilating his novel, not merely with thousands of crossings-out in black crayon,[17] but by compressing the action drastically, as well as by modifying the description of characters, in the hope of removing anything that Viking might find objectionable. However painful it is for the reader to sift through the detritus of such desperation, it is nevertheless instructive to learn what Kerouac was willing to sacrifice when, after having come so close to realizing his long-deferred dream, he faced the awful prospect of having it snatched away again. In the end, virtually none of the cuts were made in the published text, which leads one to believe that Cowley never saw these changes, since he would have been delighted to have been able to work with a much shorter, less complicated text, in which Kerouac clearly made an attempt to simplify his style. The second source of the typescript's attraction is the words, phrases, and even entire pages that Kerouac added to the scroll text, virtually all of them of his own volition (they are not the kind of changes that Cowley was urging) and most of which he retained in the final draft that he submitted to his editors. These show how the more mature writer and man looked back on his work of some five years earlier and attempted to improve it, as well as make it conform more accurately to his present view of the past.

Dating the second typescript through the evidence of its changes, that is, differences between its typed text and that of the scroll, as well as differences between its typed text and the excisions and additions that were made upon it in Kerouac's hand, is facilitated by the ominous warnings that Cowley sent Kerouac in the fall of 1955. On September 16, he for the first time formally alerts Kerouac to Viking's fear of libel suits (he probably spoke with Kerouac about this in 1954), which, he says,

may prevent the book's publication. On October 12, he again warns Kerouac about this concern, but more forcefully, saying that the typescript has been in the hands of one of Viking's lawyers for the past two weeks and that the changes to the characters that Kerouac is willing to make and has written to him about "aren't nearly enough." The final letter in which Cowley expresses his concern over libel is dated November 8.[18] He tells Kerouac that the Viking lawyer has prepared a brief on the matter and is still "considerably exercised about the danger of libel suits."

By the end of February 1956, Kerouac had lost all hope that Viking would proceed with the project, a state of mind that can be deduced from a February 29 letter to him from his agent, Sterling Lord, who pleadingly exclaims, "For God's sake, don't give up!"[19] One gathers from Lord's letter that Kerouac had been unable to contact Cowley, did not even know his whereabouts, and thought that he had abandoned him and his novel. Lord gives Kerouac the reassuring news that Cowley is in California, and that upon Cowley's return to New York in April, Lord will try to assuage his concerns about the novel. At some point between November 8, 1955, and March 21, 1956, Kerouac must have written to Cowley about changes that he had been making to the text or intended to make in accordance with Cowley's instructions, since on March 21 Cowley writes to Kerouac encouragingly:

> I think you have absolutely the right angle now for changing the characters in "On the Road"—those that have to be changed. My great worry is the Denver section [Part One, Chapters 6–10], because some of the people mentioned there are the sort who get bothered if they're talked about and bring suits. Making Mr. Beattie G. Davies [the pseudonym, introduced in the second typescript, for Justin W. Brierley, a Denver businessman and high school English teacher who had also tutored Shirley Temple at MGM] a bowling alley tycoon would be marvelous, and funny too. I'll get a new look at the ms as soon as I'm back in NY—suggest the desirable cuts, mention the characters who need further disguise, then you can get to work on them in the High Sierras [Kerouac was in Berkeley at the time, receiving his mail at Ginsberg's cottage at 1624 Milvia Street, as the letter shows], which sound like a marvelous place to work.[20]

The question arises, to which "ms" does Cowley refer when he says that he wants to take "a new look" at it? That is, which typescript had he seen before he left for California and, equally important, which typescript did he see at some point after his return? Was it the second typescript (either before or after the crayoned excisions and penciled additions), or was it the initial draft of the "third" typescript, the core of which is based closely on the scroll's text, later modified by Kerouac chiefly to meet Viking's concerns but also, in some instances, reflecting Kerouac's own desire to emend the text? Of course, Cowley *eventually* saw the final version of the "third" typescript, since this is the one that contains Viking's editorial changes, and which Kerouac identified as the "Original Editors'" typescript. But is this the typescript that he saw in its unemended form before he left and that he saw, after his return from California, emended by Kerouac? After examining the second typescript, the conclusion is almost inescapable that Cowley did not see it either prior to Kerouac's revisions of it in black crayon and pencil, or after its revision, and that the

only typescript he ever saw is the one that Kerouac called the "Original Editors'" typescript. The text of the second typescript, even prior to Kerouac's crayoned excisions and penciled additions, differs from the scroll in ways that conform to Cowley's demands in the letter of September 16, 1955: stylistic and narrative simplifications; deletions and modifications of sexual descriptions and terminology; and the substitution of pseudonyms for real names and the altering of character descriptions because of libel concerns. The manuscript excisions that Kerouac made, as well as some of the additions, only carry forward this process. Therefore, had Cowley seen the second typescript, whether before or after the manuscript excisions, he would have accepted it largely as it was, perhaps with minor modifications. In fact, however, the vast majority of these changes were not transferred to the "third" typescript and do not appear in the published version.

In short, unless Cowley saw a typescript that is either no longer extant, or the whereabouts of which is unknown, one must conclude that Cowley saw only the "third" typescript, which Kerouac made in late 1953 and 1954 and added to in the late fall of 1955 and in 1956. The typescript's 1953–54 text, comprising by far its largest portion, already included some emendations that Kerouac made to the text to alleviate Viking's concerns about libel and obscenity. This should not be surprising, since when Cowley first read the typescript, in 1953, he would have told Kerouac that Viking would want him to emend the text to reduce significantly if not eliminate the risk of libel suits and an obscenity trial. But these were not the only kinds of changes that Kerouac incorporated into the "third" typescript. In 1953–54, as he would in the second typescript, Kerouac incorporated emendations into the "third" typescript for reasons of his own. One such emendation is the addition of a 200-word passage reflecting his newly found Buddhist beliefs. It appears in Part Two, Section 10, at the end of Paradise's account of recalling a past life in England, circa 1750. Kerouac writes of "the sensation of death kicking at my heels [...] and myself hurrying to a plank where all the angels dove off and flew into the holy void of uncreated emptiness" etc., ending with "I felt sweet, swinging bliss [...] my feet tingled." However, in the scroll, the passage read simply, "where all the angels dove off and flew into infinity." What had changed between April 1951 and early 1954 is that Kerouac, in late 1953, had experienced an epiphany when reading a Buddhist text in the San Jose Public Library, which would forever change his life (see Chapter 5). He now interpreted that "past life" experience in the context of Buddhist teachings of karma, illusion, and enlightenment.

Kerouac also made changes in the "third" typescript based on additions that he had made to the second typescript in late 1955. He incorporated these additions by typing the emended text on sheets that are paginated with the number of the page they succeed, plus "a," "b," etc. This would date Kerouac's final changes to the "third" typescript to probably no earlier than the spring of 1956. Once Viking received the "third" typescript, it was modified by Taylor, under the direction of Cowley and Jennison, but especially in accord with the requirements of Viking's lawyer, as will be illustrated by the comparison below of selected examples from the texts of the three typescripts—scroll, second typescript, and "third," or "Original Editors,'" typescript.

Although the second typescript's major excisions and some of its additions

1

I first met Dean not long after ~~my father died~~ *my father died and I thought everything was dead.* ~~I wouldn't bother to talk about except that he actually had something to do with my life which feeling that everything was dead. With the coming of Dean began the only part of my life you could call my life~~ *My knowledge of the beat generation and the road began.* *Before* ~~that~~ that I'd always dreamed of going west, seeing the country, always ~~vaguely~~ planning and never taking off. ¶ ~~Dean was actually born on the road, when his parents were passing through Salt Lake City in 1926 in a jalopy, on their way to Los Angeles. First~~

First reports of Dean came to me through Chad King, *who showed* ~~who sent~~ me a few letters from him written in a Wyoming reform school. I was ~~tremendously interested in~~ *amazed by* these letters because they ~~so~~ naïvely and sweetly asked for Chad to teach him all about Nietzsche and all the ~~wonderful~~ intellectual things that ~~~~ *we all admired Chad for knowing.* At one point ~~Allen~~ *Justin* Moriarty and I talked about the~~se~~ letters and wondered if we would ever meet the strange Dean ~~Pomeray~~ *Pomeray.* This is all far back, when ~~Dean was not the way he is today, when he~~ *Dean* was a young jailkid shrouded in mystery. Then news came that ~~he~~ *Re* was out of reform school and was coming to New York for the first time; also there was talk that he had just married a sixteen year old girl called Marylou.

One day I was hanging around the campus and Chad ~~and Tim Gray~~ told me Dean had just arrived and was living in a coldwater pad in East Harlem, ~~the Spanish~~ *Espan* Dean had arrived the night before, his first hour in New York, with his beautiful little sharp chick Marylou; ~~they~~ *they* got off the Greyhound bus at 50th street and cut around the corner looking for a place to eat and went right in Hector's *Cafeteria* and since then Hector's ~~cafeteria~~ has always been a big glowing symbol of New York for Dean. They spent money on beautiful big glazed cakes and creampuffs ~~like~~ *that* you never get in western cafeterias. All this time Dean was telling Marylou things like this: ¶"Now darling here we are in New York and although I haven't quite told you everything that I was thinking about when we crossed Missouri and specially at the point when we passed the Booneville reformatory(which reminded me of my jail problem)it is absolutely necessary now to postpone all ~~those leftovers~~ ~~things~~ concerning our personal lovethings and at once begin thinking of specific worklife plans..." and

hardly out, ~~leap literally~~ *dart practically* under him, ~~start the car~~ start the car with
the door flapping ~~and~~ *to* roar ~~off~~ to the next available parking spot: work-
ing like that without pause eight hours a night, *including* evening rush hours and
after-theater rush-hours, in greasy ~~chino~~ *who* pants with a frayed furlined
jacket and beat shoes that flap. Now he'd bought a new suit to go back
home in; blue with pencil stripes, vest, ~~xxxxxx~~ with a watch, ~~xxxxxxxxx~~
chain, and a portable typewriter with which he was going to start writing
a ~~book~~ *novel* in a Denver roominghouse as soon as he got a job, ~~xxxxxx~~ We had
a farewell meal of franks and beans in a 7th Avenue Riker's and then Dean
got on the bus that said Chicago on it and roared off into the night. I
promised myself to go the same way when Spring really bloomed and opened
up the land. There went our wrangler.

~~And this was really the way that my whole road experience began
and the things that were to come are too fantastic now to again. I've only
spoken of Dean in a preliminary way because I didn't know any more than
this about him then. His relation with which I never spoken on and as it
xxx
referred to his natural ways, but that's no matter.~~

He wrote me a *wild* letter enroute in Kansas City. ~~He said,~~ *"Dear Great Sal:* I was sitting
in the bus when it took on more passengers at Indianapolis, Indiana---a
perfectly proportioned beautiful, intellectual, passionate personification
of Venus de Milo asked me if the seat beside me was taken!! I gulped,
gargled and stammered NO! She sat---I sweated---She started to speak, I
knew it would be generalities, so to tempt her I remained silent. She (her
name Luciana Ricci) got on the bus at 8 P.M. (dark!) I didn't speak till
10 P.M.----in the intervening 2 hours I not only, of course, determined to
make her, but, how to DO IT. I, naturally, can't quote the conversation
verbally, however, I shall atempt to give you the gist. Without the
slightest preliminaries of objective remakrs (what's your name? where
you going? etc.) I plunged into a completely <u>knowing</u>, completely personal
and so to speak "penetrating her core" way of speech, to be shorter by
2 A.M. I had her swaaring eternal love, complete subjection to me and
immediate satisfaction, and I, anticpating even more pleasure, wouldn't
allow her to ~~xxxxxxxxxx~~ *do it* in the bus, instead, ~~xxxxxx~~ we played, as
they say, with each other. Knowing her supremely perfect being was com-
pletely mine (when I'm more coherent I'll tell you her complete history
and psychological reason for loving me) I could conceive of no obstacle

II

(handwritten top margin: Denver to see Dean & everybody & then on to the West Coast to get a ship and make enough money to support myself on my aunt's house while I finished school.)

In the month of July, 1947, having saved about fifty dollars from
old veteran benefits I got ready to go to ~~the West Coast. My friend~~
~~Remi Boncoeur had~~ ~~written me a letter from San Francisco saying I should~~
~~come out there and ship out with him on an around-the-world liner. He~~
~~swore he could get me in the engine room. I wrote back and said I'd be~~
~~satisfied with any old freighter so long as I could take a few long Pa-~~
~~cific trips and come back with enough money to support myself in my~~
~~aunt's house while I finished school. He said he had a shack in Eldine~~
~~and I would have all the time in the world to study there while we went~~
~~through the rigmarole of getting the ship. He was living with a girl~~
~~called LeeAnne, he said she was a marvelous cook and everything would~~
~~jump. Remi was an old high school friend, a Frenchman brought up in~~
~~Paris but born in New Jersey and a really mad guy---I never knew how~~
~~mad~~
~~and so mad at this time.~~ ~~He expected me to~~ ~~arrive within ten days.~~
~~My aunt was all in~~ ~~accord with this...~~ In innocence of how much I'd get involved on

(handwritten: I had big day dreams of joy over roadmaps and letters.)

the road. My aunt was all in accord with my trip to the West, she said
it would do me good, I'd been working so hard all winter and staying in
too much; she even didn't ~~~~ *(tsk-tsk)* when I told her I'd hitch hike ⊗

~~according~~ All she wanted was for me to come back in one piece. So leaving
my books on top of the desk, and folding back my comfortable home sheets
for the last time, one morning, I left with my canvas bag in which a few
fundamental things were packed, left a note to my aunt, who was at work,
and took off for the ~~~~ *West Coast and China* ~~~~ with fifty
dollars in my pocket.

What a hangup ~~I got into,~~ ~~~~ ~~As I look back on it, it's in-~~
~~credible that I could have been so~~ ~~~~ dumb. *(Here I was)* I'd been poring over maps
of the United States ~~in Far Rockaway~~ for months, even reading books about
the pioneers and savoring names like Platte and Cimarron ~~~~ and
on the roadmap was one long red line called Route 6 that led from the
tip of Cape Cod clear to Ely, Nevada, ~~~~ *where it* dipped down to Los Angeles.
"I'll just stay on route six all the way to Ely," I said to myself and
confidently started. To get to route six I had to go up to Bear Mountain
New York. Filled with dreams of what I'd do in Chicago, in Denver, and
then finally in San Fran across the bejewelled bushy night to the west,
I took the 7th avenue subway to the end of the line, ~~~~

were not incorporated into the "third" typescript or into the published version, it is nonetheless instructive to examine some of the ways in which the second typescript differs from the first (i.e., the scroll) and from the "third." One obvious point of difference between the second and "third" typescripts is that the title page of the second originally bore the title "The Beat Generation," which Kerouac crossed out and replaced with "On the Road." Another of the second typescript's obvious points of difference from the Viking editorial copy and from the published version of *On the Road*—aside from the fact that the second typescript's sections are called "Books," as in both the scroll and in the "third" typescript, and not "Parts," as in the published version, and that each of the five "Books" has a title[21]—is the name changes made to two of the central characters, Neal Cassady and Allen Ginsberg. In the scroll, Cassady is referred to by his own name, and Ginsberg is called, on the second "page," "Leon Levinsky," though Kerouac immediately adds, "I mean of course Allen Ginsberg." In the second typescript, Cassady is called "Dean Pomeray," a name that Kerouac used frequently in the proto-versions, and Ginsberg is called "Justin Moriarty." By calling Ginsberg "Moriarty," the name that Kerouac had given Cassady in some pre-scroll versions, and which he would again, in the "third" typescript and in the published text, Kerouac was encoding into the text (for only he would be aware of the name's significance) the intimate relationship that joined Ginsberg and Cassady, which is one of the themes of the first part of *On the Road*.

That the second typescript, prior to Kerouac's slashing it to ribbons with black-crayon excisions, and adding words, phrases, and occasional sentences in pencil, is a draft distinct from both the scroll and the "third" typescript is demonstrated on almost every page of the typewritten text, though space allows for examination of only a few significant instances. The character of many of these changes, moreover, shows that this typescript was revised in Kerouac's hand some time between the late fall of 1955 and early 1956. Only a few of the significant emendations and additions in the second typescript were retained in the published text. Nevertheless, these changes demand our attention, first because the changes that Kerouac made in reaction to Cowley's instructions show how much he was willing to compromise in order to ensure that his book would be published, and second, because the changes that he made voluntarily reflect his new attitude toward his road experiences, now several years past, and include his attempt to refashion his own and Cassady's personas.

The scroll opens with the words, "I first met Neal not long after my father died ... I had just gotten over a serious illness that I won't bother to talk about except that it really had something to do with my father's death and my awful feeling that everything was dead. With the coming of Neal there really began for me that part of my life that you could call my life on the road" (see fig. 4.4a). In the second typescript (see fig. 4.5a), the unemended text reads, "I first met Dean not long after I got over a serious illness that I won't bother to talk about except that it really had something to do with my awful feeling that everything was dead. With the coming of Dean there would begin for me that part of my life you could call my life on the road [_____?] that I'd always dreamed of going west [...]." Incorporating Kerouac's excisions and manuscript additions, the passage reads, "I first met Dean not long after my father died and I thought everything was dead. My knowledge of the beat

generation and the road began. Before that I'd always dreamed," etc. Finally, the "third" typescript (see fig. 4.6a), absent the minor editorial changes that were incorporated into the published text, reads, "I first met Dean not long after my wife and I split up ... I had just gotten over a serious illness that I won't bother to talk about except that it really had something to do with the miserable weary splitup and my awful feeling that everything was dead."

Kerouac's explanation for why he was feeling "dead" on the eve of meeting Cassady changes from draft to draft: in the scroll, the emphasis is on the death of his father and his own illness, the latter of which is directly related to the former; in the unemended second typescript text, his own illness only; in the emended second typescript text, the death of his father; in the final typescript, his divorce. There is no reason to suppose that these changes were prompted by anything that Cowley might have said; instead, one must assume either that Kerouac's insight into his 1947 bout of despair had changed over time, or that, by the time he reworked the "third" typescript, he thought that ascribing its cause to a woman would engage the reader more effectively than the reasons offered in the previous drafts. Certainly, Sal Paradise spends a great deal of time and energy thinking about and chasing after women, though probably no more than most young men. But his pursuits assume a richer emotional meaning if one assumes that he is desperate to replace his wife, or to forget her.

On the other hand, ascribing the cause of his depression to his father's death, as he did in the scroll, helps establish the theme of searching for fathers, first in the literal sense, since Paradise and Moriarty search for Moriarty's father, "Old Dean Moriarty" through the streets of Denver and San Francisco (when Cassady was a teenager, his father abandoned him in Denver). Second, Paradise and Moriarty, and by extension the reader, are also searching for their fathers in the metaphorical sense, which is to say, they are searching for a protective figure of authority—an emotional and spiritual refuge—in a confusing and dangerous world. Thus, the novel's final lines bring Sal's quest full circle: "and nobody, nobody knows what's going to happen to anybody besides the forlorn rags of growing old, I think of Dean Moriarty, I even think of Old Dean Moriarty the father we never found, I think of Dean Moriarty." In forsaking the opening lines that ascribe Paradise's despair to the loss of his father, Kerouac may have felt that he was not sacrificing much, since the searching-for-father theme remained woven through the text, and who can say that readers would even remember the first line when reading the last? But beyond the question of whether Kerouac made the "right" literary decision by changing the first line, and beyond the question of why he changed it, is a more basic challenge. So numerous and significant are these voluntary changes that the researcher is almost compelled to approach the novel as a compilation of texts, each reflecting a slightly different sensibility or refraction of the author's experience.

Perhaps none of the voluntary changes is so crucial to our understanding of Kerouac's evolving attitude toward his life on the road and toward the novel that he hoped would immortalize it than the three lengthy additions that he made to the text of the scroll's opening "chapters." Each of them, appropriately enough, focuses on Cassady. Two of them were introduced by Kerouac into the "third" typescript and were retained in the published novel. The third appears in the second typescript in

the form of a letter that Pomeray (i.e., Cassady) sends to Paradise, but does not appear in the "third" typescript or in the published book. The first two of these additions comprise pages-long descriptions of Moriarty (Cassady's pseudonym in the "third" typescript and published text), the purpose of which is to establish three points. The first is that Paradise and Moriarty hold each other equally in awe. This is not the impression conveyed by the rest of the novel, in which Paradise can generally be found "shambling" after Moriarty, as Paradise puts it. One can understand why, by late 1955 or 1956, Kerouac, who was no longer quite as enthralled with Cassady as he had been, should want to stress that he, too, was worthy of adoration and, moreover, that Cassady recognized this. In the first of the three added portions, we find Moriarty overcome with ecstasy in the presence of Paradise's creativity, and Paradise worshipful before Moriarty's "excitement and visions." This addition appears after Moriarty, looking over Paradise's shoulder as he writes, says, "Go ahead, everything you do is great." The scroll's next line begins, "We went to New York." But the "third" typescript and the published version instead continue, "He watched over my shoulder as I wrote stories, yelling, 'Yes! That's right! Wow! Man! And 'Phew!' and wiped his face with his handkerchief. 'Man, wow, there's so many things to do, so many things to write!," etc. The added passage ends with "where he spent days reading or hiding from the law" (see fig. 4.6c). Still, Kerouac made sure not to place himself above Cassady. Just as Moriarty is in awe of Paradise's literary creativity and hopes that through contact with Paradise his talent will be imparted to him, so does Paradise feel that Moriarty's spontaneous, oral monologues are energized by "holy lightning."

The second point that Kerouac wishes to establish, a complement to the first, is the sincerity of Paradise's affection for Moriarty (Kerouac did worry that Cassady doubted his friendship), whom he regards as a "long-lost brother" (recall the pre-scroll versions in which the Kerouac and Cassady characters are brothers or half brothers). This he does in the second large, added passage of the opening portion of the "third" typescript. This four hundred–word affirmation by Paradise of his spiritual brotherhood with Moriarty also contrasts Moriarty with Paradise's New York friends, and establishes that Paradise/Kerouac has more in common with the all-American Dionysius than he does with the Eurocentric neurotics of Morningside Heights. The passage, all but the last few lines of which can be found in Kerouac's *More Mexico Blues* notebook, which dates from September 1956 to early 1957,[22] headed "On the Road Insert," was, in fact, inserted at the end of the first chapter of Part One. It begins with the words, "Yes, and it wasn't only because I was a writer and needed new experiences, that I wanted to know Dean more" (see fig. 4.6d), and concludes with, "somewhere along the line the pearl would be handed to me."

In this passage, Moriarty is depicted as a dazzling sun-god of the American West, whose charismatic physical presence and graceful (in the religious as well as aesthetic sense), if frenzied, passage through the world remind Paradise of the youthful, athletic deities who presided over his boyhood swimming holes. Moriarty's very speech patterns are those of the young, motorcycle-riding factory hands among whom Paradise grew up. Like them, Moriarty is a working-class hero whose dirty work clothes hang from his muscular frame with such simple elegance that they seem to have been provided by "the Natural Tailor of Natural Joy." Kerouac

In the past winter in New York Dean had tried one last ~~thing for~~ *semi-joking*
attempt to reconquer Davies' influence; ~~Allen~~ *Justin* Moriarty wrote several poems, Dean signed his
name to them and they were mailed to Davies. Taking his annual trip to
New York and including this matter on his agenda Davies faced us all
one evening in the campus lounge, ~~Allen,~~ Dean, ~~Allen,~~ *Justin,* myself, ~~and~~
Tim Gray, ~~and~~ Chad King, ~~and the others,~~ *saying* "These are very interesting poems
you've sent me, ~~Dean,~~ May I say that I was surprised?"

"Ah well," said Dean "I've been studying you know."

"And who is this ~~young gentleman~~ *character* here in the glasses?" inquired
Davies. ~~Allen~~ *Justin* Moriarty stepped up ~~and introduced himself.~~ *and bowed.* "An," said
Davies, "this is most interesting. I understand that you ~~are an excellent~~ *are supposed to be*
some kind of poet."

"Oh, have you read ~~any of~~ my things?"

"Why," said Davies, "probably, probably"---and Tim Gray gripped
me by the arm and whispered: "You think he doesn't know, see?" ~~I guessed~~
~~he did.~~ That was Dean's and Davies' last stand together. Now Dean was
back in Denver with his demon poet. Davies raised an ironical eyebrow
behind ordinary rimless glasses and avoided them. Chad King avoided them on secret principles of his
own. Tim Gray believed they were out for no good. They were the under-
ground monsters of that season in Denver, together with the poolhall
gang, ~~and~~ Symbolizing this most beautifully *Justin* ~~Allen~~ had a basement apart-
ment on Grant street, ~~and~~ we all met there many a night that went to dawn--
JUSTIN ~~Allen,~~ Dean, myself, Tommy Snark, Ed Buckle, ~~and~~ Roy Johnson, ~~and~~
~~the~~ *others.*

~~First afternoon in Denver I slept in Chad King's room while his~~
mother went on with her housework downstairs and Chad worked at the
library. It was a hot highplains afternoon in July. I would not have
slept if it hadn't been for Chad King's father's invention. Chad King's
father was a self-styled inventor. He was old, in his seventies, and
seemingly feeble, thin and drawnout and telling stories with a slow,
slow relish; good stories, too, about his boyhood on the Kansas plains
in the Eighties when for diversion mind you he rode ponies bareback and
chased after coyotes with a club and later became a country schoolteach-
er in West Kansas and finally a businessman of many devices in the Den-
ver of old roundpeaked black sombreros and early derbies. He still had
his old office over the garage in a barn down the street---the rolltop
desk was still there, together with countless dusty papers of past ex-
citement and moneymaking. *A sad but energetic westerner,* He invented a special airconditioner of his

Dakar Doldrums he had finally gone through a terrible period with he called *of what*

the Holy Doldrums, or Harlem Doldrums, when he lived in Harlem in midsummer

and at night woke up in his dizzy room and heard "the great machine" descen-

ding from the sky, and when he walked on 125th street "under water" with

all the other fish and he the only broken fish. He wrote what he said was

a bop hymn to God, in infinite gravity and seriousness, that began: "Pull

my daisy...tip my cup...cut my thoughts...for coconuts...start my Arden...

rape
~~~~~~~~~ my shades...raise my garden...rose my days...say my oops...ope my shell..

~~~~~~~~~ roll my bones...ring my bell...pope my parts...pop my pot...poke

my pap...pit my plum..."

It was a riot of crazy ideas that had come to occupy his most serious brain.

He said he was ~~~~~ mad. He made Marylou sit on his lap and commanded her

to subside. He told Dean, "Why don't you just sit down and relax. Why do you

jump around so much?" Dean ran around putting sugar in his coffee and saying

"Yes! yes! yes!" At night Ed Buckle slept on the floor on cushions, Dean ~~~

~~~~~~~ *and Marylou got in Justin's bed* ~~~~~~~~~~~ and went to it, and ~~~~~ *Justin* sat up in the kitch-

*wondering what next.*
en over his lung stew ~~~~~~~~~~~~~~~~~~~~~~~~~~~~~~~~~~~~~~~~~~~~~~

~~~~~~~~~~~~~~~~~~~~~ Ed Buckle was always talking to me. "Last night

I walked clear down to Times Square and just as I arrived in the lights I

suddenly realized I was a ghost ~~~~~~~~~~~~~~~~ walking on the sidewalk.

You know," he went on, "one time I saw a vision of my mother in Farmington

Utah where I was with Al Wehle---you know Al Wehle owns a ranch in Weld

right then
County. I said 'Mother' and she ~~~~~~~ disappeared." He said these

things without comment, nodding his head emphatically; Ten hours later ~

~~~~~~~~~~~~~~~~~~~~~~~~~~~~~~~~~~~~~~~~~~~~~~~~~~~~~~~~~~, "Yep, it

was my ghost walking on the sidewalk, that's what it was."

Suddenly the night before we left Dean leaned to me earnestly and

said, "Sal I have something to ask of you---very important to me---I wonder

*That is,*
how you'll understand--- ~~~~~~~~~~~~~~~~~~~~~~~~~~~~~~~~~~~~~~~~~~~~~~~

~~~~~~~~~~~~~~~~~~~~~~~~~~~~~~~~~~~~~ He almost blushed. Finally he came out with it:

ball with
he wanted me to ~~~~ Marylou. He wanted to test something in himself and he

wanted to see what Marylou was like with another man. We were sitting in

had
Foss Bar on Eighth Avenue when he proposed the idea, ~~~~~ spent ~~ hours

walking Times Square looking for Hassel. Foss Bar was then the hoodlum bar

guys in
of Times Square, full of red shirts, turtleneck sweaters, hustlers, wild

Genet
Negro queers, sad old homos of the Eighth Avenue marts of night, junkies,

bookies, middleage detectives, safecrackers, evil plans, ~~~ all kinds of

mad sexual routines. Kinsey was there in 1945 with his notebook. *Great*

Jane Lee had flounced in there in black silk slacks. Bull had

worn his derby in there, Elmo Hassel his stolen suits.

What I wanted was to take one more magnificent trip to the West Coast and get back in time for the spring semester in school ~~and what a trip it would be~~ *and I knew* what a trip *it would be~~.~~* ~~_____~~ Dean ~~_____~~ *Also* I wanted to have ~~some time~~ *some time* with Marylou, ~~and~~ I did. We got ready to cross the groaning continent again. I drew my G.I. check and gave Dean eighteen dollars to mail to his wife: she was waiting for him to come home~~.~~ ~~_____~~ ~~O~~n Marylou's mind I don't know. Ed Buckle ~~____~~ *always* followed.

First we drove to my house~~,~~ a whole gang of ten including New York friends~~,~~ to get my bag and call ~~_____~~ Bull *Lee* ~~_____~~ in New Orleans from the phone in the Germany bar where Dean and I had our first talk years ago when he~~'d come~~ *'d come* to my door to learn about the great books. We heard Bull's whining voice eighteen hundred miles away. "Say what do you boys expect me to with this Galatea Buckle? She's been here two weeks now hiding in her room and refusing to talk to ~~_____~~ *me or* Jane or ~~_____~~ *anybody.* Have you got this character Ed Buckle with you? ~~_____~~ *Get* him down *here!* ~~_____~~. She's sleeping in our best bedroom and's run clear out of money. This ain't ~~a~~ *no* hotel." We assured Bull with whoops and cries over the phone--~~_____~~ *Lee* who above all things hated confusion. "Well," he said, "maybe you'll make better sense when you gets down here,if you gets down here."

I said goodbye to my aunt, ~~_____~~ "Be back in two weeks," and took off for California~~._____~~. You always expect some kind of magic at the end of the road. Strangely enough Dean and ~~I were going~~ *I came* to find it, alone, before we finished~~._____~~ *ever*

The New York kids stood around the car on Third Avenue and waved goodbye. "That's right, that's right!" Dean kept saying and all the time ~~____~~ *but* only concerned with locking the trunk and putting ~~___~~ proper things in the compartment and sweeping the floor and getting all ready for the purity of the road again, ~~_____~~ of moving, ~~___~~ getting somewhere, no matter where, ~~___~~ as fast as possible ~~___~~ with as much excitement ~~___~~ digging ~~___~~ all things possible.

~~Ten, and we roared off_____~~

At the last moment ~~we~~ still wanted to take Elmo Hassel with us but nobody knew where he was. ~~I_____~~ He was back on Riker's Island on another narcotics charge--~~___~~ *an* undone bird, *busted once more.*

"Whither goest thou America in thy shiny car at night?" cried poor *Justin quoting Gogol, substituting shiny car for troika, America for Russia.* ~~Dean,~~ We roared off. **********

Man you dig all this"---he was poking me furiously in the ribs to under-
stand. I tried my wildest best. Bing, bang, it was all Yes Yes Yes in the
backseat and the people up front were mopping their brows with fright and
wishing they'd never picked us up at the Travel Bureau. It was only the
beginning.

In Sacramento the ~~gay~~ *homosexual pervert* slyly bought a room in
a hotel and invited Dean and me to come up for a drink, while the couple went
to sleep at relatives, ~~and in the hotel room Dean~~ *After preliminaries*
~~broke to get money from the fag~~ ~~making his advances while~~ I
~~did in the bathroom and listened.~~ It was insane. The fag began by saying
he was very glad we had come along because he liked young men like us, and
would *you* believe it, but he really didn't like girls and had recently conclu-
ded an affair with a man in Frisco in which he had taken the male role and
the man the female role. Dean plied him with businesslike questions and
nodded eagerly. The fag said he would like nothing better ~~but~~ *than* to know what
Dean ~~felt about homosexuality.~~ Warning him first that he had once been a hustler
in his youth, Dean proceeded to handle the fag like a woman, tipping him over
~~XXXXXXX~~ legs in the air *and from my bathroom hidingplace* I heard monstrous huge thrashing *sodomies* in
the dark. *Then there were tender scenes on the floor.*

~~After all~~ *Dean's* trouble the fag turned over no money,
~~made vague promises for Denver, and~~ became ex-
tremely sullen and I think suspicious of Dean's "motives." He kept
counting his money and checking his wallet. Dean threw up his hands and
gave up. "You see man, it's better not to bother. Give them what they se-
cretly want and they of course immediately become panic-stricken." But he
had sufficiently conquered the owner of the Plymouth to take over the wheel
without remonstra*nce* and now we really traveled.

We left Sacramento at dawn and were crossing the Nevada desert by
noon after a *flying* ~~passage~~ passage of the Sierras that made the fag and the tourists
cling to one another in the backseat. We were in front, we took over. Dean
was happy again. All he needed was a wheel in his hand and four on the road.
He talked about how bad a driver Old Bull *Lee* was and to demonstrate---
"Whenever a huge big truck came it would take Bull infinite time to spot it,
'cause he couldn't SEE, man he can't SEE"---he rubbed his eyes furious to
show---"And I'd say whoop, lookout, Bull a truck, and he'd say 'Eh? What's
that you say Dean?' 'Truck! truck!' and at the VERY last MOMENT he would go
right up to the truck like this"---*and aimed the living present* Plymouth head-on at *a*
the truck roaring our way, wobbled and hovered

to be with you as much as possible, m'boy and besides it's so durned cold in
this here New Yawk..." I whispered to Remi. No, he wouldn't have it, he
liked me but he didn't like my friends. I wasn't going to start all over
again ruining his planned evenings as I had done at Alfred's in San Francisco
in 1947 with Roland Major.

"Absolutely out of the question Sal!" Poor Remi, he had a special
necktie made for this evening, on it was painted a replica of the concert
tickets, and the names Sal and Laura and Remi and Vicki, the girl, together
with a series of sad jokes and some of his favorite sayings such as "You
can't teach the old maestro a new tune." So Dean couldn't ride uptown with
us and the only thing I could do was sit in the back of the Cadillac and
wave at him. The bookie at the wheel also wanted nothing to do with Dean.
Dean, ragged in a motheaten overcoat he'd brought specially for the freezing
temperatures of the East, walked off alone and the last I saw him he rounded
the corner of Seventh Avenue, eyes on the street ahead, and bent to it again.
Poor little Laura my wife to whom I'd told everything about Dean began almost
to cry.

"Oh we shouldn't let him go like this? What'll we do?"

"Old Dean's gone," I thought, and out loud I said, "He'll be all right."
And off we went to the sad and disinclined concert for which I had no stomach
whatever and all the time I was thinking of Dean and how he got back on the
train and rode over three thousand miles over that awful land and never knew
why he had come anyway, except to see me and my sweet wife. And he was gone.
If I hadn't been married I would have gone with him again. In America
When the sun goes down and I sit on the old brokendown river pier watching
the long, long skies over New Jersey and sense all that raw land that rolls
in one unbelievable huge bulge over to the West Coast, all that road going,
all the people dreaming in the immensity of it, and in Iowa I know by now
Children must be crying in that land where they let the children cry, & tonight the stars'll be out
the evening-star must be drooping and shedding her sparkler dims on the
prairie, which is just before the coming of complete night that blesses the
earth, darkens all rivers, cups the peaks to the west and folds the last and
final shore in, and nobody, just nobody knows what's going to happen to
anybody besides the forlorn rags of growing old, I think of Dean Pomeray,
I even think of Old Dean Pomeray the father we never found, I think of Dean
Pomeray, I think of Dean Pomeray. of the Beat Generation in the idealistic
sad American night.

THE END

and dont you
know that G-d
is Poo Bear?

emphasizes the stark contrast between Moriarty's joyous, quintessentially American, life-affirming energy, and the sardonic, life-denying, neurotic, and essentially European sensibility of Paradise's New York intellectual friends. When compared to Moriarty, a Whitmanian paragon of mythic male vitality, the New York intellectuals—the "Nietzschean anthropologist," the "nutty surrealist," the "critical anti-everything," the "slinking criminals," and the snooty odalisque—seem a gaggle of neurasthenic wretches, pathetic and absurd. That Moriarty is a *western* "kinsman of the sun" only adds to his appeal and stature; he embodies the "new horizon" of the American West, a promise of fulfillment in the spirit and the flesh, a promise that can be sensed by everyone who comes into his presence. At the end of the passage, Paradise calls this promise by the richly allusive and traditional name for spiritual teaching—"pearl." By incorporating into the "third" typescript this panegyric to Cassady, Kerouac has proclaimed his apotheosis, or, perhaps more accurately, has preached his gospel.[23]

Kerouac's third major addition to the opening portion of the novel, a letter from Pomeray to Paradise that was not incorporated into the published text, appears in the second typescript, at the end of the first chapter. The letter may be, at least in part, a transcription or paraphrase of an actual letter from Cassady to Kerouac, or it may be Kerouac's fictionalized version of a typical Cassady letter. In the scroll, the sentences that end what would become the book's first chapter read, "I promised myself to go the same way when Spring really bloomed and opened up the land. There went our wrangler [i.e., Cassady]. And this was really the way that my whole road experience began and the things [that] were to come are too fantastic not to tell." The "third" typescript/published text reads, following the "wrangler" sentence, "I promised myself to go the same way when spring really bloomed and opened up the land. And this was really the way," etc. However, in the second typescript, after the "wrangler" sentence Kerouac has inserted a letter from Pomeray: "He wrote me a wild letter enroute in Kansas City. 'Dear Great Sal: I was sitting in the bus when it took on more passengers at Indianapolis, Indiana—a perfectly proportioned beautiful, intellectual, passionate personification of Venus de Milo asked me if the seat beside me was taken!!'" (see fig. 4.5b). Although Pomeray's lust for his beautiful seatmate is unfulfilled (her sister meets her in St. Louis and whisks her away), he boasts that he redeemed the frustration of this episode by ruthlessly seducing and having sex with a passive, nineteen-year-old virgin on the bus. Perhaps, on reflection, Kerouac realized that this story revealed as much about Cassady's selfishness as it did about his virility.

The importance that Kerouac ascribed to Cassady's sexuality is revealed in another addition to the second typescript, relatively minor in length. It occurs in what Cowley called "the Denver section," mentioned above. In the scroll, the description of the Denver businessman and high school teacher Justin W. Brierley appears in what would become, in the published text, the sixth chapter of Part One. Kerouac describes Brierley as "a tremendous local character who all his life had specialized in developing the potentialities of young people," and who also took Cassady under his wing. He strongly implies that Brierley was a homosexual who perpetually failed in his oblique attempts to seduce his young male protégés. In the scroll, Brierley is described as a rather plain-looking man, "except that he had a streak of

imagination which would have appalled his confreres had they but known. Brierley was purely and simply interested in young people, especially boys." Sadly for him, after having groomed them for success and having helped them win scholarships to Columbia, they return to Denver "always with one shortcoming, which was the abandonment of their old mentor for new interests. [...] He saw in Neal the great energy that would someday make him not a lawyer or a politician, but an American saint." Kerouac then relates how Neal fell out of favor with Brierley by continuing to steal cars and falling afoul of the law. Some time after arriving in New York, Cassady had Ginsberg write several poems that Cassady copied and sent to Brierley under his own name, asking that they renew their relationship. The subterfuge succeeded in piquing Brierley's interest, and he consented to meet Cassady and his friends during his annual trip to New York. After exchanging a few words with Cassady and Ginsberg, he gathered that Ginsberg was the true author of the poems, and that meeting represented Cassady's final contact with Brierley (see fig. 4.4c).

Although this entire account, which extends for about a dozen lines onto the next "page" of the scroll, is excised from the published text (because Kerouac could not alter it sufficiently to allay the Viking lawyer's concerns about libel), it is included in the second typescript, in somewhat different form, with Brierley now called "Beattie G. Davies." Kerouac also replaced the reference to Brierley's having tutored Shirley Temple with the generalization that he tutored "musical prodigies in California in the Thirties." Perhaps because Kerouac thought that he had obscured Brierley's identity sufficiently with these changes, he told the somewhat risqué story of how Brierley first met Cassady, when the latter greeted him in the nude, in the home of a mutual acquaintance.

Other changes to the second typescript show the extent to which Cowley's warnings had frightened Kerouac. In the scroll, following the Brierley narrative, Kerouac describes his first night in Denver, where he is welcomed as a guest by the parents of Hal Chase, a friend of Cassady's who had joined the Ginsberg-Kerouac circle as a Columbia freshman in the fall of 1946, and whose stories about the car-jacking poet-philosopher imbued him with a mythic grandeur in Kerouac's and Ginsberg's eyes. (Chase's letters to Cassady, in Denver, about Kerouac and Ginsberg prompted Cassady to come to New York in December 1946 with his wife, Luanne. It was Chase who introduced Cassady to Ginsberg and Kerouac.) The scroll text describing his visit to the Chases is reproduced in the second typescript almost ver-batim (see fig. 4.5d), but significantly, Kerouac has changed the name of Chase to "King," which no doubt reflects his attempt, despite the benignity of his description, to satisfy Cowley's demands of October 1955 to disguise the identities "of the respectable or near respectable people," who are "the sort most likely to bring suit."

It was probably shortly before Lord wrote to Kerouac on February 29, 1956, telling him not to give up, or shortly after Kerouac received Cowley's letter of March 21, that Kerouac commenced his black-crayon ravagings. Among the thousands of words sacrificed was the entire account of Paradise's meeting and staying with Chase's colorful and generous parents, including an amusing aside about freezing in Chase's bedroom because of the air conditioner invented by the elder Chase. Hal's still-beautiful and kindly mother, who, Paradise relates, had come to Colorado in a covered wagon in the 1890s, and her husband, who rode ponies bareback on

the 1880s Kansas plains and hunted coyotes with a club, must have impressed themselves on Kerouac's imagination as the embodiment of American pioneer virtues: generosity, courage, ingenious self-reliance, and self-effacing dignity. The elder Chase's exploitation by East Coast businessmen—who marketed a cleaning fluid that he had invented, but did not compensate him for it—made him an all-the-more-poignant figure, especially in the eyes of Kerouac, who, like his father, attributed much of America's economic injustice to the rapacious greed of Eastern, big-city, Big Business. That Kerouac was nevertheless willing to expunge from his novel these American originals, embodiments of the country's fast-vanishing link to the Old West, shows how thoroughly Cowley's warning had shaken him.

Little wonder, then, that he was willing to cut less meaningful passages, if the cuts would simplify the narrative. An early instance of this occurs at the beginning of the second chapter of Part One. In the scroll (see fig. 4.4d) and "third" typescript (see fig. 4.6f), Paradise relates how, in July 1947, having saved $50 from his veteran benefits, he prepared to take a road trip to the West Coast. Following this statement, Kerouac introduces the character "Remi Boncoeur," modeled on his Horace Mann schoolmate Henri Cru, who has written to Paradise about going to sea with him on a freighter. We learn the history of Boncoeur's relationship with Paradise, his plans for the two of them, Paradise's pleased reaction, Boncoeur's living arrangements in California, and why these would well suit Paradise until they shipped out. All of this, including any mention of Boncoeur, is excised from this portion of the second typescript (see fig. 4.5c). Of course, this means that when Boncoeur appears a bit later on in the novel (Part One, Chapter 11), Kerouac has to explain who he is, as well as why Paradise is meeting him, which he does in the most perfunctory manner: "I was two weeks late meeting Remi Boncoeur [till here, the scroll text], my old school friend who was going to get us both on a ship [the second typescript]." Comparison with the scroll and published text shows that other portions of this passage in the scroll, in which Paradise anticipates meeting Boncoeur, have been rewritten as well, with Kerouac supplying more detail than he had in the scroll about passing through Salt Lake City and his impression of the Sierra Nevada.

Some of the more notable revisions of the scroll via the second typescript, which were retained in the "third" typescript and in the published text, concern Allen Ginsberg. Most of them occur in the section that would be published as Part Two. Sal Paradise, in New York with Cassady, Marylou, and Ed Hinkle, is planning his second trip to California, but this time he will be setting out in Cassady's sleek and powerful, brand-new Hudson coupe, rather than hitchhiking. Ginsberg rebukes them in the cadences of an ancient Hebrew prophet and warns them that this rushing from one end of the country to the other is a pointless waste of time and energy. We learn that earlier in the year, Ginsberg, deeply depressed, signed on board a freighter bound for Dakar, and during the voyage felt on the verge of jumping overboard and drowning himself. Upon arriving in Dakar, he wandered the back streets of the city and by chance was taken in hand by a band of children and led to a witchdoctor who told his fortune. The second typescript supplies additional information about his experience (see fig. 4.5e), as well as several lines of a poem that he wrote in Dakar, "a bop hymn to God," that begins "Pull my daisy," the title of the film that Kerouac would write and star in, in 1959, with Ginsberg, Gregory Corso,

I FIRST MET DEAN not long after my wife and I split up. I had just gotten over a serious illness that I won't bother to talk about, except that it really had something to do with the miserably weary splitup and my awful feeling that everything was dead. With the coming of Dean Moriarty there really began for me that part of my life you could call my life on the road. Before that I'd often dreamed of going west, seeing the country, always vaguely planning and never specifically taking off and so on. Dean is the perfect guy for the road because he actually was born on the road, when his parents were passing through Salt Lake City in 1926, in a jaloppy, on their way to Los Angeles. First reports of him came to me through Chad King, who'd shown me a few letters from him written in a New Mexico reform school. I was tremendously interested in the letters because they so naively and sweetly asked for Chad to teach him all about Nietzsche and all the wonderful intellectual things that Chad knew. At one point Carlo and I talked about these letters and wondered if we would ever meet the strange Dean Moriarty. This is all far back, when Dean was not the way he is today, when he was a young jailkid shrouded in mystery. Then news came that Dean was out of reform school and was coming to New York for the first time; also there was talk that he had just married a 16 year old girl called Marylou.

One day I was hanging around the campus and Chad and Tim Gray told me Dean had just arrived and was staying in a coldwater pad in East Harlem, the Spanish Harlem. Dean had arrived the night before, the first time in New York, with his beautiful little sharp chick Marylou; they got off the Greyhound bus at 50th Street and cut around the corner looking for a place to eat and went right in Hector's, and since then Hector's cafeteria has always been a big symbol of New York for Dean. They spent money on beautiful big glazed cakes and creampuffs. All this time Dean was telling Marylou things like this:

"Now darling, here we are in New York and although I haven't quite told you everything that I was thinking about when we crossed Missouri and

especially at the point when we passed the Booneville reformatory which reminded me of my jail problem, it is absolutely necessary now to postpone all those leftover things concerning our personal lovethings and at once begin thinking of specific worklife plans..." and so on in the way that he had in ~~his~~ those early days.

I went to the coldwater flat with the boys, and Dean came to the door in his shorts. Marylou was jumping off the couch ~~buttoning up~~; Dean had dispatched the occupant of the apartment to the kitchen, probably to make coffee, while he proceeded with his loveproblems, for to him sex was the one and only holy and important thing in life, although he had to sweat and curse to make a living and so on. You saw that in the way he stood bobbing his head, ~~priding himself on~~ always looking down, nodding, like a young boxer to instructions, to make you think he ~~'s~~ was really listening to every word, throwing in a thousand ~~manifold~~ "Yesses" and "Thats Rights." My first impression of Dean was of a young Gene Autry---trim, thin-hipped, blue-eyes, with a real Oklahoma accent, a sideburned hero of the pure snowy West. In fact he'd just been working on a ranch, Ed Wall's in ~~Weld County~~ Colorado, before marrying Marylou and coming east. Marylou was a ~~sweet~~ pretty blonde with immense ringlets of hair like a sea of golden tresses; she sat there on the edge of the ~~bed~~ couch with her hands hanging in her lap and her smoky blue country eyes fixed in a wide stare because she ~~'s~~ was in an evil gray New York pad that she'd heard about back West, and wait~~s~~ing like a longbodied emaciated ~~Mondrian~~ Modigliani surrealist woman in a serious room. But, outside of being a sweet little ~~thing~~ girl, she was awfully dumb and capable of doing horrible things, ~~as she proved a while later. I only mention this first meeting of Dean because of what he did.~~ That night we all drank beer and pulled wrists and talked till dawn and in the morning, while we sat around dumbly smoking butts from ashtrays in the gray light of a gloomy day, Dean got up nervously, paced around thinking, and decided the thing to do was to have Marylou making breakfast and sweep~~ing~~ the floor. "In other words we've got to get on the ball, darling, what I'm saying

his handkerchief. "Man, wow, there's so many things to do, so many things to write! How to even <u>begin</u> to get it all down and without modified restraints and all hungup on like literary inhibitions and grammatical fears..."

"That's right, man, now you're talking." And a kind of holy lightning I saw flashing from his excitement and his visions, which he described so torrentially that people in buses looked around to see the "over-excited nut." In the West he'd spent a third of his time in the poolhall, a third in jail, and a third in the Public Library. They'd seen him rushing eagerly down the winter streets, bare-headed, carrying books to the poolhall, or climbing trees to get into the attics of buddies where he spent days reading or hiding from the law. We went to New York, I forget what the situation was, two colored girls—there were no girls there, they were supposed to meet him in a diner and didn't show up. We went to his parking lot where he had a few things to do—change his clothes in the shack in back and spruce up a bit in front of a cracked mirror and so on, and then we took off. And that was the night Dean met Carlo Marx. A tremendous thing happened when Dean met Carlo Marx. two keen minds that they are, they took to each other at the drop of a hat. Two piercing eyes glanced into two piercing eyes...the holy con-man with the shining mind, and the sorrowful poetic con-man with the dark mind that is Carlo Marx. From that moment on I saw very little of Dean, and I was a little sorry, too. Their energies met head-on, I was a lout compared, I couldn't keep up with them. The whole mad swirl of everything that was to come then began, which would mix up all my friends and all I had left of my family in a big dust cloud over the American Night—Carlo told him of Old Bull Lee, Elmer Hassel, Jane Lee in Texas growing weed, Hassel on Rikers Island, Jane wandering on Times Square in a benzedrine hallucination, with her baby girl in her arms and ending up in Bellevue...and Dean told Carlo of unknown people in the West like Tommy Snark, the clubfooted poolhall rotation shark and cardplayer

YES, AND IT WASNT ONLY BECAUSE I WAS A WRITER and needed new experiences, that I
wanted to know Dean more, and because my life hanging around the campus had reached
the completion of its cycle and was stultified, but because, somehow, in spite of
our difference in character, he reminded me of some long-lost brother, the sight of
his suffering bony face with the long sideburns and his straining muscular sweating
neck made me remember my boyhood in those dye-dumps and swim-holes and riversides
of Paterson and the Passaic----the way his dirty workclothes clung to him so grace-
fully, as though you couldnt buy a better fit from a custom tailor but only earn it
from the Natural Tailor of Natural Joy, as Dean had, in his stresses. And in his
excited way of speaking I heard again the voices of old companions and brothers
under the bridge, among the motorcycles, along the wash-lined neighborhood and
drowsy doorsteps of afternoon where boys played guitars and their older brothers
worked in the mills. All my other current friends were "intellectuals"----Chad
the Nietzschean anthropologist, Carlo Marx and his nutty surrealist low-voiced
serious staring talk, Old Bull Lee and his critical anti-everything drawl----or else
they were sulky slinking criminals like Elmer Hassel, with that hip sneer----Jane
Lee the same, sprawled on the Oriental cover of her couch, sniffing at the New
Yorker Magazine. But Dean's intelligence was every bit as formal and shining and
complete, without the tedious intellectual-ness. And his "criminality" was not
something that sulked and slinked and sneered; it was a wild yea-saying Overburst
of American Joy; it was Western, the west wind, an ode from the Plains, something
new, long prophesied, long a-coming--(only stole cars for joy rides)----. Besides
all my New York friends were in the negative, nightmare position of putting down
society and giving their tired bookish or political or psycho-analytical reasons,
but Dean he just raced in society, eager for bread and love; he didnt care one way
or the other "So long's I can get that lil ole gal with that lil sumpin down there
tween her legs, boy" and "So long's we can EAT, son, year me? I'm HUNGRY, I'm

STARVING, let's EAT RIGHT NOW!"——and off we'd rush to EAT, whereof, as ~~sayeth~~ saith

Ecclesiastes, "It is your portion under the sun"...

 A western kinsman of the sun, Dean, although my aunt warned me that he

would get me in trouble, I could hear a new call and see a new horizon, and believe it

at my young age, and a little bit of trouble or even Dean's eventual rejection of me

as a buddy, putting me down as he would later on starving sidewalks and sickbeds——

what did it matter? I was a young writer and I wanted to take off.

 Somewhere along the line I knew there'd be girls, visions, everything;

somewhere along the line the pearl would be handed to me.

2.) Set Catch line

In the month of July, 1947, having finished a good half of my novel and having saved about fifty dollars from old veteran benefits I was ready to go to the West Coast. My friend Remi Boncoeur had written me a letter from San Francisco, saying I should come out there and ship out with him on an around-the-world liner. He swore he could get me into the engine room. I wrote back and said I'd be satisfied with any old freighter so long as I could take a few long Pacific trips and come back with enough money to support myself in my aunt's house while I finished my book. He said he had a shack in Mill City and I would have all the time in the world to write there while we went through the rigamarole of getting the ship. He was living with a girl called Lee Ann; he said she was a marvelous cook and everything would jump. Remi was an old prep-school friend, a Frenchman brought up in Paris and France and a really mad guy---I didn't know how mad and so mad at this time. So he expected me to arrive in ten days. I wrote and confirmed this...in innocence of how much I'd get involved on the road. My aunt was all in accord with my trip to the West; she said it would do me good, I'd been working so hard all winter and staying in too much; she even didn't complain say too much when I told her I'd have to hitch hike some, ordinarily it frightened her, she thought this would do me good. All she wanted was for me to come back in one piece. So leaving my big half-manuscript sitting on top of my desk, and folding back my comfortable home sheets for the last time one morning, I left with my canvas bag in which a few fundamental things were packed, left a note to my aunt, who was at work, and took off for the Pacific Ocean like a veritable Ishmael with the

he was poking me furiously in the ribs to understand. I tried my wildest best.
Bing, bang, it was all Yes Yes Yes in the backseat and the people up front were
mopping their brows with fright and wishing they'd never picked us up at the
Travel Bureau. It was only the beginning too.

After a wasted night in Sacramento, The fag slyly bought a
room in a hotel and invited Dean and I to come up for a drink, while the couple
went to sleep at relatives, and in the hotel room Dean tried everything in the
book to get money from the fag. It was insane. The fag began by saying he was
very glad we had come along because he liked young men like us, and would we be-
lieve it, but he really didn't like girls and had recently concluded an affair with
a man in Frisco in which he had taken the male role and the man the female role.
Dean plied him with businesslike questions and nodded eagerly. The fag said he
would like nothing better but to know what Dean thought about all this. Warning
him first that he had once been a hustler in his youth, Dean asked him how much
money he had. I was in the bathroom. The fag became extremely sullen and I
think suspicious of Dean's final motives, turned over no money, and made vague
promises for Denver. He kept counting his money and checking on his wallet. Dean
threw up his hands and gave up. "You see, man, it's better not to bother. Offer
them what they secretly want and they of course immediately become panic-stricken."
But he had sufficiently conquered the owner of the Plymouth to take over the wheel
without remonstrance, and now we really traveled.

We left Sacramento at dawn and were crossing the Nevada desert
by noon after a hurling passage of the Sierras that made the fag and the tourists
cling to each other in the backseat. We were in front, we took over. Dean was hap-
py again. All he needed was a wheel in his hand and four on the road. He talked
about how bad a driver Old Bull Lee was and to demonstrate----"Whenever a huge big
truck like that one coming loomed into sight it would take Bull infinite time to
spot it, cause he couldn't SEE, man, he can't SEE--"--he rubbed his eyes furiously to
show----"And I'd say whoop, lookout, Bull, a truck, and he'd say 'Eh? what's that you

and several other mutual friends. During Ginsberg's reproachful speech aimed at bringing Paradise, Cassady, and their companions to their senses, he utters one of the more famous lines in the novel, which has been famously associated with him ever since: "Whither goest thou America in thy shiny car at night?" (see fig. 4.5f). This line does not appear in the scroll, in which he asks only, "What kind of sordid business are you on now? I mean, man, whither goest thou?" These Ginsberg-related changes have nothing to do with Viking's concerns and can be attributed only to Kerouac's desire to improve the text.

In light of the changes that Kerouac introduced into the second typescript in order to meet Viking's demands, it might seem surprising to find in it an elaboration of a sexual encounter between Cassady and a homosexual in a hotel room. The incident begins in Book Three, Chapter 5, with Paradise and Cassady in the back seat of a Plymouth, whose owner ("a tall thin fag") is headed home to Kansas. That night, the owner pays for a hotel room for all three of them, reveals his sexual orientation, and asks Cassady what he "thought about all this." In the scroll we read that after Cassady warns him that he had been a hustler in his youth, "Neal proceeded to handle the fag like a woman, tipping him over legs in the air and all and gave him a monstrous huge banging [illegibly emended in Kerouac's hand]. I was so non-plussed all I could do was sit and stare from my corner. And after all that trouble the fag turned over no money to us, tho he made vague promises for Denver, and on top of that he became extremely sullen and I think suspicious of Neal's final motives." (see fig. 4.4a).

In the second typescript, we get a somewhat more graphic description of the encounter and its aftermath. Also, Kerouac adds a line that places Paradise in the bathroom, rather than in the main room, where he is an eyewitness cowering in the corner, filled with fright, no doubt, but whether also with excitement or disgust cannot be said. What is striking about the scroll's description of this event is Kerouac's use of the quaint "non-plussed" to describe Paradise's state of mind. Surely the phrase is too moderate for so extreme a situation, and the suspicion arises that Kerouac, whether consciously or not, used it so that he would not have to confront or describe the feelings that witnessing the scene unleashed in him. Placing Paradise in the bathroom allows Kerouac the freedom, in the second typescript, to describe what he "hears" more graphically than he described, in the scroll, what he saw. The second typescript reads: "The fag said he would like nothing better than to know what Dean felt about homosexuality [Kerouac added this phrase by hand]. Warning him first that he had once been a hustler in his youth Dean proceeded to handle the fag like a woman, tipping him over legs in the air and from my bathroom hiding place I heard monstrous huge thrashing sodomies in the dark. Then there were tender scenes on the floor. After all Dean's trouble the fag turned over no money," etc. (see fig. 4.5g). Kerouac has removed mention not only of Paradise's presence in the room, but of his "non-plussed" reaction to the encounter, which Kerouac must have later seen was an evasive way to describe Paradise's emotional state.

Kerouac may have felt free to add detail and drama to the scene (the "monstrous huge thrashing sodomies" and the "tender scenes on the floor") since the car owner was a stranger, his name was not mentioned, and, therefore, libel would not be an issue. As for why he removed his alter ego as an eyewitness to the scene, a

possible answer may be found in Kerouac's extreme ambivalence about his occasional homosexual urges and indulgences. In rewriting this passage, he may have wanted, consciously or not, to distance himself from what might be interpreted as his complicity or interest in the encounter. In the "third" typescript and in the published text, all description of the sexual encounter has been removed, and the passage, consequently, reads very awkwardly: "Warning him first that he had once been a hustler in his youth, Dean asked him how much money he had. I was in the bathroom. The fag became extremely sullen and I think suspicious of Dean's final motives, turned over no money, and made vague promises for Denver" (see fig. 4.6g). Cassady, Ginsberg, and several others of Kerouac's friends had given him, as the Viking lawyer insisted, signed statements permitting him to write about them, but Cassady may not have known that Kerouac had included the scene in the book. If Kerouac informed him about it as the emendation process intensified in late 1955 and 1956, Cassady may have objected to its inclusion. On the other hand, its excision may represent just one more instance of Kerouac's being forced by Cowley et al. to omit "objectionable" material, thereby eviscerating the scene and impoverishing the depiction of Cassady.

But Kerouac was also capable of inflicting damage on his own. *On the Road* ends with one of the best-known passages in the novel, and with good reason—it is one of the finer lyrical passages in American literature, the beauty and power of which Kerouac exceeded only in the final two chapters of *The Dharma Bums*. As we saw in the previous chapter, Kerouac, in January 1951, had composed something very much like the passage as we know it, in the "'Ben Boncoeur' Excerpt." Unfortunately, because of the depredations of the dog Potchky, the scroll text of the novel's concluding ten or so 'pages" has not survived. But there is no reason to think that the second typescript differs from it significantly, except, of course, for the additions that Kerouac has added in pencil (see fig. 4.5h). He retained the first of the two additions in the "third" typescript and in the published text: "children must be crying in that land where they let the children cry, & tonight the stars'll be out and don't you know that God is Poo[h] Bear?" The introduction of this sentimental note is unfortunate, and typical of Kerouac. In this case, as in many other voluntary additions that appear throughout the second typescript, he should have left well enough alone. In the end, he did have the good sense not to ruin the novel's final elegiac note with the second typescript's penciled addition, "of the Beat Generation in the idealistic sad American night." Perhaps when he added this gaseous rhetorical flourish he was still calling the novel "The Beat Generation" and wanted to recall the title in the book's final line; or perhaps, since he had complied with Cowley's instruction not to use the title, he thought it desirable to throw it in at the end. "The idealistic sad American night" unfortunately recalls the overwrought style of the pre-scroll versions, in which a mere tacked-on adjective or adverb is meant to convey to the reader a world of ideas and symbolic meanings. The second typescript contains many such steps backwards. Fearful that Viking would renege on its commitment and that *On the Road* would never be published, Kerouac, having slashed his text to bits, reverted to his worst literary habit—grandiose, Wolfean sentimentality—mistaking it for inspiration.

Yet, in the end, Kerouac rejected these impulses and retained most of his

improvements, as well as the scroll text almost in its entirety, which is the form in which the novel was published. Although the published text often skips a disconcerting beat (which the scroll, whatever its flaws, does not), this is attributable not to Kerouac, for the most part, but to Taylor (no doubt pressured by Viking's lawyer), who flattened the conversational rhythm and diluted the emotional content of various scenes by crudely breaking up and re-forming many of the longer sentences; who sanitized the so-called "sex scenes" beyond recognition and, sometimes, coherence; and who removed sexual terminology. This last category of changes was far from innocuous since it compromised the tone of frank self-expression and honesty of the narrative voice, and the authenticity of the narrator's character. Viking's fear of libel suits (whether reasonable or not), as reflected in Taylor's work on the text, also added to the occasional narrative choppiness and detracted from the scroll's richness of characterization.

The portions of the scroll's text through which Taylor hacked are dense tangles of sexuality, conversational rhythm, and picaresque, often surreal action, in which the characters come to life. The vibrant bemusement, rage, wonder, or despair of the narrator's voice in numerous asides set the various elements of these tangles chafing against each other, raising a smoky wisp of grim or antic humor from the friction of their interaction. Now, with the undergrowth cleared, the brambles cut back, and the sentences forced into neat rows, the contrapuntal polyphony is often reduced to a few weak scratches in a reedy breeze. Yet, despite all that was lost, the narrative, in its essential complexity, remained intact, as did the lyrical passages describing the American landscape. But knowing now the degree to which Cowley was urging Kerouac to emend the text, and knowing as well that Kerouac had capitulated to all of his demands in the second typescript, even beyond what was plausibly necessary, the question arises as to why Kerouac did not submit the second typescript to Cowley, and why Cowley agreed to accept the "third" typescript as the basis for the published text. Unfortunately, Kerouac's diaries and journals contain no entries for this period, except for the summer of 1956, when he was a fire watcher atop Desolation Peak, in the Cascade Mountains, and these do not address the issue.

The answer to the conundrum may be no more complicated than Kerouac's being able to convince Cowley, when he saw him face to face, to relent on his objections to the narrative's complexity and "digressions" and to confine his editorial excisions, i.e., those that he communicated to Taylor, to the matters of sexuality and libel. The chopping up into short sentences many of the longer passages in the scroll, some of which originally read like the more stylistically advanced (and better) *Visions of Cody* and Burroughs's *Naked Lunch*, may have been the result of Taylor's initiative rather than Cowley's. Regardless of who was responsible for this category of emendation, those who had read the scroll did not think that the editing had improved it. In a late 1957 letter to Kerouac, his friend Philip Whalen, who had read the scroll text and had just read the published book (or at least a portion of it, since he takes up the subject again in early 1958), writes, "And I wish ROAD hadn't been edited all to hell, but what there is is still great."[24] As for Kerouac, he is characteristically at odds with himself. He complained to one friend that Viking had "castrated" his book. (This is sheer hyperbole; for an example of a "castrated" text, see what Kerouac himself did to his second typescript.) To another friend he gloated over his

cleverness in frustrating Viking's intentions and in preserving the book's magic. His ambivalence may be traceable to his discomfort at having himself emended the scroll for his own purposes, something that he would not wish to admit to his public or even to his friends, especially now that he had been for some years an advocate of "spontaneous prose" and the maxim "first thought, best thought."

When asked by interviewers how long it took him to write *On the Road*, he invariably replied "three weeks," without elaboration. While this answer is accurate, it is not true. He had worked on the novel for almost four years prior to creating the scroll, and would later alter its text in significant ways, of his own volition (as well as by compulsion), in 1953, 1954, late 1955, and 1956. But having waited for more than six years for the novel's publication, and, as always, conflicted about who he was as a person and as a writer, he needed to claim a public identity—master of literary improvisation, the Charlie Parker of letters—so that it might not be taken from him in moments of solitary doubt. The irony was that he had won the right to claim this title for the unpublished *Visions of Cody* and *The Subterraneans*, and not for *On the Road*.

Whatever its place in the Kerouac canon, it cannot be denied that *On the Road* was the key that opened for him, in William Blake's phrase, "the doors of perception." It was a debt that Kerouac never forgot. Even in the 1960s he writes of *On the Road* as he would of an old friend. He even gave pride of place in his Archive to the novel's proto-versions. Here we find the Old West/New West sagas, the "American Times" fragments, the "Cast of Characters," the "Flower That Blows in the Night," and scores of other nascent efforts. Origins were always important to Kerouac, and however far he traveled, whether as writer or spiritual seeker, he carried them with him because it was from them that he thought he drew his strength.

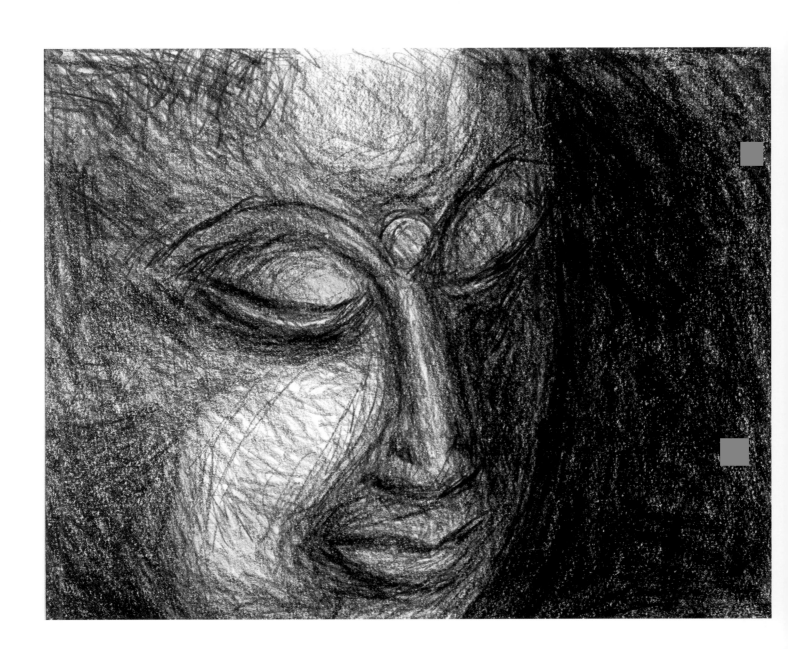

The Buddhist Christian

It is no exaggeration to say that Kerouac, at least by the time he wrote *The Town and the City*, saw his own literary efforts and those of his favorite authors as a form of spiritual discipline. Although he thought carefully and worked hard in the mid-1940s to develop a style he called lyrical prose, he felt that literature's essential task was to carry readers into the author's spiritual experience of the world and thereby to transform them in the way he had been transformed. This missionary zeal cannot be explained only by Kerouac's early environment and conditioning, although these factors did play a role in the particular forms it took. He was brought up in a household strongly imbued with the Roman Catholic faith, and attended parochial school through the fifth grade. His father was not particularly religious, but he did observe all of the norms of Roman Catholic practice. His mother, however, was a fiercely pious woman who believed absolutely in the religious orthodoxies of her French-Canadian community, and she, with the assistance of some of his parochial school teachers, systematically inculcated all of this—including fearful superstitions about members of other faiths—into her son. (Kerouac recalls, in *Visions of Gerard*, that some of the nuns at his French-Canadian parochial school would warn their young students that Protestants had tails.) Also exercising a strong religious influence on him was the idealized memory of his dead brother, Gerard, who became for him the paragon of Christian innocence and, later, Buddhist enlightenment.

These outside influences aside, Kerouac, even as a child, seems to have experienced intimations of the spiritual path he would travel, which would lead him outside the Church and to the Buddhist sutras (the teachings of the Buddha), and especially into the embrace of the bodhisattva[1] of compassion, Avalokitesvara, whom Kerouac tried to fashion into a Christ-like personal savior. His earliest spiritual awareness seems to have sprung from a source deeper than any specific teaching or doctrine. In 1941 he typed a one-page recollection of a childhood epiphany that revealed to him the ultimate unknowability and beauty of the world. Entitled "My Sad Sunset Birth," it begins:

> The day I was born, there was snow on the ground and the descending sun colored westwise windows with an old red melancholia, as of dream. I was walking home with my sled, aged six. Suddenly, I stopped in my tracks and stared, standing quietly on the sidewalk in Centralville. "What is this," I asked myself, noticing the sudden swoop of a sad moment as it flew across our rooftops. "What is this strange thing I see?" In that manner, I was born into the world, February 1929, just before supper. [...] The wisp of winter's dusk

Fig. 5.1

"Face of the Buddha." Pencil on paper, [1958?]. 7.5" × 9.5".

caught hold of me—for the first time in my little life I was puzzled by the sound of children's voices, the smell of snow at sunset, the vapors which puffed from my mouth with every icy exhalation, and above all, that fleeting old sadness which hung tenderly over the crimson houses of Centralville.[2]

His memory of this event, in which the world's wonder and ultimate mystery overwhelmed him, also inspired a 1953 short story, "New England in Winterland" (retitled "Home at Christmas" for its publication in the December issue of *Glamour*), and possibly the painting "Boy in the Snow at Night" (see fig. 2.4).

Kerouac's first extant writings about religion per se are of a very different kind, however, and date from the fall semester of his freshman year at Columbia, in 1940. The journal essay in which they are recorded, written probably under the spell of Marx's theory of dialectical materialism, marks the beginning of a brief period that lasted until 1942, during which he expressed a deep skepticism, often harsh and mocking, about the Christian idea of God. In this essay, entitled "Thought," he writes contemptuously: "About the notion of God, and his nearness to us, with the universe in his pocket, and ourselves as his masterpiece—'in his image.' What insufferable, even contemptible, egoism! 'Then,' they ask, 'if there is no God, who is man?' Let us say that Man is a creature on the puny earth, laughing with his brothers [...] or just say Noble Man. That is enough God for anyone." Several pages further on, he wonders if Jesus would have condemned adultery had contraceptives existed in his time, and answers ambivalently, "(PROBABLY NOT) (PROBABLY SO)," and continues, "His disciples were saps but what in heaven compelled him to preach so! What a man for the B.C.'s! (He might have read Indian or Chinese scripture!) No!" The emphatic character of Kerouac's negative reply and the disdain reflected in the word "saps" almost certainly indicate that he was voicing an opinion regarding the differences between the sets of teachings (i.e., Jesus' teachings are too different from those of the East to have been influenced by them), not evaluating the historical record. Although Kerouac's involvement in Eastern spirituality is often traced to early 1953 (see below), we can see in these lines, and in a personal reading list on the previous page, that both the Indian and Chinese scriptures interested him as early as 1940. But a few pages later, he seems to renounce any form of spirituality in favor of simple materialism: "Science is truth. Any statement to the contrary is a left-over of superstition & outworn theology[.] ... For religion is naught but comfort, & seeks a false human dignity. Science dignifies Man <u>more</u> than religion."[3]

By 1942, Kerouac had reaccepted the idea of a personal God, but the Eastern traditions continued to intrigue him, apparently because of their harmony with natural law; that is, just as there was a law of cause and effect in the physical realm, so there was such a law in the spiritual. In a journal entry in 1942 on Hinduism, he presents his understanding of the principle of karma, though he does not use the term, and considers the possibility that God is "a mass of intelligence" rather than a personal being. He then asks, "Shall we have to be empirical to deny this, or truthful? Think ... Or shall we even deny it?" Then, retreating from the possibility, he adds, "Perhaps we shall have to grow prejudiced, fearful, and hopeful in order to believe it." He combines the word "hopeful" with the negative attributes of prejudice and fear in an attempt to portray the Hindu idea of an impersonal, divine system of reward and punishment as a kind of false "comfort," which two years earlier he had

ascribed to Christianity. In truth, he found no comfort in the idea of an impersonal divinity and never would, even at the height of his commitment to Buddhism. But even at this tentative stage he cannot dismiss the idea entirely: "Let us think clearly on all matters, even though men in the past have reached the same conclusions—most of them. Remember Wolfe and Saroyan's God, and Ecclesiastes."[4] That is, although most "men in the past," at least in the Western tradition, had accepted the idea of a personal God, Kerouac still asserts the need to remain open to the possibility that the idea is false.

His spiritual search was reflected in the conflict of values that he perceived in the differences between small-town and big-city life. By October 1944, having begun the novel that would become *The Town and the City*, he identified this theme almost immediately in his notes and drafts as the heart of the novel. The opposition of town and city was an opposition not only of virtue and vice, but of a closeness to and alienation from nature. For Kerouac, the natural world was an expression of the spiritual, and those who separated themselves from nature alienated themselves from their essential being. This conviction accounted, in large part, for the sadness and compulsive vice that he and Peter Martin, his primary alter ego in *The Town and the City*, discerned in their big-city intellectual friends, with the best among them struggling through the darkness toward the light of divine salvation.

The trauma that Kerouac suffered as a result of his father's death in May 1946 only intensified the struggle to come to his own understanding of spirituality. Barely six weeks later, he wrote sympathetically in his journal about the Hindu concept of Maya—humanity's illusion that the material world and its separate entities comprise the entirety of existence.[5] Emerging from this principle is Hinduism's ahistorical view of the world, which Kerouac contrasts with that of "Faustianism" (the secular Western view of history, exemplified by "Nietzsche, Goethe, Spengler"). Although he implicitly counts himself among the Faustians, he recognizes this allegiance as a form of conditioning, and he shows great sympathy for Hinduism's acceptance of the "world-as-itself," in contrast to Faustianism's insistence on the "world-as-myself." But Kerouac was not yet ready for an Eastern approach to the divine, and so, in 1947, fervent expressions of faith in a personal God burst forth, in the form of eight psalms written in two modes: fervent thanksgivings to God for the joy he has been granted, and tearful pleas to God that He ease his anguish (see fig. 5.2). Reprising the theme of the novel he is writing, most of the psalms express revulsion toward the city, a source of evil. An explicitly literary note is sounded as well, in a psalm in which he cites the example of the seers who have walked the same difficult and glorious path he now trods. Perhaps unsurprisingly for a writer who regarded great literature as a form of holy writ, these prophets are not biblical, but literary: "A psalm and a hymn of praise: for there spread the fields, far beyond this city, and in the fields, the woods, on the earth, on the sea—there I see Thoreaus, and Whitmans, and Melvilles, and Thomas Wolfes, and there are the colleagues of my time who have cried out to You, God, and writ their cryings, and published your name[....]" One of the psalms even sounds an explicitly Christian note. In it, Kerouac thanks God for shedding His light "upon the sorrowful weary city men, the melancholy women, within those black towers and byways[....] Your light wide over the city and the bridge at morning—and I am saved, my Saviour, saved!"[6]

Fig. 5.2

JOURNALS 1948 / Journal 1939–1940, p. 7.
9.75" h.

Following a group of seven psalms dated
1947 (an eighth is written toward the end of
the notebook), Kerouac commences a
"Composing Diary" for the period November
1–December 1, 1948. This is followed by a
page and a half of entries made in July 1950,
after Kerouac had returned from Mexico City
to his mother's Richmond Hill home. The
notebook is the one in which he began his
Horace Mann journal in 1939, with an
affirmation of his literary ambitions, which is
why the notebook cover bears the date
1939–40. Probably in preparation for using
the notebook again in 1948, he tore out the
leaves on which he wrote in 1939 about join-
ing the ranks of Dickens and Thackeray (see
fig. 2.14).

— PSALMODY —

God, I cannot find your face this morning:
the night has been split, a morning
light has come, and lo! there is the
city, and there are the city men
with their wheels coming to swallow
darkness under towers.
Ah! Ah! there's a rage here, God, there's
a bridge too upon which the wheels
collide, beneath which they bring
more wheels and tunnels, there's a
fire raging here over dull multitudes.
God I have known this city and stayed
here trapped and full of rage, I have
been a city man, with wheels, and
walkings all about inside, I have
seen their faces all around me here.
I must see your face this morning, God,
your face through dusty windowpanes,
through steam and furor, I must
listen to your voice over these clankings
of the city: I am tired, God, I
cannot see your face in this history.

So certain has Kerouac now become of his belief in God that he analyzes and
disproves to his own satisfaction the atheistic/agnostic hypothesis that he had for-
merly embraced, that is, that God is a projection of the psyche that originates in a
child's faith in his father's authority and in the sense of security which that faith
provides. "This," says Kerouac in a 1947 essay, "God as the Should-Be" (subtitled
"The Huge Guilt"), in the richly varied *Forest of Arden* journal, "is the idea men have
of God." But when the child grows up and sees "that his father knows very little
more than the child himself [...] then the child is in danger of growing cynical about
the entire matter, or despairing, or mad" (see fig. 5.3).

For Kerouac, that the God idea may be a psychological projection is not a rea-
son to dismiss it, but is a demonstration of its truth. Adapting Descartes' ontological
argument to his purposes,[7] he writes: "that children and fathers should have a notion
in their souls that there must be a way, an authority [...] in all the disorder and sorrow
of the world—that is God in men." The sense of guilt accompanying this belief in an
authority is only a further confirmation of God's existence. At this point in his life,

Entry for August 23, 1948, p. [13] in *1947–'48*
JOURNALS FURTHER NOTES / Well, this is
the forest of Arden—, **May 5–September 9,**
1948. 8.25" h.

This journal opens with a group of one- and
two-page essays and more than a dozen pen-
sées of only a paragraph or a few lines in
length. The essays include a reflection
(engendered by a newspaper report on
General Douglas MacArthur's having banned
kissing on the Tokyo streets) on white
America's fear of sexuality; the greatness of
Dostoevsky's artistry in the story "A Raw
Youth"; "AMERICA and RUSSIA"; a "STATE-
MENT OF SANITY"; and (shown here) "God
as the Should-Be," subtitled "(THE HUGE
GUILT)."

> **God as the Should-Be** (THE HUGE GUILT)
>
> The most beautiful idea on the face of the earth is the idea the child has that his father knows everything, knows what should be done at all times and how one should live always.
>
> This is the idea men have of God.
>
> But when the child grows up and learns that his father knows very little more than the child himself, when the child seeks advice and meets with fumbling earnest human words, when the child seeks a way and finds that his father's way is <u>not enough</u>; when the child is left cold with the realization that no one knows what to do — no one knows how to live, behave, judge, how to think, see, understand, no one knows yet everyone tries fumblingly — then the child is in danger of growing cynical about the entire matter, or despairing, or mad.
>
> But that children and fathers should have a notion in their souls that there must be a way, an authority, a great knowledge, a vision, a view of life, a proper manner, a 'seemliness' in all the disorder and sorrow of the world — that is God in men. <u>That there should be something to turn to for advice is God</u> — God is the 'should-be' in our souls. No matter if actually there is <u>nothing</u> that should be done, no matter if science shows us that we are natural animals and would do better living without 'unnatural qualms,' without inner stress, without scruples or morals or vague trepidations, living like the animals we are, without guilt or horror — that we believe that there <u>should be something, that we are guilty thereby, is God.</u>

Kerouac sees himself as a believer who has successfully struggled through a crisis
of faith, and he is understandably impatient with those who have, for fashion's sake,
adopted the cynic's pose. On the page following "God as the Should-Be," entitled
"The Philosophic 'Why,'" Kerouac tells of an encounter with a Columbia student
"philosopher" who asked him what he had been doing lately. When Kerouac replied,
"Writing a novel," the young man mockingly asked, "Why?" Kerouac seethes at the
memory of this facile condescension: "The man who enters the house of doubt-and-
wherefore and sneaks out the back way has no right to ask the man who has entered
the house of doubt-and-wherefore and explored all the rooms and left the way he
came in[,] <u>why</u> he should do anything. [...] Why crap on him, I even know the wall-
termites in the house of doubt-and-wherefore by their first names."

Kerouac's encounter with Neal Cassady and with Cassady's gift, as Kerouac saw
it, to live fully in the moment, sensually and intelligently—that is, with the intelli-
gence of wonder and of disregard for social proprieties or accepted moral norms—
began to work a transformation in Kerouac's psyche, as did his road trips, spent

largely in Cassady's company. His experience of the desolate and wild beauty of the vast and varied American landscape, as well as the many kinds of people he met on the road and in the downbeat sections of the cities he passed through, also changed him. This rush of new experience and the accompanying state of heightened awareness seems to have created in him a state of readiness for the moment in 1953, in San Jose, where he was staying with Cassady and his wife, Carolyn, when he entered the public library, opened a book, and encountered the words of the Buddha.

He had happened upon Volume X of *The Sacred Books and Early Literature of the East*, which was devoted to "India and Buddhism in Translation," though, in light of his earlier interest in Eastern religion, we may assume that he had purposefully made his way to the shelves containing books on this subject. As he would recall years later in a notebook, in the first of four chapters of an unfinished work, "The Long Night of Life," until he opened the book "accidentally to 'The life of the Buddha' and saw these words: 'O worldly men! How fatally deluded! Beholding everywhere the body brought to dust, yet everywhere the more carelessly living; the heart is neither lifeless wood nor stone, and yet it thinks not "All is Vanishing"'— my life was a puzzle, suffering was my constant activity, and the knowledge of death was a knife in my throat." The words "Repose beyond fate" struck him with great force, as did many other of the Buddhist teachings that he began devouring, and on New Year's Eve, in the midst of the reveling crowds, he realized that the goal of transcending suffering was "inevitable and prophesied somewhere." Asking himself how he has been so fortunate as to have had the Dharma, the underlying order of existence, revealed to him, he answers that the reason lies not in the mechanical operation of cause and effect, which brought him to the library that day, nor in the "bleak thoughts" he was thinking as he prepared to read the book, an allusion to the skeptic's objection that he merely needed to believe in something. Rather, he writes, his discovery of the Dharma "was the manifestation of the universal essence of mind revealing itself to itself, as before and before, as now and now again, as after and long after indeed. As already."[8]

Very soon after this experience, Kerouac began the process of recording the fruits of his study of Buddhism, as well as commenting on its teachings. In this effort he was aided by *A Buddhist Bible*, edited by Dwight Goddard, who played a crucial role in introducing Buddhism to the West. Kerouac inscribed the front flyleaf of his copy (now in the Berg Collection) with a quotation from the second-century Asvaghosha's *Life of the Buddha*: "In solitude of desert hermitage nourish a still and peaceful heart."[9] From late 1953 to February 1956, he kept what might be called a Buddhist journal, comprising eleven notebooks containing his rigorously analytical explications of Buddhist teachings and of the nature of meditation, and filled with examples from his own experience, as well as tales of the Buddha and the bodhisattvas. (A few of the *Dharma* notebooks, as they are titled, also contain drafts of fiction and essays, as well as journal-like entries on personal and literary matters.) The "Dharma" texts would become the basis of *Some of the Dharma*, published in 1997.

The first of these notebooks reveals a typically Kerouacian impulse to begin at the beginning or at least nearly so: his first "Dharma" entries concern the study of Chinese (the Chinese forms of Buddhism especially appealed to him at first), beginning with "The 4 Tones of Chinese" (see fig. 5.4). Kerouac occasionally uses these

Fig. 5.4
Dharma (A) 1953, [December] 1953, p. 39.
10" h.
The first part of this notebook includes accounts of various trips to California and Mexico; poetry; the draft of an unpublished reminiscence entitled "The Coming of Cold Jazz"; nutritional information; and Kerouac's opinions of his friends.

notebooks to contrast the Buddha with Christ, and Buddhism with Christianity. Although he does not deny that Jesus was spiritually enlightened, or that one can find spiritual truths in the New Testament or certain books of the Hebrew Bible, he feels that he has now found something better: "REPOSE BEYOND FATE—REST BEYOND HEAVEN! Buddha goes beyond Christ—for I have had a vision of the anxieties of Heaven (Mexico City Benzedrine Vision Dec 1952)[.]"[10]

In Buddhism's teaching that to live an unenlightened life is to suffer, Kerouac found what he misinterpreted as a metaphysical affirmation of his own melancholia and his romantic tendency to project his emotional states on nature. If he was suffering, the trees at which he was looking were also suffering, an attitude that has nothing to do with the Buddhist teaching that nature and the mind are one. This Romantic fallacy intensified his revulsion against the encroachments of technology and urban sprawl upon the countryside, and helped fuel a deep, lifelong resentment against America's consumerist ethos. In the notebook *Dharma (1),* his extended entry for "May 1954" includes a passage (see fig. 5.5) in which he imagines that he is "The Tathagata" (the name that the historical Buddha, Siddhartha Gautama, used when referring to himself) who sees the "tormented Karma" that has produced trees that are "umbrellas of living pain," and who also sees "the even greater torment in manufactured automobiles sitting staring in steel in the street— [...] American know-how is not savior of world but its curse in the struggle to understand emancipation—"[11] What makes all of this bearable to Kerouac, at least in theory, is the Buddhist idea that everything is constantly passing from one state to another, which is to say, dying. For Kerouac this means that everything is already dead. Tormented all his life by a fear of death, he tried to find comfort in this idea,

Fig. 5.5

Dharma (1), December 9, 1953–May 14, 1954, 8th page, verso, from beginning. 6" h.

facing page:

Fig. 5.6a–b

Dharma (4), Fall 1954–January 1955. 6" h.

Fig. 5.6a: leaf [20], recto.

That the first part of this page was based on a work by the Buddhist scholar John Blofeld is indicated by Kerouac's mention of his name and of a work (*Life in a Buddhist Monastery in China*) that he supposedly published, in which there was a reference to the Buddhist vow not to rest until every creature in the world has found enlightenment. (Kerouac may actually have been reading Blofeld's *The Huang Po Doctrine of Universal Mind*, 1947.) The second quotation, regarding the meditation practice of *pi-kuan* (literally, "wall examining," which was supposedly brought by Bodhidharma to China with Buddhism itself), Kerouac attributes to "Goddard," i.e., the Buddhist scholar Dwight Goddard, who published practical manuals of Buddhist meditation in the 1930s.

Fig. 5.6b: leaf [4], verso.

How can you sit there and tell me that, as long as all will be gone in seven million milliards, all is not already gone?
THE TATHAGATA [HE WHO HAS COME AND GONE] sees the torment
The tormented Karma, with a single thought looking at trees, their misty unreal rise from the ground like umbrellas of living pain, then with a double thought he sees the even greater torment in manufactured automobiles sitting staring in steel in the street — Civilization takes us one more step removed from intuitive realization of what has been made manifest in this we call our life — American Know-how is not savior of world but its curse in the struggle to understand emancipation —

All things are dead in a dream
§ — The Diamond Statement — °
NOTHING'S ALIVE
FOR THE UNIVERSE
IS A DREAM
ALREADY ENDED
"Dead eyes see" — Ginsberg, 1949
"The soul is dead." — Kerouac 1949

as he does at the beginning and the end of the passage about the suffering expressed by trees and cars. At the bottom of the page, he connects the Buddhist teaching that all existence is in a constant state of flux to his and Ginsberg's 1949 insights into death-in-life.

Buddhism's emphasis on compassion resonated deeply in Kerouac's psyche, and he regularly took pains in his *Dharma* notebooks to elaborate on it, often quoting from anecdotes enshrined in Buddhist tradition. November 1, 1954, found him in The New York Public Library, where he read about the Buddhist practice of buying and setting free captive fish and animals, and he recorded his positive reaction in the notebook *Dharma (4)* (see fig. 5.6a). The last few pages of this notebook contain a detailed and rigorously systematic analysis of the Buddhist teaching that the components of the material world, including space, are not ultimately real. Kerouac's exposition (which continues into the next notebook) is an adaptation of part of the Surangama Sutra, one of the main points of which is that knowledge of the Dharma (in this context, the teachings of the Buddha) is useless unless one has the ability to meditate. Kerouac offers a step-by-step analysis of the process of seeing, in an attempt to prove that the act cannot take place unless perception and the objects perceived "both belong by nature to the Mysterious Mind Essence" (see fig. 5.6b). At this point, in late 1954, Kerouac's disdain for Christianity, at least in its

DHARMA (4)
New York Public Library
Nov. 1, 1954

The ancient original use of tea —
to calm the mind before meditation.

In China the true Buddhist some-
times buys captive fish & animals &
sets them free — also makes sym-
bolical offerings to the poor homeless
ghosts and spirits that throng the air!

"The stupendous vow never to
rest in this life or in lives to come
until every living creature has been
saved." — Life in a Buddhist Monastery
in China, Blofeld

The practise of PI-KUAN — three
years in one room, food slipped
to you, a little garden to pace in
— "his body was imprisoned but his
mind & spirit were free to traverse
the unseen realms of bliss, while other
men who have freedom of body are
mentally bound by circumstances, by

What'll I do? You mean what'll I dream?

THE SURANGAMA SUTRA
(Wording re-arranged for the
Understanding of Western Minds)
Suppose you're looking at all those
beautiful springs and pools out there.
I want to show you that the loca-
tions of contact between your cons-
ciousness or shall we say your per-
ception of those objects, and the
objects themselves, that is, the
springs and pools themselves, both be-
long by nature to the Mysterious
Mind Essence. Understand? Both locations of
your eyeballs that see the objects, and
the objects themselves.

Now what do you think, as you
turn your eyeballs and make con-
tact with the springs and pools.
What is it that develops your cons-
ciousness of the springs and pools?
Is it the springs and pools, or is
it your eyeballs? If it's the
eyeballs that develop it, then
objects themselves are inert and
dead, and the consciousness of ob-
jects plus the objects themselves are
developed by the eyeballs. So
when you turn your eyeballs and look
at space, as space is or different

following pages:

Fig. 5.7a–b

Book of Dreams, [1960]. 11" h.

The final typescript draft of *Book of Dreams*,
for which Kerouac made two title pages, as
well as a ribald frontispiece constructed from
newspaper clippings, is the only one that he
illuminated throughout, using brightly col-
ored, decorative motifs and full-page abstract
drawings to enhance the text.

traditional form, seems to have been intensifying, as can be seen in the sneering
aside, "The Christians & their anthropomorphic fairy tales."[12]

Kerouac's obsession with his dreams, from an early age, is well known, and
his commitment to Buddhism did not much weaken their fascination for him. In
1952 he began planning and writing *Book of Dreams*, in which he records and inter-
prets his dreams; he would continue to work on it fitfully for the next eight years
(see fig. 5.7a–b).[13] (City Lights published excerpts from *Book of Dreams* in 1961, and
it was published in its entirety in 1981.) In January 1955, still in the throes of his
intense and unrelenting process of reading and analyzing the sutras, he writes in
the *Dharma* (5) notebook that he is considering using a famous passage from the
first section of the Lankavatara Sutra, which reads, "What do you think, Mahamati
[a disciple of the Buddha], is this dreamer who is letting his mind dwell upon the
various unrealities he has seen in his dream—is he considered wise or foolish?"[14]
The clear sense of the passage in context is that, yes, such a person is, indeed, a
fool. Kerouac's willingness to consider using the quotation as an epigraph for *Book
of Dreams* shows the extent to which he was able to confront and even publicly
acknowledge his own inconsistencies.

Kerouac did occasionally record that he had experienced dreamless sleeps,
especially during the period in 1954–56 when he seems to have been practicing

in the up and down America, you've all seen it you ignorant pricks
that cant understand what you're reading, there, with sidestreets,
trees, night, mist, lamps, cowboys, barns, hoops, girls, leaves,
something so familiar and never been seen it tears your heart out---
I'm dashing down this street, cloppity clip, just left Neal and *Cody*
Evelyn
Carolyn at a San Francisco spectral restaurant or cafeteria table
at Market and Third where we talked eagerly plans for a trip East it
was (as if!) (as if there could be East or West in that waving old
compass of the sack, base set on the pillow, foolish people and
crazy people dream, the world wont be saved at this rate, these are
the scravenings of a---lost---sheep)---the Carolyn of these dreams *Evelyn*
is an amenable---Neal is---(cold and jealous)---something---dont *Cody*
know---dont care---Just that after I talk to them---Good God it's
taken me all this time to say, I'm riding down the hill---it becomes
the Bunker Hill Street of Lowell---I'm headed for the black river on
a white horse---it broke my heart when I woke up, to realize that I
was going to make that trip East (pathetic!)---by myself---alone in
eternity---to which now I go, on white horse, not knowing what's
going to happen, predestined or not, if predestined why bother, if
not why try, not if try why, but try if why not, or not why---At the
present time I have nothing to say and refuse to go on without fur-
ther knowledge.

AND MEXICO CITY, A SPECTRAL ONE WITH WISHED FOR PIERS sitting at
the base of gloomy gray Liverpool-like Ferrocarril---I and a horde
of young generation in suits with prom flower girls attend a melee,
a gathering, at a building, a tower---so crowded, I, among bachelors,

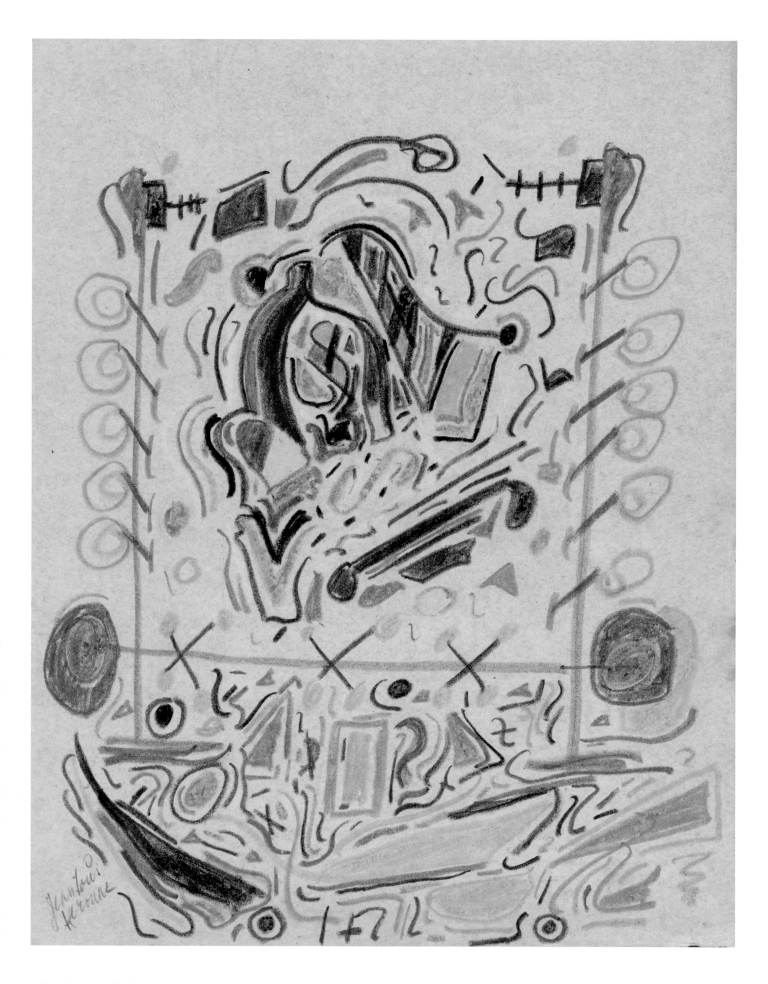

Fig. 5.7b: drawing following p. 179. THE BUDDHIST CHRISTIAN

Fig. 5.8

Dharma (5), January 2–February 3, 1955,
leaf 42, recto. 6" h.

meditation energetically on a daily basis. In early 1955, he writes in the *Dharma (5)* notebook of having fallen one night into a dreamless sleep from which he emerged into a state of "Citta-Vritti-Nirodha" (see fig. 5.8), a Sanskrit phrase that is part of a famous Hindu saying, "The aim of Yoga is the intentional stopping of the spontaneous fluctuations of consciousness," which are the words that begin the ancient sage Patanjali's Yoga Sutras. Kerouac reports that on this occasion, despite becoming aware in his sleep of a loud sound outside his room, which he only later identified as that of a diesel engine, he did not awaken. As his mind began to form an image of what might have caused the noise, the colored spots that had appeared in his mind, as part of its automatic process of searching for the cause of the noise, "suddenly vanished." This was the moment of "Citta-Vritti-Nirodha." Then, as his thought process remained quiescent, his awareness suddenly expanded to encompass "all kinds of subconscious continuations of my Buddhahood effort to suppress consciousness," upon which realization he awakened, with the following words filling his mind: "Karma is accumulated in the mind due to ignorance."[15] That is, the laws of cause and effect in the psyche continue to function because of the failure to see that they are illusory.

The Buddhist teaching that life is a dream from which every sentient being

Fig. 5.9

**Second page of entry for April 3, 1955, in
Dharma (7), April 3–July 4, 1955. 6" h.**
The first five pages of this notebook are
devoted to fragmentary recollections of per-
sons and events, which Kerouac has entitled
"Book of Memory" and, parenthetically,
"Tics." Toward the end of this page he
invokes Avalokitesvara, but his association of
Avalokitesvara's message of compassion with
suicide as a form of "Human Heroism" is
the product purely of Kerouac's melancholy
temperament.

END PRIDE, PARANOIA ENDS —
I seek the perfection of unconsciousness —
Psychoanalysis: making the best of Saussara —
consciousness —
 I cant meditate on perfection with
my legs hurting, thorns in the flesh —
 The Buddha Nirmanakaya and
the messiah made flesh, to re-teach
again among the Defiled and Fallen,
promising Purity and Grace again —
This is the essence of Buddhist Christianity
— God is Mind Essence, the Father of
the Universe, the Manifesting Agent —
Atman is Soul and only appears to
exist, like body, which is but a spectral
Heaven Stuff —
 For a Central Reason...
 All Suffering is Mental Suffering... I'm
a mental sufferer, but I can only be
cured to accept things like a dog —
As I am now, I dont want to live
another minute — All the kinds of
pain, why should I wait for the new
kinds — I know there is no self,
There is no me, but my itching skin!
my mortal bones! my damp heart
and hot brow!
 Avalokitesvara whispers me the
news: — Suicide is a Human Heroism —
 There is no happiness in these
hausjawed yellers of the earth —
Pity on them — but what can I

needs to awaken became an ever-more-pressing imperative for Kerouac as he pro-
gressed in his meditation and in his study of the sutras. On the night of February 5,
1955, he records in *Dharma (6)* a feeling of happiness that arose in him sponta-
neously. He observes that it was not a normal kind of happiness ("neither a happi-
ness nor not a happiness"), but one in which he realized "the bliss of knowing
that our lives are but dreams, arbitrary conceptions, from which the big dreamer
wakes—What could be more like a dream, with birth the falling-asleep, & death the
awakening from sleep?" He also discovers that the meditative state, in which the
realization of bliss occurred, has an important physical component, which he com-
pares to "an athletic physical accomplishment," adding, "now I know why I was an
athlete, to learn physical relaxation, smooth strength of strong muscles hanging
ready for Nirvana."[16]

Despite the rigor with which Kerouac immersed himself in a study of the
sutras, he could never entirely reconcile himself to the idea of a universe that lacked
a personal deity who could feel compassion for His suffering creatures. This is why
he so desperately sought solace in Mahayana Buddhism's Avalokitesvara, the bodhi-
sattva of compassion, "he who hears the cries of the world." Kerouac's diaries are
filled with hymns of thanks and tortured prayers of supplication to Avalokitesvara,

and he even began a novel about him. It is probable that the teachings and lore surrounding this bodhisattva helped kindle in Kerouac a new appreciation of Christianity, allowing him to see correspondences between the teachings of the Buddha and of Jesus. A form of what might be called Buddhist trinitarianism (the Trikaya doctrine, positing a threefold manifestation of the Buddha's body) may also have played a role in reversing his former hostile attitude to Christianity. On April 3, 1955, in Rocky Mount, North Carolina, in the *Dharma (7)* notebook (see fig. 5.9),[17] Kerouac explicitly identifies the "Buddha Nirmanakaya" (the manifestation of the Buddha's body in time and space), with "The Messiah made flesh" (Jesus Christ), who entered the world "to re-teach among the Defiled and Fallen, promising Purity and Grace again—this is the essence of Buddhist Christianity." Despite this melding of Christianity and Buddhism, Kerouac adheres to the Buddhist doctrine, however uncongenial to his temperament, that the individual soul[18] is an entity that, like the physical body, only seems to be real.

Although Kerouac had come to identify Christ with a reincarnation of the Buddha, it was Avalokitesvara who remained his primary object of devotion and supplication. In a prayer written on December 27, 1955, in the *Dharma (8)* notebook, Kerouac appeals first to Avalokitesvara, "thou Hearer & Answerer of Prayer," before he calls on "Lord, Tathagata, Sugata, Buddha" (i.e., the three names of the Buddha). Several days later, in an entry headed "SAMADHI OF JAN 1, 1956,"[19] Kerouac acknowledges Avalokitesvara's compassion ("Avalokitesvara hears & answered my prayers"), although he stresses that he is aware that "in truth, there is no Avalokitesvara in the sense that we (non Buddhas) might think 'he' 'is'—there is much bliss that this lil suffer wont matter." At this point, although Kerouac sees Jesus as a Buddha, he cannot accept him as the equal of "the final One Buddha Vehicle." Kerouac charges Jesus with having sugar-coated the truth, which was faithfully expounded by the Buddha, so that it would appeal to the mass of humanity. In his entry for January 28, 1956, he writes, "Jesus was a Buddha who taught a skilful vehicle which is not the final One Buddha Vehicle—That's all I have to say about the Good Lord Jesus—he gildeth the lily, with talk, of fathers in heaven—but perhaps that's what's needed, men'll refuse to understand the bare truth—Nonetheless, for me, [i]ts gotta be the Bare True [...]."

Kerouac's typescript of *Some of the Dharma* is generally faithful to his notebook texts, and includes drawings either based on those in the notebooks or, such as the drawings for the "Six Senses," produced especially for the typescript. His study of Buddhism is reflected in other works as well. These include a retelling of the life of the Buddha, in 1954, in a work that bears the working titles STOP AND WAKE UP / ESSENTIAL MIND[:] *The Story of Buddha / Buddha Tells Us OR WAKE UP*, but was revised and retyped as *Wake Up*,[20] under which title it was posthumously published in installments in the Buddhist periodical *Tricycle* (1993–95). As he informs us in the "Author's Note," this compendium of excerpts and paraphrases from Buddhist scriptures also contains "new words of my own selection." Drawing on many Buddhist scriptural sources to tell the story of the Buddha's life, the book at its "heart" is an "embellished précis of the mighty Surangama Sutra whose author, who seems to be the greatest writer who ever lived, is unknown." (This note represents another deviation by Kerouac from Buddhist orthodoxy. Traditionally, all

Fig. 5.10

DB (1) ["Stenobloc" *Dharma Bums*]. Pencil drawing on vertical spiral-bound notebook cover, [1956]. 8" x 5".

Toward the end of *The Dharma Bums*, recalling his descent from Desolation Peak, Kerouac writes of Gary Snyder, "And suddenly it seemed I saw that unimaginable little Chinese bum standing there, in the fog, with that expressionless humor on his seamed face. It wasn't the real-life Japhy of rucksacks and Buddhism studies and big mad parties at Corte Madera, it was the realer-than-life Japhy of my dreams, and he stood there saying nothing."

of the sutras are regarded as the transcribed teachings of the Buddha.) Kerouac is clear and bold in stating his intentions: "The purpose is to convert." The epigraph he chose for the title page, a prayer written by the Buddhist scholar Dwight Goddard, offers adoration both to "Jesus Christ, the Messiah of the Christian World," and to "Gothama Sakayamuni, the Appearance-Body of the Buddha," a further confirmation of the extent to which, already by 1955, Kerouac had begun to integrate Buddhist and Christian spirituality.

The work that, more than any other, has popularized Kerouac's espousal of Buddhism is probably *The Dharma Bums*, written in 1956 but not published until 1958. This novel, in its largest part, is Kerouac's re-creation of the time he spent in Berkeley and Mill Valley, California, in 1955, during which period Allen Ginsberg introduced him to Gary Snyder, a young poet and translator of ancient Chinese and Japanese poetry. Kerouac and Snyder became friends, sharing a cabin for several months in Mill Valley, as well as a strong commitment to Buddhism. Snyder had

Fig. 5.11

"Bodhidharma Hoiko." Pencil on paper, ca. 1956. 12.50" x 9.25".

Bodhidharma brought Buddhism from South India to China, probably no later than the year 479. He became especially prominent in the Zen canon of Buddhist teachers not merely because he was the first to bring Buddhism to the Far East, but because the Lankavatara Sutra, on which he focused, became especially prominent in Chinese Zen, which was later brought to Japan. Bodhidharma deemphasized ritual, doctrinal formulations, and a belief in Heaven, in favor of meditation and direct apprehension of truth. His practice of confronting his disciples with paradoxical assertions or riddles led to the development of koans in Japan. In art, he is traditionally portrayed with a fierce expression and is heavily bearded, probably reflecting his description in Chinese texts as a "blue-eyed barbarian." Kerouac based this drawing on a late nineteenth-century Japanese ink-and-brush painting of Bodhidharma that is in the Archive.

worked as a fire lookout in the Cascade Mountains, and it was through him that Kerouac became a lookout on Desolation Peak, in July–August 1956. The last few chapters of *The Dharma Bums* recount Kerouac's experience on the mountain, and the book's final two chapters contain some of the finest lyrical prose in American literature. The notebooks for *The Dharma Bums*, like the published text, show the affection Kerouac felt for his hiking companion, Snyder (called "Ryder Japhy"), who had introduced him to the mountains and embodied for him the purity of disciplined and compassionate Zen Buddhist practice (see fig. 5.10). But Kerouac soon found Zen to be too cold and dispassionate, too "impersonal," for his needs, although at first, under Snyder's influence, he was attracted to it. Reassured to learn that Zen masters were reputed to have occasionally drunk to excess, he interpreted this as a license to indulge his alcoholism, a self-indulgence that was to become a point of contention between him and Snyder, who felt that Kerouac's excessive drinking was an obstacle to his spiritual advancement. In the *Some of the Dharma* typescript, Kerouac reproaches himself with the observation that "Drinking heavily,

Fig. 5.12

"The Drinkers." Oil and pencil on paper, ca. 1960. 12.5" x 9.25".

"Drinking heavily, you abandon people—and they abandon you—and you abandon your-self—It's a form of partial self murder but too sad to go all the way— [...] the kind of drinking that seeks to abandon people is done in public"; Jack Kerouac, in *Some of the Dharma* (1997).

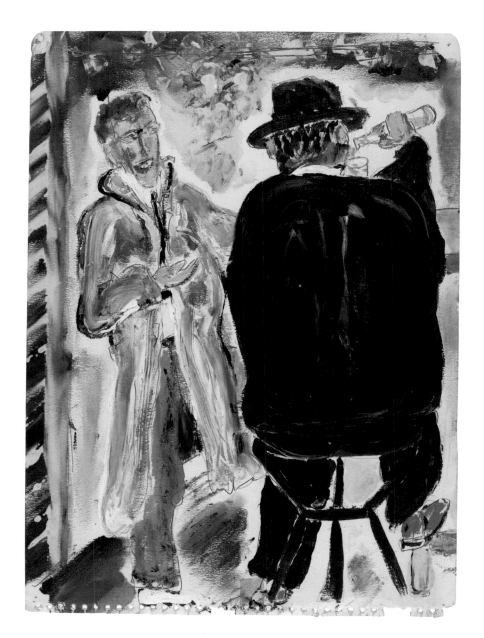

you abandon people—and they abandon you—and you abandon yourself—It's a form of partial self murder but too sad to go all the way—"[21] Later, Snyder's leftist politics would alienate Kerouac, and Kerouac expresses in his diaries his resentment toward Snyder, which was part of a pattern of rejection in the early 1960s, which he began with Ginsberg and that he would repeat with almost all of his Beat friends.

By the summer of 1956, and the sixty-three-day solitary sojourn atop Desolation Peak, Kerouac had begun to intensify the process of integrating the Christian idea of a personal God into his increasingly idiosyncratic interpretation of Buddhism. His *Dharma* entry for July 27, 1956, seems to establish an identity between the "Nothingness" of Buddhism and the "holy spirit" of Christianity: "The primordial essence is dreaming this up like a mind but it's not really a mind—The holy spirit is the eternal continuation—The only reason why we can conceive of Nothingness is because we're already conceived of Somethingness—the Eternal Nothingsomething, the endless words of mystery, the Infinite Dontcare, is Ta—To be and not to be—"[22] But the lengthy journal and diary entries explicating Buddhist

Fig. 5.13

"God." Oil and pencil on paper, signed "Jean-Louis Kérouac," [September–October 1956]. 9" x 12".

In an April 28, 1957, letter to Ed Adler (published in Adler's *Jack Kerouac: The Lost Paintings*, 2004), Kerouac identifies this painting as his first: "I haven't had chance to tell you but I've begun to paint, hence all the excitement about painting, started in Mexico City last October, first with pencil, then chalks, then watercolor, then paint ... my first painting[,] God." However, when he wrote to Peter Orlovsky about it very soon after completing it, he referred to it as "my most recent painting."

teachings and occasionally relating them to Christian precepts, and the verbose proclamations of having found salvation in "Nothingness," "Mind Essence," or the "holy spirit," often have about them the desperate quality of whistling in a graveyard. To Kerouac's credit, however, he did not attempt, at least in the *Dharma Bums* notebooks, to minimize the severity and extent of his bouts of terror, boredom, loneliness, and despair on the mountain top, although the novel moderates these aspects of his ordeal. On one night, he records being suddenly overcome by a primal fear of monsters, believing for a moment that the Abominable Snowman, of whom he sketched a picture, had appeared at his cabin window.[23]

Having passed, severely shaken, through the extended crisis of a two-month confrontation with himself, barely hinted at in the almost cheery conclusion of *The Dharma Bums*, Kerouac began ever more insistently expressing in his diaries the need for a personal God, even as he otherwise continued to explicate the sutras and to interpret his perceptions and meditations in accordance with them. His return to the idea of a personal God even at the height of his immersion in Buddhism was visually expressed in his painting "God" (fig. 5.13).[24]

In his diary *1958 Orlando Blues*, Kerouac engages in a far-ranging exploration of comparative religious study, encompassing Hinduism and Buddhism, focusing especially, in a Hindu context, on the idea of *samsara* (the cycle of reincarnation), and on the Buddhist concept of "mind essence." But these analyses are interspersed with Kerouac's tormented search for a personal God, and fittingly, the notebook contains sketches of both the Buddha and Jesus.[25] In the April 7 entry, Kerouac writes:

Fig. 5.14

**"The Cross." Oil on cardboard, ca. 1962.
16" x 12".**

In Ed Adler's *Departed Angels: The Lost Paintings* (2004), this painting is mistakenly reproduced in browns and bronzes. Kerouac wrote this about his experience of the Cross in *Vanity of Duluoz* (Book Thirteen, Chapter XI): "Yet I saw the cross just then when I closed my eyes after writing all this. I cant escape its mysterious penetration into all this brutality. I just simply SEE it all the time, even the Greek cross sometimes. I hope it will all turn out true."

Are we fooling ourselves about Heaven? about a personal feeling that we're going to be saved by "someone"—"He cant dream" I thought tonight about God; that to one life is a dream may be "wrong"— [...] "God wants us to believe that there's a mystery," says Ma. There is a mystery. It's breaking our hearts not to mention our heads. [...] we're just deeply ignorant in our words, in our ways, I say. I wish God would solve the problem of mind-wonder in the human world.

I feel that there's a personal Saviour, but I cant know it. I feel the Presence, I feel the lesson it's teaching. I wish I was smart. I wish I could save all living creatures from worry & pain.

"Mind-wonder" is a phrase that bears a positive connotation in a Buddhist context, but for Kerouac, now, it describes an agonizing condition of fearful doubt. In a poem written in 1958, entitled "God" (published in *Pomes All Sizes* in 1992), Kerouac confronts, alternately, God as the totality of what is and God as controller of the universe, a Being separate from it, asking if He is the victim of His own murders (that is, by killing those who were created in his image), "Or is God just the golden hover / light manifesting Mayakaya / the illusion of the moon, branches / across the face of the moon?" Then, addressing God with accusatory anger, insisting that He explain the mystery of His existence, he demands, "Thou high suffermaker! / Tell me now, in Your Poem!"

During the first year or so of his involvement with Buddhism, Kerouac's diary and journal references to Christianity were dismissive, even disdainful, but by the spring of 1955 he had begun to see Buddhism as the spiritual paradigm in which Christianity could be enfolded and find meaning; that is, he had become a Christian Buddhist. In 1957, a shift begins; although he continues to explain the world in its cosmic perspective in accord with Buddhism, Christianity has begun to be the preferred mode of his personal religious expression. In January 1957 he composes a prayer addressed first to Jesus and then to the Buddha, whom he seems to identify with God the Father, but the portion addressed to Jesus is much lengthier and more heartfelt: "Jesus Christ forgive me! / Make me whole in aim, / Holy and Kind, wise, / Patient as Thy Blood / [...] / Punished for my sins, / [...] / Jesus Christ forbear! / Drive the Devil from my Brain / O Holy Buddha! / Father of God!" etc.[26] By 1959, confronted by the inability of Buddhist doctrine and meditation to resolve his fears and conflicts, he had made a decisive return to Christianity, though of an idiosyncratic, Gnostic form, still heavily inflected by the Buddhist teachings he had systematically and rigorously analyzed and absorbed (the astounding record of which may be found in his journals and diaries, as well as in several Buddhist works that he wrote), and by the fruits of his disciplined meditation practice; all of which is to say, he had now become a Buddhist Christian.

By October 1959, he had begun to compare the works of heterodox Christian philosophers and mystics to the teachings of the Buddha, which he had now become very careful to distinguish from Buddhism as an organized religion and system of belief. In a journal entry of October 14,[27] he faults Kierkegaard for believing that boldness is the proper reaction to God's grace, and says that his mistaken views could have been corrected had he read Meister Eckhart, Dionysius the Areopagite, or the Buddha. He then observes that Buddhism in all its organized forms

Fig. 5.15

"The Vision of the Shepherds." Oil on board, signed "Kérouac," ca. 1962. 14.5" x 18".

represents a heretical deviation from "the [Buddha's] vision under the Bo-Tree: i.e., that the cause of death is birth," an attitude very much like the one he had adopted in regard to Christianity, though in the latter case he was prepared to be even more amenable to the dictates of tradition, especially in regard to liturgy and ritual, and to accommodate himself to its authoritarian structure, as can be seen, for instance, in *Visions of Gerard*.

Kerouac's return to Christianity continued apace. His diary entry for July 5, 1961, written in Mexico City, elaborates on God's grace and His separateness from human beings (no more of the Buddhist "Mind Essence," which exists both within and without), and the Devil makes yet another appearance.[28] But Kerouac is far from espousing straightforward Christian theology. He reprises an idea that he had articulated in a Buddhist context in *The Dharma Bums*: that human beings are "fallen angels" who, because of their failure to fathom the nothingness that is the source of all existence, were made flesh so that they could experience loss and thereby learn from their suffering that all suffering is illusory. Now, adapting the idea to a Christian context, he writes:

> Nothing else in the world matters but the kindness of Grace, God's gift to suffering mortals (sentient beings are mortal beings). Can it be that the Angels fell because they were clamoring for mortal existence, for some reason, so God let them try it, reserving Grace to protect them, & now they want <u>out</u> but the wheel has got to turn its Full Turn[.] Therefore God <u>is</u> separate from us, like

Fig. 5.16

"Crucifixion Drawing in Blue Ink." Pen and pencil on paper, ca. 1963. 8.5" x 11".

the Only One in the Golden Eternity[29] who was by my side tho I had no self left but hisun—Just look how close this is to Catholic Theology! So there is a Devil too! I'll be damned! (damned no more, amen)[.]

Kerouac's interest in making art had always been linked closely to his spiritual journey, and as we have seen, he began, as early as 1956, to draw and paint works on Christian themes. Around 1959, such works became a staple of his artistic production, and included depictions of the Annunciation, the Vision of the Shepherds (fig. 5.15), the Cross (fig. 5.14), Christ on the Cross (fig. 5.16), numerous Pietàs, and the Virgin Mary. The Columbia freshman who had called Jesus' disciples "saps" and who, in his early Buddhist phase, had referred to Christianity itself as an "anthropomorphic fairy tale," was now drawing devotional images of the Virgin. In 1962, he wrote three prayers to Jesus, in one of which he even asks for a blessing for Pope John XXIII.[30] The final prayer of this "Book of Prayers"[31] (he apparently intended to write more than three) could have been written by the fervently devotional Kerouac of the postwar years or, indeed, the Kerouac who, even as he proclaimed the greatness of the sutras, could not find the consolation he wanted in them and turned to the God of his childhood: "Why do you let the Devil do this to us, unless now you want us to see the Devil clearly? I see him, Lord, languishing in our midst [....] Shoo him away. Give us Leave to Love Again, To Love Only[.]" The prodigal son, laden with doubts throughout his years of wandering, had returned home, only to find that he still could not lay down his burden.

On Writing and the Creative Act

For those who are interested in Kerouac primarily as a writer, rather than as a cultural figure, Beat icon, or lifestyle guru, perhaps the most interesting of his diary and journal reflections are the hundreds of entries in which he formulates his literary mission and, by turns, frets and exults as he attempts to find a voice of his own in which to articulate it. (Many of these reflections, self-interrogations, and pronouncements have been quoted or cited in earlier chapters, in relation to Kerouac's nascent literary efforts and to the writing of *The Town and the City* and *On the Road*.) After completing *The Town and the City*, he was ready to absorb fully into his writing the life lessons he had learned since his first road trip, in the summer of 1947, and questions about literary ends and means assumed a new immediacy. Like one of his heroes, Walt Whitman, he now sought to make literary expression an act that partook of his moment-to-moment experience, combining past and present. One senses that he yearned to be able to say, as Whitman did in *Leaves of Grass* (in the poem "So Long!"), "This is no book; whoever touches this, touches a man."

Although *On the Road* only partially fulfilled this intention (*Visions of Cody* and *The Subterraneans* are more authentic and successful attempts), as early as 1945 he was expressing Whitmanesque statements regarding the necessity of emphasizing truth over technique, which he expressed for a time, again like Whitman, in terms of an opposition between American and European sensibilities. In a journal entry for July 14, 1945,[1] he observes that his novel *Orpheus Emerged* is "American," "organic," and "particular," whereas his story "The Haunted Life" is "European," "stylized," "lyric & general." He wonders if he can combine all of these attributes, both American and European, in his writing, and in the next paragraph poses the challenge more elementally, showing that he has understood that a writer's "style," if it is to convey his truth, can emerge only out of his experience of life, out of who he is: "Must find my own style; myself, in sooth. [Note the blind innocence of using so quaint an archaism in a passage devoted to finding one's true self!] What do I, as a personality, particularly want to say in order to release my sequestered evocations [...]." For Kerouac, style is not simply, or even primarily, a matter of technique; what he realized, perhaps intuitively, is that, at least for his purposes, the writer must learn technique but then forget it, so that it can unconsciously serve his vision. Kerouac did not reject virtuosity per se, merely its cultivation as an end in itself. In this regard, we find in the November 30 entry of his 1949 *Road-Log*, which was examined in the context of his struggles with *The Town and the City* and *On the Road*, the manifesto-like declaration: "IT'S NOT THE WORDS THAT COUNT BUT THE

Fig. 6.1

"Beached Boats at Sunset." Pastel on cardboard, ca. 1958. 6" x 9".

RUSH OF TRUTH WHICH USES WORDS FOR ITS PURPOSES; as a virtuoso performing on his instrument may use any combination of notes within a beat (the word) but it is the melody of the bar that matters. It's not the design, but the picture; not the curve, but the form. On and on in inane comparison ... An artist cannot translate the passionate intensity of life without working in passion himself. [...] These things have a verisimilitude depending on their resemblance to the beat of life."[2]

Perhaps it is inevitable that a writer, however confident, who consciously attempts to break with literary tradition should be consumed with the question of how to define himself in terms of the literary categories he hopes to transcend. Literary self-definition, as we have seen, was a burden that Kerouac assumed early in life, in 1939, as a senior at Horace Mann, in the journal entry in which he expressed his hope to join "those old gladiators" Johnson, Dickens, and Thackeray (see fig. 2.14), and it was a burden he would never lay down. On November 18, 1957, he writes in one of his *Orlando* journals, "I'm not a romantic surrealist poet, I'm a linguistic poet—I'm interested in sounds, the 'K' in Keltic languages, the 'A's' & soft consonants of Latin languages, the 'l's & 'u's of Japanese, the 'TL's' & 'C's' of Aztec—" He then transcribes a ditty he had earlier composed and notes that it "is interesting to me because I didn't know what it meant when I wrote, it, hearing just the sound, & now I know what it means anyway [...]—what interests me is the singsong ditty sense, the funny <u>French</u> rhythm of that." Always sure of himself as a lover of language, he is much less so when attempting to define the genre of literature he is writing. On December 5, under a blue and orange crayoned heading "THE DHARMA BUMS," he notes that after a long day of "shooting baskets," writing, and drinking, "I'm sad because there seems to be no climax in the story & all I got left now is Gary's hike to Potero meadow, with me, which ain't very dramatic [Kerouac was yet to write the book's powerful and joyous final two chapters]—But I'm not a 'novelist' anyway, just a characterizer of real people in prose reports—"[3]

The question of whether or not he was a novelist was one that vexed him primarily because of the sniping of critics and writers. Even so-called supporters could be patronizing. The journalist Seymour Krim, at the request of Kerouac's publisher, Coward-McCann, wrote an introduction to the novel *Desolation Angels* (1965) in which he declares Kerouac to be an important, pioneering author. But he also takes the opportunity to lecture him about the limitations of his autobiographical novels, asking that he please not write any more of them. Although Kerouac himself, on occasion, confessed in his diary that he was growing tired of the Duluoz Legend, he of course was insulted that the person hired to introduce his latest book should take the opportunity to embarrass him publicly, and that his publishers should applaud the effort. That Krim wrote it with a breezy, coterie-hipster knowingness and a tone of personal familiarity (an approach that continues to characterize much of the literary criticism and biographical writing about Kerouac and the Beats) no doubt contributed to Kerouac's angry reaction to the introduction in his diary.[4] The incident reveals the extent to which Kerouac was regarded by his ostensible allies as a species of idiot savant who did a certain kind of thing very well, but lacked the maturity to set limits for himself, and the sophistication to know when he was being insulted. Despite such treatment from "friends" and much worse from foes, Kerouac was sure enough of how he wanted to write[5] (whatever the resulting litera-

Fig. 6.2

"Essentials of Modern Prose," 1953, p. [1].
13.75" h.

[Facsimile of manuscript, with handwritten annotation at top:]
1953
Orig. Ms. of
Essentials of
Modern Prose — (in pencil below)

NOTES ON MODERN PROSE Jack Kerouac

the most interesting undisturbed flow from the mind is also the simplest least

sophisticated, least learned or versed, in forms and rotes of style , structure--

spontaneous prose is modern prose and the more subconscious, the more in a

trance the author, if possible as yeats in his later trance writing he attributed

to 'mediums'

Essentials

1. Undisturbed flow from the mind of privately personal colloquial language

SETUP 1. The object is set before the mind, either in reality as in sketching [...] or semi-before the memory [...] it becomes the sketching from memory a definite image—

PROCEDURE 2. sketching language is undisturbed flow from the mind of personal secret idea-words, blown (as per jazz musician) on subject of image

METHOD 3. No period, separate sentence-structures already disturbedly riddled by false colons + timid usually needless commas —— but the vigorous space dash separating rhetorical breathings (as jazz musician drawing breath between outblown phrases) — "measured pauses which are the essentials of our speech" — "divisions of the sounds we hear" — "time & how to note it down"

SCOPING 4. Not 'selectivity' of expression but following free deviation (association) of mind into limitless blow-on-subject seas of thought, swimming in sea of English with no discipline other than rhythms of rhetorical exhalation & expostulated statement, like a fist coming down on a table with each complete utterance, bang!

LAGS IN PROCEDURE 5. No pause to think of proper word but the infantile pileup of scatological buildup words till satisfaction is gained, which will turn out to be a great appendage rhythm to a thought

ture might be called) and of the significance of his innovations to formulate and
publish his principles of writing.

 We have seen, in Chapter 2, a selection of his thoughts on literary composi-
tion—on style and on the relationship of style to content—as set forth in his jour-
nals and notebooks. But his first thoroughly elaborated set of writing principles
appears in a 1953 manuscript entitled "Essentials,"[6] which was published five years
later in *Evergreen Review* (Summer 1958) as "Essentials of Spontaneous Prose."
Significantly, when Kerouac was in the process of organizing his Archive, he added
to the manuscript the title "Essentials of Modern Prose," disdaining the word

"spontaneous" (fig. 6.2). A close reading of these prescriptions explains Kerouac's deemphasis of the "spontaneous" element. In the "Essential" called "Center of Interest," he urges the would-be writer to disdain preconceived ideas about how to describe the image in his mind, and, rather, to begin "from jewel center of interest in subject of image at moment of writing, and write outwards swimming in sea of language to peripheral release and exhaustion—" Kerouac often compared his ideal of literary composition to a jazz saxophonist improvising upon a melody, in which a wealth of experience and skill is put to the service of spontaneous, improvisatory creation. In the dictum "Center of Interest" he writes, "tap from yourself the song of yourself [an echo of Whitman's "Song of Myself"], *blow!—now!—your* way is your only way—'good'—or 'bad'—always honest, ('ludicrous'), spontaneous, 'confession-al'[7] interesting, because not 'crafted.'"

This much remained a constant in his approach to writing for the rest of his life, though as we shall see presently, he twice, for a period of at least several months, considered a more studied and traditional approach to literary composition, which he had practiced as a youth. But though he generally forbids emendations ("afterthink"), the two exceptions he allows, "poetic or P.S. [i.e., postscript] reasons," are broad enough to encompass substantial rewriting. It would seem from the rest of this "Essential" and the last one, "Mental State," that the improving impulse that Kerouac feared ("Never afterthink to 'improve' or defray impressions") was directed not so much against aesthetic improvement (since "poetic afterthinks" are permitted) as against the impulse to censor a thought or description that might prove painful to the writer. This is why in "Mental State" he advocates writing "without consciousness," a phrase that he places in quotation marks since he does not mean it literally, further defining the state as one in which the writer is granted access to the "uninhibited interesting necessary."

As Kerouac himself recognized, the principles articulated in "Essentials" are best suited to the kind of writing that is based directly on one's own experiences. Ironically, by the summer of 1958, when "Essentials" was published, he had temporarily tired of this approach (he would later recover his enthusiasm, lose it again, and then recover it for good),[8] in large part, it seems, because he was bored with writing about himself. In his *Northport / Sketches (1) / Summer '58* diary, he writes, "Must get to WORK or go broke!—I'm sick of spontaneous prose & my Duluoz self—why not epics about people I never knew, visions of em?" Nine pages later, after mentioning that he has just watched a public television program he identifies as "Rocket Ship Show Jock-O," he reflects that the show has made him "realize I could write epics about the contemporary scene, like Balzac, one after the other, but it wd. mean having to leave the house & drinking [Kerouac was in the throes of a rare teetotaling struggle, consuming only the occasional beer] & batting around—getting high—digging everything[.] Instead, this summer, I'd been thinking in terms of a quiet recollection of childhood joys, putting them together as MEMORY BABE making it a book about faith, really, about Ti-Jean's faith in ECSTASY[.]"[9] (Indeed, Kerouac further on in the notebook began writing "Memory Babe," which would comprise the opening sections of *Doctor Sax.* The "Memory Babe" text, in the notebook, is introduced by a quotation from Cervantes, beneath which Kerouac sketched a portrait of the bespectacled author, writing by candlelight; see fig. 6.3a.

Fig. 6.3a–b *Northport / Sketches (1) / Summer '58*, June 19–Labor Day [September 1], 1958. 5" h.

Fig. 6.3a: **Leaf [24], recto: Miguel de Cervantes Saavedra.**
Kerouac's caption reads: "'A good heart breaks bad luck,' said Cervantes, poor by the candlelight[.]"

Fig. 6.3b: **Leaf [30], recto: Emily Dickinson.**

This notebook contains about a dozen sketches, including a portrait of Emily Dickinson;[10] see fig. 6.3b.) By the summer of 1961, Kerouac has banished all doubt about his life's work, and no longer envies Balzac his grand tableaux. Exulting in his own originality and talent, he declares: "This system [of writing], which I formulated in 1943 in Liverpool England [see "Liverpool Testament," discussed and illustrated (fig. 2.22) in Chapter 2] & got underway in 1951 for good, will enable me to be like Balzac without 'inventing' characters, since Destiny has already provided me with the characters in pure real form, & enable me to be like Proust in total concentraded [sic] memory recall at will (visions of things instead of only just stories, & stories there'll be)—The Duluoz Legend is my life & joy[.]"[11]

How one ought to write remained for Kerouac a sacred subject, and because of this, as well as the ridicule he had suffered at the hands of the literary establishment, he was zealous in protecting his status as a literary innovator. In 1962, in the unpublished typescript "HISTORY OF THE THEORY OF BREATH AS A SEPARATOR OF STATEMENTS IN SPONTANEOUS WRITING,"[12] he quotes from his "Procedure" and "Method" essentials in order to show that Allen Ginsberg stole his ideas about writing and incorporated them into his "Notes Written on Finally Recording 'Howl,'" composed in 1959 and "printed on the back of his Fantasy recording of 'Howl.'" Kerouac then quotes from his "essentials": "No periods separating sentence structures already arbitrarily riddled by false colons and timid usually needless commas—but the vigorous space dash separating rhetorical breathings, as jazz musician

Fig. 6.4

"HISTORY OF THE THEORY OF BREATH AS A SEPARATOR OF STATEMENTS IN SPONTANEOUS WRITING," 1962, p. 2. 11" h.

On the verso of this page, Kerouac writes about the need for the "emancipation of American language from that of British, the emancipation of spontaneous vernacular American English from rulebound traditional British English with its grammatical syntactical & socio-psychological prohibitions against the expression of the mind itself."

drawing breath between outblown phrases ... in rhythms of rhetorical exhalation and expostulated statement." He follows this with a passage by Ginsberg, allegedly plagiarized from the quoted passage, mocking with an exasperated "(!)" Ginsberg's assertion that he learned to write poetry "arranged by phrasing or breath groups into little short line patterns according to ideas of measure of American speech I'd picked up from William Carlos Williams." The exclamation mark expresses Kerouac's exasperation, as if to say, "It was not Williams who taught you this, it was I!" The rest of the passage is similar enough to Kerouac's ideas and phrases to make clear why his suspicions were aroused: "My romantic inspiration, Hebraic-Melville bardic breath ... one spontaneous phrase after another linked within the line by dashes mostly ... New speech-rhythm prosody[.]"

Certainly there is a similarity in both writers' reference to the jazz saxophonist's breathing as a model for literary composition, though they might have discussed this idea with each other even before Kerouac composed "Essentials." Most of the rest of Kerouac's piece comprises a lengthy list of other alleged plagiarisms by Ginsberg from "Essentials" and from a later Kerouac piece, "Belief and Technique for Modern Prose," which was published in *Evergreen Review* (Spring 1959).[13] What irritates Kerouac as much as the plagiarism is that Ginsberg, "Like 99.9% of American poets," is ignorant of "breath and phrasing in jazz improvisation within the set bars of a chorus, he thinks jazz is just a 'sound' and to the ear of a jazzman also just a sound." Kerouac explains that to play a long musical phrase on a wind instrument the musician needs to take a deep breath and that if, for whatever reason, he happens to take a short breath, he can play only a short phrase. In either case, the phrase "has to hang on the harmonic clothesline and at the same time keep track of the break into the next chorus. To the jazzman breath-measure is the natural suspiration of a simple story-line musical or otherwise, the stress of telling, of drawing thy breath in pain to tell the story all within the disciplinary structure of the 'tune,' the harmonic line with its delimited bars and bridges repeating one strict chorus after another." For Kerouac, literary composition is an analogous form of creation: "In spontaneous prose or poetry there is the same logical rule, it has to be observed right on the dot in the fire ordeal of time passing by once and forever or hold your tongue" (see fig. 6.4).

Kerouac also takes Ginsberg to task for "trying to separate his poetry from my prose," in the course of which attempt, Kerouac alleges, Ginsberg denigrates all prose as inferior to poetry, and then compounds his error by identifying poetry with prosody. By identifying these two forms of literary expression, Kerouac explains, Ginsberg's hoped-for comparison of his own poetic practice with jazz improvisation disintegrates, since prosody in a jazz context can mean only the "measure of the beat," not the "breath," which is essential for "improvising upon the harmonic line." In any case, Kerouac points out, prosody considered not as metaphor but strictly in a literary context cannot embrace the entirety of poetic expression, since it denotes only "the metrical aspect of versification," not "the breath-separations of the phrases improvising the story line, whether in a poem or a story." (At the very bottom of the page, Kerouac confesses with characteristic honesty that, however justified his attack on Ginsberg, he was motivated by selfishness: "I set this down selfishly for my own sake, almost maliciously, but it's true. Ideas are universal yet never universally invented[.]")

2

just like jazz or a hundred races that or a great oration.

or runner or orator

To the jazzman breath-measure is the natural suspiration of a simple story-line
musical or otherwise, the stress of telling, of drawing thy breath in pain to tell
the storyXWXKX, and all within the disciplinary structure of the "tune," the harmonic
E line with its measured delimited bars and bridges repeating from one strict chorus
to another.. Inxtryingxtoxseaparaxkex In prose or poetry there is the same logical rule,
rule, and in spontaneous prose or poetry it has to be observed right on the dot in
thexordealxofxtimexpassingxxin the fire ordeal of time passing by once and forever
or hold your tongue.' No jazzman ever went back and revised his solo because sponta-
neous art, like action painting, is once and forever or nothing: a discipline to be
copared truly to the Medisxxx Ordeal by fire or by water when you had to get out
in time or perish.

 Ginsbwrg, in trying to separate his poetry from my prose, calls all prose
"poor human prose" or "prosaic lapse" and other derogatory versifyer talk & he uses
the term prosody, the glowing all-inclusive term prosody.

 Yet prosody if applied to jazz would only apply to the measure of the
metronomic beat, not to the breath-measuring of the effort to improvise the melody
line; and if applied to writing would only aply to the metrical aspect of versifica-
tion, not thex to the breath-separations of the expostulated speech line. *Defi—*

sort of include
 But he uses the term "prosody" hoping it will apply to his poetry as well
as to my prose and my original theory on prose merge with "his" theory on poetry, but
It's the same theory, cunningly bunted but too late and fouled back.

*+ I've used it as the working method for both my
prose + poetry for nine into eight years*

*(Prosody:— That part of grammar treating of
the quantity of syllables, or accent, and
of the laws of versification or metrical
composition.)*

*A phrase improvising the story line—
whether in a poem or a story.*

*I set this down selfishly for my own
sake, almost maliciously, but it's the truth.
Ideas are universal yet never universally
invented*

Jazz was not the only extra-literary model that Kerouac employed in his literary practice and theory. The very first of the "Essentials," "Set-Up," reads, "The object is set before the mind, either in reality as in sketching (before a landscape or teacup or old face) or is set in the memory wherein it becomes the sketching from memory of a definite object-object." Kerouac's visual sense was every bit the equal of his aural. Since early adolescence he had regularly sketched and drawn, and from the early 1950s on, he began to sketch in his diaries and journals landscapes and portraits of friends and acquaintances. But the full extent of his talent as an artist was not revealed until he created his first painting, in 1956, a portrait entitled "God" (fig. 5.13). As a writer/artist who was seeking to transcend traditional literary categories, Kerouac found it natural to apply to literary composition the lessons of observation and creation he had learned in his drawing and painting. Yet, interestingly, it was not Kerouac who first saw the connection between these two aspects of his creativity. In a 1952 letter to Ginsberg, he says that their friend Ed White had suggested that he should write the way he sketched:

> Sketching (Ed White casually mentioned it in 124th St. Chinese restaurant near Columbia, "Why don't you just sketch in the streets like a painter but with words") which I did ... everything activates in front of you in myriad pro-fusion, you just have to purify your mind and let it pour the words (which effortless angels of the vision fly when you stand in front of reality) and write with 100% personal honesty both psychic & so on etc. and slap it all down shameless, willynilly, rapidly until sometimes I got so inspired I lost con-sciousness I was writing. Traditional source: Yeats' trance writing, of course. It's the *only way to write*.[14]

Once the suggestion was made, Kerouac would have immediately intuited the con-nection between the visual and the unconscious, or the "trance" state, because of the predominantly visual element of dreams, which had always seemed to him to be a door to a deeper understanding of the mind and, indeed, the cosmos. To tap into this energy while writing would naturally have seemed to him a method that held great promise.

In the fall of 1956 Kerouac undertook his first serious painting, as noted above, the portrait he called "God." But it was his April 1957 trip to France (following a visit to Burroughs in Tangier), where he was overwhelmed by the beauty of the Provençal landscape and by an eclectic group of masterpieces in the Louvre, that seems to have made him determined to become an artist.[15] The paintings and drawings, in a variety of media, that Kerouac produced as a result of this determination were not a dilettante's pretentious self-indulgences, nor were they the whimsical confections of a writer attempting to relax after literary exertion. Rather, the imagination from which they sprung and the techniques of expression that shaped and colored them also gave birth to his novels, short stories, poems, psalms, and dream books. In many of his sketches, even the most rudimentary, a great economy of line creates dynamic energy, and bold strokes of painted color allusively convey complex layers and volumes of space (see, for instance, "The Vision of the Shepherds," fig. 5.15).

In one of Kerouac's most joyous and exuberant letters, written at the conclu-sion of his trip to France, he enthuses to Ed White over the paintings he saw in the

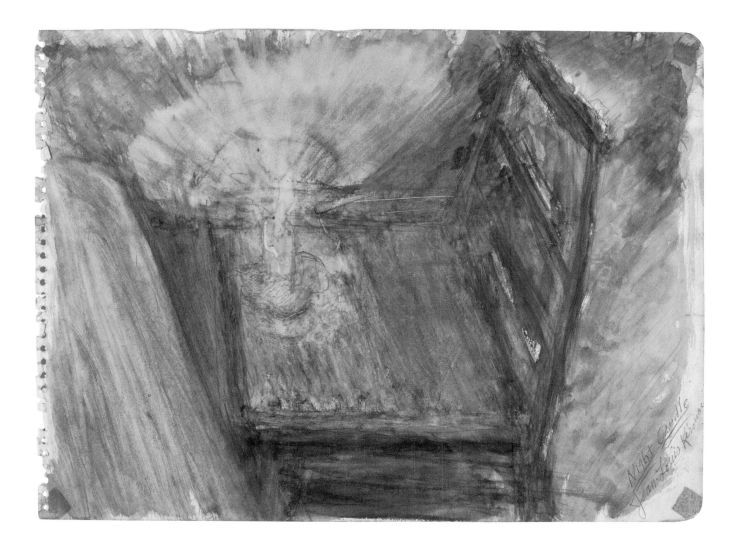

Fig. 6.5

"Night Candle." Watercolor and pencil on paper, signed "Jean-Louis Kérouac," ca. 1957. 9" x 12.5".

Louvre, and it is in these lines that one begins to appreciate that ~~for Kerouac painting was as vital and essential a passion as writing~~. The letter is that of a *painter* writing about painting. Having studied with great intensity the works of Rembrandt, he finds that "St. Matthew being Inspired by the Angel is a MIRACLE, the rough strokes, so much so, the drip of red paint in the angel's lower lip making it so angelic and his own rough hands ready to write the Gospel (as I will be visited).... Also miraculous is the veil [of] mistaken angel smoke on Tobiah's departing angel's left arm." The lesser masters intrigue him, too: Tiepolo, Canaletto, Pittoni, Guardi. Then it is on to David, Girodet-Trioson, Fragonard, Gros, "and suddenly face to face staring at me, a Rubens! A big smoky Rubens (La Mort de Dido) which got better as I lookt, the muscles' tones in cream and pink, the rim shot luminous eyes, the dull purple velvet robe on the bed."[16]

He writes with equal excitement and detailed observation about Goya and Brueghel, but especially about Van Gogh, as he recalls how he was driven into ecstasy by his "crazy blue Chinese church, the hurrying women, the spontaneous brush stroke, the secret of it is Japanese, is what for instance makes the woman's back, white, because her back is unpainted canvas with a few black thick script strokes (so that I wasn't wrong when I started painting God last Fall in doing everything fast like I write and that's it) ...[.]" His description of another Van Gogh

Fig. 6.6
"Van Gogh" / "La Marde." Pencil on paper, ca. 1957. 12" x 9".

following pages:

Fig. 6.7
"Young Man with Goatee." Watercolor, oil, pastel, and pen on paper, ca. 1957. 11" x 8.5".

Fig. 6.8
"My Brunette." Pastel on paper, signed "Kérouac," ca. 1958. 17" x 14".

painting, whose title he cannot remember but the subject of which is a garden, captures the intensity of that artist's method and effect: "with insane trees whirling in the blue swirl sky, one tree finally exploding into just black lines, almost silly but divine, the thick curls and butter burls of color paint, beautiful rusts, glubs, creams, greens, a master madman, Rembrandt reincarnated to do the same thing without pestiferous detail ...[.]" Probably very soon after Kerouac wrote this letter, he painted "Night Candle" (fig. 6.5), intentionally echoing Van Gogh's "Gauguin's Armchair," painted in Arles (1888) and now hanging in Amsterdam's Van Gogh Museum. Kerouac also produced a pencil sketch of Van Gogh, which he subtitled "La Marde" (fig. 6.6), and a dark portrait in purples and greens of a harrowed young man with a goatee, which may also have been intended to portray the troubled artist (fig. 6.7).

Kerouac's best portrait was one of his earliest oil paintings, depicting the red face of a middle-aged man in a bowler hat, and entitled simply "Man" (fig. 6.9). It strongly recalls the work of the expressionist painter Chaim Soutine (1893–1943), whose work Kerouac admired.[17] Later, Kerouac's love of color and the sea combined in a pastel drawing of beached boats at sunset (fig. 6.1). Although he never attended art school classes, he did study informally with the painter Dody Müller (née Dolores James),[18] with whom he had an affair; his pastel drawing "My Brunette" (fig. 6.8) may be a portrait of her. We should not be surprised that he did not seek formal schooling. Müller was a respected artist and, after all, he had been drawing his entire life. But most important, painting had come to him miraculously, like a sacred vocation, and he rejoiced in learning to paint in the divinely inspired doing of it. In his July 4, 1957, diary entry, he revels in the certainty that he was destined to be an artist: "I cant decide yet who to paint, I mean, whether it shd. be for divine accident or divine miracle or for human ethical satisfaction! If for human, I wd. labor for days like Rafael to get the divine look, but the Divine comes of itself in 3 minutes, nay, one! My painting career is completely fore ordained, that much I know—that is, materials come to me as if they wanted to become what they do become (paper, paints, etc.)[.]"[19]

Just as Kerouac had found in his sketching a key to writing, so now he found in his writing new insights into art. As he saw it, visual and literary art were both nourished by the same creative force, and to be rendered truthfully they needed to be approached and executed in the same manner. His January 27, 1959, diary entry contains the following prescriptions for painting:

> 1. ONLY USE BRUSH, no knife to mash and spread and obliterate brush strokes, no fingers to press in lines that aren't real
> 2. USE BRUSH SPONTANEOUSLY: i.e. without drawing: without long pause or delay, without erasing ... pile it on
> 3. FIGURE MEETS BACKGROUND OR VISA [sic] VERSA BY THE BRUSH
> 4. PAINT WHAT YOU SEE IN FRONT OF YOU, NO "FICTION"
> 5. STOP WHEN YOU WANT TO "IMPROVE"—IT'S DONE[20]

Very little would have to be changed in the wording of these five principles to recognize their presence in Kerouac's literary practice. Indeed, except for the words "brush" and "paint," numbers 2, 4, and 5 are virtually verbatim repetitions of literary principles that he enunciated in "Essentials," as well as in his diaries, journals,

Fig. 6.7: "Young Man with Goatee." 182

Fig. 6.8: "My Brunette."

and letters. The principles are followed by five corresponding elaborations, evidence for each of which can be found in his literary works, but perhaps the one that makes most explicit the connection between his art and his writing is his elaboration of point number 4: "By painting only from the living model before your eyes, by avoiding fictional imaginary themes, you get true lines, true light, & truth."

By 1963 Kerouac had become consumed by his painting and ruefully admitted in his diary that he preferred it to writing: "The art of painting is so absorbing, I think I would lose my health practicing it—wouldn't think of when to eat or exercise or even sleep—I wish writing interested me half as much—"[21] Much of his apparent lack of interest in writing probably stemmed from the indifference of mainstream literary figures—writers as well as critics—to him and his work, unless it was to dismiss him as a squanderer of his talent in pointless experimentation, or as someone who never had any talent to waste. But in Kerouac's view, it was other novelists who were wasting their time. He saw the persistence with which they adhered to worn-out structures and approaches to character and narrative as evidence of cowardice or a lack of imagination and talent, an attitude that dates back to at least as early as 1953.[22] He would periodically survey the literary scene, probably more than his better-known colleagues did, because he felt himself undervalued. In 1961, he derides Faulkner's and Hemingway's work as "pap & piffle," "with their big 'human courage' bullshit themes underlying stories of depraved cruelty—All you have to do to win the Nobel Prize in this world is to talk about 'the courage of Humanity'—what self flatulation[.] No wonder they'll never give it to Celine—'the Courage of Humanity' indeed—All dying to be fucked up the ass but never admitting it[.]"[23] By 1963 he generally regarded even his former Beat friends, with the exception of Burroughs, as a dead loss, more because of their leftist political views than their literary efforts, though his comments in this regard can be acidic enough. Surveying the literary scene in August 1963, he says of Michael McClure's *Meat Science Essays* (1963) that they "are abstract unclear 'essays' of avant garde cant—& phoney Lifejoyism—" As for the rest of the literary scene, "Most of the American novelists who are writing in my time, like Styron, Albee [who is, of course, a playwright, not a novelist], Mailer, Roth, Bellow etc. and even Lowry are padding their books with cant, abstract 'evaluative' & 'analytic' cotton stuffing to pillow out their stories which are no thinner or thicker than my own stories but they stuff them fat—it must be a relief for a literary stranger to just read a straight unstuffed tale concerning what happens next—In a butter-like smooth unrevised, unashamed prose rush with sensations flashing throughout, and no ANALYSIS—Really (And with no false political idealism)[.]"[24]

Aside from Burroughs,[25] the only other apparent exception to the general disdain with which he viewed contemporary novelists at this time was Vladimir Nabokov (whose Archive is also in the Berg Collection). In a typed postcard to Lawrence Ferlinghetti dated June 15, 1962, Kerouac writes, "Just read Nabokov's *Lolita* which is one of the classics of world literature and ranks with Joyce, Proust, Mann and Genet in the divine solipsism of modern literature."[26] Like Nabokov, Kerouac was a dedicated reader of the dictionary, and as a lover of word sounds he delighted in finding those particular words, no matter how archaic or technical, that fulfilled as precisely as possible his descriptive, rhythmic, alliterative, and

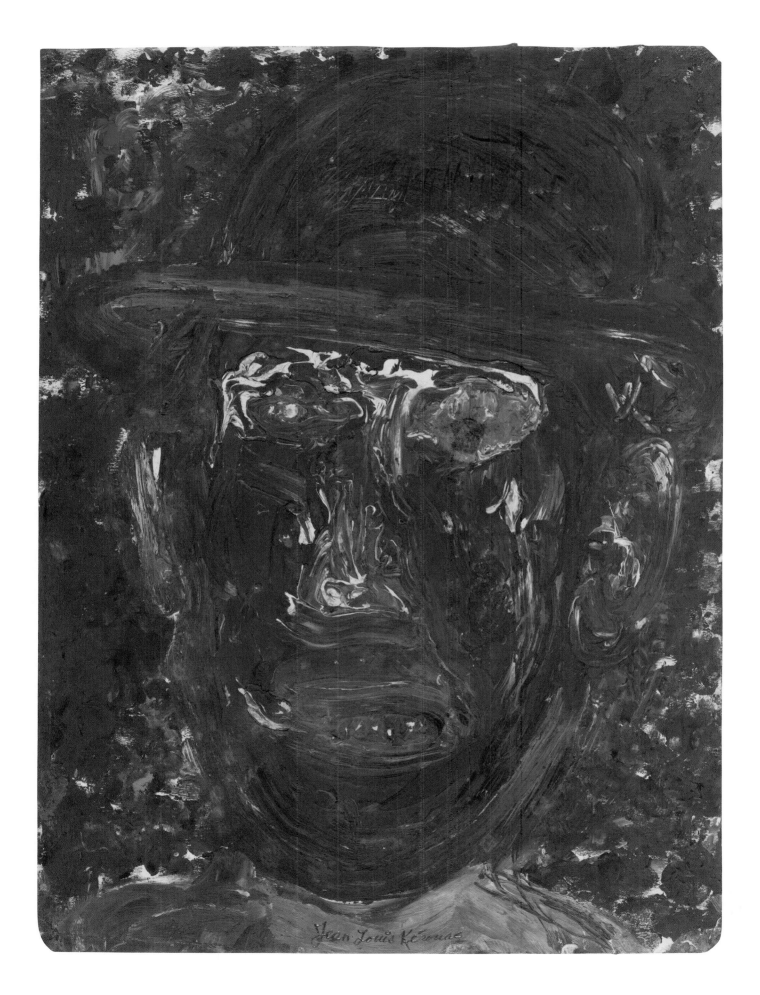

onomatopoetic needs: for instance, "esculent," from a seventeenth-century word meaning "edible" and used especially in regard to vegetables; and "prognathic," describing the shape of a skull in which the teeth protrude from the base of the nose. Kerouac invents a new form of "esculent" for *On the Road* (Part Two, Chapter 10): "where the menus themselves were soft with foody esculence as though dipped in hot broths and roasted dry and good enough to eat too [...]." He uses "prognathic" in Chapter 33 of *The Dharma Bums*: "The new moon disc was prognathic and secretly funny in the pale plank of blue over the monstrous shoulders of haze that rose from Ross Lake." Kerouac also was not above converting an archaism from, say, a noun to a gerund, if its sound fit the sense he wanted to convey and might also remind the reader of another word that would complement the first word's meaning, as in this passage from Chapter 34 of *The Dharma Bums*: "Finally the snow came, in a whirling shroud from Hozomeen by Canada, it came surling my way sending radiant white heralds through which I saw the angel of light peep [...]." "Surling" is a seventeenth-century word meaning a surly fellow, but in Kerouac's usage it evokes a combination of "surly" and "whirling," with the evocation of "surly" forming a bracing counterpoint to the joyful "radiant white heralds."

In 1956 Kerouac, as we saw, confided to his diary that the only writer he could bear to read was Shakespeare. By 1962 he had added Burroughs and Nabokov to the list, but Shakespeare still ranked supreme. In 1963, in an unfinished draft of an essay bearing the working title "Shakespeare,"[27] Kerouac contemplates the sixteenth-century poet-playwright's greatness, imagining the Hollywood spectacles he might have created as a screenwriter/director "with DeMille equipment on the redcoats of Canada 1890, the court of Catherine the Great, Napoleon and the whiff of grapeshot." His final, ringing pronouncement on Shakespeare is: "He stands by himself alone in heaven as the greatest writer in any language in any country anytime in the history of the world—" This judgment teaches an important lesson about Kerouac as a writer and student of literature. For someone who self-consciously set himself the task of discarding traditional literary forms, two of his most impressive characteristics are a love of the canon of British and American literature (with some notable exceptions, such as Henry James) and the catholicity of his taste. He was not one to stand upon the ramparts of his ego and sniff haughtily down his nose at the wasteland of literature below. When he said that he did not like what his contemporaries were writing, he spoke from experience, having respected them enough at least to read what they wrote (which was more, for instance, than Truman Capote had done when he wittily observed, upon hearing that Kerouac wrote *On the Road* in three weeks, "That's not writing, that's typing"). As for the centuries-old classics and those of the recent, modernist past, he was happy to affirm their lasting value. He had read and pondered the lessons of the canon of British and French literature (in the original), as well as of the most important Russian novelists in translation. The best work of Rabelais, Spenser, Donne, Cervantes, Swift, Dostoevsky, Turgenev, Tolstoy, Balzac, Stendhal, Dickens, Conrad, Proust, Joyce, and Eliot he regarded as immortal, as he did the best of the renowned nineteenth-century Americans— Emerson, Whitman, Thoreau, Dickinson, Melville, and Twain—and, to a lesser extent and more recently, Wolfe and Fitzgerald. But he also read and appreciated minor Elizabethan poets (e.g., Nicholas Breton) and Restoration dramatists (e.g.,

William Congreve). Reputation counted for little with him; he always judged for himself.

To understand Kerouac's ambition as a writer, one must above all appreciate that he forsook the traditional novel because he felt that he had to, not because he believed he was a "better" writer than the masters who had come before him, or to innovate for the sake of innovation. In fact, as we have seen, his early work was self-consciously derivative, even cripplingly imitative. But in his search to find a voice authentically his own, one that would allow him to give creative expression to his experience as an American "outsider" in a country that was alienated from itself, that is, from its rural, pioneering roots, and that had even less in common with contemporary, war-weary Europe, he was fortunate enough to discover an approach to writing that had grown out of his own experience of the world. It depended both on years of apprenticeship and on being receptive to the meaning of all of one's responses to one's observations, thoughts, and feelings—"spontaneous prose," he called it. Its lineaments can be discerned as early as 1944, when, in "'God's Daughter's' Method" (see Chapter 2), he proclaimed categorically that it was the writer's responsibility to communicate the sensual moment, but first to see it, without preconceptions, as the new thing that it is. For several years in the mid-1940s, pursuit of this ideal of literary expression led Kerouac down a road that took him away from spontaneity, as we saw in the 1944 "On the Technique of Writing" (see fig. 2.25), in which his sensitivity to rhythm, alliteration, mood, tone, and imagery compelled a painstaking search for "le mot juste" in every phrase. Kerouac soon realized that his need to express the sensual moment entailed that the moment of recollection, purely apprehended, also be recorded honestly, before the self-censoring mechanism of shame and ego distorted it and the writer began to emend the truth of what he had written.

The seed of this realization had been planted with Cassady's December 1950 letter; it received necessary nourishment a month later, from his friend Ed White's recommendation to write in the manner that he sketched. Finally, in June 1951, during his long convalescence in the Bronx V.A. hospital, the seed swelled and matured (in the early spring of 1962 he wrote to his friend the Swiss Abstract Expressionist Hugo Weber that the hospital stay "was actually the turning-point in my system of narrative art—It was there, day after day in bed thinking, that I formulated all those volumes (16) I've written since"),[28] until it sprouted in the writing experiments of late October 1952, and flowered in *Visions of Cody*, *The Subterraneans*, and *Doctor Sax*.

From *Visions of Cody*, here is a typical passage, lucid, alliterative, harmoniously rhythmic in its parts and in its whole—the evocation of Cody's sensations on a hot, sweaty day joined to a starched Latinate word form, and Latin-rooted words to Anglo-Saxonisms (a technique learned from Shakespeare), thereby producing a balanced mixture of poignancy and absurdity, of universal and particular, all of which culminates in an utterly original image expressed with the pith and pungency of folk speech: "Cody finally forgetting he was wearing a suit, forgetting the high entrapment of the collar and the woolly stifling around his armpits and the unfamiliar scuffling cuffs out of which he soon in fact resumed telling Watson further things and all things about himself, gesturing out of the shiny round starch his big grimy cracked hands that were not at all the hands of an absorbed banker in the

street but more like a dirt farmer's at a funeral and worse like horny toads in a basket of wash."[29] This, perhaps even Capote would admit, is very good typing indeed.

To explain how Kerouac accomplished this feat (as well as thousands of others like it in *Visions of Cody* and other works) "spontaneously," one must remember that he had been working on *Visions of Cody*, under various titles, for years; had written and rewritten portions of several other novels and scores of short stories; and had filled a hundred diaries and journals with carefully crafted entries over the prior decade. (As we have seen, this was also true for *On the Road*.) Burroughs says that when he met Kerouac in 1945, the latter had already written upwards of a million words. Even allowing for a devoted friend's hyperbole, there is no question that Kerouac spent much of almost every day from 1940 to 1960 writing, and did not slow down all that much thereafter, despite the debilitating effects of progressively worsening alcoholism. True, he sometimes "let fly," as it were, but as the journals and drafts of short stories and novels show, he also assiduously took apart, emended, and reassembled sentences, paragraphs, and even phrases in myriad combinations, until the music and sense of the words satisfied his ear.

As a result of these years of hard work Kerouac came to realize that his actual experience of the world, that is, his moment-to-moment sense of and reaction to it, could be expressed only in a style that reflected an in-the-moment mode of creation. By the early 1950s his relationship to his writing had become, at its best, akin to that of a Zen calligrapher to his art. As the master lowers his brush to a point on the paper, chosen in the unknown, innocent present, he allows his entire life experience and arduous training to flow through his hand into the handle, and pull the densely inked bundle of hairs silkily across the blank expanse before him. Revision is not permitted or, more important, even desired. In this manner, a great work of art may be completed in minutes. It would be just as true to say, however, that the artist's entire life to that point had contributed to his creating the assured strokes of the resulting masterpiece. On the other hand, if the amount of time spent executing a work of art and faithfully rendering the surface detail of its subjects are the primary determinants of aesthetic value, then let us not waste a moment on Zen calligraphy, or, for that matter, on the sketches and drawings of Rembrandt, Matisse, and Picasso, but instead gather before the canvases of the academic painter Adolphe-William Bouguereau and his ilk, and gaze enraptured upon them instead.

This is not to argue that Kerouac was the literary Rembrandt or Picasso of his age. His spontaneous prose often dissolves into puddles of incoherence, sentimentality, and self-pity, and the flashes of hipster jargon (though not nearly so frequent as caricatures of him would suggest) served merely to curry favor with the bi-coastal coterie of Beat cultists and as an escape from the hard work of real writing. His merits, however, many of which have been described in this and preceding chapters, should also be equally apparent, though the literary significance of his overall achievement has not been evaluated here. This is a question that remains to be answered by critics, scholars, and writers in the decades to come; and should his work be found wanting by this or some future generation of readers, then he will have suffered a fate no worse than that of scores of other writers and poets who have moved in and out of favor over the years. What we owe Kerouac, however, as we do any serious artist, is to judge him fairly; that is, without preconceptions. In

his case, this means free from the bias against (or, for that matter, attachment to) the Beat movement and all that it supposedly represented and engendered.

Such a judgment should be easier to render now that his diaries, journals, notebooks, and drafts are available to reveal the acuity of his perception and intellect, his profound understanding of the literary forms that he was attempting to transcend, the grimly self-critical resolve with which he labored to forge a means of expression equal to this effort, and the seriousness with which he searched for meaning in his life through his art. Perhaps the force of their testimony will shatter enough prejudices to allow his work to be seen afresh. Toward the end of his life, he at least pretended to regard the question of his literary legacy as merely another vanity: "I stalked the streets of life [...] whooped, hallelujah'd [...] But nothing ever came of it."[30] Whatever *we* may think came of his life and his work, let us grant him at least an occasional kindness and imagine him sitting quietly beside Burroughs on the Tangier beach, "listening to sounds of the afternoon or even of Friday afternoon in the Universe, the soundless hum of inside silence."[31]

Notes

"Berg Collection" refers to the Henry W. and Albert A. Berg Collection of English and American Literature, Humanities and Social Sciences Library, The New York Public Library. The Jack Kerouac Archive and the William S. Burroughs Archive are housed in the Berg Collection.

Chapter 1: "The Beat Generation"

1. *On the Road*, Part Three, Section 3, p. 195, in: *On the Road, The Dharma Bums, The Subterraneans* (New York: Quality Paperback Book Club, 1995).

2. The Archive contains Kerouac's February 1948 transcription of Huncke's legendary, in Beat circles, "Penn Station Notes," holograph in pencil on unlined paper, February 1948, 4 p. (2 leaves); Box 44, folder 21. On the last page of the transcription, Kerouac quotes from a letter that Ginsberg wrote to Cassady at this time: "The most depressing thing is to get up to go to school and wake him, and see him lift up his head, staring blankly, dumb, biting his lips, for half an hour at a time."

3. In a diary entry for June 22, 1960, Kerouac records his reactions to the publication of Norman Mailer's *Advertisements for Myself* (1959), among which is the following observation, part of a longer passage on the origin of "hip": "He also thinks 'hipster' is a 1952 word! WOW! It's 1943 or so—with roots in 1937—And 'beat' goes back to 1910 I'm sure (in the Negro South of early blues)—(Jack Teagarden says 'I sure is beat' in an old recording with Louis Armstrong in a way that makes it seem already well-established before recording dates in 30's[)]" (see *Summer 1960*, holograph diary in pencil, in spiral notebook, June 8–July 30, 1960, [144] p. (71 leaves); Kerouac Archive, Box 57, envelope 5.

4. Entry for June 21, 1957, in: [Jack Kerouac]. *1957 / Berkeley Way 1957*, holograph diary in pencil, in spiral notebook, June 19–July 5, 1957, [18] p. (18 leaves); Kerouac Archive, Box 56, envelope 4. *Lucien Midnight* was published posthumously as *Old Angel Midnight* in 1976, and illegally in 1973, in Britain.

5. [Jack Kerouac]. *Dharma (A) 1953*, holograph notebook in pencil, in spiral notebook, [December] 1953, [59] leaves; Kerouac Archive, Box 49, envelope 1. Quotation from 10th leaf, recto, from end.

6. [Jack Kerouac]. ["Neal is Beatific, I am beatific, Allen was beatific"], holograph in pencil on spiral notebook paper, [Fall 1954], 1 p.; Kerouac Archive, Box 3, folder 23. Mendès-France was the French Prime Minister who, in 1954, relinquished French territorial claims in Indo-China, for which he was attacked as a traitor in viciously antisemitic terms by nationalist and Roman Catholic leaders; Schulberg was a Hollywood screenwriter and former member of the Communist Party who, before the House Un-American Activities Committee, named other Party members (his betrayal of his leftist friends should have delighted Kerouac); and Gold was a friend of Ginsberg's whose first novel Viking published in 1951, perhaps thereby irking Kerouac, since Viking had at first refused *On the Road*.

7. The alleged connection of Judaism to Aramean culture, except for its language, Aramaic, is inexplicable (even if one assumed that Aramean culture was somehow proto-"Marxist"), since the Arameans, an ancient Semitic tribe living in what is now Syria, battled the Israelites of Kings Saul, David, and Solomon throughout the eleventh century B.C.E. Aramaic would later evolve into the lingua franca of the ancient Middle East, for which reason passages can be found in the biblical books of Daniel and Ezra. During the period of its greatest extent in the region, Jewish religious leaders chose Aramaic as the language of the Gemarah, the oral body of Jewish law (codified ca. 500 C.E.), so that it would be understandable to far-flung Jewish communities.

8. Entry for February 8, 1956 (8th leaf, recto, of entry), in: [Jack Kerouac]. *Dharma (8)*, holograph notebook in pencil, in spiral notebook, December 15, 1955–February 8, 1956, [97] leaves; Kerouac Archive, Box 49, envelope 9.

9. Leaf [32], verso, in: [Jack Kerouac]. *G*, holograph notebook in black pen, in spiral notebook, containing observations on Allen Ginsberg, address to Gregory Corso, notes on the derivation of the Kerouac name, lists of names, ca. 1967, [54] leaves; Kerouac Archive, Box 42, envelope 5. Kerouac's French was often ungrammatical and misspelled, and he could not speak or write it without the occasional use of English words. But the "corruption" to which he refers has nothing to do with grammar and accent; rather, he is identifying who is and who is not morally entitled to participate in Gallic culture by speaking French.

10. Jack McClintock. "Jack Kerouac Is On the Road No More," in *The Floridian*, [Sunday supplement to the] *St. Petersburg Times*, October 12, 1969; with Stella Sampas's penned inscription on first page of article, "Interview took place Sept. 3rd & a few weeks later"; Berg Collection.

11. "'I was suddenly free to love myself again, and therefore love the people around me, in the form that they already were,'—that last phrase, it strikes a big blue bell in my big blue behind—(since I already wrote it)": *G* (see note 9 above), leaf [33], recto. Elsewhere in notebook *G* (leaf 25, verso), Kerouac sarcastically attributes authorship of his works to "an obscure Jewish boy living in the Lower East Side who is the first Jewish writer of original creative genius in history, and his name is Abraham Slivovitz." Kerouac then "reveals" that not Slivovitz, but Jack Kerouac, is indeed the author of the works attributed to Kerouac and that proof of his authorship lies in his "provable handwriting." For Kerouac, Ginsberg's alleged plagiarism is merely an instance of a trait com-

mon to thieving Slivovitzes, who must plagiarize because they lack "original creative genius."

12. Ibid.

13. [Jack Kerouac]. [Draft for responses to John Clellon Holmes questions, with notes on novels and other subjects, and plot outline for] "VANITY OF DULUOZ (To The Wars)," with, on 5 versos, draft for responses to David McCullough's Farrar, Straus public relations questions, holograph in pencil on lined yellow legal pad paper, [June 1963], 29 p., including sketch (16 leaves); Kerouac Archive, Box 12, folder 45.

14. *Vanity of Duluoz* (New York: Penguin Books, 1994), Book Eleven, Chapter XII, p. 204.

15. Entry for July 24; leaf [29], recto, in: [Jack Kerouac]. *1945*, holograph journal in pencil, in spiral notebook, including, with allusions to the "Galloway" novel, "The Artist of Today," "My Dying City," "The Mystical Experience," and other essays, poems, miscellaneous notes, notes on Dostoevsky, and other prose works, July 24–December 1, 1945, [43] leaves; Kerouac Archive, Box 53, envelope 4.

16. "On Bill Burroughs," pp. [15–19] in: [Jack Kerouac]. *1946 Journals*, holograph journal in pencil, in spiral notebook, signed, September 3–October 9, 1946, [43] leaves plus one leaf tipped-in; Kerouac Archive, Box 53, envelope 8.

17. William S. Burroughs, in a contents description for folio 167 of his Archive, gives an account of writing the story with Elvins, and how he later had to work from memory in order to incorporate it into the novel *Nova Express*.

18. "Jack Kerouac," typescript with holograph emendations in pen, n.d., 6 p.; William S. Burroughs Archive, folio 167.

19. John Clellon Holmes. Typed letter, with holograph emendations in pencil, signed, to "Holder/Adelheim," August 26, 1978, 4 p. (2 leaves); Berg Collection, Box 12.

20. Entry for July 29, 1963, in: [Jack Kerouac]. *Summer & Fall 1963*, holograph diary in pencil, in spiral notebook, July 3–December 13, 1963, 89 leaves; Kerouac Archive, Box 58, envelope 6

21. Kerouac Archive, Box 2, folder 33.

22. Gregory Corso. "Bomb," typescript, typed by Jack Kerouac, "BOMB" and "CORSO" in blue pen on verso in Kerouac's hand, "Gregory Corso / 9 rue Git-Le Coeur" typed at head of leaf, [1957?], 4 p. joined (1 leaf); Kerouac Archive, Oversize +++.

23. [Jack Kerouac]. "NOTES FROM A LETTER (to Temko, Dec. 13, '48)," typescript, 1 p.; Kerouac Archive, Box 4, folder 70. Temko won the 1990 Pulitzer Prize for architectural criticism as a critic for the *San Francisco Chronicle*.

He appears in *On the Road* as Roland Major, a would-be Hemingway, and as "a choleric, red-faced, pudgy hater of everything, who could turn on the warmest and most charming smile in the world when real life confronted him sweetly in the night."

24. *The Hip Generation* was one of the nearly one hundred titles Kerouac considered for *On the Road* (see Chapters 3 and 4 below). In August 1952, he entitled the draft of the first eleven pages of an unwritten book about his Beat friends *The History of the Hip Generation*: [Jack Kerouac]. "THE HISTORY OF THE HIP GENERATION, (First seven chapters), BOOK ONE The Hip generation Went on Strike Against Men," typescript with holograph emendations in pencil, Rocky Mt. [N.C.], August 1952, 11 p. (11 leaves); Kerouac Archive, Box 15, folder 3.

25. [Jack Kerouac]. *Mexico Summer 1957*, holograph diary in pencil, in spiral notebook, July 29, 1957, [66] leaves; Kerouac Archive, Box 56, envelope 6.

26. [Jack Kerouac]. "Beat Generation. Tangier," holograph manuscript in pencil on spiral notebook paper, foliation in red pen, March 26, 1957, 16 p. (16 leaves); Kerouac Archive, Box 19, folder 2.

27. [Jack Kerouac]. *MORE MEXICO BLUES / WASHINGTON DC BLUES / POEMS 1957*, holograph in pencil in bound, vertical notebook, including "Orizaba Rooftop Blues in Choruses, Oct. 26, '56," "ON THE ROAD insert" (leaf 39r–leaf 45r), and 3 portrait sketches, October 1956–[January] 1957, [52] leaves; Kerouac Archive, Box 35, envelope 4.

28. Entry for February 7, 1965, in: [Jack Kerouac]. *Jan.–Feb. '65*, holograph diary in pencil, in spiral notebook, January 13–February 27, 1965, [91] p. (45) leaves; Kerouac Archive, Box 58, envelope 11.

29. In 1960, excerpts from Mailer's *The Deer Park* appeared in *The Beats: A Gold Medal Anthology*, ed. Seymour Krim (Greenwich, Conn.: Fawcett Publications, Inc., Gold Medal Books, 1960).

30. Entry for February 11, 1960 [incorrectly dated "January 11, 1960"], in: [Jack Kerouac]. *Early 1960*, holograph diary in pencil, in spiral notebook, February 8–April 2, 1960, 68 leaves; Kerouac Archive, Box 57, envelope 3.

31. Entry for April 18, 1960, in: [Jack Kerouac]. *Boog of Spring 1960*, holograph diary in pencil, in sewn notebook, April 4–June 6, 1960, 56 leaves; Kerouac Archive, Box 57, envelope 4.

32. Jack Kerouac. Typed letter with holograph additions in black pen, signed, August 23, 1968, 2 p. (1 leaf); Kerouac Archive, Box 13, folder 22.

33. [Jack Kerouac]. *Journal—(Stupid)* [inside title *The Stupid Journal*; contains plans for "My life's design"; "The time has come to begin working/writing seriously," etc.], holograph journal in pen, in sewn notebook, November 26–December 15, 1941, 12 leaves; Kerouac Archive, Box 6, folder 3.

34. Anne Morrow Lindbergh, *The Wave of the Future: A Confession of Faith* (New York: Harcourt, Brace and Co., [1940]), pp. 18–19.

35. Pp. [15–19] in: [Jack Kerouac]. *1946 Journals* (see note 16 above).

36. Jack Kerouac. "Article on Youth Movements," typescript, signed, [1949], 2 p. (2 leaves); Kerouac Archive, Box 44, folder 5. The date is deduced from the essay's placement among other dated papers.

37. By 1961 he could at least joke with himself about the subject; after listening to a recording of Bach's *St. Matthew Passion* by an angelic-voiced boy's choir, an account of which he gives in *Desolation Angels*, he bemusedly confides to his diary, "I'm the only queer in the world who likes women's bodies," adding, below this remark, that the same must have been true of Bach; see 16th leaf, recto, in: [Jack Kerouac]. *B 1962*, holograph notebook in pencil, in spiral notebook, containing miscellaneous notes, lists, and sketches, 1962, 59 p. (59 leaves); Kerouac Archive, Box 42, envelope 2.

Chapter 2: "Early Life, Influences, and Writings"

1. *Visions of Gerard* (New York: Penguin Books, 1991), pp. 7–8.

2. Jack Kerouac. ["I was born in 1922"], typescript, 1959, 1 p.; Kerouac Archive (+++).

3. "Prayed to Gerard to find some way to stop me drinking—After all, I could always amuse like I did in 1939 in N.Y.—amuse & be muse—" Last portion of entry for [Tuesday, September 16?, 1958], in: Jack Kerouac. *Fall 1958*, holograph diary in pencil, in spiral notebook, September–December 13, 1958, [128] p. (63 leaves); Kerouac Archive, Box 56, envelope 12.

4. *Visions of Gerard*, p. 15.

5. The influence of Eastern spiritual traditions on Kerouac appears in many passages in *Visions of Gerard*, as when the clouds that Gerard gazed upon are described as "Tao phantoms" (p. 8). Several pages later, Buddhist references are combined with Christianity, when Kerouac says that he fully realized the "immortal idealism" imparted to him by his "holy brother" only with the "waking re discovery" of "Buddhism, Awakenedhood—Amazed recollection that from the very beginning I, whoever 'I' or whatever 'I' was, was destined, destined indeed to meet, learn, understand Gerard and Savas [i.e.,

his close friend Sebastian Sampas] and the Blessed Lord Buddha (and my sweet Christ too through all his Paulian tangles and bloody crosses of heathen violence)—To awaken to pure faith in the bright one truth: All is Well, practice Kindness, Heaven is Nigh" (pp. 13–14).

6. Jack Kerouac. Photocopy of typed letter, signed, to Caroline Kerouac, March 14, 1945, 3 p. (3 leaves); Kerouac Archive, Box 74, folder 23.

7. Gabrielle Kerouac. Autograph letter in pencil, signed, to Jack Kerouac, Sunday, [no month] 26, 1952, 14 p. numbered 1–13 (7 leaves); Kerouac Archive, Box 67, folder 7.

8. Both letters are now housed in Columbia University, Butler Library, Rare Books and Manuscripts Library.

9. Entry for October 5, 1961, in: [Jack Kerouac]. *Orlando Fall 1961*, holograph diary in pencil, in spiral notebook, September 9–October 13, 1961, 39 leaves; Kerouac Archive, Box 57, envelope 14.

10. Entry for December 15, 1961, in: [Jack Kerouac]. *1961 / Late Fall / Early Winter '62*, holograph diary in pencil, in spiral notebook, October 20, 1961–January 1, 1962, 73 leaves; Kerouac Archive, Box 57, envelope 15.

11. Jack Kerouac. [Diary for January–February, and a few days in March 1935, with references to the period 1932–34, including a review of 1934 "in brief," and lists of "chums' weights," "favorite things," etc.], holograph diary in pencil, [40] leaves; Kerouac Archive, Box 56, envelope *.

12. For an example of one such sports notebook, see: Jack Kerouac. *Diary / Whole Year of 1936*, holograph in pencil, in bound notebook, January 1–September 17, 1936, 58 leaves (including text on verso of front cover and 2 blanks); Kerouac Archive, Box 59, sleeve 3. Kerouac also wrote about his and his friends' 1938 baseball exploits in a sandlot league funded by the W.P.A. (see, e.g., Kerouac Archive, Box 59, sheets 4 and 6). His love of statistics and record keeping of all sorts (he was a lifelong, compulsive list maker) is displayed in his accounts of their fortunes as the Pawtucketville Blues against other teams. Pawtucketville is a Lowell neighborhood.

13. Jack Kerouac. *SPORTS OF TODAY*, typescript with holograph note in pencil, June 19–22, 1937, [nos. 1–4], signed "Jack Lewis," [4] p.; Kerouac Archive, Box 59, sheet 83.

14. Kerouac's approving tone in anticipation of so seemingly modest an achievement illustrates one of the lost charms of the pre-playoff baseball era, when a team did not have to be a "post-season" contender to command its fans' loyalty and affection. Fans took pride in their team's improvement over the previous season's performance, even if the team did not win the pennant and advance to the World Series. Issue

"STROLLING ALONG FLATBUSH," in: *SPORTS: DOWN PAT*, typescript on orange paper, issues [1–14], [Fall 1937–Spring 1938], 14 p.; Kerouac Archive, Box 59, sheet 90.

15. The undefeated 1940 Boston College team that Leahy coached, of which Kerouac would have been a member, was the greatest in the school's history, outscoring its opponents 320 to 52 and winning the Sugar Bowl versus Tennessee on January 1, 1941. The next year, Leahy became coach at Notre Dame, where he won five national championships and thirty-nine straight games in the late 1940s. He was inducted into the Football Hall of Fame in 1970.

16. In a 1942 journal entry, Kerouac expresses certainty that he will be admitted to Notre Dame (he must have been in communication with Coach Leahy), but realizes the precariousness of his situation because of the draft. This entry follows his departure from Columbia in October 1941, when he quit the football team because he was disgusted with his lack of playing time. See p. 2 of: [Jack Kerouac]. *The Stupid Journal*, including "Study Plan," holograph journal in black and blue pen on notebook paper, pages torn out of sewn notebook, January–March 29, 1942, [20] p. (10 leaves); Kerouac Archive, Box 6, folder 47.

17. *Vanity of Duluoz*, Book Two, Chapter I, p. 28.

18. Ibid., Book Two, Chapter I, p. 28.

19. Ibid., Book Two, Chapter I, p. 29.

20. Almost a quarter of a century later, in Kerouac's introduction (never published) to his replies (see Chapter 1, note 13) to a set of questions posed to him, for publication, by John Clellon Holmes, Kerouac would compare the football gridiron to a medieval Burgundian battlefield, on which the knights joust in honor of their fathers; see leaf 1, recto.

21. From *Vanity of Duluoz*, Book Two, Chapter V: "And further, he [the Horace Mann coach] teaches me to quick-kick, which means, you're lined up as tho ready to receive the ball and run with it. You make a step as tho you're going to plunge into the line. Instead you take one quick step back, still bending low, and just plunk the ball on a low line drive over everybody's head [...] and that's one of the tricks that made our team not only the high school champs of New York City that year but what they called in the paper 'the mythical prep school champs' of New York City."

22. Calling these writers journalists may reflect Kerouac's own affection for the profession. Jack Kerouac. :—*Journal*—: *Fall, 1939*, holograph journal in black pen on lined notebook paper torn from sewn notebook, signed, September 21–25, 1939, 10 p. (5 leaves); Kerouac Archive, Box 5, folder 10.

23. His report card for the second quarter, November 10, 1939–January 26, 1940, indicates that although he was tardy only twice, he was absent seven and a half days in a ten-week period, which may have been owing to illness, but also, as we learn in *Vanity of Duluoz*, to the occasional bout of hooky (see Kerouac Archive, Box 78, folder 1).

24. *Vanity of Duluoz*, Book Two, Chapter VIII, p. 43.

25. Ibid., Book Four, Chapter I, p. 59.

26. "I'm hanging around and there's the call 'Jack-eeee' out on Gershom Avenue. I go out, look down the long fifteen steps of the street porch and there stands a curly black-haired boy strangely familiar. 'Aint you the guy called me from the street when I was twelve on Sarah Avenue?' 'Yeh, Sabby Sayakis.' 'Didnt I know you on the sandbank?' 'Yes.' 'Whattaya want?' 'Just wanta see you, talk to you. Always wanted to.' [...] 'Oh now I remember you, Greek kid, used to hang around, ah, with Tsotakos or sumptin, on the sandbank, come from Rosemont.' 'Since the river flooded in 1936, we've moved to Stevens Street.' 'Oh, yass,' I said like W. C. Fields, thinking, inside, 'So ... *nu*?' [...] 'Do you read Saroyan?' he says. 'Thomas Wolfe?' 'No, who are they?'" (*Vanity of Duluoz*, Book Four, Chapter I, p. 60). The manuscript of the essay is in private hands.

27. *Vanity of Duluoz*, Book Three, Chapter VIII, pp. 74–75.

28. Jack Kerouac. *COLUMBIA / Oxford / WORKING PHILOSOPHY + MINERVA=STABILITY*, holograph in pencil on lined, three-holed paper, 1940, 48 leaves; Kerouac Archive, Box 4, folder 2.

29. Jack Kerouac. *Journal of an Egotist*, typescript, signed, 1940, 14 leaves; Kerouac Archive, Box 4, folder 3.

30. In one of his "1944 'Self-Ultimacy'" journals, he notes that the critic Lionel Trilling, who tried to place one of Kerouac's short stories and essays in the *Kenyon Review*, did not care for this work: "Trilling no like"; see entry for February 27, 1945, in: [Jack Kerouac]. [List of significant dates in the period February 25–June 28, 1945, with dates from January 16, 1946–May 1955 on verso], holograph in pencil on three-holed paper, 1 p.; Kerouac Archive, Box 43, folder 5, item 2.

31. Entries for June 6, pp. [6–7], and June 15, p. 14, in: Jack Kerouac. *Diary Beginning June 1, 1941*, holograph diary in pencil and pen on lined paper, in sewn notebook, signed, with penned comments, June 1–19, 1941, 16 p. (8 leaves); Kerouac Archive, Box 6, folder 2.

32. *Vanity of Duluoz*, Book Four, Chapter IX, p. 75. Kerouac's reference to "America as a Poem"

is an echo of Emerson's remark—paraphrased by Whitman in *Leaves of Grass*—that America is the greatest poem.

33. Kerouac's desire to fill his fiction so explicitly with philosophical rationales seems foreign to such works as *On the Road* and *The Subterraneans*, in which the ideas are implied in the action and motivation of the characters. But in his youth, he was more eager to prove his *bona fides* as an intellectual. For example, Yeats's theories on the will and its association with the soul, especially as expounded in *A Vision* (1937), intrigued Kerouac in the mid-1940s. As he would write on p. 3 of this group of "Self-Ultimacy" papers, "The felicitous combining of philosophy and art elicits the greatest satisfaction to the writer"; Jack Kerouac. "The Zarathustrian principle of life is opposed by the principle of love," holograph in pen and pencil on three-holed paper, from the "1944 'Self-Ultimacy' Period" papers, [Fall] 1944, 25 p. (14 leaves); Kerouac Archive, Box 43, folder 13.

34. Jack Kerouac. "ANSWERS TO JOHN HOMES'S QUESTIONS FOR USE IN HIS NON-FICTION BOOK, TO BE QUOTED IN THEIR ENTIRETY EACH ONE," carbon typescript (leaf 3 is original), signed, June 1963, 6 p. (6 leaves); Kerouac Archive, Box 12, folder 44.

35. [Jack Kerouac]. *The Stupid Journal* (see note 16 above). Quotation from p. 18.

36. [Jack Kerouac]. *1945 Journals*, holograph notebook in pencil, in spiral notebook, July 14–November 6, 1945, 9 leaves; Kerouac Archive, Box 53, envelope 5.

37. Jack Kerouac. *1947–'48 JOURNALS FURTHER NOTES / Well, this is the forest of Arden—*, holograph in pencil, in sewn notebook, signed, May 5–September 9, 1948, 47 leaves; Kerouac Archive, Box 54, envelope 7. Quotation from p. [23].

38. *Vanity of Duluoz*, Book Five, Chapter III, p. 92.

39. *Journal—(Stupid)* (see Chapter 1, note 33), p. 2.

40. Ibid., pp. 20, [24].

41. Jack Kerouac. ["I am going to stress a new set of values"], typescript, [1941?], 2 p. (2 leaves); Kerouac Archive, Box 6, folder 11.

42. *Vanity of Duluoz*, Book Six, Chapter III, p. 108.

43. Ibid., Book Six, Chapter V, p. 112.

44. [Jack Kerouac]. *GROWING PAINS or A MONUMENT TO ADOLESCENCE / Voyage to Greenland*, holograph journal in pencil on lined, three-holed paper, July 18–August 19, 1942 (with second title and epigraph added in blue pen, April 17, 1949), with poem and related short story, "The Communist"; epigram; "General Plan" for a four-part, "free verse" work on humanity's passage from world war to world peace (with part of Part One); "A fellow-scullion's calculations"; variations on similar metaphorical phrases; and his bonus money calculations for overtime; 74 p. (45 leaves) including title page; Kerouac Archive, Box 47, folder 10. Quotation from p. 40.

45. Jack Kerouac. *MERCHANT MARINER / FIRST MANUSCRIPT—MARCH, 1943 / THE SEA IS MY BROTHER*, holograph in pencil on lined, three-holed paper, 1943, 160 leaves including title page with illustration, with holograph note in blue ink on separate leaf of paper, added ca. 1968; Kerouac Archive, Box 22, folder 9.

46. [Jack Kerouac]. "Do not ask me why. I'm in a ward in the Naval Hospital," holograph in pencil on "U.S. Naval Training Station, New Port R.I." stationery, 2 p. (1 leaf), in: [Miscellaneous holograph and typescript notes, poems, essays, journal entries, quotations, recorded dreams, erotic thoughts, etc.], 37 leaves, from the "1944 'Self-Ultimacy' Period" papers; Kerouac Archive, Box 43, folder 18.

47. *Vanity of Duluoz*, Book Ten, Chapter VII, p. 175.

48. Jack Kerouac. "Liverpool Testament," holograph in pencil on lined, three-holed paper, with title in purple felt-tipped marker, Liverpool, England, September 24, 1943, 6 p. (3 leaves); Kerouac Archive, Box 47, folder 3.

49. *Vanity of Duluoz*, Book Eleven, Chapter IV, p. 190.

50. Ibid., Book Eleven, Chapter VII, p. 194.

51. Ibid., Book Eleven, Chapter VIII, pp. 196–97.

52. [Jack Kerouac]. "Dialogs in Introspection," holograph in pencil and red pencil on lined paper, 8 p. (8 leaves), from the "1944 'Self-Ultimacy' Period" papers; Kerouac Archive, Box 43, folder 2; and [Jack Kerouac]. "Les Reves en écoutant DeBussy," holograph in pen and pencil on paper, October 31, 1944, 2 p. (1 leaf), from the "1944 'Self-Ultimacy' Period" papers; Kerouac Archive, Box 43, folder 5, item 1. "Les Reves en écoutant DeBussy" is a two-page prose poem about the sea, which we presently learn is a lunar sea from which the poet views Earth. Fearing an unseen threat, he rows his boat to safety and, exhausted, sleeps. The second page, written at a later date, in pencil rather than in the pen of the first, shows none of the surreal gloom of the first. Rather, Kerouac engages in a close observation of nature, and sings his resulting, joyful awareness of the unity of existence. The interaction of a close observation of

the natural world and a resulting expression of joy or awe would become one of the hallmarks of Kerouac's style. He would use the phrase with which this page begins ("Now, I see the earth spinning toward the moon") in *The Dharma Bums*.

53. *Vanity of Duluoz*, Book Thirteen, Chapter V, p. 255.

54. Jack Kerouac and William S. Burroughs. *I Wish I Were You (1945) Philip Tourian Story / '45 Ryko Tourian Novel*, typescript carbon with Kerouac's pencil emendations, first title in holograph pencil, second title in holograph red pen, both authors' names signed by Kerouac in pencil, 1945, 51 leaves (title page on verso of insurance form, leaves 1–32, 35–53, with insurance form comprising final, unfoliated leaf); Kerouac Archive, Box 15, folder 19.

55. [Jack Kerouac]. "God's Daughter," with "For God's Daughter" [notes] and "The 'God's Daughter' Method," holograph in black and blue pen on three-holed paper, [1945], 27 p. (13 leaves) misnumbered 1–26; 2 p. (1 leaf); 2 p. (1 leaf), from the "1944 'Self-Ultimacy' Period" papers; Kerouac Archive, Box 43, folder 16.

56. [Jack Kerouac]. "On the Technique of Writing:—," holograph in black pen on lined paper, 14 p., in spiral notebook "I Bid you Love Me—workbook," holograph in pen and pencil on lined paper, including conversations with Allen Ginsberg, Joan Vollmer, and John Kingsland; essay "THE SONG OF REBIRTH"; journal entries; poem "PAIN AND POESY"; notes on characters in "Galloway" novel [i.e., *The Town and the City*]; "Letters I should write …"; "Notes On a Projected essay [philosophical principles of his art]"; all in spiral notebook, November 10–December 26, 1944, 29 leaves; Kerouac Archive, Box 53, envelope 3. Among other such writings is "A Dissertation on Style," holograph in pencil on lined paper, October 8, 1944, 2 p. (1 leaf), from the "1944 'Self-Ultimacy' Papers"; Kerouac Archive, Box 43, folder 18.

57. Jack Kerouac. *"Galloway" And all its appurtenances / "I Bid You Love Me"* [crossed out on title page], holograph in ink and pencil on three-holed paper, signed, November 4, 1944, [58] p. (29 leaves), not including title page, numbered 1–26, 32–63, lacking pp. 27–31; bloodstained; from the "1944 'Self-Ultimacy' Period" papers; Kerouac Archive, Box 43, folder 6.

58. [Jack Kerouac]. *1944 "Galloway" Novel "Michael Daoulas[,]" A Later Re-Doing of Vanity of Duluoz of '42*, holograph and typescript, signed, 1944, [57] p. (including title page and poem on verso of leaf) (42 leaves); Kerouac Archive, Box 22, folder 2. The title character's name is spelled "Dalouas" in this draft; the

name on the title page, "Daoulas," was added by Kerouac in the course of organizing the Archive in the 1960s.

59. Ibid., p. 12.

60. Jack Kerouac. *NOTES ON GALLOWAY AND AN AMERICAN PASSED HERE / 1945 DAOULAS "GALLOWAY" / THE PLAN FOR THE NOVEL "Galloway" (Forming a large part of Book Three of "The Town and the City"),* holograph in pencil on three-holed paper and typewritten page and portions of three other pages, with blue, three-holed paper covers (subtitle "1945 DAOULAS 'Galloway,'" in red pen), signed, September 1945, 69 p. (61 leaves, including covers); Kerouac Archive, Box 9, folder 2.

61. Rants against what Kerouac perceived as an exaggerated influence on the arts and on American culture in general by homosexuals can be found throughout his journals and diaries from this period to the end of his life. Among the "Galloway"-era journals, another such instance is found in the second of two *1946 Journals,* this one for the period May–July 1946, entitled "For the Re-Writing & re-Styling of 'T&C'" (Kerouac Archive, Box 53, envelope 8). It includes a two-page essay, "The Homosexual Intelligentsia in America" / "A Discordant Little Note," which argues against "the great homosexual intellectuals of America," who have distorted the meaning of the word "maturity," which used to be identified with marriage, parenthood, and accepting "a particular rôle in [...] human society," into a meaning that is "strictly applicable to their own states of mind only," dismissing those who, like himself, enjoy "Bing Crosby or Betty Grable or anything similarly 'vulgar' and 'quite without taste [...].'" He then sets up a series of oppositions between homosexuals and the "average dolt" (in which category he ironically includes himself), to the advantage of the latter. He ends the essay with a question that he might not have allowed himself if the essay had been submitted for publication: "And who abandoned homosexuality at puberty?"

62. In a three-page collection of notes on the "Galloway" novel dated May 1945, Kerouac included a critique of Joyce's stream-of-consciousness technique, upon which he hoped to improve: "Joyce abused the stream of consciousness by making it too intensely personal, in the sense that it had to be more uncommunicative and was less poetic," although, Kerouac explains parenthetically, it was uncommunicative not because it was less poetic, but because it was too personal. "In brief, Joyce did not exercise creative selectivity upon the stream of consciousness. [...] the kind that lumps the multiverse trivialities in one universal pattern, puts it in its proper place, and explores in turn more exhaustively the creatively interpretive introspective mind, the trained subconscious." But

Kerouac enthusiastically praises Molly Bloom's concluding interior monologue, in which, Kerouac says, the stream-of-consciousness technique is successful because it deals in "Particular generalities rather than general particulars; the universal, not the multiversal"; from: [Jack Kerouac]. [Notes on "Galloway" novel]: "OUTLINE for 'Galloway' MAY DAY 1945," holograph in pencil on spiral notebook paper, 1 p.; "GALLOWAY notes (Daoulas)," holograph in pencil on three-holed paper, 1 p.; "Notes on 'Galloway' style," holograph in pencil on lined paper, 1 p., with two "Galloway" poems for character Allan Mackenzie on verso; "'Galloway' will not be a best seller," holograph in pencil on three-holed paper, 1 p., from the "1944 'Self-Ultimacy' Period" papers, May 1945; Kerouac Archive, Box 43, folder 17.

63. Jack Kerouac. "Notes for an American Passed Here," holograph in pencil on lined paper, [1945], 18 p. (10 leaves); Kerouac Archive, Box 9, folder 10.

64. But Kerouac did not abandon the Dostoevsky comparisons entirely. In a one-page, hand-emended typescript entitled "Some Town and City Conclusions," dating probably from 1948 (judging from its location in the Archive, Box 4, folder 18), Kerouac, ascribing masochism and "intellectual decadence" to big-city liberals who rush to the South to "fight for the Negro" only out of a desire to prove their moral superiority to everyone else, contrasts them with the characters Peter Martin and his father, who possess the ideal balance of strength and "Christian saintliness and Myshkin-idiocy," an allusion to the central character of Dostoevsky's *The Idiot.*

65. Jack Kerouac. "Scenes and Sequences FROM THE TOWN AND THE CITY / PART ONE / THE TOWN: GALLOWAY / BOOK ONE / Appurtenances and Preludes / (I–Towards Galloway," holograph in pencil, in spiral notebook *1946 Journals* (March 18–June 30, 1946), with holograph note at end dated 1947; with list of "States I've Been In" on last page; and with fragment of poem, typescript/holograph in pencil; signed; 70 p. (37 leaves), not including blank pages or laid-in fragment; Kerouac Archive, Box 53, envelope 10.

66. Entry for March 7 in: [Jack Kerouac]. *1947 Journals,* holograph in pencil, in spiral notebook, February 24–March 7, 1947, 38 leaves; Kerouac Archive, Box 54, envelope 1.

67. *1947–'48 JOURNALS FURTHER NOTES / Well, this is the forest of Arden—* (see note 37 above).

68. Jack Kerouac. "LINES DEDICATED TO ALLEN GINSBERG," typescript, signed "Jack," January 23, 1950, 1 p.; Kerouac Archive, Box 2, folder 6.

Chapter 3: "*On the Road* Proto-Versions: Drafts, Fragments, and Journals"

1. However, as early as 1940 Kerouac had written, as he would continue to write, of his fascination with the "road," and the life lessons that may be learned from it; see the short story "Where the Road Begins," written in reaction to his leaving Lowell for New York: [Jack Kerouac]. "WHERE THE ROAD BEGINS," typescript with penciled and penned holograph emendations, [December] 1940, 4 p. (4 leaves); Kerouac Archive, Box 4, folder 6.

2. In the strict sense, all of the pre-scroll drafts are fragments, since they do not comprise mature efforts by Kerouac to deal with plot, character, and style. These drafts must be distinguished from those that are only a few pages in length and were probably started merely to see how a particular scene might be written or a character delineated. Many drafts carry titles that bear no resemblance to the title "On the Road," and, indeed, the content and style of the drafts, even those so titled, bear no resemblance to the text of the scroll or of the published novel. But all of the drafts that are examined in this chapter, as well as scores of others, were grouped together chronologically by Kerouac, and their status as *On the Road* proto-versions is clear.

3. Jack Kerouac. *1947–1948 JOURNALS NOTES,* holograph journal in pencil, in notebook, signed, June 16, 1947–May 4, 1948, 45 leaves; Kerouac Archive, Box 54, envelope 6.

4. Jack Kerouac. *Ray Smith Novel of Fall 1948 (last chapt. is "Tea Party"[)],* typescript and penciled holograph, the first 7 leaves of which are on the versos of employee Time Report forms for the Marin County Housing Authority, with holograph emendations in pencil and title page in red pen, with "'48" in blue pen, signed, Fall 1948, [53] p. variously numbered (44 leaves); Kerouac Archive, Box 24, folder 6.

5. [Jack Kerouac]. "PLOT OF 'ADVENTURES ON THE ROAD,'" holograph in pencil on blank paper, [1949], 4 p. (2 leaves); Kerouac Archive, Box 44, folder 20.

6. Jack Kerouac. *RAIN AND RIVERS[:] The Marvelous notebook presented to me by Neal Cassady in San Francisco:—Which I have Crowded in Words—:,* holograph in pencil, in sewn notebook, signed and dated, January 31, 1949, "(Begun) 'Frisco—," final entry February 1954, with blank entry for 1955 ("Rocky Mt. [N.C.] to Mexico City"), 69 leaves; Kerouac Archive, Box 55, envelope 1. Many of the road entries were written after the fact; this is certainly true of those for the trip to California, since it was only after their arrival in San Francisco that Cassady presented Kerouac with the ledger book.

7. [Jack Kerouac]. *1949 JOURNALS / 1949 ROAD-LOG*, holograph in pencil and blue pen, in spiral ledger notebook, April 27, 1949–July 24, 1950, 51 leaves; Kerouac Archive, Box 55, envelope 2.

8. Jack Kerouac. "NIGHT NOTES & Diagrams for ON THE ROAD," holograph in pencil and blue and violet pen on three-holed paper, signed, completed November 1949, 55 p. (31 leaves); Kerouac Archive, Box 23, folder 2. His views on De Quincey had changed. Six months earlier, on May 5, 1949, he had written in the *1949 Road-Log* (p. 15): "Here's what I think of De Quincey—he is conscious of his reputation as De Quincey, and so absorbed in this that his work is useless, i.e., it reveals nothing," etc.

9. "Night Notes," p. 5. See also p. 37, in which, in a list of scenes for *On the Road*, Kerouac includes "Glee of the Bayou Dark; mansion of the snake."

10. Ibid., p. 30.

11. Ibid., p. 54. The dichotomy in sensibility was usually phrased in terms of "hot" and "cool," since both groups saw themselves as hipsters. The term "Beat" would not become current in hipster circles for a few years. But by opposing "hip" to "cool," Kerouac was showing where his allegiance lay. Within a year he was analyzing the hipster scene in terms of "hot" and "cool," which he also applied to jazz, in favor of the former.

12. [Jack Kerouac]. "The Hip Generation, I[.] EARLY APPURTENANCES," typescript and penciled holograph, with penciled holograph emendations, September 1949, [23] p. (18 leaves, with duplicate numerations); Kerouac Archive, Box 4, folder 22. The overlapping concerns of "Night Notes" and "The Hip Generation" regarding characters and themes will be shown immediately below, but in this regard it should also be noted that on the first page of the fifth draft fragment, beginning "My chiefest memories," the alter-ego narrator tells of a childhood fantasy clearly based on *Doctor Sax*: "I had seen the word 'malodorous' somewhere in a book and I thought it was the most beautiful word in the world, which it nearly is. Armed with this word, and the idea that a wizard lived somewhere along the South Platte River in a castle, my thoughts were filled with the Wizard Malodorus (a happy misspelling) and how at any moment he might appear at my window, caped, slouch-hatted, green-eyed, to beckon me to adventures with him in the big night outside—," etc.

13. During this period, while he was working for 20th Century–Fox writing script synopses, Kerouac wrote several screenplay treatments about the return of a long-absent gun-fighting hero and the corruption of the Old West by the forces of commercialism (see, e.g., "Return of Sam Horn," [1949]; Kerouac Archive, Box 44, folder 3, and "THE LAST GUNFIGHT (or 'The Sins of the Fathers')," June 27, 1950; Kerouac Archive, Box 2, folder 17). Kerouac submitted the latter to Fox, but it was rejected, with grace, by a production executive, Bertram Bloch, with a good analysis of the story's strengths and weaknesses (Box 2, folder 17).

14. "The Hip Generation," verso of first page of "Details of the 'Day When Everything Happened.'"

15. William Cannastra was also a friend of W. H. Auden's and knew Howard Moss and Tennessee Williams. The parties in his apartment were often frenzied, occasionally orgiastic, affairs, and Cannastra, when in the company of others, was loud and excitable, like "Wayne." He was killed when, clowning in a moving subway car, he stuck his body out of the window just before the train entered the tunnel.

16. [Jack Kerouac]. "CAST OF CHARACTERS IN 'ON THE ROAD' AS RECONCEIVED FEB. 15, 1950," typescript with holograph emendations in pencil, February 15, 1950, 1 p.; Kerouac Archive, Box 1, folder 33.

17. Jack Kerouac. *EARLY 1950 Notebook*, holograph in pencil on lined, spiral notebook paper, February 15–March 20, 1950, signed, 22 p. (11 leaves); Kerouac Archive, Box 55, folder 3.

18. The one-page Breton draft opens, "About myself there is little to say. I was born a mute, and my name is Nicholas Breton": Kerouac Archive, Box 2, folder 4. Kerouac notes that "An English poet by that name, not a mute, lived in Queen Elizabeth's time," and quotes from a love poem that Breton wrote. Breton was not Kerouac's fictional creation, but a real poet (1545?–1626), the son of a wealthy Essex merchant, who wrote religious and pastoral poetry, verse satires, and prose. Although he was a Protestant, his poetry is filled with references to the Virgin and Mary Magdalene, which would have appealed to the Roman Catholic Kerouac.

The one-page Duchamp fragment (Kerouac Archive, Box 2, folder 9), in which the name "Ben Boncoeur" is also suggested but crossed out, contains a chronology for the novel covering the period 1924–50. As in the February 1950 "On the Road" cast of characters list, the hero, unlike Kerouac, played minor league baseball. Kerouac had originally begun the chronology with 1922, the year of his own birth, which was intended to be the birth date of Duchamp, but changed it to 1924. He also indicates that he now conceives of *The Town and the City* and *On the Road* (the new Galloway novel) as the first two novels in an extended series: "part I 'Home,' part II 'On the Road,' as Wolfe & Dos Passos were divided (& Galsworthy?) and of course Céline."

19. [Jack Kerouac]. "'*Road*'" *Workbook*, holograph notebook in pencil, in sewn notebook, July 1950, [144] p. (76 leaves, not including 32 blanks), with 13-p. (9-leaf) insert, in pencil, pen, and typewriter; Kerouac Archive, Box 2, folder 13. In this very journal, in an entry dated October 6, Kerouac has written a one-page treatment of a stage play about the Civil War, which features two Southern brothers competing for the love of a Northern woman, a fatal duel between prospective fathers-in-law, matricide, suicide, and madness.

20. He also calls her "the Jinny bitch," referring to Jinny Baker, the woman with whom he fell in love in the summer of 1948, but who ultimately rejected him. Years later, he stapled a newspaper photo of a bathing suit–clad Shirley MacLaine onto the journal entry for June 25, 1948, in his *Forest of Arden* notebook (see Chapter 2, note 37), writing on the clipping "Jinny's exact likeness."

21. Also in July 1950, Kerouac compiled a list of characters, "Cast of Road," and a three-column "Outline of first sev. chapters," for a "Road" novel draft bearing five possible working titles: "The Wild Americans"; "('Along the Wild Road')"; "On the Road"; "Hoodlum Saints"; "Hipster Saints" (Kerouac Archive, Box 1, folder 20). In the list of characters we find the Boncoeurs again, as well as [Ray] Smith, the narrator, who was also the narrator-hero of Kerouac's unpublished *Ray Smith Novel* (its working title) of 1948 (see note 4 above). The outline reveals that Kerouac was already planning the book that would become *Visions of Cody*, about the life of Neal Cassady (here "Dean Pomeray") before he came to New York. Kerouac instructs himself to "Write a private metaphysical novel—and save yourself for Road. Write, in fact a metaphysical Dark Corridor." The private metaphysical novel may be the book that became *The Town and the City*, and which was almost finished. "Dark Corridor" was a short story in the form of a dramatic monologue that he wrote in 1944, which formed part of his "Self-Ultimacy" papers (Kerouac Archive, Box 43, folder 3).

22. Jack Kerouac. *Private Ms. of Gone on the Road Complete First Treatment And With Minor Artistic Corrections*, typescript with holograph pencil emendations and two pages of penciled holograph on versos, signed, August 1950, 33 p. (33 leaves, including title leaf and one blank leaf; final page of text on verso of penultimate leaf): Kerouac Archive, Box 1, folder 37. The identity of the continuation manuscript is yet to be determined.

23. America's involvement in the Korean War began within days of the war's commencement on June 25, 1950.

24. But as in most pre-scroll versions, the missing father remains an important part of the

plot. Although this feature of the protagonists' lives was borrowed from Cassady's life story, Kerouac seems to have felt it as well, perhaps because of his conflict with Leo. The last line of the published version of *On the Road* implies that Cassady's search for his father, Old Dean Moriarty, "the father we never found," was a metaphor for the search in which all of the novel's on-the-road characters were engaged.

25. [Jack Kerouac]. *American Times*, October 2–4, 1950, [Nos.] 1–3, holograph in pencil in newspaper format, 6 p. (4 leaves); Kerouac Archive, Box 1, folder 3.

26. Kerouac placed this sheet in the Archive folder immediately following the one that houses *American Times*. An indication that Kerouac still considered *Doctor Sax* as part of *On the Road* is that he exclaims in an asterisked note, "Doctor Sax told by Doctor Sax himself!"

27. [Jack Kerouac]. "On the Road, Écrit en Français," holograph in pencil on lined, three-holed paper, January 19, [1951], 10 p. (5 leaves); Kerouac Archive, Box 2, folder 41.

28. [Jack Kerouac]. "'BEN BONCOEUR' EXCERPT (Written Jan. 1951 in Richmond Hill) / EXAMPLE OF HOW TO BEGIN A GREAT NOVEL," holograph in pencil on lined, three-holed paper, 34 p. (17 leaves) numbered 1–33; Kerouac Archive, Box 2, folder 42. He has also written on the slip, "(Good) (Influenced by [Feodor Dostoevsky's] 'The Possessed')."

29. [Jack Kerouac]. "Love and Sadness, A Drama on the Racks: Whither Goest Thou, America?," holograph in pencil on lined, three-holed paper, two drafts, [late March 1951], 4 p. (2 leaves); Kerouac Archive, Box 2, folder 44.

30. The scroll and published versions of the novel's final paragraph are virtually identical except for the passage about children crying and Pooh-Bear, which Kerouac added in 1956 to the first of the two extant post-scroll typescript drafts (see Chapter 4).

31. [Jack Kerouac]. *LA NUIT EST MA FEMME / LES TRAVAUX DE MICHEL BRETAGNE*, holograph in pencil on lined, three-holed paper, February–Spring 1951, 57 p. (30 leaves), not including title page in blue pen on three-holed paper, "LA NUIT EST MA FEMME, Winter–Spring, 1951"; Kerouac Archive, Box 15, folder 20.

32. [Jack Kerouac]. "MICHAEL BRETAGNE" [excerpts from *La Nuit Est Ma Femme*, translated into English], typescript with penciled emendation, early 1951, 2 p. (2 leaves); Kerouac Archive, Box 15, folder 21.

33. Jack Kerouac. "Flower That Blows in the Night," typescript with holograph emendations in pencil, signed, [March 11–12], 1950, 13 p. (13 leaves); Kerouac Archive, Box 1, folder 35.

34. In the penciled note on the first page, just below the crossed-out paragraph about hipsters, Kerouac wrote that Robert Giroux, his Harcourt, Brace editor, retitled this piece "GO GO GO" in March 1950. Kerouac's *Early 1950 Notebook* (see note 17 above) dates the composition of "GO GO GO" more specifically, to March 11–12.

35. [Jack Kerouac]. "WATSON'S GANG," holograph in pencil on paper, [February or March 1951], 4 p. (1 leaf folded in half); Kerouac Archive, Box 15, folder 24. Quotation from p. [2].

36. Jack Kerouac, *Visions of Cody*. Introduction by Allen Ginsberg (New York: McGraw-Hill Book Company, 1972), pp. 66–67.

37. [Jack Kerouac]. Table of characters, events, and chronology, 1946–51, for a proto-version of the "Road" novel, holograph in pencil, [1951], 1 p., with outline map of the United States on verso; Kerouac Archive, Box 3, folder 10.

38. Jack Kerouac. "ON THE ROAD PROSPECTUS," typescript, signed "John Kerouac," [March? 1951], 2 p. (2 leaves); Kerouac Archive, Box 15, folder 26. Quotation from p. 2. The dating of this piece derives from internal evidence as well as its place in the alpha-numeric organizational system that Kerouac imposed on about a third of his Archive. In Kerouac's organizational scheme, the prospectus follows the *La Nuit Est Ma Femme* typescript, which was completed probably about a month before he began composing the scroll on April 2 or 3.

Chapter 4: "*On the Road*: The Scroll and Its Successors"

1. [Jack Kerouac]. [*On the Road*], typescript scroll, with holograph emendations in pencil and blue pen(?), with note in pencil in outer margin at end, [April 1951], 119' 5" long; from the collection of James Irsay.

2. This had been the apartment of William Cannastra, with whom Joan Haverty had been living when he was killed in the subway accident mentioned in Chapter 3, note 15.

3. Jack Kerouac. "(Original Self-Instructions List for composing On The Road 1951) (Sat at side of typewriter as Chapter guide)," typescript with holograph penciled emendations, [April 2?], 1951, 1 p. (1 leaf), and with holograph in blue pen on paper slip containing description attached; Kerouac Archive, Box 2, folder 45.

4. In 1958 Kerouac typed out a list of his residences from May 1951 to April 1958, called "Jack's Whereabouts Since 1951," which he updated by hand in 1960, 1961, and 1962. In it he notes the Haverty apartment address for May 1951 and adds parenthetically "(told by wife to leave house)." For June 1951 he lists his "whereabouts" as "lost at W. 21st Street, living

with Lucien and Allen" (Kerouac Archive, Box 13, folder 5).

5. Kerouac had asked Ginsberg to act as his literary agent after he completed the scroll. The earliest known letter from Kerouac to Cowley dates from November 21, 1953 ([Jack Kerouac]. Typed carbon copy letter, with holograph excision in pencil, to Malcolm Cowley, November 21, 1953, 1 p.; Kerouac Archive, Box 64 folder 16; original, signed, in Newberry Library), in which he addresses him as "Mr. Cowley" and refers to Arabel Porter, the editor of the anthology *New American Writing* (see below), which published one of his pieces, indicating that Cowley was already acting as his agent.

6. Jack Kerouac. Typed letter, unsigned, to Malcolm Cowley, August 6, 1954, 1p. The letter is in the Newberry Library.

7. Malcolm Cowley. Typed letter, signed, to Jack Kerouac, July 12, 1955, 1 p.; Kerouac Archive, Box 64, folder 16.

8. Malcolm Cowley. Typed letter, signed, to Jack Kerouac, September 16, 1955, 1 p.; Kerouac Archive, Box 64, folder 16.

9. Jack Kerouac. *On the Road* [*The Beat Generation* excised], typescript with numerous holograph excisions in black crayon and additions in pencil, signed, [1955–56], 295 p. (paginated 1–297, with pagination skipping p. 136 and p. 166), plus title page and chapter contents page (297 leaves); with holograph account in pencil of childhood walk in winter, on versos of pp. 46–35, and 4 lines about Neal Cassady on verso of p. 1; Kerouac Archive, Box 25.

10. Jack Kerouac. *ORIG. EDITORS' TYPED MS. of "ON THE ROAD,"* typescript with holograph emendations in pencil, and with numerous excisions and emendations in (two?) editors' hands, in red and blue pencil and blue pen, with manila postal envelope addressed to Kerouac (City Lights, San Francisco, address crossed out, replaced with Orlando address), postmarked 1957, but dated "1953" in black felt marker below "BEAT GENERATION" and "'ROAD,'" 1953–54, late 1955, 1956, 340 leaves; Kerouac Archive, Box 26.

11. The typescript is composed of two different paper stocks, the mingling of which, with one significant exception (the addition of the passage about Cassady being a "western kinsman of the sun"), is confined to the second half of the typescript; but the additions and excisions of text are not linked to the stock of paper on which they are typed.

12. I am indebted to John Sampas for this information, as well as for drawing my attention to the significance of Kerouac's having crossed out the Lord/Colbert name and address.

13. In a letter of September 20, 1955, Kerouac tells Cowley, "Any changes you want to make okay with me. Remember your idea in 1953 to dovetail trip No. 2 into Trip No. 3 making it one trip? I'm available to assist you in any re-arranging matters of course" (Jack Kerouac. Typed letter, signed, to Malcolm Cowley, September 20, 1955, 2 p.; Newberry Library).

14. Toward the end of the famous scene in a San Francisco jazz club, someone has written in the margin of p. 224, beside the red pencil–highlighted name "Connie Jordan": "who is he? name, libel?" Kerouac would not have had to ask himself this question. He knew that Connie Jordan was a tenor saxophonist. The editor, however, is concerned about libel, and so wants to know if the name is real or a pseudonym. Having learned the truth, perhaps from Kerouac, perhaps from a Viking researcher, the editor supplies the pseudonym "Ronnie Morgan."

15. A photocopy of this memo is in the possession of John Sampas.

16. The scroll contains approximately 8,700 lines, with about 16 words per line = 139,200; the second typescript contains about 11,286 lines, with about 14 words per line = 158,004; and the "third" typescript contains about 9,716 lines, with about 18 words per line = 174,888.

17. In most cases, the underlying text is impossible to read with the naked eye, and will require technological intervention, which is a task that still waits to be carried out.

18. Malcolm Cowley. Typed letter, signed, to Jack Kerouac, October 12, 1955, 1 p.; Malcolm Cowley. Typed letter, signed, to Jack Kerouac, November 8, 1955, 1 p., annotated and signed by Kerouac "JK." See note 8 above for the letter of September 16. All three letters are in the Kerouac Archive, Box 64, folder 16.

19. Sterling Lord. Typed letter, signed, to Jack Kerouac, February 29, 1956, 1 p.; Kerouac Archive, Box 64, folder 16.

20. Malcolm Cowley. Typed letter, signed, to Jack Kerouac, March 21, 1956, 1p.; Kerouac Archive, Box 64, folder 16.

21. Book One: "Get High and Stay High"; Book Two: "I Can Drive All Night": Book Three: "A Hundred and Ten Miles an Hour"; Book Four: "The Bottom of the Road"; Book Five: "'Can't Talk No More ... [.]'"

22. Kerouac was in Mexico City from September to November 1956, during which period this insert was written. The dating of the insert to no earlier than September 1956 constitutes virtually incontrovertible proof that the added portions of the "third" typescript date from no earlier than November 1956, when Kerouac returned to New York, where the note-

book insert would have been copied during the production of the composite "third" typescript; see MORE MEXICO BLUES / WASHINGTON DC BLUES / POEMS 1957 (see Chapter 1, note 27).

23. Although the comparison would be blasphemous, one wonders whether Kerouac saw himself playing the role of St. John the Baptist to Cassady's Jesus.

24. Kerouac Archive, Box 72, folder 36.

Chapter 5: "The Buddhist Christian"

1. A bodhisattva is an enlightened being who is dedicated to assisting all sentient beings to become enlightened.

2. [Jack Kerouac]. "My Sad Sunset Birth," typescript, [1941], [1] p.; Kerouac Archive, Box 32, folder 3.

3. "Thought," pp. 2–3 in: [Jack Kerouac]. 1940, holograph journal in pencil and pen (and epigram in purple crayon probably added later), in sewn notebook, signed on various pages, November 3, 1940–July 22, 1941, 47 p. (34 leaves) not including blanks; Kerouac Archive, Box 53, envelope 1. Kerouac's early interest in Eastern religions is confirmed by an undated, typed "Book List" in which he tells himself to "Delve into Chinese and Hindu thought," which can be dated to 1941 based on its proximity to dated papers in the Archive see Kerouac Archive, Box 5, folder 59.

4. Pp. 5–6 in: [Jack Kerouac]. Holograph notes on Hinduism, literary composition, authors, and literary projects, in pencil, in sewn notebook, lacking front cover, October 1942, 22 p. (16 leaves); Kerouac Archive, Box 6, folder 67.

5. [Jack Kerouac]. 1946 Journals, holograph journal in pencil, in spiral notebook, June 30, 1946, [37] leaves plus 1 leaf laid-in; Kerouac Archive, Box 53, envelope 10.

6. Jack Kerouac. JOURNALS 1948 / Journal 1939–1940, holograph in pencil on lined paper, in sewn notebook, signed on front cover; Kerouac Archive, Box 54, envelope 8. Quotation from p. 7.

7. Descartes reasons thusly in his "Fifth Meditation": "But if the mere fact that I can produce from my thought the idea of something entails that everything which I clearly and distinctly perceive to belong to that thing really does belong to it, is not this a possible basis for another argument to prove the existence of God? Certainly, the idea of God, or a supremely perfect being, is one that I find within me just as surely as the idea of any shape or number. And my understanding that it belongs to his nature that he always exists is no less clear and distinct than is the case when I prove of any

shape or number that some property belongs to its nature."

8. Jack Kerouac. The Long Night of Life, holograph in pencil, in sewn notebook, signed "John Kerouac," early 1956, 25 p. (13 leaves, with approx. 10 leaves torn out of front); Kerouac Archive, Box 51, envelope 4. The four chapters of "Long Night" are "My Discovery of the Dharma"; "Birth"; "The Castle"; and "Gerard." Into Volume X of The Sacred Books and Early Literature of the East, "India and Buddhism in Translation," which is now in the Archive, Kerouac pressed a tree leaf, in an opening from the Dhammapada, a series of 423 verses in Pali proclaimed by the Buddha on 305 occasions.

9. Kerouac also inserted a tree leaf in "India and Buddhism in Translation" at the beginning of the Dana Paramita, a discourse on the practice of charity, and at the beginning of the Diamond Sutra, one of the Buddha's fundamental teachings and the sutra Kerouac most often cited in his Buddhist writings.

10. Dharma (A) 1953 (see Chapter 1, note 5). Quotation from p. [47].

11. [Jack Kerouac]. Dharma (1), holograph in pencil, in spiral notebook, December 9, 1953–May 14, 1954, [72] leaves; Kerouac Archive, Box 49, envelope 2. Quotation from 8th page, verso, from beginning.

12. [Jack Kerouac]. Dharma (4), holograph in pencil, in spiral notebook, Fall 1954–January 1955, [69] leaves; Kerouac Archive, Box 49, envelope 5. Quotation from 15th leaf from end, recto.

13. Jack Kerouac. Book of Dreams, illuminated carbon typescript with holograph notes, signed, [1960], 293 p. (not including blank leaves used as section dividers, 4 full-page drawings in colored pencil, and one drawing in colored pencil affixed to blank leaf); Kerouac Archive, Box 48, folders 14–15.

14. [Jack Kerouac]. Dharma (5), holograph in pencil, in spiral notebook, January 2–February 3, 1955, [56] leaves; Kerouac Archive, Box 49, envelope 6. Quotation from leaf 22, recto.

15. The date of composition of the Yoga Sutras is disputed, but estimates range between 200 B.C.E. and 400 C.E. Kerouac wrote about the doctrine of karma at length in the Dharma and Dharma Bums notebooks, as well as in later notebooks and diaries. He believed absolutely in the doctrine's truth. In September 1956, in Mexico City, he ascribes to his karma the difficulty of his and even the world's situation. Burroughs, he records, has put him out of his bed (he fears that a woman who has invaded his room may kill him) though he is suffering from "dysentery cramps," and he must lie on

the stone floor with "cockroaches & bedbugs." Meanwhile, Burroughs, having taken too much Secanol, is urinating in the bed. To make matters worse, Kerouac is encountering resentment at being a "gringo" in Mexico City, which he now calls "a land of vicious idiots." "The whole world is getting sick—War coming—" And what is the reason for all of this suffering? "All because I killed that mouse [recounted in *The Dharma Bums*] & abdicated my position as holy angel of heaven—"

16. Leaf 7, recto, in: [Jack Kerouac]. *Dharma (6)*, holograph notebook in pencil, in spiral notebook, February 4–March 30, 1955, [54] leaves; Kerouac Archive, Box 49, envelope 7. This notebook also includes what Kerouac calls the "First chapter for Road & Path," a narrative of the spiritual journey of Peter Martin, the central character of *The Town and the City*.

17. [Jack Kerouac]. *Dharma (7)*, holograph in pencil, in sewn notebook, April 3–July 4, 1955, [70] leaves; Kerouac Archive, Box 49, envelope 8.

18. Kerouac uses the Hindu term "Atman," which is traditionally applied either to the individual soul or, for those who do not accept the reality of such an entity, to the impersonal divinity that coexists both "within" and "without" each being, filling the cosmos.

19. *Dharma (8)* (see Chapter 1, note 8). "Samadhi" is a Sanskrit word meaning "to establish or make firm," and in both Hinduism and Buddhism it refers to a non-dualistic state in which the unity of all existence, including all consciousness, is seen.

20. Jack Kerouac. *Wake Up*, typescript with holograph and typescript title page and several holograph emendations in pencil, signed "Prepared by Jack Kerouac," 1955, 122 pages (122 leaves, excluding initial two blank leaves) including title page and "Author's Note" page; Kerouac Archive, Box 51, folder 6.

21. Jack Kerouac. *Some of the Dharma*, typescript, with blue pen and pencil holograph emendations, signed, 1953–56, 385 p. (not including page with design for "Confessions Concerning the Vanity of Duluoz [...]"); Kerouac Archive, Box 50, folders 1–4. Quotation from p. 105.

22. [Jack Kerouac]. *Dharma (1956) Desolation Peak*, holograph notebook in pencil, in spiral notebook, June 18–September 26, 1956, [90] leaves; Kerouac Archive, Box 56, envelope 1.

23. Ibid., leaf [34], recto.

24. Kerouac wrote about this painting to Peter Orlovsky, Ginsberg's partner, in a letter of October 11, 1956: "My most recent painting now is an oil painting called 'God'—it shows his sad & beautiful face in the sky— [...] his

mouth is a marvel of expression, as if he's saying 'Aw poor Peter—poor Allen—poor Gregory [Corso]—poor Laff [Lafcadio Orlovsky, Peter's brother] in the dishpans—poor Jack on the roof [...].'" Quoted in Ed Adler, *Departed Angels: The Lost Paintings* (New York: Thunder's Mouth Press, 2004), p. 197. The phrase "poor Jack on the roof" is an allusion to his living, at the time of writing, on the top floor of a small apartment building in Mexico City.

25. [Jack Kerouac]. *1958 ORLANDO BLUES / NORTHPORT FIRSTDAYS*, holograph diary in pencil and blue pen, in spiral notebook, February 20–June 25, 1958, 114 p. (56 leaves, including 1 leaf laid-in); Kerouac Archive, Box 56, envelope 10. The sketches are on leaf 24, recto, and leaf 26, recto, respectively.

26. [Jack Kerouac]. *FEB '57 / Bila Kayf*, holograph diary in pencil, in spiral notebook, January 7, 1957–February 21, 1957, [110] p.; Kerouac Archive, Box 56, envelope 2.

27. [Jack Kerouac]. *Fall 1959–To 1960 (Jan.)*, holograph diary in pencil, in spiral notebook, October 2, 1959–January 6, 1960, 176 p. (87 leaves); Kerouac Archive, Box 57, envelope 1.

28. Entry for July 5, 1961, in: [Jack Kerouac]. *MEXICO 1961 FIRST WEEKS*, holograph diary in pencil and pen, in spiral notebook, June 28–July 5, 1961, 62 p. (30 leaves); Kerouac Archive, Box 57, envelope 28.

29. At Gary Snyder's urging, Kerouac wrote a sutra, *The Scripture of the Golden Eternity*, in 1956; it was published in 1960.

30. In 1963, Kerouac painted a portrait of Pope John's successor, Paul VI, while he was still Giovanni Cardinal Montini.

31. [Jack Kerouac]. "Book of Prayers," holograph in pencil on spiral notebook paper, 1962, [3] p. (3 leaves); Kerouac Archive, Box 12, folder 49.

Chapter 6: "On Writing and the Creative Act"

1. P. 3, in: *1945 Journals* (see Chapter 2, note 36).

2. *1949 JOURNALS / 1949 ROAD-LOG* (see Chapter 3, note 7).

3. Leaf 14, recto, in: [Jack Kerouac]. *1957 Notes Orlando*, holograph in pencil and colored crayons, in spiral notebook, including *Play Act III Beat Generation*, notes for *Memory Babe* and about *The Dharma Bums*, and poems, prose, and sketches, November 9, 1957–February 8, 1958, 72 leaves; Kerouac Archive, Box 55, envelope 7.

4. Entry for February 7, 1965, in: *Jan.–Feb. '65* (see Chapter 1, note 28).

5. In 1956, he asserts (18th leaf from end, verso) in the *Dharma (8)* journal (see Chapter 1, note 8): "I'm in the same position as Mozart or

Rembrandt, I have complete mastery of my art but only a handful of people care to concede it."

6. [Jack Kerouac]. "Essentials of Modern Prose," holograph in pencil with emendations, with typescript fragmentary draft of "NOTES ON MODERN PROSE," excised, at head of first page, with later holograph title in blue pen and dating in red pen, 1953, 2 p. (1 leaf); Kerouac Archive, Box 16, folder 49.

7. In Kerouac's 1963 "Written Address to the Italian Judge," a lecture in the form of a letter to a judge presiding over a trial, apparently fictional, in which Kerouac is being charged with obscenity for his novel *The Subterraneans*, he describes the novel's style, which he says he has invented: "whereby the author stumbles over himself to tell his tale, just as breathlessly as some raconteur rushing in to tell a whole roomful of listeners what has just happened, and once he has told his tale he has no right to go back and delete what the hand hath written [....] This decision, rather, this vow, I made, with regard to the practice of my narrative art, frankly, Gentlemen, has its roots in my experience inside the confessionals of a Catholic childhood. It was my belief then that to withhold any reasonably and decently explainable detail from the Father, was a sin, although you can be sure that the Father was aware of the difficulties of the delicacy involved. Yet all was well." Typescript carbon, May 23, 1963, 4 p. (4 leaves); Kerouac Archive, Box 12, folder 47.

8. In the diary for the summer of 1957 (Jack Kerouac. *1961[:]MEXICO LAST DAY + ORLANDO and ORLANDO LATE SUMMER*, holograph diary in pencil and blue pen, in spiral notebook, late Summer 1961, [30] leaves; Kerouac Archive, Box 57, envelope 13), which he spent in Mexico City, Kerouac writes on August 20: "1. The Duluoz Legend continues[.] 2. But no longer has to be written in sprinting, spontaneous prose except when I feel like it—When you're 40 it's time for the old athlete to walk, not run (Kerouac's 2nd period)—3. All installments OF the Legend since the first one, ROAD, have been about a central person or group of persons & will continue so, as character studies in full depth[.] 4. To bring absorbed pleasure into the rest of my life, work, I'm allowed to go slow, discuss, hearken back or forward, all I want—or run if I want, on any page[.]" And in a diary entry of July 30, 1963 (*Summer & Fall 1963*; see Chapter 1, note 20), after citing Ezra Pound's dismissal of *Finnegans Wake* as "bourgeois technique," Kerouac draws an analogy from this criticism to aspects of Céline's and his own work, saying that both he and Céline "just blew [their] stories out [...] but lately I've been contemplating slower technical absorbing exercises—!? Who Knows[.]"

9. Leaf 32, recto, in: [Jack Kerouac]. *Northport / Sketches (1) / Summer '58*, holograph diary in pencil, in spiral notebook, June 19–Labor Day [September 1] 1958, [68] leaves; Kerouac Archive, Box 56, folder 11. Quotation from leaf [32], recto.

10. In 1957, in Mexico City, Kerouac wrote in his diary a pornographic prose poem to Dickinson, which begins innocently enough: "Sweet Emily Dickinson, who played with your hair? Who counted the pimples on your moonlight chin? Who wiped away the smut of your disregard of natural phenomena in hairy men? Who taught you love of cock? Who taught you cunt? O sweet Emily, if death stepped in your proud door, did I, the lily weep? Did I the marble gated phagri bleed iron chocolate tears? Meet you in the churchyard"; in: *Mexico Summer 1957* (see Chapter 1, note 25).

11. Entry for August 20, 1961, in: *1961 Mexico[:]Last Day + Orlando and Orlando Late Summer* (see note 8 above).

12. Jack Kerouac. "HISTORY OF THE THEORY OF BREATH AS A SEPARATOR OF STATEMENTS IN SPONTANEOUS WRITING," typescript with holograph emendations in pencil, and holograph page, signed, dated 1962 in red pen, 3 p. (2 leaves); Kerouac Archive, Box 12, folder 39.

13. In June 1963, John Clellon Holmes sent Kerouac a list of questions for an article that he was writing on him. Kerouac's draft replies (see Chapter 1, note 13) to several questions differ significantly from the typed and published replies. Kerouac says that he is indebted to Ginsberg for introducing him "to surrealism as well as to the Dark Archangel demoniac vision of lines in poetry, & to free use of everyday language in poetry." However, this acknowledgment of a debt does not survive in the typescript or the published text.

14. Allen Ginsberg Archive, Stanford University.

15. The fullest treatment of Kerouac's art is Ed Adler's *Departed Angels: The Lost Paintings* (New York: Thunder's Mouth Press, 2004).

16. Ibid., p. 139.

17. Kerouac pasted a cut-out of Soutine's name and a reproduction of one of his paintings into a scrapbook that he compiled around 1967 and jokingly attributed to "Mémère." The scrapbook (in the Berg Collection) contains collages of newspaper and magazine advertisements, placed in amusing and ribald juxtapositions, and accompanied by an occasional ribald remark in his hand; political cartoons; pictures of cats; and reproductions of photographs of artists and their work.

18. Müller, with her husband, Jan, founded the Hansa Gallery, an artists' cooperative in New York, in 1952; it was disbanded in 1959. In the diary entry for February 5, 1959, Kerouac writes, "I'm going to Ask Dody to marry me"; [Jack Kerouac]. *Winter 1958–59*, holograph diary in pencil and blue pen, in spiral notebook, December 14, 1958–March 15, 1959, [130] p. (64 leaves); Kerouac Archive, Box 56, envelope 13.

19. *1957 / Berkeley Way 1957* (see Chapter 1, note 4).

20. *Winter 1958–59* (see note 18 above).

21. Entry for July 31, 1963, in: *Summer & Fall 1963* (see Chapter 1, note 20).

22. In a diary entry from 1953, Kerouac reacts to a derogatory remark by Gore Vidal about Malcolm Cowley, Kerouac's editor and advocate at Viking, as an attempt by Vidal to make himself the "new critic of the new generation," a role that, Kerouac feels, Vidal is not qualified to assume, since, in Vidal's judgment, America's three best writers are Paul Bowles, Carson McCullers, and Tennessee Williams. Kerouac savages all three, calling Bowles "a second rate re-hasher of anecdotes about foreign countries"; McCullers, "a silly pretentious cunt with a flair for follies[?]"; and Williams, a "mediocre dramatist" who "only degrades Women every chance he gets." The contemporary "great" American writers, Kerouac says, are himself, "Burroughs, Ginsberg, possibly Huncke, possibly Fitzgerald (Jack), maybe even Henry Dressler (who knows)—"; Jack Kerouac. *1953:—NOTES AGAIN—:*, holograph in pencil, on paper torn out of sewn notebook, containing diary entries November 20–December 3, 1953, 9 p. (5 leaves); Kerouac Archive, Box 18, folder 8.

23. Entry for July 13, 1961, in: [Jack Kerouac]. *Mexico Last Weeks*, holograph diary in pencil, in spiral notebook, July 6–21, 1961, 52 p. (30 leaves, not including inside of covers); Kerouac Archive, Box 57, envelope 12.

24. Entry for August 6, 1963, in: *Summer & Fall 1963* (see Chapter 1, note 20).

25. In his draft response (see Chapter 1, note 13, and note 13 above) to one of John Clellon Holmes's questions, Kerouac says of Burroughs: "A master of English prose & possibly an important medical scientist for all I know—Charming dinner companion & companion of afterdinner strolls on Boulevards—Masterful raconteur, private lecturer—A Faustian Wizard—Genius of language[.]" Asked by Holmes who are his literary forebears, Kerouac answers, Thomas Wolfe, Walt Whitman, Herman Melville, and Henry David Thoreau.

26. Jack Kerouac, *Selected Letters, 1957–1969*, ed. Ann Charters (New York: Viking, 1999), p. 342.

27. "Shakespeare," in: [Jack Kerouac]. *C*, holograph notes in pencil, in spiral notebook, with notes also on James Joyce and Balzac, an outline for *Vanity of Duluoz*, football reminiscences, draft of "Voyage of the Noisy Gourmets," draft of "MC" [Mexico City?], and drafts of letters, beginning November 21, 1963, [51] leaves; Kerouac Archive, Box 42, envelope 3.

28. Jack Kerouac. Autograph letter (pencil on spiral notebook paper), signed, to Hugo Weber, [April? 1962], 1 p.; Kerouac Archive, Outgoing Correspondence, Box 75.

29. *Visions of Cody*, p. 63.

30. *Vanity of Duluoz*, Book Thirteen, Chapter XIV, p. 268.

31. Ibid., Book Eleven, Chapter XIV, p. 207.

Checklist of
Works
Illustrated

With the exception of the scroll typescript of *On the Road*, all works illustrated are from the collections of The New York Public Library's Humanities and Social Sciences Library, predominantly the Henry W. and Albert A. Berg Collection of English and American Literature, which houses the Jack Kerouac Archive and the William S. Burroughs Archive.

In dimensions, height precedes width. For manuscripts and typescripts, height only is given.

Titles of artworks are rendered in three ways. Titles assigned by Kerouac are given in quotation marks. Titles assigned by Ed Adler, in his *Departed Angels: The Lost Paintings* (New York: Thunder's Mouth Press, 2004), are given in quotation marks and enclosed in square brackets. Titles assigned by the present author are given in brackets, without quotation marks.

1.1 Allen Ginsberg, photographer. "Jack Kerouac Avenue A across from Thompkins [sic] Park 1953 New York, his handsome face looking into barroom door—This is best profile of his intelligence as I saw it Sacred, time of <u>Subterraneans</u> writing." Black-and-white photograph, signed, [October?] 1953. 11" x 14". The Miriam and Ira D. Wallach Division of Art, Prints and Photographs, Photography Collection.

1.2 Allen Ginsberg, photographer. "Wise Herbert Huncke, grateful for the attention, a knowing look. 1984." Black-and-white photograph, signed. 11" x 14". The Miriam and Ira D. Wallach Division of Art, Prints and Photographs, Photography Collection.

1.3 Jack Kerouac, artist. "Morningside Heights." Pencil sketch, signed "JK," April 30, 1957. 6" x 4". In: *FEB.–May '57*, holograph diary in pencil, in spiral notebook. Kerouac Archive, Box 56, envelope 3.

1.4 Unknown photographer. Black-and-white photograph of Allen Ginsberg, early 1940s. 5" x 4". Berg Collection, Box PB2.

1.5 [Allen Ginsberg]. "Strophes: Howl for Carl Solomon / first page sample of 5 page work in progress." Typescript draft, [1955?], 1 p. 11" h. Berg Collection, Box AC2.

1.6 [Gordon Ball[, photographer. Color photograph of Allen Ginsberg and Peter Orlovsky at kitchen table, [June 1996], 8" x 11". Berg Collection, s7.

1.7 Allen Ginsberg, photographer. "W. S. Burroughs explaining cycles of History to the Charming Young American Jack Kerouac. Photo by the Well-Groomed Hungarian, 1953." Black-and-white photograph, signed. 11" x 14". The Miriam and Ira D. Wallach Division of Art, Prints and Photographs, Photography Collection.

1.8 William S. Burroughs. "Panama: Paregoric gags you" [first line]. From: "Original material for Naked Lunch and Soft Machine, and earlier. Mostly unpublished[.] Material dates from 1954. Most of it was written after 1957 and before 59. Mostly written in basement room of Villa Mouneria" [heading, in blue pen holograph, is taken from folio front cover]. Typescript and holograph, with holograph emendations in pencil and blue pen and underlinings in blue pen, 1954–59, 71 p. 11" h. William S. Burroughs Archive, Folio 17.

1.9 [Victor Bockris], photographer. "Burroughs and Bowie Knife." Black-and-white photograph, 1979. 10" x 8". Berg Collection +Burroughs ZP8 B63 1977 vol. 1, sheet 34.

1.10 Allen Ginsberg, photographer. "Neal Cassady drove Prankster's Further bus to visit Millbrook 1964, I went up from New York with Kesey brothers, [Timothy] Leary joshing Neal.

Election time bus sign: 'A vote for Goldwater is a vote for Fun.'" Black-and-white double photograph, signed, [July] 1964. 14" x 11". The Miriam and Ira D. Wallach Division of Art, Prints and Photographs, Photography Collection.

1.11 Allen Ginsberg, photographer. "Peter Orlovsky age 21[,] Jack Kerouac Age 35[,] William Burroughs Age 43, The Beach Tanger Maroc with boy observer. 1957 March–April." Black-and-white photograph, signed. 11" x 14". The Miriam and Ira D. Wallach Division of Art, Prints and Photographs, Photography Collection.

1.12 Unknown photographer. Sebastian and Stella Sampas, Lowell, Mass., Easter 1943. Sepia-toned snapshot. 4.5" x 3.25". Kerouac Archive, Box 81, sheet 65.

1.13 Allen Ginsberg, photographer. "Probably 704 E. 5 Street Apartment, Kerouac's last visit to my house—a few days after Kesey/Neal Millbrook visit. I had some DMT left. 1964." Black-and-white photograph, signed. 14" x 11". The Miriam and Ira D. Wallach Division of Art, Prints and Photographs, Photography Collection.

2.1 [Jack Kerouac], artist. ["Self-Portrait as a Boy"]. Oil, crayon, charcoal, pencil, and ink on paper, ca. 1960. 13" x 10.5" unframed; in Kerouac's frame. Berg Collection.

2.2 Jack Kerouac, artist. ["The Crucifix Clothesline"]. Pastel, charcoal, and pencil on paper, signed "Jean-Louis Kérouac," ca. 1958. 11.5" x 17.5". Berg Collection.

2.3 [Jack Kerouac], artist. [Two Girls in the Woods]. Oil, crayon, and ink on paper, ca. 1960. 9" x 13.5". Berg Collection.

2.4 [Jack Kerouac], artist. [Boy in the Snow at Night]. Oil and enamel on board, ca. 1958. 11.9" x 12.2". Berg Collection.

2.5 Unknown photographer. Gerard Kerouac. Confirmation photograph, in color, ca. 1927. 10.5" x 8". Kerouac Archive, Box 81, sheet 43.

2.6 Jack Kerouac, artist. [Valentine's Day card to mother]. Crayon and pencil on paper, February 14, 1933. 5" x 3". Kerouac Archive, Box 74, folder 24.

2.7 Unknown photographer. Left to right: Jack Kerouac, Caroline ("Nin") Kerouac, Gabrielle Kerouac, and Leo Kerouac. Black-and-white snapshot in bar, with Kerouac's blue-penned holograph identification of subjects and date on back of snapshot, 1944. 3.5" x 5.75". Kerouac Archive, Box 81, sheet 3.

2.8 [Jack Kerouac]. [List of Women]. Holograph in pencil and pen, 1962, 1 leaf (2 p.). 10.75" h. Kerouac Archive, Box 12, folder 58.

2.9 [Jack Kerouac], artist. "Lilith." Multicolored felt pens on paper, ca. 1964. 11" x 8.5". Berg Collection.

2.10 Jack Kerouac. *Diary / Whole Year of 1936.* Holograph in pencil on lined paper, in bound notebook, January 1–September 17, 1936, 58 leaves (including text on verso of front cover and 2 blanks). 8.5" h. Kerouac Archive, Box 59, sleeve 3.

2.11 Photographer unknown. Jack Kerouac scoring the game's only touchdown for Lowell against Lawrence High School. Black-and-white photograph, [1939]. 3.25" x 4.75". Kerouac Archive, Box 81, sheet 2.

2.12 [Jack Kerouac]. Mock panegyric for Joe DiMaggio written in Italian accent and broken syntax. Typescript on orange paper, [1941?], 1 p. 3.75" h. Kerouac Archive, Box 60, sleeve 27.

2.13 Unknown photographer. Jack Kerouac at bat. Black-and-white photograph in: Horace Mann School for Boys. *The Horace Mannikin.* Fieldston, N.Y.: Horace Mann School for Boys, 1940. 9" h. Berg Collection +Kerouac ZA3 H67 1940.

2.14 Jack Kerouac. *:—Journal—: Fall, 1939.* Holograph journal in black pen on lined paper torn from notebook, signed, September 21–25, 1939, 10 p. (5 leaves). 9.5" h. Kerouac Archive, Box 5, folder 10.

2.15 Sackley Studio, Lowell, Mass. Sebastian Sampas in Army uniform. Sepia-toned photograph, signed by Sampas, [1942]. 9.5" x 6.5" in studio frame. Kerouac Archive, Box 81, sleeve 69.

2.16 [Jack Kerouac], artist. "Stella by Jack." Pencil on lined notebook paper, ca. 1963. 9" x 12". Berg Collection.

2.17 Jack Kerouac. *COLUMBIA / Oxford / WORKING PHILOSOPHY + MINERVA= STABILITY.* Holograph in pencil on lined, three-holed paper, 1940, 48 leaves. 8.5" h. Kerouac Archive, Box 4, folder 2.

2.18 Jack Kerouac. *Diary Beginning June 1, 1941.* Holograph diary in pencil and pen on lined paper, in sewn notebook, signed, with penned comments, June 1–19, 1941, 16 p. (8 leaves). 9.75". Kerouac Archive, Box 6, folder 2.

2.19 Jack Kerouac. ["I am going to stress a new set of values"]. Typescript, [1941?], 2 p. (2 leaves). 11" h. Kerouac Archive, Box 6, folder 11.

2.20 [Jack Kerouac]. *GROWING PAINS or A MONUMENT TO ADOLESCENCE / Voyage to Greenland.* Holograph journal in pencil on lined, three-holed paper, July 18–August 19, 1942 (with second title and epigraph added in blue pen, April 17, 1949), with poem and related short story, "The Communist"; epigram; "General Plan" for a four-part, "free verse" work on humanity's passage from world war to world peace (with part of Part One); "A fellow-scullion's calculations"; variations on similar metaphorical phrases; and his bonus money calculations for overtime; 74 p. (45 leaves) including title page. 8.5" h. Kerouac Archive, Box 47, folder 10.

2.21 Jack Kerouac. *MERCHANT MARINER / FIRST MANUSCRIPT—MARCH, 1943 / THE SEA IS MY BROTHER.* Holograph in pencil on lined, three-holed paper, 1943, 160 leaves including title page with illustration, with holograph note in blue ink on separate leaf of paper, added ca. 1968. 9.5" h. Kerouac Archive, Box 22, folder 9.

2.22 Jack Kerouac. "Liverpool Testament." Holograph in pencil on lined, three-holed paper, with title in purple felt-tipped marker, Liverpool, England, September 24, 1943, 6 p. (3 leaves). 11" h. Kerouac Archive, Box 47, folder 3.

2.23 Jack Kerouac]. "Dialogs in Introspection." Holograph in pencil and red pencil on lined paper 8 p. (8 leaves), from the "1944 'Self-Ultimacy' Period" papers. 9.5" h. Kerouac Archive, Box 43, folder 2.

2.24 Jack Kerouac and William S. Burroughs. *I Wish I Were You (1945) Philip Tourian Story / '45 Ryko Tourian Novel.* Typescript carbon with Kerouac's pencil emendations, first title in holograph pencil, second title in holograph red pen, both authors' names signed by Kerouac in pencil, 1945, 51 leaves (title page on verso of insurance form, leaves 1–32, 35–53, with insurance form comprising final, unfoliated leaf. 11" h. Kerouac Archive, Box 15, folder 19.

2.25 [Jack Kerouac]. "On the Technique of Writing:—." Holograph in black pen on lined paper, 14 p., in spiral notebook "I Bid you Love Me—workbook." Holograph in pen and pencil on lined paper, including conversations with Allen Ginsberg, Joan Vollmer, and John Kingsland; essay "THE SONG OF REBIRTH"; journal entries: poem "PAIN AND POESY"; notes on characters in "Galloway" novel [i.e., *The Town and the City*]; "Letters I should write …"; "Notes On a Projected essay [philosophical principles of his art]"; all in spiral notebook, November 10–December 26, 1944, 29 leaves. 8.5" h. Kerouac Archive, Box 53, envelope 3.

2.26 Jack Kerouac. *"Galloway" And all its appurtenances / "I Bid You Love Me"* [crossed out on title page]. Holograph in ink and pencil on three-holed paper, signed, November 4, 1944, [58] p. (29 leaves), not including title page, numbered 1–26, 32–63, lacking pp. 27–31; bloodstained; from the "1944 'Self-Ultimacy' Period" papers. 9.5" h. Kerouac Archive, Box 43, folder 6.

2.27 Jack Kerouac. *NOTES ON GALLOWAY AND AN AMERICAN PASSED HERE / 1945 DAOULAS "GALLOWAY" / THE PLAN FOR THE NOVEL "Galloway" (Forming a large part of Book Three of "The Town and the City").* Holograph in pencil on three-holed paper and typewritten page and portions of three other pages, with blue, three-holed paper covers (subtitle "1945 DAOULAS 'Galloway,'" in red pen),

signed, September 1945, 69 p. (61 leaves, including covers). 9.5" h. Kerouac Archive, Box 9, folder 2.

2.28 Jack Kerouac. "Notes for an American Passed Here." Holograph in pencil on lined paper, [1945], 18 p. (10 leaves). 10" h. Kerouac Archive, Box 9, folder 10.

3.1 Jack Kerouac. *1947–1948 JOURNALS NOTES.* Holograph journal in pencil, in notebook, signed, June 16, 1947–May 4, 1948, 45 leaves. 8.5' h. Kerouac Archive, Box 54, envelope 6.

3.2 Jack Kerouac. *1947–'48 JOURNALS FURTHER NOTES / Well, this is the forest of Arden—.* Holograph in pencil, in sewn notebook, signed, May 5–September 9, 1948, 47 leaves. 8.5" h. Kerouac Archive, Box 54, envelope 7.

3.3a–b Jack Kerouac. *RAIN AND RIVERS[:] The Marvelous notebook presented to me by Neal Cassady in San Francisco:—Which I have Crowded in Words—:.* Holograph in pencil, in sewn notebook, signed and dated, January 31, 1949, "(Begun) Frisco—," final entry February 1954, with blank entry for 1955 ("Rocky Mt. [N.C.] to Mexico City"), 69 leaves. 9.25" h. Kerouac Archive, Box 55, envelope 1.

3.4a–b [Jack Kerouac]. *1949 JOURNALS / 1949 ROAD-LOG.* Holograph in pencil and blue pen, in spiral ledger notebook, April 27, 1949–July 24, 1950, 51 leaves. 9.75" h. Kerouac Archive, Box 55, envelope 2.

3.5a–d Jack Kerouac. "NIGHT NOTES & Diagrams for ON THE ROAD." Holograph in pencil and blue and violet pen on three-holed paper, signed, completed November 1949, 55 p. (31 leaves). 9.4" h. Kerouac Archive, Box 23, folder 2.

3.6 [Jack Kerouac]. "The Hip Generation, I[.] EARLY APPURTENANCES." Typescript and penciled holograph, with penciled holograph emendations, September 1949, [23] p. (18 leaves, with duplicate numerations). 11" h. Kerouac Archive, Box 4, folder 22.

3.7 Jack Kerouac. *EARLY 1950 Notebook.* Holograph in pencil on lined, spiral notebook paper, February 15–March 20, 1950, signed, 22 p. (11 leaves). 9" h. Kerouac Archive, Box 55, folder 3.

3.8 [Jack Kerouac]. "'Road" Workbook. Holograph notebook in pencil, in sewn notebook, July 1950, [144] p. (76 leaves, not including 32 blanks), with 13-p. (9-leaf) insert, in pencil, pen, and typewriter. 8.75" h. Kerouac Archive, Box 2, folder 13.

3.9 Jack Kerouac. *Private Ms. of Gone on the Road Complete First Treatment And With Minor Artistic Corrections.* Typescript with holograph pencil emendations and two pages of penciled holograph manuscript on versos, signed, August 1950, 33 p. (33 leaves, including title leaf and one blank leaf; final page of text on verso of

penultimate leaf). 12.25" h. Kerouac Archive, Box 1, folder 37.

3.10 [Jack Kerouac]. *American Times*, October 2–4, 1950, [Nos.] 1–3. Holograph in pencil in newspaper format, 6 p. (4 leaves). 12.25" h. Kerouac Archive, Box 1, folder 3.

3.11 [Jack Kerouac]. *LA NUIT EST MA FEMME / LES TRAVAUX DE MICHEL BRETAGNE*. Holograph in pencil on lined, three-holed paper, February–Spring 1951, 57 p. (30 leaves), not including title page in blue pen on three-holed paper, "LA NUIT EST MA FEMME, Winter–Spring, 1951." 9.5" h. Kerouac Archive, Box 15, folder 20.

3.12 Jack Kerouac. "Flower That Blows in the Night." Typescript with holograph penciled emendations, signed, [March 11–12], 1950, 13 p. (13 leaves). 12" h. Kerouac Archive, Box 1, folder 35.

3.13 [Jack Kerouac]. Table of characters, events, and chronology, 1946–51, for a proto-version of the "Road" novel, holograph in pencil, [1951], 1 p., with outline map of the United States on verso. 12" h. Kerouac Archive, Box 3, folder 10.

3.14 Jack Kerouac. "ON THE ROAD PROSPEC-TUS." Typescript, signed "John Kerouac," [March? 1951], 2 p. (2 leaves). 11" h. Kerouac Archive, Box 15, folder 26.

4.1 [Jack Kerouac], artist. "ON The Road: A MODERN PROSE NOVEL." Design for front cover of proposed paperback edition of *On the Road*, in pencil and red pen, with typed note by Kerouac to A. A. Wyn at top, 1952. 11" x 8". Kerouac Archive, Box 16, folder 28.

4.2 [Arvind Garg], photographer. Color photograph of 454 West 20th Street, New York City, 2006. 18" x 12". Berg Collection.

4.3 Jack Kerouac. "(Original Self-Instructions List for composing On The Road 1951) (Sat at side of typewriter as Chapter guide)." Typescript with penciled holograph emendations, [April 2?], 1951, 1 p. (1 leaf). 9.25" h.; with attached holograph in blue pen on paper slip containing description. 3" h. Kerouac Archive, Box 2, folder 45.

4.4a–e [Jack Kerouac]. [*On the Road*]. Typescript scroll, with holograph emendations in pencil and blue pen(?), with note in pencil in outer margin at end, [April 1951]. 119' 5" long. From the collection of James S. Irsay.

4.5a–h Jack Kerouac. *On the Road* [*The Beat Generation* excised]. Typescript with numerous holograph excisions in black crayon and additions in pencil, signed, [1955–56], 295 p. (paginated 1–297, with pagination skipping p. 136 and p. 166), plus title page and chapter contents page (297 leaves); with holograph account in pencil of childhood walk in winter, on versos

of pp. 46–35, and 4 lines about Neal Cassady on verso of p. 1. 14" h. Kerouac Archive, Box 25.

4.6a–g Jack Kerouac. *ORIG. EDITORS' TYPED MS. of "ON THE ROAD."* Typescript with holograph emendations in pencil, and with numerous excisions and emendations in (two?) editors' hands, in red and blue pencil and blue pen, with manila postal envelope addressed to Kerouac (City Lights, San Francisco, address crossed out, replaced with Orlando address), postmarked 1957, but dated "1953" in black felt marker below "BEAT GENERATION" and "'ROAD,'" 1953–54, late 1955, 1956, 340 leaves. 11" h. Kerouac Archive, Box 26.

5.1 [Jack Kerouac], artist. ["Face of the Buddha"]. Pencil on paper, [1958?]. 7.5" x 9.5". Berg Collection.

5.2 Jack Kerouac. *JOURNALS 1948 / Journal 1939–1940*. Holograph in pencil on lined paper, in sewn notebook, signed on front cover. 9.75" h. Kerouac Archive, Box 54, envelope 8.

5.3 Jack Kerouac. *1947–'48 JOURNALS FUR-THER NOTES / Well, this is the forest of Arden—*. Holograph in pencil, in sewn notebook, signed, May 5–September 9, 1948, 47 leaves. 8.25" h. Kerouac Archive, Box 54, envelope 7.

5.4 [Jack Kerouac]. *Dharma (A) 1953*. Holograph in pencil, in spiral notebook, [December] 1953, [59] leaves. 10" h. Kerouac Archive, Box 49, envelope 1.

5.5 [Jack Kerouac]. *Dharma (1)*. Holograph in pencil, in spiral notebook, December 9, 1953–May 14, 1954, [72] leaves. 6" h. Kerouac Archive, Box 49, envelope 2.

5.6a–b [Jack Kerouac]. *Dharma (4)*. Holograph in pencil, in spiral notebook, Fall 1954–January 1955, [69] leaves. 6" h. Kerouac Archive, Box 49, envelope 5.

5.7a–b Jack Kerouac. *Book of Dreams*. Illuminated carbon typescript with holograph notes, signed, [1960], 293 p. (not including blank leaves used as section dividers, 4 full-page drawings in colored pencil, and one drawing in colored pencil affixed to blank leaf). 11" h. Kerouac Archive, Box 48, folders 14–15.

5.8 [Jack Kerouac]. *Dharma (5)*. Holograph in pencil, in spiral notebook, January 2–February 3, 1955, [56] leaves. 6" h. Kerouac Archive, Box 49, envelope 6.

5.9 [Jack Kerouac]. *Dharma (7)*. Holograph in pencil, in sewn notebook, April 3–July 4, 1955, [70] leaves. 6" h. Kerouac Archive, Box 49, envelope 8.

5.10 [Jack Kerouac], artist. *DB (1)* ["Stenobloc" *Dharma Bums*]. Pencil drawing on vertical spiral-bound notebook cover, showing hiker with backpack in mountains, [1956]. 8" x 5". Berg Collection.

5.11 [Jack Kerouac], artist. "Bodhidharma Hoiko." Pencil on paper, ca. 1956. 12.5" x 9.25". Berg Collection.

5.12 [Jack Kerouac], artist. ["The Drinkers"]. Oil and pencil on paper, ca. 1960. 12.5" x 9.25". Berg Collection.

5.13 Jack Kerouac, artist. "God." Oil and pencil on paper, signed "Jean-Louis Kérouac," [September–October, 1956]. 9" x 12". Berg Collection.

5.14 [Jack Kerouac], artist. [The Cross]. Oil on cardboard, ca. 1962. 16" x 12". Berg Collection.

5.15 Jack Kerouac, artist. [The Vision of the Shepherds]. Oil on board, signed "Kérouac," ca. 1962. 14.5" x 18". Berg Collection.

5.16 [Jack Kerouac], artist. "Crucifixion Drawing in Blue Ink." Pen and pencil on paper, ca. 1963. 8.5" x 11". Berg Collection.

6.1 [Jack Kerouac], artist. [Beached Boats at Sunset]. Pastel on cardboard, ca. 1958. 6" x 9". Berg Collection.

6.2 [Jack Kerouac]. "Essentials of Modern Prose." Holograph in pencil with emendations, with typescript fragmentary draft of "NOTES ON MODERN PROSE," excised, at head of first page, with later holograph title in blue pen and dating in red pen, 1953, 2 p. 13.75" h. Kerouac Archive, Box 16, folder 49.

6.3a–b [Jack Kerouac]. *Northport / Sketches (1) / Summer '58*, holograph diary in pencil, in spiral notebook, June 19–Labor Day [September 1] 1958, [68] leaves. 5" h. Kerouac Archive, Box 56, folder 11.

6.4 Jack Kerouac. "HISTORY OF THE THEO-RY OF BREATH AS A SEPARATOR OF STATE-MENTS IN SPONTANEOUS WRITING." Typescript with holograph emendations in pencil, and holograph page, signed, dated 1962 in red pen, 3 p. (2 leaves). 11" h. Kerouac Archive, Box 12, folder 39.

6.5 Jack Kerouac, artist. "Night Candle." Watercolor and pencil on paper, signed "Jean-Louis Kérouac," ca. 1957. 9" x 12.5". Berg Collection.

6.6 [Jack Kerouac], artist. "Van Gogh" / "La Marde." Pencil on paper, ca. 1957. 12" x 9". Berg Collection.

6.7 [Jack Kerouac], artist. [Young Man with Goatee]. Watercolor, oil, pastel, and pen on paper, ca. 1957. 11" x 8.5". Berg Collection.

6.8 Jack Kerouac, artist. "My Brunette." Pastel on paper, signed "Kérouac," ca. 1958. 17" x 14". Berg Collection.

6.9 Jack Kerouac, artist. "Man." Oil on paper, signed "Jean-Louis Kérouac," [1957]. 12.25" x 9.25". Berg Collection.

Suggested Reading

Adler, Ed. *Departed Angels—The Lost Paintings—Jack Kerouac*. New York: Thunder s Mouth Press, 2004.

Cassady, Carolyn. *Off the Road: Twenty Years with Cassady, Kerouac and Ginsberg*. London: Black Spring Press, 1990.

Cassady, Neal. *Collected Letters, 1944–1967*. Edited by David Moore. New York: Penguin, 2004.

Charters, Ann. *Kerouac: A Biography*. New York: St. Martin's Press, 1973, 1987.

Clark, Tom. *Jack Kerouac*. San Diego: Harcourt Brace Jovanovich, 1984.

Coolidge, Clark. *Now It's Jazz: Writings on Kerouac & the Sounds*. Albuquerque: Living Batch Press, 1999.

Johnson, Joyce. *Minor Characters: A Beat Memoir*. New York: Houghton Mifflin, 1983.

Kerouac, Jack. *Selected Letters, 1940–1956*. Edited with an Introduction and Commentary by Ann Charters. New York: Viking, 1995.

———. *Selected Letters, 1957–1969*. Edited with an Introduction and Commentary by Ann Charters. New York: Viking, 1995.

———. *Windblown World: The Journals of Jack Kerouac, 1947–1954*. Edited by Douglas Brinkley. New York: Viking, 2004, 2006.

Myrsiades, Kostas, ed. *The Beat Generation: Critical Essays*. New York: Peter Lang, 2002.

Nicosia, Gerald. *Memory Babe: A Critical Biography of Jack Kerouac*. New York: Grove Press, 1983.

Theado, Matt. *Understanding Jack Kerouac*. Columbia: University of South Carolina Press, 2000.

Acknowledgments

I wish to thank the following individuals for their special efforts on behalf of the book and the exhibition:

John G. Sampas, Executor of the Jack and Stella Kerouac Literary Estate, and the youngest brother of Kerouac's wife, Stella, for permission to quote and reproduce images from the Jack Kerouac Archive, and for his generosity in sharing his knowledge of Kerouac's work and life; H. George Fletcher, Brooke Russell Astor Director for Special Collections and head of the Exhibitions Program, for his support of the exhibition from its inception; Dr. Declan Kiely, former Berg Collection archivist and now Robert H. Taylor Curator of Literary and Historical Manuscripts at the Morgan Library, for his meticulous processing of the Jack Kerouac Archive and his finely detailed electronic finding aid, without which the book and the exhibition would have been much the poorer; Karen Van Westering, Manager of Publications, for coordinating the book-publication project both within the Library and with Scala Publishers; Barbara Bergeron, Editor, Publications Office, for her inspired and sure-handed pruning of a sprawling and complex text, and for her eagle-eyed editing of the exhibition texts; Joan Sherman, Professor Emeritus of English at Rutgers University and Berg Collection volunteer, for so carefully combing through Kerouac's diaries in search of entries about women and sexuality; Nina Schneider, Berg Collection Librarian, for, prior to the creation of the finding aid, compiling a list of *On the Road* proto-version fragments, and whose research uncovered a 1950 photograph of downtown Denver that appears in the exhibition; Philip Milito, Berg Collection Technical Assistant, for helping coordinate and supervise most of the book's photographic shoots; and David Lowe, Specialist, Photography Collection, for his assistance in finding the exhibition photographs that are drawn from that collection.

The Exhibitions Program Office: Susan Rabbiner, Manager of Exhibitions, for supervising and managing the complex logistics and finances of mounting the exhibition and displaying the *On the Road* scroll, and her staff, especially Jeanne Bornstein, Research Coordinator, and Kenneth Benson and Meg Maher, Assistant Research Coordinators, for handling many logistical aspects of the exhibition planning; Myriam De Arteni, Exhibitions Conservator, for her carefully executed treatments and her display guidelines, and her staff, Susan Fisher and Eric Kidhardt; Jean Mihich, Registrar, and Caryn Gedell, Associate Registrar, for arranging for the transport of the scroll to the Library; and Andrew Pastore, Installation Coordinator, and his staff: Patrick Day, lighting and installation; Andrew C. Gaylard, framing; and Thomas G. Zimmerman and Sarah Seigel, mounts fabrication.

Exhibition and Graphic Design: Roger Westerman, Exhibition Designer, for successfully implementing an imaginative and viewer-friendly design despite having to accommodate the bisection of Gottesman Exhibition Hall by sixty feet of the unfurled scroll; Kara Van Woerden, Senior Designer, Graphic Design Office, whose design motifs, creatively drawn from the exhibition's themes, graphically linked its sections and enhanced the ease and pleasure with which it could be navigated.

Volunteer Office: Maura Muller, Volunteer Coordinator, and the docents, who so eagerly shared their knowledge of the exhibition with the public.

About the Berg Collection

The Henry W. and Albert A. Berg Collection of English and American Literature was assembled during the first few decades of the twentieth century by Dr Albert A. Berg and his elder brother, Henry, renowned physicians at New York's Mount Sinai Hospital, and presented to The New York Public Library in 1940 by Albert, in his brother's memory. The original collection comprised highlights of the canon of English and American literature, numbering some 3,500 printed volumes and pamphlets by more than one hundred authors, as well as groups of prints and drawings. It has grown through purchase and gift to include some 35,000 printed items and 2,000 linear feet of manuscripts and archives, containing the writings and correspondence of more than four hundred authors, and thousands of photographs, prints, drawings, and paintings of and by them. In addition to the Jack Kerouac Archive, recent acquisitions include the archives of writers Paul Auster, William S. Burroughs, and Terry Southern. The Berg Collection's web page is accessible through The New York Public Library's Research Libraries website: www.nypl.org/research/.

About the Author

Isaac Gewirtz is Curator of the Berg Collection. The author of *"I Am with You": Walt Whitman's Leaves of Grass (1855–2005)*, he curated the Library exhibition of the same title, as well as the exhibitions *Victorians, Moderns, and Beats: New in the Berg Collection, 1994–2001* and *Passion's Discipline: The History of the Sonnet in the British Isles and America*. He has also been the curator of numerous exhibitions at other libraries and the author of several accompanying publications. Dr. Gewirtz received his Ph.D. in Renaissance History from Columbia University.

Index of Names